THE SPOKEN IMAGE

LEEDS COL OF ART & DESIGN

R31130X0084

The Spoken Image

Photography and Language

CLIVE SCOTT

REAKTION BOOKS

Published by Reaktion Books Ltd
79 Farringdon Road, London EC1M 3JU, UK
www.reaktionbooks.co.uk

First published 1999

Printed and bound in Great Britain by
Biddles Ltd, Guildford and King's Lynn

British Library Cataloguing in Publication Data

Scott, Clive, 1943–
 The spoken image: photography and language
 1. Photography, Artistic 2. Photography – Language
 I. Title
 778.9

ISBN 1 86189 032 X

Contents

Acknowledgements

I would like to express my warm gratitude to Julia Cazorla whose resourceful clear-sightedness did so much, against the odds, to make the pursuit of photographic permissions pleasurable and invigorating, and to Michael Brandon-Jones for his very helpful advice and photographic expertise in the preparation of negatives and prints.

My thanks also go to all who have supplied me with prints and transparencies, with permissions to reproduce images, or with both. Every effort has been made to track down and locate copyright holders.

<div align="right">C. S.</div>

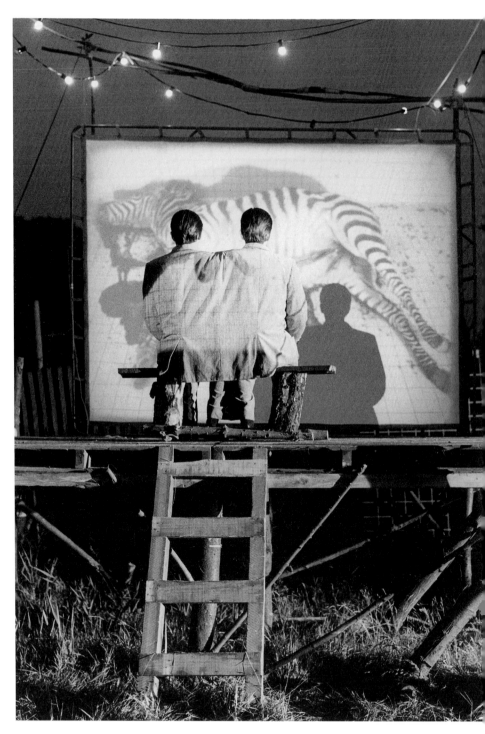

1 Still from Peter Greenaway's *A Zed & Two Noughts*, 1985.

Introduction

We are all aware of the photographic trap: to treat the photograph as if it were reality duplicated. To surrender to this illusion is perfectly understandable; the necessary co-presence of the photographer and the photographed in the photographic act ensures that the photographer 'was there', a witness at first hand; and the camera merely records the configurations of light reflected off objects put in front of it, mechanically and without censorship. But commentators have been quick to point out that the equation of photographic perception with human perception is built on very shaky foundations. Renaissance perspective is a *conventionalized* way of representing spatial relations, and the eye/camera analogy — which proposes that the retina is exactly like a photographic plate — is flawed because the retinal image is no more than the raw material of human perception; human perception is an active, ocular engagement in an environment over a period of time.[1] Photography, in other words, may be realistic in relation to other media which are, roughly speaking, subject to the same conventions (e.g. painting), but is not realistic in relation to human-eye reality. Realism is something our perceptual culture has educated, or persuaded, us into. But the *cultural* fact remains that photographs are believed to have evidential force and the ability to authenticate real events. Terence Wright suggests an elegant resolution:

> That a single photograph may display two or more indices of movement clearly suggests that any workable theory of photography must abandon the opposition of naïve realism and conventionalism. Instead we can propose a theory of 'natural correspondences' between the photograph and the perceived environment which operates in conjunction with pictorial conventions.[2]

However, the shifting history of perceptual psychology is only half of a problem whose other half is the photographic image's subsequent dissemination, circulation, presentation.

The photograph very quickly ceases to be the property of the photographer, and becomes subject to the often competing choices of other people; it is 'put to use'. These various interferences concern the photograph's generical placement (photojournalism, documentary, portraiture, reportage, etc.), its contexts of presentation, the rhetorical purposes it may be called upon to serve, and above all, perhaps, the language(s) by which it is accompanied. Max Kozloff makes the point with invigorating bluntness: 'However they are conceived, images have to be mediated by words';[3] and Victor Burgin reinforces the case:

> We rarely see a photograph in use which is not accompanied by writing: in newspapers the image is in most cases subordinate to the text; in advertising and illustrated magazines there tends to be a more or less equal distribution of text and images; in art and amateur photography the image predominates, though a caption or title is generally added. But the influence of language goes beyond the physical presence of writing as a *deliberate* addition to the image. Even the uncaptioned photograph, framed and isolated on a gallery wall, is invaded by language when it is looked at.[4]

We are familiar with manipulations of the image by cropping, air-brushing, montaging, digital 'remastering'[5] and so on; we are also familiar with the distortions effected by language, economies with the truth, the pre-empting of perceptual possibilities. But we are perhaps less familiar with the range of different kinds of linguistic accompaniment, and how these vary from genre to genre; and less familiar, too, with the expressive implications of the syntax and punctuation which characterize these linguistic accompaniments. These are the essential concerns of Part I of this book.

Part I shares some of the concerns of Mary Price's *The Photograph: A Strange, Confined Space* (1994).[6] But although Price is concerned to show how 'the language of description (be it title, caption, or text) is deeply implicated in how a viewer looks at photographs' (blurb), she does not attempt to differentiate linguistically between different types of description, nor to investigate the

linguistic structures employed in those descriptions. Her interest lies principally in a certain vocabulary, in certain metaphors, by which photography is characterized, and these are fascinatingly woven around a sustained critique of Walter Benjamin's photographic writing.

More pertinent to my enterprise here are remarks made by Peter Wollen in his suggestive essay 'Fire and Ice' (1989), where he briefly refers to the presiding linguistic models used in titles and captions, and speculates about their relation to genres or to particular photographers:

> News photographs tend to be captioned with the non-progressive present, in this case a narrative present, since the reference is to past time. Art photographs are usually captioned with noun-phrases, lacking verb-forms altogether. So also are documentary photographs, though here we do find some use of the progressive present. The imperfective form is used more than usual, for example, in Susan Meiselas' book of photographs, *Nicaragua*. Finally, the imperfective is used throughout in the captions of Muybridge's series photographs, in participle form.[7]

I am interested not in testing the statistical truth of Wollen's observations but in following them up, by looking at the grammatical and syntactical characteristics of titles and captions in certain photographic genres.

Chapter 1, 'The Nature of Photography', explores the relative distances and proximities between language and the photographic image, by tracing the 'life' of a photograph through C. S. Peirce's semiological categories of index, icon and symbol. The Peircean categories have long been applied to photography, but with disagreement, and without a proper exploration of the relation between them. I try to express the relation as a progressive (or regressive) one, an itinerary that different genres of photography may undertake in different directions. Chapter 2 considers some of the ways in which photographs interact with their titles and captions, while making a distinction between these two terms; ultimately it argues that photographs are semantically richer the more 'speechless' they are. Chapter 3 examines the different languages used to present documentary photography, and centres this general investigation on the work of Don McCullin. Chapter 4 looks at the activity

of captions in newspapers (on a specific day in July 1993), and how their syntactic structure affects the way we respond to the photographs and their 'news'; here, for example, attention is paid to what is insinuated by the use of colons and suspension points. Chapter 5 turns to fashion photography, to the different layers of language that accompany the fashion photograph and the way in which these complicate the reader's relation to the photograph itself; we also discover how adjectival strings equate with the fashion notions of 'combination' (matching, teaming) and the 'accessory'.

Throughout these chapters, the emphasis is squarely on photographic genres in their contemporary guises. No attempt is made to trace either the history of the genres concerned or the history of the relationship between the visual and verbal in the world of photography. The purpose of this book is to provide the 'consumer' of photographic images with a means of integrating linguistic awareness into photographic response, that is, into a response principally to *current* photographic sources. It is intended that this 'integration of linguistic awareness' should also provide the reader with methods and tools of analysis, features to look out for, and ways of transforming data into interpretation. In short, and in the book as a whole, I have concentrated not on contexts of production but on aspects of the context of reception, of reading; not on social backgrounds but on psycho-perceptual mechanisms; not on histories of relationship – between high and low cultural forms of photography, for instance – and development, but on encounters with individual images and works, in their own space as it were. Of course, history intervenes, because I have not tried to keep it out; but it does so unsystematically and untendentiously.

Throughout Part I, I have made occasional reference to literary texts, not only because writers are often photographers (e.g. Zola, Shaw, Tournier, Guibert), but also because our assessment of photography, and in particular our ways of talking about it, are often generated by literature: for example, even when they are writing about photography, Benjamin, Sontag and Barthes remain essentially literary critics. Equally, in Chapter 3, I have used Hitchcock's *Rear Window* as an allegory of documentary photography, because the filmic and the photographic have closely intertwined destinies, share a medium and inevitably reflect upon each other. This reciprocal, and often mutually corrosive, scrutiny is

particularly evident in films that investigate the making of narrative; this is why Greenaway's *A Zed & Two Noughts* and Antonioni's *Blow-Up* are crucial to the concerns of Part II.

If Part I explores the photographic image's harassment by, and frequent subjection to, language, Part II moves in the opposite direction, and considers the capacity of the photograph to match, complement and even supplant language in narrative enterprises. The seeds of this particular proposition have already been sown in Chapter 2.

Chapter 6 presents a study of Peter Greenaway's *A Zed & Two Noughts*, as a way of dramatizing the relationship, and exploring the ground, between the photographic and the filmic (and, indeed, the painterly). This chapter implicitly advances the argument that, of all modern visual media, film is the one best equipped to handle (post)modern narrative, an argument explicitly questioned in Chapter 10. Just as *Rear Window* provided an allegory for documentary photography, so *A Zed & Two Noughts* fulfills this function for narrative photography. One of the compromises between the filmic and the photographic, the magazine photo-story, is the subject of Chapter 7. While the photo-sequences of the photo-story devalue the expressive and narrative power of the individual image, making this particular solution to photographic narrative seem peculiarly gauche, an attempt is made to retrieve from it a social and existential subtext by which the genre might be explained, particularly in relation to its teenage readership. Chapter 8 examines the narrative potentialities of the single and compound photograph, and the ways in which various photographers and photographic genres have tried to overcome the medium's narrative limitations.

This discussion acts as a prelude to Chapter 9, an investigation of the collaborative work of John Berger and Jean Mohr, which progresses from a belief in the indispensability of language to photographic narrative (*A Fortunate Man* and *A Seventh Man*) to the discovery of narrative versatility in the photo-sequence alone. Nevertheless, Berger and Mohr's thinking about photography as 'another way of telling', independent of language, is still underpinned by a linguistic theory of photography. In conclusion, Chapter 10 briefly considers other examples of the photo-sequence (by John X. Berger and Victor Burgin), in which photography, no longer dependent on text for its ability to speak, can turn to

text/language as to a partner (and possible competitor) in the game of meaning. In this game, in which the score is constantly lost or erased, and in which the players are likely to change the rules as they go along, no result is to be expected. The chapter closes by returning to that other game with which Part II began, the game between the photographic and the filmic, with language as the ball-boy. An analysis of Antonioni's *Blow-Up* explores the protagonist's inability to become a true protagonist, seeing this as exemplary of the modern narrative predicament. The earlier part of the chapter, however, has already shown that the filmic has no monopoly of this kind of telling.

Photography is such a fluid, mobile, unstable medium, so diverse in its applications, that any writer who takes it as a subject should avoid being too categorical about any aspect of it. In various writings, for example, Benjamin makes a distinction between painting and photography based on the indispensable activity of the practising hand in the one, and the absence of handwork in the other.[8] This distinction is also part of David Hockney's thinking about photography.[9] But many photographers would argue, I am sure, that the finger which releases the shutter is an essential instrument of the photographer's deep psycho-physical involvement with his subject, and the co-ordination of eye and finger in the taking of a photograph is quite as complex as that called upon in drawing, even if very different in nature. A study of the history and changing significations of the handling of cameras has yet to be written; we can only speculate about its possible findings. Nevertheless, it remains inevitable that anyone who essays a typification of photography, or a classification of photographic species, must commit themselves to argumentative positions that engage with the categorical. If photography is to be thought about at all, these gambles must be taken, and I have certainly not resisted them. I would, therefore, exhort the reader to treat confident assertions with the utmost circumspection, and consider them as the necessary staging posts of the thinking process.

Titles and Captions

ONE

The Nature of Photography

A recurrent question about photography is how much self-expression it allows the photographer. There are two standard positions, each corresponding to a different location of photographic skill. The opposition is neatly summed up in Bioy Casares's novel *The Adventures of a Photographer in La Plata* (1989). The hero Nicolasito Almanza declares: 'I am convinced that all of photography depends on the moment we press the release [...] I believe that you're a photographer if you know exactly when to press the release.' In making this declaration he is responding to the opinion expressed by Mr Gruter, owner of a photographic laboratory: '[...]sometimes I wonder if the true work of the photographer doesn't begin in the dark room, amid the trays and the enlarger.'[1] Roughly speaking, then, the first version maintains that the photograph 'happens' in the act of taking, in visual contact with the world, which exercises the photographer's ability to see *into* his environment, to anticipate, to intuit oncoming revelation or significance in his surroundings; the second version, on the other hand, implies that the taking of the photograph is only the necessary bridge between the creative interventions of the pre-photographic and the post-photographic.[2]

In the first version, self-expression means responsiveness to the circumambient 'dynamic', an empathy with it that endows the perceiver with a special visual sensitivity to the scene's subtlest nuances and fluctuations. Self-expression thus lies in the *taking* of an expressive image, not in any imposition of self on scene; in other words, 'subjectivity' is not conceived as an egoism out to appropriate the world but as a rare capacity which seems passive but is in fact an active inhabitation of, or co-operational relationship with, the living environment. The notion of the camera itself, reduced to a 'sensitive plate', expresses this state of active availability to one's surroundings.

The art of this first version lies principally in seeing and in capitalizing upon chance. As far as the latter is concerned, we might

argue as follows: given that the speed of the shutter is what marks photography off from all other visual media, chance is crucial to any 'aesthetic', and indeed any expressivity, associated with photography, even at its most deliberately posed. In this regard, photography has aesthetic affinities with Surrealism,[3] for the Surrealists not only looked upon chance as the instigator of images – with the implication 'the greater the element of chance, the more suggestive, the more profound the image' (one thinks particularly of the Surrealism's founding image, culled from Lautréamont's *Les Chants de Maldoror*: 'He is beautiful [...] like the *chance encounter*, on a dissection table, of a sewing machine and an umbrella' (my italics);[4] they also believed in 'le hasard objectif' ('objective chance'), that magical way in which external reality often fulfils the desires and impulses projected into it, a preordained coincidence. As a photographer, Edouard Boubat explains, one must be prepared to be surprised by chance: 'I am surprised by the photos I find. *I* don't make the landscape. It's already there. I'm all the more surprised because I don't do anything. All you have to do is open your eyes and release the shutter from time to time.'[5]

Skill, then, lies in the ability to surprise chance, to anticipate it. Ultimately though, one needs both capacities, the reactive and the anticipatory. In Guy Le Querrec's words: 'I would like always to be available: available to be surprised by what I didn't expect and sharp enough to recognize what I expected. Two different kinds of surprise [...]. The important thing is to succeed in taking those photos which confirm my feeling about life.'[6] If the Surrealist courts the 'merveilleux quotidien' ('the magic in the everyday'), a photographer such as Lartigue seeks to 'attraper l'émerveillement qui passe' ('to capture the passing wonderment'),[7] and photographers are best able to provoke reality into providing moments of revelation by being emotionally attuned to their surroundings – as Guy Le Querrec implies, emotion passes through the eye – and totally assimilated into them, so that no self-awareness in the environment inhibits its spontaneous self-expression. But the photographer, of course, also has to be able to see.[8] Photographic seeing itself follows two different persuasions: (1) the eye of the photographer is an SLR camera, the brain the film, so that his camera merely registers what he has already seen (this would be the view,

for example, of Le Querrec, Cartier-Bresson or Lartigue: 'it is not the camera which takes the photo, it is the eyes, the heart, the stomach, all that');[9] (2) the camera is a different kind of seeing, and the photographer has to learn what its eye will reveal, can reveal, in those split seconds which elude us, which, with our lazy and selective optical habits, we always miss. Walter Benjamin calls the place in visibility peculiarly occupied by the camera 'the optical unconscious':

> It is a different nature which speaks to the camera than speaks to the eye: so different that in place of a space consciously woven together by a man on the spot there enters a space held together unconsciously. While it is possible to give an account of how people walk, if only in the most inexact way, all the same we know nothing definite of the positions involved in the fraction of a second when the step is taken.
>
> Photography, however, with its time lapses, enlargements, etc. makes such knowledge possible. Through these methods one first learns of this optical unconscious, just as one learns of the drives of the unconscious through psychoanalysis.[10]

The eye of the camera sees an alternative, parallel, or imbricated reality to which we must accustom ourselves, for the camera is the eye of modern technology, and this is the eye we must adopt if we are not to become 'the illiterate' of the twentieth century. This was the programme pursued by Moholy-Nagy, and the new kinds of vision he attributes to photography are: abstract seeing (photogram), exact seeing (reportage), rapid seeing (snapshots), slow seeing (prolonged time exposures), intensified seeing (micro-photography, filter-photography), penetrative seeing (radiography), simultaneous seeing (transparent superimposition) and distorted seeing (optical jokes).

What then interferes most with photographic seeing? Perhaps we should mention just three things for the moment. First, seeing is interfered with by the intrusion of function, and most particularly by that function of photography which is, precisely, to supplant seeing: 'Most tourists feel compelled to put the camera between themselves and whatever is remarkable that they encounter. Unsure of other responses, they take a picture. This gives shape to experience: stop, take a photograph, and move on.'[11] As an instrument of mental 'tourism', the camera colonizes reality, takes possession of it, turns

it into the impotence of image, something without the right of reply, something subservient to the photographer's gaze. Photographs of this kind do not relate to the present in which they are taken, but to the future in which they will be viewed, the future of the album or slide-show. At the same time, paradoxically, the photographer can use the photograph to authenticate experience.

The second factor of interference lies in the degree to which the photographer is identified by his/her subject (and therefore specifically reacted to, prevented from seeing), or unidentified (and therefore free to see, to capture the spontaneous, but also invasive, deceitful, voyeuristic). Nowhere is the dilemma greater than in the highly moral universe of documentary photography (see Chapter 3). The ideal would seem to be 'identification as a photographer, but total social assimilation', a mixture that many photographers would like to feel was achievable, but about which one cannot but be sceptical. Brassaï in the Paris underworld had typical ambitions: 'But it was very difficult to overcome their distrust of me. Despite the [popular dance-hall] owner's acceptance, in the eyes of some of them I was still an informer. What I wanted was for the suggestion to take photographs not to seem to come from me, but from them.'[12] Some believe that the subject's awareness of the photographic act produces an emotional exchange peculiar to it and valuable for that very reason:

> For a long time I sneaked my photographs; that is, took them unknown to whomever I was photographing [...] But it's really only a second-best, and I realize now that, terrifying as it may seem, a confrontation with the person photographed is always preferable. For it's a good thing for the actual taking of the snap to be reflected in one way or another in the face or attitude of the subject: as surprise, anger, fear; amusement or flattered vanity; buffooning or obscene or provocative gesture.[13]

The final factor that interferes with seeing is, of course, language. Photographs of the kind we are discussing are pre-linguistic, a 'truth' of vision before it has achieved formulation. If we wish to take this journey in reverse, to return to that freshness of vision associated with the pre-conceptual, pre-interpretative, then language must be forcibly stripped away. Paul Theroux's Maude Pratt (*Picture Palace*, 1978) expresses it thus:

The beauty of photographs, I told those publishers, was that they required no imagination. They took your breath away, dragged you under and kept you there. The written word was just a distraction, and anyone who wrote about pictures was just showing off. No one got fat reading about food – he just got hungry.[14]

What Maude's final sentence proposes is that a photograph is its own reality, has its own autonomy which words can only cast in doubt. But Maude is already taking us several steps from our first vision of the photograph, and towards the second, for the kind of photograph she is speaking of is already an image in its own right, a reality in its own right, and no longer the record and certification of a contact with that other environment we call 'reality'. And though she speaks of language as an irrelevance, she can at least imagine that words provide the viewer with an appetite for the viewed. As we shift, then, from our first version of photographic art to the second, we shift from contact or record to image.

The second version affirms that self-expression can infiltrate the photographic process potentially at all points where choice is involved – angle of vision, b/w or colour, *cadrage* (framing), shutter speed, focal depth, printing paper, etc. In other words, the ability to express oneself as a photographer is proportional to one's mastery of photographic technology, and this may lead to an equation of self-expression with photographic experimentation (a photomontage can be more self-expressive than a family snap). *Photographic Tricks Simplified* (1974) makes this position clear:

> So-called 'straight' or documentary photographers might well ask, 'What is wrong with reality realistically presented?'. The answer is simply enough, 'Nothing'. Realistic and documentary photography have served as invaluable recording and informational tools for well over a century. But in recent years, adventuresome, creative photographers have begun to experiment with their medium just as painters of the late 19th century broke away from the tradition of representational painting to explore the varied avenues of abstract art.[15]

So lenses, filters, multiple exposure, panning, racking, paper grain, reticulation, solarization, photogram, cropping, flopping, etc. constitute the vocabulary of the photographer, a vocabulary he puts

together to create a language all his own, an idiolect. Photography is not bound by any obligation to reality; like any other art, it is a set of resources which can be put to a variety of uses, and out of which a style can be forged. The quotation above imagines, for its own benefit, that there is such a thing as a 'neutral' photography, even though the logic of its own 'creative' claims would necessarily imply that such a thing is impossible, since even 'neutrality' is a choice. Since documentary photography is low on the scale of experiment or avant-gardism, it follows not only that it is less expressive, but that – in much the same way as a family snap – it fails to exploit the technical versatility of the camera. Nevertheless, the expressivity of a photograph is much more likely to be found in appropriateness of means than in virtuosity.

The anonymous writers of *Photographic Tricks Simplified* assimilate photographic experimentalism to avant-gardism in painting. This reveals one of the many paradoxes within photographic thinking: the technology which should liberate photography from painting – painting's own technology is primitive and very slow-moving – is used to argue for photography's 'painterliness'. This leads to the proposal that those such as documentary photographers, photojournalists and family snappers who resist the painterly in photography, its 'image-making', 'visual design' and 'selection and abstraction' aspects, and instead cultivate its immediacy, the directness of its referentialty, are furthest from the peculiar spirit of photography. And yet Benjamin bemoans the fact that the time photography spent pleading its cause in the courts of the fine arts was spent pleading a cause that was not its own.[16] It is the visual arts that have provided photography with its generical structure and many of its compositional conventions, and this is, after all, not surprising. The camera developed out of the draughtsman's technical aid (the *camera obscura*),[17] and many early photographers were refugees from the fine arts. The photograph supplanted many of the functions of art, for example society portraiture (the miniaturists) and the provision of realistic records (architecture, the *métiers*, tourism), and at the same time perpetuated many of the visual 'codes' of post-Renaissance Western art: the rectangular (or oval) frame, the distinction between black/white and colour, Renaissance perspective, the flattening effects of monocular vision and fixed focus.

But these confusions in thinking about the relationship between photography and painting are no different from the confusions about whether the photograph is coded or not. Frank Webster (1980) believes that in speaking of photography as uncoded, visually innocent, passively referential, we are deceiving ourselves:

Against this tendency it is important to perceive photography as a *selection* and *interpretation* of the world in two respects. First, from the point of view of the photographer who selects and interprets a scene or incident in the process of encoding an image. Second, from the perspective of a viewer who interprets (reads) the photograph in the process of decoding. This orientation views the photographic communication as an active process of interpretation, by both the creator and the viewer.[18]

This would also appear to be the view of John Berger:

Every image embodies a way of seeing. Even a photograph. For photographs are not, as is often assumed, a mechanical record. Every time we look at a photograph, we are aware, however slightly, of the photographer selecting that sight from the infinity of other possible sights.[19]

And yet, in *Another Way of Telling* (1982), his view seems to have shifted a little, taking photography towards the uncoded. Here he speaks of the photograph as a 'quotation' from appearances, rather than being the 'translation' of appearances that drawing is;[20] and the photograph can only quote because it has no language of its own, because 'its figuration is not impregnated by experience or consciousness'.[21] In saying this, Berger is consciously harking back to Roland Barthes's essay 'The Photographic Message' (first published 1961), in which he argues that the photograph is a message without a code or, rather, full of the codes of its subject matter, but without a code as a medium.[22] And yet Barthes's work moves, if anything, in the opposite direction, towards the view that the photograph is after all coded, that the principal distinctions between the artistic media are distinctions of degree and emphasis; what photography depicts, whether coded or uncoded, is time, not an object:

The realists, of whom I am one and of whom I was already one when I asserted that the Photograph was an image without code

– even if, obviously, certain codes do inflect our reading of it – the realists do not take the photograph for a 'copy' of reality, but for an emanation of *past reality*: a *magic*, not an art. To ask whether a photograph is analogical or coded is not a good means of analysis. The important thing is that the photograph possesses an evidential force, and that its testimony bears not on the object but on time. From the phenomenological viewpoint, in the photograph, the power of authentication exceeds the power of representation.[23]

Barthes pirouettes out of a tight spot. It would be ridiculous to deny that, in our 'practical' experience of photographs, the sense of directness of contact with the subject is the source of photography's power to 'speak'. And Barthes's development of the notion of *punctum* (the unpredictable penetration of the spectator by a particular visual detail) is a strategy to outwit the process of codification, which takes place in the establishment of *studium* (shared cultural information of 'average' interest): however conventionally (symbolically) readable a photograph may be, it cannot fully suppress a certain lack of mediation, and this anarchic, self-imposing aspect becomes laceratingly manifest in the *punctum*, the pre-linguistic and language-denying moment of visual contact with the photographed subject. The *punctum* of Barthes's *Camera Lucida* is a later version of the notion of 'trauma' he developed in 'The Photographic Message':

> Is this to say that a pure denotation, a *this-side of language*, is impossible? If such a denotation exists, it is perhaps not at the level of what ordinary language calls the insignificant, the neutral, the objective, but, on the contrary, at the level of absolutely traumatic images. The trauma is a suspension of language, a blocking of meaning. Certain situations which are normally traumatic can be seized in a process of photographic signification but then precisely they are indicated by a rhetorical code which distances, sublimates and pacifies them. Truly traumatic photographs are rare, for in photography the trauma is wholly dependent on the certainty that the scene 'really' happened: *the photographer had to be there* (the mythical definition of denotation).[24]

We do not have to limit Barthes's notion of trauma to encounters with catastrophes, shipwrecks and violent death – any encounter with

reality which is direct enough, 'shocking' enough, to leave us speechless will qualify. And 'trauma' relates to another mode of meaning developed by Barthes in his essay 'The Third Meaning: Research Notes on Some Eisenstein Stills' (1970), namely 'the obtuse meaning':

> The obtuse meaning is a signifier without a signified, hence the difficulty in naming it. My reading remains suspended between the image and its description, between definition and approximation [...] The pictorial 'rendering' of words is here impossible, with the consequence that if, in front of these images, we remain, you and I, at the level of articulated language – at the level, that is, of my own text – the obtuse meaning will not succeed in existing, in entering the critic's metalanguage.[25]

Barthes the semiologist is tirelessly at work to preserve something which escapes signification, which resists assimilation by language, and which cannot be said to have an objective existence, even though the spectator experiences it as a 'penetrating trait'.[26]

Punctum,[27] trauma, obtuse meaning, all these kinds of experience of the visual relate to our first version of photographic expression, to a direct physical connection, which may also turn out to trigger an involuntary memory, or some other deeply embedded association, as we shall see. The experience of trauma etc. is highly individualized, subjective, unshareable (pre-linguistic and therefore incommunicable). Barthes's *Camera Lucida* does not contain the photograph around which the whole text revolves (his mother as a young girl, in a winter garden setting) because no reader could see the photograph as *he* does; it would inevitably acquire a meaning beyond trauma, a *studium* rather than a *punctum*. Moreover, if Barthes chooses a photograph of his mother as he never knew her, as a young girl, it is because no conventional modes of recognition interfere, there is no distraction by either the need or the ability to locate the photograph, to understand it as a *shared* experience: Barthes sees a woman he has not seen before, and the shock of personal discovery and deep recovery is that it is his mother.

These kinds of confusion about the nature of the photograph – between the painterly and the non-painterly, the coded and the uncoded – and the proliferation of a terminology in an effort to describe the properly photographic effect, derive largely from the

continued assignment of photography to the semiotic category reserved for painting, the iconic; Katie Wales, for example, treats the photograph as an iconic sign: 'An obvious kind of resemblance, and most common, is the visual one, and examples of iconic signs would be photographs, certain map symbols and road signs, all with varying degrees of iconicity depending on the "accuracy" of representation'.[28] But to speak about the relative 'accuracy' of photographic representation seems to many modern commentators to overlook the fact that, whatever its conventions/codes, the photographic image is produced by reality itself, by the light patterns reflected off the subject. The referent (subject) is not so much the signified (representation) of a signifier (photograph) – it is already imprinted in, burned into, the signifier. In *The New Photographer* (1980), Frank Webster quotes from Larkin's poem 'Lines on a Young Lady's Photograph Album' (*The Less Deceived*, 1955), which not only distinguishes photography from art, but insists on photography's empirical truth:

> But o, photography! as no art is,
> Faithful and disappointing!
> [...]
> How overwhelmingly persuades
> That this is a real girl in a real place,
>
> In every sense empirically true!

Nevertheless, he concludes, 'Photography is, to adopt the terminology of semiology, an "iconic" mode of signification.'[29]

Larkin's poem uses 'forms of stylization or eighteenth-century artifice' and 'rhetorical flourishes' to 'mount a defense against naked feeling and supply a foil for or a contrast to picture taking', as Jefferson Hunter points out.[30] What we are left with, however, is a sense of photography's ability to disempower language, to be so undeniable that language cannot negotiate with it, cannot bend or belittle its evidence. We shall surely have to examine the proposition that because it is framed, past, locked out of continuity, impervious now to any 'blind field' (the extension of space and time beyond the photographic frame), the photograph endows its subject with a peculiar sovereignty, as well as vulnerability; that the subject enters into possession of the photo; that the interested or implicated

viewer can himself be subjugated: 'From every side you strike at my control,' as Larkin puts it (this will be a central concern of Chapter 3). The inevitable pastness of the photo is, to Barthes, the source of its innate melancholy; photographs *seem* to give us what, in fact, they dispossess us of. By the same token, however, they may arouse our jealousy, or desire, because they also *restore* to the subject a past we may not be privy to:

> In short, a past that no one now can share,
> No matter whose your future ...

Larkin's exploration of this emotional state leads him to remark, with a striking prescience:

> Or is it just *the past?* Those flowers, that gate,
> These misty parks and motors, lacerate
> Simply by being over ...

These words take us straight to Barthes's *punctum*, the laceration of the spectator by a detail, or by the very pastness, the 'that-has-been' of the photo. And it is Barthes who most clearly makes the point that photography does not belong to the iconic, but to the indexical: 'I call "photographic referent" not the *optionally* real thing to which an image or a sign refers, but the *necessarily* real thing which has been placed before the lens, without which there would be no photograph.'[31]

The index, in the sign-system developed by the American semiotician C. S. Peirce (1839–1914), whose *Collected Papers* (8 vols) were published between 1931 and 1958, is the sign in which the relationship between sign and object, or signifier and signified, is one of causal, sequential or spatial contiguity. Just as the finger actually, physically, points to its object, so smoke is an *index* of fire, a weathercock of wind direction, slurred speech of drunkenness. The photograph is related to its subject or referent by physical contiguity; the camera must be *present* to its subject; one cannot exist without the other's being there too.

The icon, on the other hand, presents a relationship of resemblance or imitation, not a record; the icon need not be present to what it represents, it can be an imaginative, and imaginary, reconstruction. Although a painting or diagram may seem to mirror

the referent, in the way that a photograph does, there is always an element of transformation (i.e. of coding) added to the element of likeness. This may be some distortion or redistribution of actuality (imagined or copied), but it will always include the intrusions of style (of individual or genre).

Many would perhaps argue that the distinction between index as the sign of photography and icon as the sign of painting is a fundamental, ontological one. What is important is that the indexical view of photography moves its essential being from the image produced ('second version' of photographic art) to the act of taking the photograph ('first version'); and those hordes of happy snappers represent photography's real function much better than the few art photographers whose work ends up in galleries. What further arguments can one adduce for this radical differentiation?

First, we might propose that the indexical nature of photography is borne out by the location of the notion of authenticity, in comparison with its location in painting. In the sequence: (a) subject/referent <—>(b) camera <—> (c) photographer, the guarantee of authenticity lies between (a) and (b). In the sequence: (a) subject <—> (b) painting <—> (c) painter, the guarantee of authenticity lies between (b) and (c). In photography, 'faking' means changing the relationship between (a) and (b); whereas in painting changing means maintaining an authenticity (pastiche, parody, imitation, adaptation). In painting, 'faking' means reproducing the relationship between (b) and (c), copying exactly; whereas in photography, reproducing means maintaining an authenticity (further prints from the same negative).

Second, one might maintain that it is only in the taking of a photograph that those features peculiar to photography, features that it does not share in any way with painting, are active. We have already had occasion to refer to photography's dependence on light from an external source and on the necessary presence of the subject/referent. As early as 1859, Baudelaire was complaining about photographers' attempts to depict historical scenes:

> Strange abominations manifested themselves. By bringing to-
> gether and posing a pack of rascals, male and female, dressed up
> like carnival-time butchers and washerwomen, and in persuading
> these 'heroes' to 'hold' their improvised grimaces for as long as

the photographic process required, people really believed they could represent the tragic and the charming scenes of ancient history.[32]

Photography, because of the presentness of its referent, can only be history, it cannot represent it; or, put the other way round, it can represent the anachronistic, but cannot be anachronistic. Oscar Rejlander's *Two Ways of Life* (1857), a combination print of 30 negatives, may work as an allegorical *tableau vivant* but certainly would not convince as a documentary image of the Roman world. It is not surprising that his disciple Henry Peach Robinson abandoned historical photography: 'Photography can only represent what is before it [...] [This saying] clears off all the past, the dead, and gone, and vanished [...] Much is denied to us in poetry, history and legend.'[33] If painting has the power to make the past present to us, photography may only do the reverse.

A third factor is the instantaneity of the shutter release. Certain choices may precede this moment, but at this moment the shutter dictates; the pre-digital photographer can only 'revise' the image in very limited ways and even then the photograph is an unavoidable given. The camera makes the *instant* available to us, as opposed to the moment (see below); in doing this, it seems to oust duration, the sense of the ongoing, from the image.[34] Instantaneity is what creates the photographer's special relationship with chance, or fosters the development in the photographer of those empathetic or intuitive skills which allow chance to be anticipated. Instantaneity also has connections with spontaneity and with the indexical photo's capacity to capture the photographer's subjectivity. The family snap would have no value if it were not firmly embedded in a specific instant of history; and the specificity of that instant is the irrepressible impulse to photograph it, the *sign* of the photographer's inner need to express his subject. Instantaneity also lets loose what we have called, following Benjamin, the 'optical unconscious'. If one justification for photography is that it makes visible things we do not normally see – the momentary passage of an emotion across the face, the mechanics of locomotion or the swing of a golf club, the half-concealed corpse (*Blow-Up*, see Chapter 10) – then instantaneity is the key to this visible but unseen (unseeable) world.

While our vision, through the habits of convenience and ease, generalizes, summarizes, elides, the camera compels us to look at everything with a non-discriminating, non-opportunistic eye. The photograph, particularly in its early, grainy, paper-printed forms, often found that detail was not a forte, that the dramatization of light contrasts compensated for this absence; and it is true that from the earliest days, the imperfections of the technology encouraged the promotion of the painterly 'théorie des sacrifices'. Delacroix noted in his *Journal* (1 September 1859): 'The photographs which capture more are those in which the very inability of the process to render things in an absolute way, leaves certain gaps, certain "rests" for the eye, which allow it to concentrate on a restricted number of objects.'[35] This principle became central to the theoretical writings of P. H. Emerson (1856–1936), and modern photographic commentators advising about visual design pay much attention to the processes of selection and abstraction.[36] The fact remains, however, that we might identify 'unselective seeing' as a fourth feature peculiar to the camera (though not to the photographer), and it is the insistence of non-motivated detail – detail not motivated by aesthetic, expressive, didactic purposes – in the photograph which justifies the discovery of *punctum*, and against which we can measure the 'candour' of photography's contact with reality.

The fifth feature of photography which relates specifically to the taking of the photograph is its inbuilt amateurism. We are all familiar with the Kodak slogan 'You Press the Button. We Do the Rest', which accompanied the introduction of the box camera, roll film and industrial processing in the late 1880s. To suggest that, while the painter needs to acquire the skills of his trade, the photographer does not, is to put the opposition too categorically; but the fact that photography has a peculiar relationship with chance, and that the 'realization' of the photograph can be undertaken by someone other than the photographer, do constitute real differences:

> Usually the amateur is defined as an immature state of the artist: someone who cannot – or will not – achieve the mastery of the profession. But in the field of photographic practice, it is the amateur, on the contrary, who is the assumption of the professional: for it is he who stands closer to the *noeme* [meaning] of Photography.[37]

Before turning aside from this set of features, we should return briefly to the notion of authenticity. In his treatment of the indexical nature of photography, Philippe Dubois picks out characteristics of the photograph which relate to authenticity and which set photography's authenticity apart from that of the practising artist (originality, stylistic idiom, authorship, signature). These are: attestation (bearing witness to the existence of what is photographed – the identity photo); designation (photographs point things out without affirming anything about them); singularity (the photograph's referent is unique and happens only once – it can be reproduced but not repeated). Growing out of the consideration of these characteristics is Dubois's assertion that the 'meaning' of the photograph is, in the first instance, pragmatic rather than semantic; that is to say, its primary sense is its reference.[38] As a further means of consolidating the indexical nature of the photograph, we might point to some of the functions that we ask photography to perform, functions peculiar both to photography and to the taking of the photograph. Many family snappers and touristic photographers would argue that the photographs they take, far from being substitutes for experience, are *aides-mémoire*, that photographs are not themselves memories but triggers of memory. We shall investigate this proposition further in Chapter 8; suffice it to say here that this function, in which the photograph says simply 'This happened' and not 'This means . . .', tends more towards the indexical than towards the iconic.

As a symptom of the modern malady of exclusively ocular relationship, the photograph is also significant as 'taking'. Voyeurism is looking through the camera, through a frame, through a window, isolating and fetishizing, breaking down responsibilities connected with the *continuity* of experience and one's *own visibility*; the camera, one comes to believe, conceals the photographer. This myth of invisibility has different repercussions for the photojournalist. If Baudelaire objected to the photograph's attempt to colonize the territory of historical representation, he also derided its immediate cultivation of the pornographic:

It was not long before thousands of pairs of greedy eyes were glued to the peepholes of the stereoscope, as though they were the skylights of the infinite. The love of obscenity, which is as

vigorous a growth in the heart of natural man as self-love, could not let slip such a glorious opportunity for its own satisfaction.[39]

The stereoscope is the perfect simulacrum of the camera, a piece of equipment which allows the viewer to isolate and insulate himself, to seem to manipulate the visible. And the voyeuristic option relates immediately to the function of the camera as a means of taking possession of the photographed, here graphically described by Michel Tournier:

> For it is plain that photography is a kind of magic to bring about the possession of what is photographed [...] One cannot avoid a comparison with the painter, who works openly, patiently and patently laying down on the canvas, stroke by stroke, his own feelings and personality. The act of photography, on the other hand, is instantaneous and occult [...] The artist is expansive, generous, centrifugal. The photographer is miserly, greedy, and centripetal. In other words I am a born photographer. As I don't possess the despotic powers to procure me actual possession of the children I've decided to get hold of, I make use of the snare of photography.[40]

But for all this evidence, the distinction photography = index vs. painting = icon is clearly inadequate. The emergence of photography as indexical is traced by Dubois[41] as a historical shift in critical perception (photography as mirror of real > photography as transformation of the real > photography as trace of the real), a change of critical emphasis rather than of the photograph's nature. But we clearly need an account of photography which subsumes both the first and second versions of photographic art which were outlined at the beginning of this chapter. A more accurate view might be: the photograph is both indexical and iconic[42] in the following senses: (1) the photograph has a large dose of the iconic from the outset; (2) all photographs, individually, become images, move from the indexical to the iconic, without, however sacrificing their indexicality; (3) phot-ography as history, that is, the corpus of all photographs ever taken, follows an itinerary from the indexical to the iconic, without, again, jettisoning indexicality. Viewed from this perspective, the recent critical focus on the indexical is an attempt to combat this ubiquitous drift, and to re-establish, if not

the essential nature of photography, at least its primal, primordial condition.

It is not difficult to deal with (1), which applies to the photographer who in taking a photograph is already making an image. This involves maximizing decision prior to the shutter release – choice of subject, lens, filter, film, angle, proximity, etc. – and minimizing chance (more 'pose', less instantaneity, etc.). The resulting photograph is a record not of reality but of a set of judgements made in front of reality.

And about category (3), photography as history, little need be said. With the passage of time, photographs gradually lose their indexical reliablility – we cannot say exactly what the circumstances of their taking were – and thus are compelled to fulfil a representative role. Individuals can recover trauma and *punctum* from them, but this is all that is left of their originating indexicality. Correspondingly, their generalized, educative, cultural value, their *studium*, increases. All photographs become, with time, documentary. What is left of photographs in history is a history of photographs and photographic history.

Much more complex is (2), which entails a transformation of the status of the photograph between the negative and the print, regardless of choices that might be made in the darkroom (format, chemical mix, paper) and beyond (mounting, context, circulation); it presupposes that the negative is the real photograph and that the print is a meta-photo, already a 'version' of the real photo. In the passage already quoted from Tournier's *The Erl-King*, the hero, Abel Tiffauges, goes on to allude to this transformation of the indexical into the iconic:

> But for me, though I do not reject the power of magic, the object of the act of photography is something greater and higher. It consists in raising the real object to a new power – the *imaginary power*. A photographic image, which is indisputably an emanation of reality, is at the same time consubstantial with my fantasies and on a level with my imaginary universe. Photography promotes reality to the plane of dream; it metamorphoses a real object into its own myth [...] That being so, it is clear I don't need to photograph all the children in France and in the world to satisfy the need for exhaustiveness which is my torment. For each photograph

raises its subject to a degree of abstraction which automatically confers on it a certain generality, so that every child photographed is a thousand children possessed.[43]

The changes that a photograph undergoes merely by virtue of being removed from the place of its taking, by being turned from a snapshot into an image, by becoming a signifier, now with a signified as well as a referent, might be listed as follows:

(a) The photograph acquires a cultural independence and can stand on its own to constitute a sign.
(b) The photograph becomes subject to language.
(c) Connotation superadds itself to denotation (another way of saying that the photograph has *both* a signified and a referent, is both coded and uncoded). This is to re-emphasize the *co-existence* of the iconic and indexical.
(d) Self-expression becomes as much a matter of 'style' as of 'contact'. Authenticity begins to displace itself towards the photographer.
(e) The instant is transformed into the moment. The sense of duration within the image increases. The image loses instantaneity even though it may present the instantaneous.
(f) The viewer's awareness of, or need for, the 'blind field' is much reduced and may even be eradicated.
(g) The image's relationship with authenticity becomes more complicated, because it is pulled in different directions (see [d] above), and because it is further affected by the function the photograph is called upon to perform.
(h) As images, photographs become the way we represent things (events, people) to ourselves rather than being substitute realities to which we respond.
(i) Photography leaves one world, in which it enjoys features not shared by the other arts, and enters another, in which features are shared, although their specific modes of operation may be different.

Most of the processes itemized here will not require further commentary. But (b), (d), (e), (h) and (i) may benefit from additional explanation.

(b) What language might supply at the indexical stage is information about the circumstances of the photograph's taking, not information about meaning (i.e. language with a pragmatic rather than semantic purpose, language about the when and where, and not about the what and why). Descriptive language at the indexical stage would be tautologous: the photographer knows what he is taking and he is taking no more than he knows. Even when the image is developed and printed, and delivered to an audience, language may be tautologous: 'This is a cow by a windmill.' But processes of identification may also become necessary: 'This woman is my mother, and that is Uncle Frank.' At the same time, because the photograph is now constituted as an image, and is in circulation, questions of what and why must find their answer. Language is now called upon not only to identify, but to explain, justify, give shape to the viewer's attention, indicate the level at which it is to be apprehended (indexical, iconic, symbolic). The sovereignty that the 'photograph' enjoyed as an indexical sign gives way to vulnerability as an iconic sign, as an image. Paradoxically, its achievement of cultural independence also entails cultural assimilation, and this in turn means dependence on other codes within the cultural system. As an index, the photograph was, paradoxically, culturally un assimilable because it was itself tautologous, supernumerary, extra-cultural, or because its discharge of 'significance' was entirely subjective, visceral, inarticulable (trauma, *punctum*, obtuse meaning). Images are by definition the 'language' of an interpretative community, and can be interpreted by the language of that (speech) community.

The debate about the possibility of photographic style (d) remains unresolved. Many such as Susan Sontag would argue that style cannot exist in the photograph (thanks to its indexical origin), or can exist only in short sequences on the same subject:

The very nature of photography implies an equivocal relation to the photographer as *auteur*; and the bigger and more varied the work done by a talented photographer, the more it seems to acquire a kind of corporate rather than individual authorship. Many of the published photographs by photography's greatest names seem like work that could have been done by another gifted professional of their period [...] Even after knowing they were all taken by Muybridge, one still can't relate these series of pictures

to each other (though each series has a coherent recognisable style), any more than one could infer the way Atget photographed trees from the way he photographed Paris shop windows.[44]

Without style it follows that, although quality of product is possible, intention is not: viewers identify intention by their own ability to respond coherently and relevantly to the image in front of them. But absence of style has its consolations: photography gives authorship to chance, or to the finger on the shutter release, and in so doing wrests art from the clutches of a self-perpetuating elite sustained by the religion of art, and delivers it to a people eager to explore the politics of art.[45]

Others, however, argue that style does exist in photography, but that it is more dispersed, more a combination of disparate factors – subject matter, camera, darkroom habits, point of view, etc. – than something unitary, and that it can have multiple embodiments in the work of a single photographer. But this can produce the kind of discourse about photographic style which cannot but twist and turn on itself. Commenting on two photographs by Lord Snowdon, 'one somewhat mannered and informal in design', of Norman Hartnell, the other 'surprisingly bleak', of Sir John Betjeman, Michael Freeman writes:

> Both illustrate the intention of one notable photographer not to be constricted by a recognisable style. If any of Snowdon's pictures share a common feature, it may be the particular degree to which the light is diffused (he has a small daylight studio), but the effect can be seen in pictures by other photographers.[46]

The important thing is that the photograph as image has pretensions to style because of the painterly techniques it uses, and because the notion of quality is naturally mobilized. What is equally important is that language alone can be relied upon to give a photograph an intention. Benjamin makes captions the *sine qua non* of an engaged, future photography, although ironically, it will require the photographer to read his own photographs in order to write them: 'But isn't a photographer who can't read his own pictures worth less than an illiterate? Will not captions become the essential component of pictures?'[47] And photographers have had their work talked into museums and galleries by a language dependent on the lexicon of

painterly terms,[48] or on the lexicon of job-references, supplied by celebrated sponsors (see Chapter 3). This latter, in particular, reveals that a language appropriate to the photograph is difficult to find (because of the indexical origin) but that the photograph is vulnerable to inappropriate languages, since moral qualities are by definition impossible to demonstrate or ascertain (in a visual medium).

With regard to (e), the instant is a 'digital' experience of time and perception, seized only in itself, as the smallest division of psychological or perceptual time. In fact it is so limited, both temporally and experientially, that it tends to exclude us, to evict us from ongoing process. In their instantaneousness, things are taken away from us, fall behind us, are rendered insignificant by a once-only-ness. The moment, on the other hand, is an 'analogue' experience of time and perception; we experience moments in relation both to other, adjacent moments, and to other time. Because of this power of metonymic and metaphorical relating, the moment seems expandable, both spatially and temporally; we feel able to inhabit it and be inhabited by it, have a greater sense of subjective presence. We are, in this momentary experience, susceptible to the beckonings of memory and feel a power to persist. This distinction between instant and moment is perhaps similar to the distinction that Benjamin makes between *Erlebnis* and *Erfahrung*, between, on the one hand, the modern kind of shock experience, by which we are beset and which we ward off, and, on the other, the kind of experience which is admitted, digested over time, becomes part of our developing inwardness and is accessible to memory:

> The greater the share of the shock factor in particular impressions, the more constantly consciousness has to be alert as a screen against stimuli; the more efficiently it is so, the less do these expressions enter experience (*Erfahrung*), tending to remain in the sphere of a certain hour in one's life (*Erlebnis*). Perhaps the special achievement of shock defence may be seen in its function of assigning to an incident a precise point in time in consciousness at the cost of the integrity of its contents.[49]

The 'spreading' of the photograph from the indexical to the iconic is therefore an opportunity to redeem the instant from itself, to change the short-lived and over-localized *Erlebnis* into a more generalized, inhabitable, and therefore fruitful, *Erfahrung*. We

could then perhaps summarize some of the distinctions we have made between the indexical and the iconic in the following table:

Indexical	Iconic
Past reality	Present use
Non-painterly	Painterly
Uncoded	Coded
Erlebnis	*Erfahrung*
Instant	Moment
Punctum (trauma, obtuse meaning)	*Studium*
Prelinguistic	Linguistic

Photographic representations of events (h) can be exemplified by the Vietnam War. If we think of this purely in terms of photographic experience, several privileged images will come to the surface: Nguyen Kong Ut's photograph of a napalmed girl (1972), the photograph by either Tim Page or Philip Jones Griffiths of a boy weeping for his twelve-year-old sister laid out in the back of a pick-up truck (1968); Ron Haeberle's picture of a group of My Lai villagers before being shot (1968), Don McCullin's photo of a dead North Vietnamese soldier lying among his personal effects, including photographs of a girlfriend/wife (1968); or Eddie Adams's picture of a Vietcong prisoner being summarily executed by the Saigon Chief of Police (1968). There is some consolation to be drawn from the idea that certain photographs are sifted out by time and the extent of their circulation, and achieve a representative status: whatever other photographs of Vietnam the individual mind may conjure up, there is a small corpus of photographs that express our corporate sense of the war, our sense that the war was a corporate experience, for which we all bear some responsibility. The more troubling thought is that a photographer may anticipate this process and, where reportage is concerned, engage in one of two 'impure' forms of picture-taking: either the photographer is already thinking of the photograph as an image made rather than taken, so that aesthetic awareness ousts social/moral responsibilities; or the photographer already chooses events, scenes, which he considers representative: again the indexical immediacy of reactive contact is sacrificed to a view with an ulterior motive, a view which wishes to shape or predict our perception of history, even before it has been made. This

latter observation should not, however, be allowed to disqualify photographers from pursuing their own agendas; quite clearly, photographers such as Philip Jones Griffiths and Tim Page were driven by complex motives in their coverage of the war in Vietnam.

Finally, we turn to (i): photography's relationship with painting within the iconic. This is a difficult relationship, because, although there are many similarities, the differences are crucially important. These similarities and differences may be considered under two headings: (i) technical and (ii) generical. Examples under (i) might include: the fact that both the painting and the photograph are framed, although photography derives its *cadrage* from the perceiving mechanism (camera) rather than from the support (canvas); photography's *cadrage* is flexible, does not guarantee compositional values in the way that the painting's frame does, and because it is placed *on* reality naturally activates awareness of a 'blind field'. Both painting and photography (and cinematography) have black-and-white and colour available as different languages; but aside from the question of differences of control of the medium,[50] the expressive significance of the distinction between the two varies from medium to medium. In painting, black-and-white is often associated with the fantasies and memories of the psyche (as in the work of Max Klinger and Odilon Redon), allowing the graphic exploitation of blank space, while colour promotes the sense of natural harmony and extroversion, with filled space. In photography, black-and-white is connected with truth, stylization, the tonal language peculiar to an art of light, design made visible, essentialism, self-expressivity (cf. Lartigue: 'It is difficult to marry what the lens sees with what one has in oneself. Black and white makes things easier'),[51] while colour is pleasure, vulgarity, distraction, emotion, accessibility.

Portraiture in both painting and photography involves posing, but the pose in photography, whatever the physical configuration, is animated by a peculiar psychological apprehension, the anticipation of the instant of taking, the *critical* release of the shutter not evident in the painted portrait (this is not true of posing in fashion photography – which we shall look at in Chapter 5 – or nude photography; each genre has its own codes of posing). Relatedly, while a smile in a painted portrait may be emotionally meaningful (pleasure, satisfaction, temperamental disposition, etc.), the smile in the

photograph is a conventional arrangement of the face, without emotional implications, designed to erase apprehension and minimize the non-photogenic.

In terms of (ii), we would argue that, although painting and photography share the same genres, the parameters of each are rather different. What photography has done, by and large, is to use its indexical dimension and its technology to increase generical ranges, or the number of species within the genre. Thus, for example, in nude photography, beside the art nude, we find the pornographic nude (Braquehais), the documentary nude (Bellocq), the psychological nude (Brandt), the distorted nude (Kertész), the portrait nude (Lindbergh), the fashion nude (Newton), the biomorphic nude (Lategan). Similarly, in portraiture, we might mention photography's cultivation of the serial portrait (Rodchenko), the close-up portrait (Cameron), the vortographic portrait (Coburn), the family-snap portrait, the solarized portrait (Man Ray), mechanical and literary portraits (Futurist photography), and so on.

The transformational tendencies activated by the shift from the indexical to the iconic carry the iconic over into the third of Peirce's semiotic categories, the symbolic. Where the icon institutes a relationship of resemblance, between sign and object, signifier and signified, the symbol institutes one of translation. That is to say, the symbolic requires a process of interpretation to get from signifier to signified, because the relationship is unmotivated, conventional, arbitrary: the symbol neither points to nor resembles what it stands for. The symbolic code is the code of language, and the more the visual becomes involved in the language system, the more it will be carried over into the symbolic, the more deeply it will be carried into the semantic (not 'What is it?' but 'What does it mean?'), and towards the abstract.

This might be simply illustrated by the photograph of Jane Morris (illus. 2) which Rossetti turned into the symbolic chalk drawing *Pandora* (1869; one of several versions). Indexically, the photograph (taken by John Parsons) belongs to a day in 1865 at Cheyne Walk; Jane Morris leans up against the pole of a marquee. The traumatic features are perhaps the hands – and particularly the protective thumb – and the increasing disorder of the dress's folds, as the eye follows it out of darkness to the light. Iconically, this is a picture of a woman whose hunched shoulders, clasped

hands and down-tilted head suggest sorrow, apprehension, secrecy. This is the point, too, at which compositional features will be referred to, to establish the picture's status as image, as independent artifact: the descending diagonals at whose juncture (the top of the guy rope) downward pressure is exerted on Jane's head; the uprights of the marquee which she cannot straighten herself to (hers is a concave posture); the empty area to her left with its single traversing diagonal and the altogether busier composition from which she looks away. She also looks away from the picture's shadow, which is concentrated along her right side.

Already our analysis is playing with the symbolic. Why are her hands clasped in this way? What is the connection between her hands and her expression and posture? Why is she the centre of darkness? Why is she turned to the light, and to free space, the exit? Why does her dress pass from severe folds to crumpledness? Rossetti's chalk drawing can connect and resolve these questions at a single stroke. Jane Morris's real meaning, symbolic meaning, the meaning which the photograph cannot express but language can, because it has access to translation, interpretation and abstraction, is that Jane

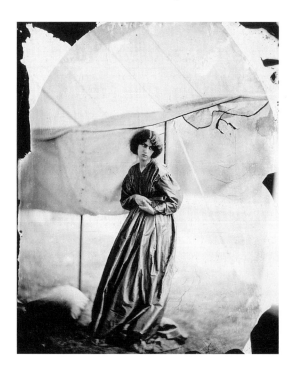

2 John Parsons,
Photograph of Jane Morris,
1865 ('Pandora' pose).

figures Pandora ('all gifts'), Zeus's revenge on Prometheus. But the photograph gives us a new view of that myth: Jane is not the image of flattery and guile, but an unwilling instrument, herself a victim of the evils she brings and which she tries to conceal and restrain. She has none of the equanimity of the chalk drawing. And her dress whose folds enfold a darkness, a threat, lose their foldedness as they come to the light, release secrets which produce 'vicissitudes' in the material. The symbol delivers the index-become-icon further into the hands of language, which draws the innocence of vision into the deviousness of association.

If we represent graphically the three categories of sign, the three levels of relationship with language, then we can begin, tentatively, to map on to this grid the relative positions of the different photographic genres, with indications of their capacity for movement across boundaries. For just as photographic meanings are highly fluid, so too are the genres that help create those meanings:

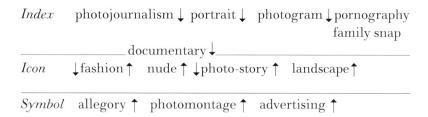

Index photojournalism ↓ portrait ↓ photogram ↓ pornography
 family snap
_____ documentary ↓ _____
Icon ↓ fashion ↑ nude ↑ ↓ photo-story ↑ landscape ↑

Symbol allegory ↑ photomontage ↑ advertising ↑

This grid is both rough-and-ready and incomplete. But perhaps it does indicate certain underlying trends. Many genres which we situate in the iconic stratum, which start from a base in which the indexical is already minimized, unavoidably hark back to the indexical; the nude, for example, is to be seen as pornography transcended or sublimated. Even in the symbolic stratum, the indexical continues to exert its pull; much advertising photography, for example, is perceived as a fiction, as theatrical décor, an invitation to fantasy. And yet, if the advertiser is to persuade the viewer that the product is obtainable, that the photograph does have a referent to be found in the shops, then the advert must somehow keep a hold on the indexical. This often involves including a separate, 'straight' photograph of the product somewhere within the advert, either montaged on to the main photograph (car adverts) or as a 'signature' at the bottom right of the page (perfume adverts). All photographic

products cash in on authenticated origins in the indexical. Even the persuasive force of a photomontage, which as a photographic construct cannot in any sense be related to an initial 'taking', depends to some extent on photography's innate power to attest, bear witness and reveal. Without its ability to refer to photographic origins, photomontage could not act as a critique of photography, of that lazy, complacent, newsy photography which always accepts what it sees and remains blind to what its conventionality hides from it.

In the next chapter, I will consider how the semiotic categories explored here are reflected in titles and captions, and what lessons about photography can be drawn from the latter. But before moving on to that task, I would like to turn to one further photograph, *La Péniche aux enfants, sur la Seine* ['The children's barge, on the Seine'], January 1959, by Willy Ronis (illus. 3), and trace how our relationship with it shifts from the indexical through the iconic to the symbolic.

The photograph provides us with a visual jolt: we see a water-borne street, or water-borne backyard (the washing). Its instantaneity is inscribed in the running child, the churning water. The high camera angle allows us a view of the river and quays which the children do not have; and their limited field of vision explains the self-engrossment they can find in their play. But this perhaps leads to another jolt – our immediate sense not only of the physical distance which separates the children from the spectators on the quay, but also of the psychological distance, the distance between their orientations of consciousness. The immediacy of our relationship with the photograph derives from the way in which the high camera angle both places us in the picture space and casts us as overseers, endows us with a certain 'parentality', in relation to the children. Another potential source of *punctum* is the isolated, 'orphaned' item of washing at the bottom of the picture.

As we shift from the indexical to the iconic, we take advice from the title, because one function of titles is to give the image coherence, to select its principal signifying elements. This may make us reverse our perspective: the children cannot see the river or the quays, but conversely, the spectators cannot see the children; the children are a secret cargo, their play is being smuggled along the river. This doubling of perspective (from bottom of picture to top, and vice versa) keeps visual activity within the frame, increases the autonomy

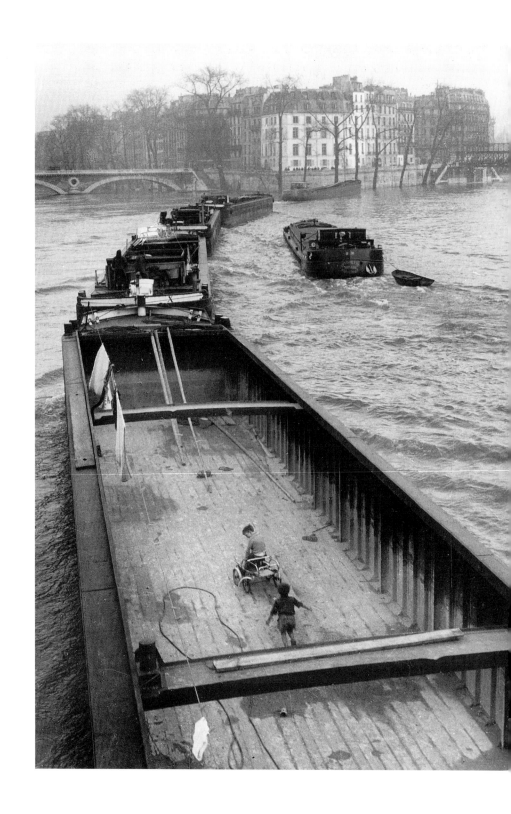

of the image. And the presence of the point of view of the quayside spectators in the picture is reinforced by the fact that the quays at this point push out into the river like the prow of a ship. The string of barges is directed towards the right to avoid a collision, so that it ends up as something bi-directional, because the children's barge, and the solitary barge in convoy, to the right, are directed towards the left-hand bridge. The two bridges increase compositional presence, both by the symmetry of their positions and by the way they close off access to the 'blind field' – they are, in fact, the Pont Louis Philippe (on the left) and the Pont St Louis (on the right), as we look down towards the western tip of the Ile St Louis.

From the iconic we drift towards the symbolic. The children are already generalized as 'children' (rather than being X and Y); the barge, however, is not 'une péniche' (a randomly seen, perhaps unexpected, barge) but 'la péniche aux enfants' (a specific barge which has acquired a special destiny, as a haven for children, a barge about which we already have a complicit knowledge, which we can be counted upon to recognize). Has this barge been gradually adapted for children's holidays, for play? This vessel, so utilitarian, grim and expressionless, is in fact dedicated to delight and fantasy, to a world invisible to adults (the quayside spectators). And what, then, do the lines of the composition mean? These barges, heading initially with the children, towards the neo-classical stone bridge, towards a better life, towards a more cultural and stylish existence, are, at the last moment, diverted towards the other bridge, the wrought-iron bridge, the industrial, low-class bridge, to which the barge naturally belongs. Early ambitions and aspirations, then, are snuffed out, and, under the supervisory gaze of the spectators, the barges change course and submissively return to their proper station.

Whatever the barges do, however, and whatever the quayside spectators think they can see, the direction of the children and their careless, insubordinate, secret play continue to engage the complicity of the viewer. 'La péniche aux enfants' is the barge which never surrendered itself to its public status and function, which made up its mind covertly to celebrate children, the unsubjugated, the free, and thus to celebrate the child in itself.

3 Willy Ronis, *La Péniche aux enfants, sur la Seine*, 1959.

Title and Caption: Projecting the Photographic Image

Baudelaire's scathing attack on the photographic mentality, in 'The Modern Public and Photography' (*Salon of 1859*), is prefaced by a digression on the decline of art evidenced in its dependence on the witty or oblique title. The catalogue of the Salon provides Baudelaire with many examples of titles which, by their very ingenuity, bear witness to a loss of faith in the suggestive power of the image itself:

> My dear M****,
> If I had time to amuse, I could easily do so by thumbing through the pages of the catalogue, and extracting a list of all the ridiculous titles and laughable subjects that aim to attract the eye. That is so typical of French attitudes. The attempt to provoke astonishment by means that are foreign to the art in question is the great resource of people who are not painters born.[1]

Baudelaire picks out, for instance, *Amour et gibelotte* ('Love and rabbit stew'), the title of a canvas by Ernest Seigneurgens, and wonders whether the artist might have arranged a quiver, wings and blindfold on the corpse of a skinned rabbit. He concludes that the proper title should be Personnes amoureuses mangeant une gibelotte ('Loving couple eating rabbit stew'). Equally, apropos of a canvas by Joseph Gouezou entitled *Monarchique, catholique et soldat* ('Monarchist, Catholic and soldier'), he imagines two possible scenarios: a figure doing three things at once, namely fighting, taking communion and attending the 'petit lever' of Louis XIV; alternatively, it depicts a warrior tattooed with fleurs-de-lis and devotional images.

Baudelaire warns of a crisis of aesthetic faith. The artist uses the title to hedge his bets, to enhance, to 'relever' his tired dish. But more important, perhaps, the inventive title serves up significance in a puzzle with an instantaneous key. This strategy is necessary in the new art environment where the fast-food principle has come to

predominate, where the gallery-going public wants both entertainment and quick semantic returns. The influx of these kinds of title reflects a profound change of psychological and perceptual stance towards reality, of which photography is a major symptom.

We might immediately distinguish three roles for picture titles:

(a) as destination, as that which explains and synthesizes the image, gives it its coherence – this is particularly the function of allegorical or descriptive titles;

(b) as point of departure, something minimal and non-interfering, which orientates the spectator and then leaves the image to do its work;

(c) as parallel but displaced commentary, set at a distance from the picture, so that the meaning is neither in the picture nor in the title, but in their point of convergence. Image and title are the two terms of a metaphor: confronted by *Amour et gibelotte*, Baudelaire explains: 'I am groping about in an effort to relate intimately these two ideas, the idea of love and the idea of a skinned rabbit dished up as a stew.'[2] This is the kind of title favoured by 'literary' artists such as Odilon Redon ('A title is justified only when it is vague, indeterminate and when it aims even confusedly at the equivocal')[3] and Man Ray ('I've always attached titles to my objects. They do not explain the work but add what you might call a literary element to it that sets the mind going').[4]

The titles of which Baudelaire speaks belong essentially to type (c), that is to a code of translation, the linguistic or symbolic code. Baudelaire wants to turn these titles into type (a), the descriptive, that is into a pictorial mode, the iconic. Type (b) belongs peculiarly to the photographic mode, the indexical; these titles merely tell us where and when the image was 'taken'.

It is not surprising that the downmarket version of the conundrum title (type [c]), with its sudden, if not blinding, revelation, with its assurance that the whole answer can be acquired at a stroke, once the initial difficulty of the rebus has been cracked and the reward triggered, should have monopolized advertisements. The advertisement is built on that piquant mixture of magic and science, fantasy and acquirability, which grows from the negotiation between image and language. The rebus is the method by which the advert identifies its customer, and by which the customer registers that s/he has been chosen. It is in the world of advertisement, in

particular, that photography must parade its experimentality, its artifice, so that its images can be realized, actualized in the language of the well-trained sales assistant, in the name of the accessible product (as already mentioned, adverts, and especially perfume adverts, conventionally have a reliable, no-nonsense image of the product and its title at the bottom right of the page, the point of the eye's disengagement from the image). As we shall see, the negotiation between image and language often involves both linguisitic shifters and pictorial shifters, that is, words and images whose referent depends on who is speaking or looking.

Man Ray's celebrated *Violon d'Ingres* (1924; illus. 4) is a rebus image which makes available a series of meanings none of which is experientially involving for the viewer. Because Ingres played the violin as a hobby, the phrase has come to mean 'a hobby' or 'a pastime'). For Man Ray/Ingres, woman is a musical instrument, and erotic adventures and fantasies are a hobby (the photograph intertextually refers to Ingres's *La Baigneuse de Valpinçon* [1808]). For Man Ray/Ingres, a woman's ability to be a musical instrument is proportional to her ability to be Oriental – when Ingres played the violin, he was indulging not in a hobby, but in vicarious sex; also in a vicarious form of painting. This photograph is Surrealism's 'fleshly' riposte to the perverse asceticism of Cubism's musical instruments. Rewarded by the satisfactions of decipherment and intertextual recognition, we can feel that we possess the photograph, that we have consumed it.

What happens when one substitutes *Dunlopillo* (illus. 5) as the title of Man Ray's photograph? In effect, very little. The rebus's sexual innuendoes are increased by the instability, indeed interchangeability, of the referent of the second-person ('you' is both photographic model and reader, male and female, desiring and desired); by the 'shiftingness' of the model herself (for the female reader, she is 'me'; for the male reader, she is a bed-companion; for the manufacturers, and possibly for readers, she is a representative user of Dunlopillo; by the transferability of the language of beds to the language of female pneumatics:

> The galaxy of tiny pores in each Dunlopillo mattress also create [*sic*] a natural airing system to keep your mattress so cool and dry, it simply never needs turning.
> What's more, thanks to the special qualities of latex, we can offer

a complete range of mattresses. So whether you prefer a firmer or a gentler support, you can be sure we have your dream mattress at hand.

Language has, as it were, become a pimp in the subtextual decipherment of the rebus. In the textual deciphermemt which follows on, it attempts to recover some of its innocence: 'Next time you see a Dunlopillo bed, be our guest: treat yourself to a lie down. It's sure to bring a smile to your face – and to your back.' Similarly, while Nylax (illus. 6) press Man Ray's image into the service of their laxative, they provide the solution to their cryptic clue without more ado: 'For times when your body's out of tune'. Here, Man Ray's image is the pretext for a language which takes the shame out of bodily functions; solving the rebus adds to the discovery of a remedy the equally important discovery of a linguistic route out of the literal, out of the socially embarrassing.

What the rebus title does, apart from activating commodity relationships with the spectator, is to deliver the photograph from its inherent gratuitousness, incoherence, randomness, and make it the instrument of a design. True, it trades on the photograph's inability to establish, of itself, the identity of its subject, and exploits its deictic ambiguity, its natural propensity for the shifter. But the triumph of the rebus title is precisely the triumph of the transformation of the inchoate into the semantically precise, even if multiform. The key to this transformation is the removal of the photograph from its origins in the indexical, and its propulsion through the iconic to the symbolic, where it can more easily connive with language. But if the title gives meaning, who gives the title? Here we turn to a distinction which we have hitherto ignored, between title and caption.

It should be said immediately that a rebus title is, more accurately, a caption. The distinguishing characteristic of the caption is that it is already a step away from the image towards its assimilation by, and interpretation through, language. While a title does not belong to discourse, is no more than an identifying tag, the caption is spoken; it is an intervention, a response forestalling the response of the viewer. There are basically two kinds of caption: (1) the rebus, which makes the photograph dependent on its purveyor (usually the photographer, or a newspaper editor) to achieve its very meaning

4 Man Ray, *Le Violon d'Ingres*, 1924.

5 Dunlopillo advertisement.

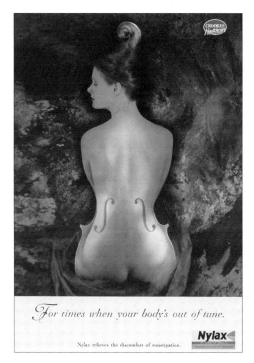

6 Nylax
advertisement.

(the punning photo-captions in *The Guardian* are a good example of the popular rebus); and (2) the quotational or direct-speech caption, which creates meaning by address, or by a spoken complicity between purveyor and viewer. We find the quotational caption in the literary images of Pictorialist photography, and the direct-speech caption in the family album and the tabloid press. As with the rebus, the innate candour of the image is subjugated to the guile of language.

In his *A Short History of Photography* (1931), as already noted, Walter Benjamin imagines that if politically motivated photographs are to escape from a world of coincidence and uncomprehended processes, they must have the critical awareness, the constructive function, which a caption guarantees: 'But isn't a photographer who can't read his own pictures worth less than an illiterate? Will not captions become the essential component of pictures?'[5] In the tabloid press, the caption serves not so much the raising of political awareness as the consolidation of the readership; the news is sifted and presented by a fun-loving, parental persona who enjoins upon the reader an acceptable and communal response. The mediating voice not only makes meaning, but reassures the viewer and patronizes the image at the same time (see Chapter 4).

Benjamin's first question – 'But isn't a photographer who can't read his own pictures worth less than an illiterate?' – reveals the special problem solved by the caption, that of authorship. Both Benjamin and David Hockney remind us of the absence of the practising hand in photography. Hockney, like Benjamin, believes that the hand is to some extent restored in photomontage and photo-collage; of his own 'joiners' he says: 'With my work you can have photographs using chemical inventions to bring the hand in. The joiners bring the hand back. There's no way you can start joining pictures together mechanically, and the more complicated the photography is, the more subtle the hand work becomes.'[6] While it is easy enough to find the self-expressive motif, it is extremely difficult to express the self as the operator of the camera. Feminist photography, for instance, has been preoccupied with *self*-portraiture simply because to express the self, the self must be as much the motif as the operator. The caption seems to allow the intervention of the operator through a side door, as a bystanding consciousness presiding over the image. But, of course, this is a pyrrhic victory.

The caption never coincides with the image, never exists in the same time: it either precedes the image, as it may do in a rebus – the image is called upon to encode or enigmatize the caption – or succeeds it, acts as a reaction. Consequently, meaning itself is displaced, removed from the image: the image is either only part of a metaphor or the instigator of a presiding voice which, in return, endows it with a justification.

Two further observations should be made about the caption, observations that might apply to Henry Peach Robinson's *Come Along!* (1884) or *Gossip on the Beach* (1884; illus. 7), for instance. In both of these photographs, the captions convey the paternalistic, worldly-wise condescension of the urbanite, the rural tourist, passing the foibles of the naïve and native in review. But more importantly, they remind us how shallow the narrative space created by a caption is – all we are invited to envisage is the just-before and the just-after of the event. In Robinson's case, this is partly because the careful composition and the combination printing tend to destroy the sense both of living atmosphere and of a 'blind field'.

In this respect, *Gossip on the Beach* might initially seem something of an exception. Certainly, it is a combination print, and certainly the distribution of figures and lobster pots is planned to the last detail. There are two pyramidic structures, the smaller of which – the younger children – constitutes part of the larger. In their allusion to a rock-formation, these lobster pots offer a piece of visual playfulness (a beach geology formed by the local métier),

7 Henry Peach Robinson, *Gossip on the Beach*, 1884.

providing compositional continuity to take the eye across the foreground in an uninterrupted, inclusive sweep). Nevertheless, the image achieves a certain atmospheric spontaneity, thanks partly to the 'opening up' of the 'blind field': the apex of the larger pyramid, formed by the shrimping net, is cut off by the frame, as are both ends of the line of lobster pots. Furthermore, the good-humoured talk of the foreground group acts as a modal contrast for the mother and child further along the beach, who are isolated in a space of their own, sombrely lit, disregarded, pinched between the frame of the shrimping net and the back-basket. About this haunting pair (abandoned mother, fallen woman, bereaved widow?) one has more curiosity than about the group of gossipers. Unfortunately, the spatial relations between gossiping group and mother and child are unconvincingly represented. And the haziness generated by aerial perspective begins too abruptly behind the foreground group, particularly in relation to the mother and child on the right. So the photograph starts to split into its constituent elements again, and the potential complexity of a potentially non-narrative image is pictorially sacrificed to the pleasure of patronizing the harmless mores of the coastal community in a narrative whose before and after is without either duration or consequence.

Larger narrative trajectories are difficult in photography, because photography is unable to use pictorial space to map unfolding time, as painting can. Paradoxically, however, it is precisely narrative that photography's arbitrariness seems to make indispensable to us, if we are ever to construct purpose and intention out of its images. The shallowness of photographic narrative may well intensify photographic action, have the capacity to imprison us in event, in a way that painting cannot – certainly, in *Come Along!*, Robinson uses this fact to increase the meretricious excitement of an insignificant incident. Nevertheless, it is part of the general charge brought against photography, that its images are without duration, an issue about which we shall have more to say. It might be argued that the absence of duration in the photograph is a reason for the documentary photographer's moral frustration and a justification of the photoessay, that form of narration not *in* photos, but *with* photos.

The second observation is this: the caption, as mediation, offers the promise of a contact between the viewer and the viewed.[7] Many commentators would argue that this is a mirage, a pathetic

bandage on the wound of photography, that wound being the photographic image's inescapable pastness. It may be that photography is a desperate clinging on to life which paradoxically kills what it tries to keep animate. Putting it less extremely, we can say that the photographic image cuts itself off from us by the very virtue of its being taken, that there is only a *history* of photographs, that the motif is by definition out of reach. Titles, as opposed to captions, measure these distances. They compel us to make meaning out of inaccessibility and therefore, with the passage of time, out of an increasing dose of unreliability.

In his novel *La Goutte d'or* ('The Golden Droplet', 1985), Michel Tournier makes a fundamental distinction between the Islamic graphic sign and the Christian image, between the Islamic essentialization of experience in the abstract (the golden droplet itself) and Christendom's addiction to illusionistic representation. Within the tradition of representation, Tournier makes a further distinction between the icon (an image with a transcendental 'blind field') and the idol (the fixating fetish-image). In learning calligraphy, the Saharan hero, Idris, acquires the wherewithal to liberate himself from the tyranny of the image by the process of self-inscription. If photography has a special complicity with the pornographic, it is because the camera, acting as a window between the viewer and the viewed, creates a distance not of aura, but of dispossession, a discontinuity likely to activate the reification or idolization of the viewed. The pornographic magazine uses captions precisely to conceal the reality upon which it depends for its addictiveness: captions imply accessibility, possibility of relationship, while the photographs purvey a distance that absolves the reader from relating, from interesting himself in the life of another, and allows desire to realize itself in 'manipulation'.

Moreover, where the pornographic image is untitled, or minimally titled – is Louis-Camille d'Olivier's image (illus. 8) to be called *Nu*, or nothing? – its very muteness increases the 'heaviness' of the relationship between viewer and viewed; titles/captions can be useful escape-routes from the prison-house of the unavowable. Dispossessed of the subject by the camera's window, the viewer engineers repossession by constructing a window (the mirror) within the window, an alternative route of access, by intensifying fixatedness, or idolization, in multiplied frames. The mirror that appears

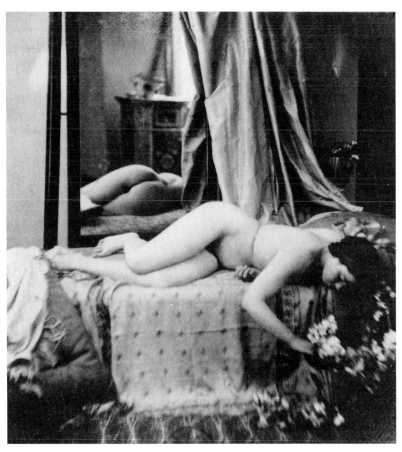

8 Louis-Camille d'Olivier, *Nu*, 1853–4.

so frequently in nineteenth-century pornographic photographs has many functions: it insinuates narcissism and the auto-erotic; it becomes a displaced viewer; it is the site of the model's vulnerability, or lack of self-consciousness; and it multiplies point of view, implying that the space of the photograph can be entered, that the viewer is free to move. But most importantly, perhaps, it allows the viewer, even though identified and dispossessed, to enjoy all the intimacies and privileges of the concealed spy. This paradoxical combination is echoed in another feature of pornographic photography: it offers carnal 'palpability' in a medium which lacks tactile values.

The paradoxes of pornographic photographs suggest that in photography, the characteristic relationship between viewer and

viewed is one of stand-off: a transfixative connection is established, from which nothing can be learned and out of which no meaning other than fixation can be unravelled. This is how Tournier puts it:

> These Moslem adolescents, submerged in the big occidental city, were subjected to all the assaults of the effigy, the idol and the figure. Three words to designate the same servitude […] Only one key can remove these chains: the sign […] The image is indeed the opium of the Occident. The sign is spirit, the image is matter. Calligraphy is the algebra of the soul traced by the most spiritu-alized organ of the body, its right hand. It is the celebration of the invisible by the visible.[8]

Writing transforms the image into drawing, into that which constructs a continuity between artist and model. Its hesitant, fluid or multiple lines are processes of dematerialization and decipher-ment. By uncovering the invisible in the visible, writing transforms the idol into an icon.

Unfortunately, the titles of photographs are not calligraphic translations of the image. They are edicts designed to reinforce the idol-like nature of the image. In other words, it is perhaps not so much the viewer who is slavishly subject to the viewed, as the viewed which is rendered powerless by its subjection to its title. How is this so? A graphic representation of photographic meaning in terms of a Saussurean model would look something like this:

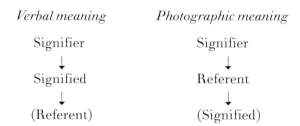

Photographic meaning bypasses or postpones signification to assert its purely evidential or indexical value. In fact, it might be more accurate to reverse the arrow between Signifier and Referent in the right-hand column, to underline the fact that photography does not aim to *represent* reality (although, of course, that is what it does), but rather to duplicate it, to *take* it. However much we may argue that photography is coded (by Renaissance perspective, by rectangular

framing, by colour or its absence, by monocular vision, by floating scale, etc.), that it is a long way from natural vision, that any process of selection is a process of semantic loading, we cannot escape photography's inherent referentiality. However much Robinson, for example, may have attempted to convert picture-taking into picture-making, to leap-frog referentiality into signification, to consign referentiality to fiction, he cannot persuade us to suspend our disbelief. What we see if we look at Robinson's work referentially is staged tableau, studied pose and absence of atmospheric envelope.

But photography's monopoly of the referential can only be enjoyed with the consent of the title. The title alone directs referentiality to a target; the title alone authenticates the authenticity of the photographic image.

This crucial role of entitlement, this lack of the photographer's faith in the unsupported eloquence of his/her image, this function of the title as signature (where 'signature' means less 'I made this' and more 'I know what this is because I was there'), is nowhere more apparent than in Jean Mohr's experiment in *Another Way of Telling* (1982) with ten of his photographs. 'I often feel the need to explain my photos, to tell their story,' he writes, and adds 'Only occasionally is an image self-sufficient.'[9] Why else do we show friends and neighbours our snaps if not to become indispensable narrators, to establish and safeguard our autobiography?

Mohr asked ten interviewees to identify the subjects of the ten photographs. One shows a young man with a camera in a blossoming tree (illus. 9), and these are some of the interpretations it attracted:

MARKET GARDENER: It makes me think of someone who's looking for the best place to take a photo! He enjoys nature. He's a modern type who likes to get out of the city. He looks elsewhere for what he can't find at home.

SCHOOLGIRL: A bloke in a tree which is in flower. He's hiding and playing. And he wants to show to somebody that he's hiding.

BANKER: A link between the person and the way the picture has been taken. It's symbolic: youth, beauty, the spring of life. I like his expression, it's healthy both physically and morally. If only there were more young people like that...

PSYCHIATRIST: A Spanish worker in an orchard full of blossoms. A contrast between the fact that he's proletarian, and it's spring-

time in the countryside. Yet no, there isn't really a contrast. I can see he's carrying something – but cameras aren't white. He looks surprised but not guilty. Perhaps there's a girl sunbathing in the orchard.[10]

9 Jean Mohr, *A demonstration against the war in Vietnam…*

In the absence of a title, these constructions of a symbolic signified or a fantasized referent, are implicitly disqualified by Mohr, who rounds off each set of suggestions with the heading 'What was happening' (understand 'What was *really* happening'). Here, it is 'Washington, 1971. A demonstration against the war in Vietnam. 400,000 demonstrators in front of the White House. The young man had climbed the tree so as to see better and to take his photographs.'[11]

So Jean Mohr supplies his truth, which is *the* truth, and his justification for re-appropriating his work, which is the assertion that 'Only occasionally is an image self-sufficient.' Why are photographs not self-sufficient? Because they refer too pointedly and yet do not know how to name what they refer to. Because, without a title, they are incoherent, random. Photography tends to strengthen our assumption that something is worth looking at only if we already know what it is. This seems a regrettable attitude, and for at least three reasons.

First, because photographs are photographs by virtue of their incoherence; and it is this incoherence which, far from being concealed by a title, should be laid bare if it is to be fruitful. Details distract us, disperse attention, act unexpectedly upon us. The erratic appeal of colours, too, cannot be denied or controlled; in Hansi Krauss's *Mogadishu 23 June 1993 — Somali children share a drink with a United Nations soldier at Mogadishu checkpoint*, an accident of composition and the striking quality of the colour draw the eye beyond the ostensible subject to a woman in blue, moving away in the background, even though she is out of focus.

Second, one of photography's tasks is to bear the burden of appearances, in other words, to be, like appearances themselves, that on which we exercise our intuitions, our reactions, our misunderstandings, our fantasies. There is no reason why a photograph should be more reliable than reality. Indeed, there is every reason why it should not be, if we are not, as so often in the past, to attribute to the photograph an authority far in excess of its ability to tell the truth. It is in the photograph that we most dangerously continue to confuse the conventions of realism with reality.

Finally, the process of entitlement that Mohr has in mind is that actual (as opposed to speculative or fictional) narrative continuity which is, as we have seen, alien to the single photograph. We can hardly argue that a photograph's meaning is to be discovered by

replacing its intrinsic discontinuity into the continuity from which it has been wrenched, for why wrench it out in the first place? We can hardly argue that a photograph's meaning lies in that deep narrative which the photograph itself is ontologically unable to contain, and which only the photographer is able to supply.

Of course any visual image, whether painting or photograph, needs to be identified if the construction of a 'non-erroneous' understanding is to take place. And, quite clearly, as far as Mohr's photograph is concerned, 'Man in tree at anti-war demonstration, Washington' is more suggestive than 'Man in tree, 1971'. But where a photograph differs from a painting is in the photographer's unique possession of the explanatory 'blind field'. Only when this 'blind field' is removed (by the death of the photographer?), or made irrelevant by a mode of viewing photographs which insists that they are more about the enigmas of appearances than about the establishment of facts, can photography recover that fruitful ambiguity enjoyed, as of right according to many, by painting.[12]

In Graham Swift's novel *Out of this World* (1988), a daughter alienated from her father by his photography, by his documentarist's habits of self-insulation, comes across photographs of his in which the minimalism of the titles seems to express all his disengagement, the clinical eye of the professional bystander:

> The man lying on the hot white sidewalk. They called it 'that famous shot'. In *Aftermaths* all it says is 'Oran, 1960' [...] Face up, his arms outspread and ankles crossed, and from the back of his head that long, long dark stream, stretching, stretching as if it will never end, down the street. I didn't know which was worse, that the picture contained such things or that my father had taken that picture.[13]

Sophie, the daughter, is mistaken in her judgement of her father and his photograph on three scores. First, her use of the future tense – 'stretching as if it will never end' – which develops out of a spectatorial present, loads the photograph with an immediacy it may have as picture, but which it certainly does not have as event (this photograph is not just about a loss of life, but about our loss of this loss of life). Second, a documentary photographer, such as her father Harry Beech, is concerned with the event as it reveals a condition – existential, social, political – rather than with the event

in and for itself, as part of the narrative of developing history. The latter is the concern of the photojournalist, who typically resorts to the caption to invest the image with the desired proximity and actuality. The documentary photographer is pushing the actual away towards the typical, the representative, the exemplary, and expanding event into environment.[14] So the snapshot becomes an image, and as it does so, it invites us out of the visible into the invisible, out of the indexical into the iconic. The documentary title is where we begin, is not the destination of the image, nor what teases the image into meaning in the manner of the rebus title. The documentary title is the threshold of an enquiry into the human condition, of which the image is like a glimpse or an epitome. Not surprisingly, Harry's is a title of time and place – that is, the pure indexical title of the photograph's taking, not even a bare iconic title of the photograph's motif. Harry himself seems to understand these things when he confronts another of his war photographs, this time with the minimal iconic title *Lancaster pilot*, which depicts a badly wounded airman who has managed to bring his plane home:

> That pilot was awarded, posthumously, the DFC for his act of heroism in bringing back his plane and crew. When you look at the photo you do not think, I think, of heroism. You think of pain and absurdity. But your mind focuses on that agonized young airman in an act of compassionate concentration that it would be sacrilegious to call sentimental. You think of personal things. You wonder who he was. You imagine his home some-where, his parents, his girl. You think of him as an unsuspecting schoolboy.[15]

Finally, Swift's Sophie fails to recognize that the title is not designed to be a test of the photographer's commitment, is not a profession of photographic faith. It is itself a lens, which deter-mines, or tries to regulate, the spectator's psychological distance from the image, the uses to which the image is put, the generical impli-cations that cluster round it. What the image depicts is what we see it depict; the title does not identify so much as create certain kinds of optical awareness. In the photograph everything is already there, but in no particular order and without intentionality. The title asks the photograph to have intention, to pull itself into a concerted shape, a design.

This makes one think of Cartier-Bresson, and of the contingent, unpredictable moment transformed into the 'decisive moment' (1952):

> We work in unison with movement as though it were a presentiment of the way in which life itself unfolds. But inside movement there is one moment at which the elements in motion are in balance. Photography must seize upon this moment and hold immobile the equilibrium of it.[16]

But to judge by Cartier-Bresson's own photographs, the decisive moment was not when meaning suddenly and unequivocally came to the surface of reality; it was rather a moment when meaning was made available, when the image became unreliable, when it moved out of its own field of reference. In an image of 1933, simply entitled *Valencia. 1933* (illus. 10), a child is arching his back to catch sight of a ball he has tossed in the air. But the ball is outside the frame. This invisible ball has produced a posture which the intervention of the frame allows to wander into a whole new field of potential references: the child is blind, feeling his way along the wall, from which the whitewash has been scraped, partly by his passings and repassings; or the child is ecstatically happy, head thrown back, eyes closed, denying the sordidness of the wall. In more symbolic mode, the scraped wall is like a representation of a tunnel along which the boy is finding his way, towards adulthood; it is also, symbolically, an execution wall and the child the convulsed victim. By multiplying referentiality, the image is able to reach through to significance. The logical consequence of such a move is that, to achieve significance, the image needs no referential reliability. Indeed quite the contrary: it can project its own referentialities through the process of signifying, or as an adjunct to it. It does not matter, then, that, in Cartier-Bresson's *Santa Clara, Mexico. 1934* (illus. 11), the male torso with the half-open trousers and hands clenched in apparent anguish, the head upturned, should be that of a friend called in to pose expressly alongside the eloquent 'frames' of a woman's shoes, themselves acting out the story of a relationship. The 'decisive moment' is the interface between reference (the indexical/iconic) and significance (the iconic/symbolic) – an intimation, or augury, or emerging design in appearances – and this interface is opened up by the least prejudicial of titles, the indexical (time and place of taking).

The equilibrium referred to by Cartier-Bresson, then, is to be found at the fulcrum between the intended and the unintended. In fact, it seems an inherent feature of photography that it polarizes the intended and the unintended. A snapshot is a random piece of reality with no more claim to fame than any other piece of reality. A title, and a referential (indexical/iconic) title in particular, is a symptom of our anxiety about the gratuitousness of the photographic image. The more exact the title, the more linguistic ballast is provided, the more it can become the image's reason for existing. Anything which can be identified qualifies for the archive, bears witness, is evidence. So we transform that which is without intention into that which is overdetermined by intention. But the risks connected with this kind of intentionality are huge, among them the deception of the spectator and the suicide of the image.

We sometimes see David Seymour's image of a crowd with (mostly) upturned faces under the title *Land distribution meeting. Estramadura, Spain, 1936* (illus. 12), sometimes with the title *A Public Meeting in Estremadura, just prior to the outbreak of the Civil War. Spain, 1936*, sometimes as *Air Raid over Barcelona, 1936*, and sometimes as *Air Raid over Barcelona, 1938*. Do these titles work in a mutually disqualifying way, so that we are suddenly bereft of a reason for looking? Must the judgement of the court, faced with this evidence, be 'Case dismissed'? What happens to photographs brought into discredit by squabbles over entitlement? Anxiety about the arbitrary has deprived us of a photograph whose very power to mean lay in its arbitrariness. The title tries to lock the photograph into a specificity, for it is there that we shall find its intensity, its first-handness, its irreplaceability and the erasure of incoherence. But since everything has been invested in the single-minded univocality of the specified event, all other experiences, those of Barthes's *studium* (cultural information, classifiability of contents, and general interest) and his *punctum* (the subjective, intimate, penetrative power of details) are all appropriated or suppressed by, or made secondary to, this overriding deixis. If the photograph were entitled *Spain. 1936*, or *Spain, during the Civil War* – that is, indexically, according to its pragmatics rather than to its incipient semantics – then not only would *studium* be available to us (the social context of breast-feeding, the evidences of clothing and hair-styles, crowd psychology, the status of children) but so

Henri Cartier-Bresson, *Valencia. 1933.*

Henri Cartier-Bresson, *Santa Clara, Mexico. 1934.*

would *punctum* (for example, in the oddly tangential vanity of the hair-comb of the woman whose back is so inexplicably turned towards us, or in the baby's hand on its mother's breast, or in the insistent, challenging stare of the little girl to the right, which conveys not moral outrage at the intrusions of the photographer, but a set of visual priorities totally different from that of the other participants). And, of course, such a title would allow a signified to install itself, images of the Madonna and Child, of *stabat mater*, of the relativities of human consciousness. Thus the photograph would hover unsteadily, but richly, between index (*punctum*), icon (*studium*) and symbol. It would do so because the title would not rob it of its incoherence and arbitrariness, of its need to be made into meaning and its refusal to be made. The photographic image is nomadic and unclassifiable, and we do better to release it into this mobility than to insist on its finding a place and having a cultural function.

Sometimes, even though the motif may be easily identifiable, dramatic and engaging, the distractive urge in photographic looking encourages us, after an initial process of examination and recognition, to take that motif for granted, as the given, and to look elsewhere for meaning and effect. George Rodger's photograph entitled *A woman is rescued from her home, wrecked by a V-1 bomb, London, 1943* (illus. 13) is unequivocal and moving enough. But light can be indiscriminate in its insistent selections, and here it practises variations on the tin hats of the wardens, makes studies of hands and knuckles, and gives a swirling motility to the dust. We discern the ironic words 'Illustrated' and 'Every Week' on a panel of the blasted bus. We find something Dantesque in the dust, in the light and the arms, uplifted as if in supplication, of the stretcher-bearers. And a vignette in the centre of the picture – a stretcher-bearer with his hand placed lightly on the shoulder of the man in front of him – inserts, intertextually as it were, a memory of blinded WW1 gas casualties. The woman being lifted to safety and treatment is, it seems, no more than a pretext for ocular scavenging, localized constructions of meaning, a self-replenishing waywardness of the eye.

The photograph's fluidity, between index, icon and symbol, between signifier, referent and signified, between *punctum* and

12 David Seymour ('Chim'), *Land distribution meeting. Estremadura, Spain, 1936.*

13 George Rodger, *A woman is rescued from her home, wrecked by a V-1 bomb, London, 1943.*

studium, is paralleled by a generical mobility. If we take Lartigue's image, usually called *The Beach at Villerville* (*c.* 1906), or *Cousin Caro and M. Plantevigne* (illus. 14), and call it 'M. Plantevigne, the seaside dandy!', that is, change its title to a caption, then we have a family snap, located in history, claiming a contemporaneity for itself, in which the principal figure is the portrait of a known individual. What is revealed here is an event: a boy, who is only about twelve years old and who has had his camera for a mere four or five years, expresses, through that camera, a wry admiration for a father-figure. M. Plantevigne looks so much like Lartigue's father (as depicted in a series of snapshots of 1902) that one is almost inclined to suppose a misidentification; the woman on the left is undoubtedly the photographer's mother. The 'father' stands off from his female companions, creating a space in which to perform his own elegance, the barnyard cock, full of a relaxed self-confidence which sets him apart from the meek, hurrying, faceless men in black.

If we call the photograph 'The Beach at Villerville', on the other hand, we underline the iconic and create a documentary photograph, a photograph also in history, but whose value is not in the contemporaneity it can revive but in the past to which it can testify. The

14 Jacques-Henri Lartigue, *Cousin Caro and M. Plantevigne, c. 1906.*

main figures are no longer relatives of the photographer, but representatives of a leisured upper middle class for whom a walk on the beach is a display of social standing, fashionableness, and sense of possession, of everywhere being at home, with their acquired rights. The male figure is now no longer interesting as a portrait, but as a collection of social indices.

Or again, we might call the photograph 'Passing Figures' or 'Seaside Dynamics', and thereby shift the image out of history and into the realm of aesthetics and the symbolic. The figures are now interesting less as family portraits or social epitomes than as models, tonalities, compositional factors, tempi. The black group of three, to the right, made more uniform by their boaters and their black parasols and down-tilted faces, are moving at speed, more or less in step, and will soon be out of the frame. The more artfully arranged white group, on the other hand, will never leave the frame. Not only do the women's dresses hide their movements, but their parasols balance each other out directionally. Any tendency to move to the left is countered by the boat sailing from left to right. The single male figure, in the end, is not so much walking as intending to walk. This is the artist's way of fixing his memories in amber, of resisting time's dynamic.

If I cast aside what are, after all, unreliable titles, Lartigue's image invites me to cross and re-cross generical boundaries, constantly to adjust my perceptual mode, to vary the image's proximity to me, to vary the dose of my subjective input and interpretative fancy.

By maintaining the photograph's intrinsic arbitrariness and incoherence, I maintain both its freedom and my own, its multipliability and my own ability to overcome the experience of dispossession that photographs so frequently enforce.

A photograph without a title can, at the very least, be generically subversive. Nick Waplington's photographs of two Nottingham families, *Living Room* (1991), present themselves as family snaps: they are in colour, they celebrate moments of togetherness. And yet they are not family snaps because the way in which they express togetherness often falls outside the decorums of the family snap – a child vomits on the carpet, a man sexually 'touches up' a woman. Besides, they are taken with a 6 x 9 camera designed for panoramic landscape views. Moreover, the photographs show kinds of artistic effect – blurring of the foreground figures, oblique angles, low angles, asymmetrical compositions – which would be treated as errors, attract 'Quality Control' stickers, in family snaps. And yet these are not really documentary photographs either, because their purpose is not 'guaranteed' by the probing, dispassionate, tonal/ modal language of black-and-white, and their restless dynamism makes them too involving, too engaging, for us to be able to attribute to them that exemplary status that we expect to find in the documentary photograph.

Even if one goes back to the nineteenth century, to those genre photographs which seek to encapsulate the habits and mores of different trades and professions, the index factor can undermine the *studium* value. Charles Nègre's image of two resting navvies, for example, possibly dated 1853, *Terrassiers au repos sur un boulevard de Paris* ('Navvies resting on a Paris boulevard'; illus. 15), intrigues us by the half-concealed presence of a third, recumbent figure, and by the uncanny focus it gives to the figure sitting on the upturned wheelbarrow, so that the photograph does not have an investigative modality, is not evidential, but rather dramatizes a meditative, interrogative mood emanating from this focused character. And then, over on the right, we make out the spectral traces of a fourth figure, in the process of getting up, who seems to occupy another reality, another time-scale. At the level of the signified, this photograph relates work to the wheel – figures broken on the

15 Charles Nègre, *Terrassiers au repos sur un boulevard de Paris*, 1853(?).

wheel, the wheel of fortune, spokes in the wheel – by virtue not only of the barrow's wheel but also of the lines radiating from the 'axle' of the tree. The photograph's title might want to be a summation, to direct the gaze and restrict the image's play. But this image's incoherence swallows up its title, or rather leaves it as an invitation to a visual experience which will inevitably exceed and supersede it.

It is this view of the photograph as something which cannot be entitled – or can be entitled only as an act of invitation – which helps to invalidate the claim that there is no duration in the photograph. Of course, the taking of the photograph may be instantaneous; of course, the kind of duration that can inhabit a photograph is not narrative duration. But there is, at least, a receptive time in the photograph, created precisely by its nomadic nature, by our journeys back and forth across boundaries, as we put the different layers of photographic being together.

The reputed absence of time in photography goes back to its very beginnings. Let us remind ourselves of the passage quoted earlier from Baudelaire's *Salon of 1859*: 'The attempt to provoke astonishment by means that are foreign to the art in question is the great resource of people who are not painters born.'[7] Baudelaire has nothing against the element of surprise he finds in these paintings, and by implication in photographs, as long as it is leavened by 'dream': 'I was referring just now to the artists who seek to astonish the public. The desire to astonish or be astonished is perfectly legitimate. "It is a happiness to wonder": but also "It is a happiness to dream."'[8] This quotation from Poe's 'Morella' brings into play two terms – 'astonishment' and 'dream' – which are the precursors of Benjamin's distinction between *Erlebnis* and *Erfahrung*, explored in the previous chapter, the distinction between the experience of shock and the experience of assimilation, digestion, association.

Towards the close of *A Short History of Photography*, Benjamin writes: 'The camera will become smaller and smaller, more and more prepared to grasp fleeting, secret images whose shock will bring the mechanism of association in the viewer to a complete halt.'[9] We do not assimilate photographic images, they have no opportunity to become part of our associative mechanisms, of our interiority, of our involuntary memory, because we anticipate the shock they bring and protect ourselves against it. 'There is no daydreaming surrender to faraway things in the protective eye' is the

way Benjamin puts it in his 'On Some Motifs in Baudelaire'.[20] If we yielded to every image, to every jolt of unforeseen experience, if we opened ourselves up to them, we would quickly lose our sanity. But this relationship between surprise and protection is also a commercial one, a relationship between the eye-catching commodity and the speedy transaction, where, by the act of purchase, we absolve ourselves from having either to understand or remember.

In these models of photographic production, the title is the middleman, the identifier of the danger, the circumscriber of the shock-factor, and the shop-assistant who ensures that we are sold the commodity rather than that we buy it of our own volition. But this view is much too narrow, too politically and polemically motivated. In his *Camera Lucida*, Barthes seems to side with Baudelaire and Benjamin:

> The Photograph does not call up the past (nothing Proustian in a photograph). The effect it produces upon me is not to restore what is abolished (by time, by distance) but to attest that what I see has indeed existed. Now, this is a strictly scandalous effect. Always the Photograph *astonishes* me, with an astonishment which endures and renews itself, inexhaustibly.[21]

Some dozen pages earlier, however, he has taken the opposite view:

> For once, photography gave me a sentiment as certain as remembrance, just as Proust experienced it one day when, leaning over to take off his boots, there suddenly came to him his grandmother's true face, 'whose living reality I was experiencing for the first time, in an involuntary and complete memory'.[22]

And it is not just that the photograph has access to our deep selves, helps us to discover our inner *terre natale*, becomes a repository of our desires, sensations, mentalities; the photograph does not just remember us, as we remember it – it remembers itself, too, because the *punctum*, the point with which the photograph lacerates us, is the instrument of its own resurrection: 'I had just realized that however immediate and incisive it was, the *punctum* could accommodate a certain latency.'[23]

What, then, would be our concluding observations? Because the photograph, at its taking, is pragmatic rather than semantic, indexical

rather than iconic or symbolic, it is peculiarly vulnerable to appropriation by either title or caption. It is so vulnerable, in fact, that it seems to be entirely title-dependent, as a means of escaping its own gratuitousness. Entitling and encaptioning are delicate matters, because the status and reception of the photograph depend so much upon it, as does the nature of the photograph's survival. We might prefer the indexical title, a time-and-place title, because, although apparently so uninformative, it has the ability to open up the channels to the iconic and the symbolic, while preserving the latency of the photograph's perceptibility and semantic activity. But the indexical title requires a great deal of nerve on the editor's or photographer's part. In his book of documentary photographs, *Perspectives* (1987), Don McCullin sticks mostly to minimal titles, such as *Mother and son, Liverpool*, or *Stubble burning*, or *Husband and wife. Front garden, Bradford*. Occasionally, however, his need to assuage his conscience in a declaration of commitment leads him from titles to captions, such as *Uncomfortable, unheated. Unjust* or *Disturbed exile in his Bradford slum*. It leads him from the documentary to the journalistic, from a tacit faith in the viewer to intervention. This is a topic we shall return to in the next chapter.

The truth of these observations is partly borne out by the fact that the titles of photographs are so badly and so variously remembered. It is the photograph's contents which tend to stick, but in an identifying rather than explanatory way. The titles of paintings, on the other hand, whatever their provenance, acquire a cult-like status, are suffused with the aura of the painting to which they are affixed. While the photograph may be a commodity, it is a perishable commodity and cannot hang on to its entitlement. Photographs are essentially, and against the evidence, things which have no right to survive, that pass into oblivion unless they are expressly salvaged. And they are salvaged by the same set of chances that made them, the chances of chance encounters, of *punctum*, of seeing, by grace as it were, a coherence in the wonderfully and uncontrollably incoherent.

Listening to the Documentary Photographer

At the end of Alfred Hitchcock's *Rear Window* (1954), Lars Thorwald, the wife-murderer from across the courtyard, upon whom Jeff Jefferies has been spying throughout the film, comes across to Jeff's apartment, with apparently murderous intentions. Prior to this, Lisa Freemont, Jeff's girlfriend, has crossed over to Thorwald's apartment to investigate, something that the incapacitated Jeff is unable to do. Thus the viewer, or rather a proxy of the viewer, in the person of Lisa, has entered the image, has accepted the responsibilities of involvement. She discovers Thorwald's wife's wedding ring, the ring which embodies her own desires (marriage to Jeff), the ring which incriminates Thorwald and might push him to the murder of Lisa, the ring which *must*, therefore, produce a moment of recognition between Thorwald and Jeff. As Lisa indicates through the window to Jeff that she has the ring in her possession, Thorwald sees the signal and looks across the courtyard in Jeff's direction. At this point, the ocular power that Jeff has been exerting on his environment, first through binoculars and then through a telephoto lens, is transferred from the viewer to the viewed. And to back this up, Thorwald almost immediately makes the return journey that Lisa might have made, from the image (Thorwald's apartment) to the real space occupied by the viewer (Jeff's apartment). Lisa cannot return until Jeff has had his showdown, his confrontation, with the image. But this drama of the image and specular power, in which the hero is involved only vicariously, by the proxy of Lisa Freemont, and in which the image takes its revenge and demands a reckoning, does not end there.

As Thorwald enters Jeff's apartment he asks 'What do you want from me?' He asks why Lisa, having acquired the incriminating evidence of the wedding ring, has not turned him over to the police. He suspects that Jeff wishes to blackmail him. 'Say something, say

something,' Thorwald pleads. But apart from explaining that he cannot return the ring because the police have it, Jeff remains silent. Thorwald attacks; Jeff defends himself with his flash-gun, momentarily blinding Thorwald time after time. Ultimately, and prior to his capture, Thorwald throws Jeff from the window of his apartment.

This sequence I take to be an allegory of photography; of documentary photography in particular and, more especially still, of a confrontational form of documentary photography characteristic of the twentieth century. I want to propose that the documentarist tries to enter his image, but that it is frequently only through the mediation of others that he succeeds in doing so. Ultimately, the image enters him. The photographer counters this apparent aggressiveness of the image with his flash-gun, that is to say, he is trying to respond in three different ways at once: (i) he is trying to reconvert the threatening image into an image (as if photographing the photograph); (ii) he is trying to blind the image (i.e. recover ocular power); and (iii) he is trying to throw light into the darkness, to uncover a truth, but – and I emphasize this – almost against his will; he wants to photograph without actually taking a photograph.

In the event, Jeff's defensive actions are ineffectual. He is thrown out of his apartment, out of his ocular predominance, out of his viewing space, by an image of his own making. His stubborn silence, his inability to answer the questions posed by the image, turns into a cry for help. But what must also have struck us is the fact that, initially at least, Thorwald, the image, is not as aggressive as Jeff would believe him. He comes with questions shot through with pathos: 'What do you want from me?' This is a question provoked not just by invaded privacy, but also by the sense of being exploited, for purposes invisible to the image. 'Why didn't you turn me in?' What anxieties, or fears, does the image produce to remove the photographer's sense of what is right? To Thorwald, Jeff's actions seem peculiarly arbitrary, pointless. Jeff cannot answer; at least, the only answer he can give is that another agency, the police, has the incriminating evidence. So, on this reading, the documentary photograph incapacitates the person who takes it and strikes him dumb. Sometimes we hear his cries for help, sometimes we hear the voices of those who act for him and enter the image on his behalf.

An initial objection to this allegorical reading might be a technical one: L. B. Jefferies is not, after all, a documentary photographer, but

a photojournalist. It is easy enough to suggest some crude distinctions between the photojournalist (imagined entirely as a newspaper photographer and not as a reportage photographer) and the documentary photographer. For example, the photojournalist is interested in acts and events, the documentarist in predicaments and conditions. The photojournalist deals in captions, in the interventions of the commentator and newsprint; the documentarist deals in the bare essentials of titles and looks for images that will speak for themselves. The photojournalist's photograph needs to tell us *what* something is; the documentary photograph wants to show us *how* it is. The photojournalist's camera scoops; for him, the actual is inevitably and excitingly epidermic, in constant change, instantaneous. The documentary photographer's camera insists, will not let go; it shows us something that may look like an event, but that is really evidence of an underlying status quo. The documentarist's 'event' does not change anything; it is one of those recurrent eruptions from below, a moment of manifestness.

But Jeff Jefferies has more of the potential documentarist about him than one might suspect. The racing car crash that destroyed his camera and broke his leg was an event all right; but his photograph of it does not tell us of its particularity, how it affected him, there and then. It shows, rather, how it belongs to that species of things called motor racing crashes, those hyperbolic kinds of crash which express more about motor racing than they do about crashes: speed, danger, the disintegrative capacity of thoroughbred machinery, how high-performance technology gives high performance, even at its moment of destruction. But more importantly, perhaps, the film *Rear Window* is not photojournalistic. Its ostensible subject, a murder and its discovery, is merely the vehicle of its subject. *Rear Window* is not a thriller; Lars Thorwald's murder of his wife is the lens through which we see into the psychology of human relationships and the sociology of human community. We do not, in fact, see the murder as an act; we only see its evidence. And the murder in its turn becomes an evidence, of the way we ourselves live, our own urban lives. *Rear Window*, in short, is about the transformation of the photo-journalistic into the documentary.

But one might also object that the very idea of 'documentary photography' is fundamentally flawed. The word itself was first coined in 1926, by the British film producer John Grierson, although

the recentness of the coinage probably indicates no more than that photography's documentary nature had always been implicitly accepted, and needed no advertisement. However, we should certainly bear in mind Abigail Solomon-Godeau's reminder that the notion of documentariness is an historical construct, and, for that reason, relative.[1] Equally, we should remember that 'documentary' is an ideologically loaded word: we tend to document those we imagine to be less fortunate than ourselves – documentary photography is always in some sense 'victim photography' – and for this reason, it can provoke only a charitable response, because, as we have said, it reinforces a status quo. To take a photograph at all is to proclaim a superiority, if only an economic and technological one, and the documentary photograph makes the inbuilt assumption that its subject does not take (has not the wherewithal to take) photographs of his/her own. Documentary photographs cannot, by definition, achieve neutrality; they are already produced according to the constraints of a certain visual language, according to certain spectatorial expectations.

We must remember, too, that photography in its entirety is an unstable medium, and that it only requires a change of title or context to change a photograph's generical status and intentions. We should remember what we have already proposed, that all photographs, whatever their originary genre (family snap, news reporting, portrait, landscape), are given documentary value by the passage of time, by our increasing ignorance, or, put another way, by the increasing generalization of our knowledge; that all photographs become documentary in two senses: they are documents of history, and documents of the history of photography.

But despite the salutary effect of these reminders, despite our awareness that historical relativities undermine categories, the attempt to establish something called 'documentary photography' remains, it seems to me, as imperative as it is instinctive. We map the fields of knowledge and experience by taxonomies; we need to understand what documentary photography is because it allows us to understand our relationship with photography. And it is precisely this relationship which documentary photography, perhaps more than any other kind, dramatizes.

Our relationship with photography seems, at first sight, to be one of personal dispossession. The argument would run like this: what-

ever the nature of the photographer's preparations and the viewer's responses, the camera takes the photograph, and in so doing ousts both the photographer and the viewer. The viewer cannot intervene in the image: it is past. The viewer cannot debate the meaning of the image: it has its own pre-emptive actuality. The viewer cannot retain possession of images of those he loves: the photograph makes them public property. The photographer, for his part, is superseded by his own product, or cast in the role of foster parent. Walter Benjamin, speaking initially of the painted portrait, says that interest in the sitter soon subsides:

> [...] the pictures, inasmuch as they survived, did so only as testimony to the art of the painter. In photography, however, one encounters something strange and new: in that fishwife from Newhaven [...] something remains that does not testify merely to the art of the photographer Hill, something that is not to be silenced, something demanding the name of the person who had lived then, who even now is still real and will never entirely perish into art.[2]

Let us not forget that Jeff Jefferies was thrown out of the window by his own image, Lars Thorwald, an image which once created, he could only spy on. And it is, we remember, this image that strikes him dumb, or nearly – 'Say something!'

The silencing of the photographer is, it seems, a condition of the production of the documentary photograph. The drama of Graham Swift's *Out of this World* derives from the fact that its photographer-hero, Harry Beech, can no longer communicate with his daughter Sophie, and can only relate to the world at large through photography. All his personal spontaneity, all his capacity for self-expression seems to lie in the camera. To Sophie this looks like a profound failure of fatherhood and personality. To me it looks more like a condition of documentary photography, with the damning reminder that the camera is likely to turn spontaneity into mere instantaneity, and self-expression into a strangely inverted impulse, whereby the image expresses itself at the photographer's expense.

But let us approach this more gradually. There are perhaps three founding reasons for the silence of the documentarist. First, and most obviously, the photographer must believe that his photographs are an evidence, make evident, in a way that makes speech a distraction,

a diversion of the eye from its proper subject (we remember Maude Pratt's words quoted in Chapter 1). Second, and relatedly, speech would represent a kind of moral theft – the speechlessness of the image should not be betrayed by the speech of the image-maker; that would be tantamount to using speech in order to suppress speech, an act of colonialism. Third, and most crucially for our argument, the documentarist is silent because his images strike him dumb. It is not just the viewer of the photograph who is susceptible to the traumatic experience described by Barthes; the photographer, looking through the view-finder, is equally vulnerable. At all events, one is often struck by the discrepancy between the spoken documentary which may be produced to accompany a photograph, and the photograph which is ostensibly its source.

In *Life and Landscape on the Norfolk Broads* (copyright 1886, published 1887), for example, the photographic plates, mostly by P. H. Emerson, are accompanied by a text roughly shared between Emerson and his co-author, the painter T. F. Goodall. The text attempts to turn the images into exemplars and illustrations of cultural givens, to assimilate them into a body of knowledge that already exists, to forestall any anarchy of interpretation, to 'dumb down' the potential visual power of the individual image. The photograph entitled *During the Reed-Harvest* (illus. 16), for example, along with three other images of reed-harvesting, is accompanied by a text which begins thus:

> By far the most valuable product of the swamps and rough marshes adjacent to the Broads, is the crop cut yearly from the reed-beds [...] The cutting and harvesting of the reed afford profitable employment to the Broadman, marshman, or farm-hand during the winter months, when other work is scarce; and whenever the weather permits, they may be seen busily plying the meak amid the tall yellow masses, or bringing the loaded marsh-boat across the Broad.[3]

We may, of course, even object to this text on its own terms, the terms of social custom and rural economy. How insidiously the words 'valuable' and 'profitable' encourage us to think that the reed-cutters are raking it in! How nicely the clause 'whenever the weather permits' suggests that adverse conditions are more to do with the meteorological whims of the Broads than with holes in

16 P. H. Emerson, *During the Reed-Harvest*, 1887.

the pay-packet. How nicely the phrase 'busily plying the meak', through the adverb 'busily', through the suggestion of untroubled continuity in the present participle 'plying', through the word 'ply' itself, conjures up a picture of diligent and contented industry, the unbrokenness of a folkish tradition.

Nevertheless, the photograph itself refuses to lie down, to be an illustration and a reassurance, to depict the purely social. This photograph, perhaps despite itself, pushes in the direction of the existential and metaphysical. The fate of the reed-beds to the right is paralleled by the progression of the figures laid laterally across the foreground. From unfocused, undomesticated, primal standing reed, we move to focused, bundled, cut reed, still standing, or rather held up, but soon to be stacked on its side, awaiting collection. The eye passes across a set of figures whose faces are concealed, or who are turned away from us, who do not surrender themselves to our gaze, as if they were unwilling participants in this process, as if they themselves were being made subject, cowed, against their wills. And how suitable it seems that, in the task of binding these reeds, the instrument of order, domestication, constriction, is a woman, almost made motherly by her near centrality in the image.

For all this lateral arrangement, however, this image, like most of Emerson's work, is principally frontal and confrontational. We cannot pass it by as the text would have us do, noting its typicality as we go; it requires us to face up to it, to enter it. However much the woman, turned towards us, may try to hold us in the picture's foreground, where the trade is being plied, the lines of the bound reeds ('shooves') and the cutting meak lead us inexorably into the depths of the picture, to the principal actor, who is as if renouncing this work, this condition, and setting out for the photograph's vanishing point, a beyond whose meaning we can only guess at. Alternatively, or concomitantly, he may be heading for the boat, with a figure at the stern, a fantasy image almost, or an image of fantasy. As he moves back through the picture, he comes into ever-closer contact with the reeds, the unfocused reeds, and some primitive natural origin.

Authorship – that notion made problematic by photography and made dramatically problematic by documentary photography – is centrally at stake. If the route to authorship lies through the voice that can authenticate the image rather than through the image itself, and if the intrusion of an explanatory or polemical voice is what destroys the documentariness of the documentary experience, what is the poor photographer to do?

John Berger's article on Don McCullin entitled 'Photographs of Agony' makes the just point that the reader whose attention has been arrested by a photograph may tend to feel the discontinuity (of the photographic moment in relation to continuing time) as his own personal moral inadequacy. '*And as soon as this happens even his sense of shock is dispersed*: his own moral inadequacy may now shock him as much as the crimes being committed in the war.'[4] He then goes on, however, to lament this diversion of the shock factor into moral self-examination, and its consequent de-politicizing effect. But the documentary photograph is the photograph that wishes to persist, and to be superseded neither by further events of the same kind, nor by actions taken in its name. Documentary photography exists, I think, not to improve a particular situation (though it may occasionally do this) but to increase our capacity for self-confrontation. And if this is to be achieved, we need as much to let the image enter us, in the same way that Lars Thorwald breaks into Jeff's apartment, as to send vicarious selves, like Lisa Freemont, into the image. What voices does this then leave to the spectator/documentary photographer?

Confessions of guilt? Pious self-righteousness? Or should he keep silent and let the photographs speak for themselves?

The first answer is that the documentary photographer will be spoken for; that is to say, not that someone will speak in his place, but that someone will provide him with a testimonial and confirm his credentials, will vouch for his good faith, as if accepting that he cannot speak for himself. At the outer level of this provision of testimonials is the blurb writer, whose principal task is to establish the co-ordinates of the type, the documentary photographer, and tell us that the photographer concerned fits them. These co-ordinates are a set of oppositions which the skilled practitioner knows intuitively how to reconcile.

First, the documentary photographer has compassion, a sympathy which confers dignity on his subject. Tom Hopkinson's 'Introduction' to George Rodger's photographs of the Blitz (1990) quotes a review: 'What he does is to photograph in a way that brings out the inherent nobility of his subjects.'[5] Then, despite this compassion, the documentary photographer is uncompromising, and this ability to look reality squarely in the face is what makes the good documentary photograph both intense and authoritative (according to the blurb of Chris Killip's *In Flagrante* [1988]).[6] Finally, the documentary photographer combines the authenticating force of the spontaneous and instantaneous with the enduring value of the penetrative and quintessentializing. Tony O'Shea's photographs of *Dubliners* (1990) give us 'the real Dublin', 'reveal the inner life of Dublin'.[7] The blurb on Nick Waplington's *Living Room* (1991) speaks of his 'sympathetic spontaneity' and goes on to describe him as 'a shadow, a ghost, who manages not to create a scenario but to distil its essence'.[8]

The same blurb gives some indication of the degree to which this particular vocabulary is in danger of devaluation through overuse. How often have we heard these touchstones of 'compassion' and 'dignity'; and yet they are no more than a convenient paper currency. One way of trying to revalue the terms is by setting them against each other, or seeming to use them in rather more subtle and sensitive ways. So we learn of Nick Waplington's work: 'Far from the falsely compassionate conventions of social "reportage", he draws us in, close enough to almost share in the human dignity of these difficult conditions. Finally he offers us a key that enables us to read society without caricaturing it.' So if we put all these

contradictory elements together, as the photographers themselves know how to, we arrive at a knowledge of the true calling of the documentary photographer, a calling that makes an artist of him: Hilton Kramer of the *New York Times* supplies a blurb quotation for Brassaï's *The Secret Paris of the 30's* (1976); for Kramer, Brassaï photographs 'with that special combination of detachment, excitement, and empathy we feel in an artist who has discovered his true métier'.[9]

At a level further in, testimonials are provided by the writers of introductions and epilogues. These are the photographic and cultural gurus, the elder statesman of media commentary. Their contributions fall into three principal modes. First, they may provide an authenticating background or polemical foundation for the images themselves. This involves a presentation of the place and living conditions depicted, which implies that the photographs are both necessary and eloquent. The essay by Sylvia Grant and John Berger for Chris Killip's dark view of Britain, *In Flagrante*, is a dialogue between cool appraisal and impassioned autobiography, in which the appraisal gravitates irresistibly towards the autobiography: 'On these last reaches, people make love, children are born, grandmothers make pies, families go to the seaside. And they all know what is happening: the boot is being put into the future.'[10] Thus the photographs are embedded in a coherent crusade, and their muteness is transformed into pathos, frustration, indignation, by those licensed to speak.

Second, their contributions may provide testimony by asserting that the photographer has assimilated himself into, been accepted by, become absorbed in, his subject. The relationship between photographer and photographed – rather than that between photograph and photographed, as in the first mode – is what is authenticated. About Nick Waplington's photos of two Nottingham families, in *Living Room*, Berger affirms: 'It is obvious that Nick [...] knows and loves the friends he has photographed. Obvious because of the way they don't look at him.'[11] Tom Hopkinson vouches for George Rodger's capacity for empathy by quoting Rodger himself, commenting on his photos of the Masai of Kenya:

But in such situations the technical side is the least part of it; what's vital is the contact you make with the people you're

among. Basically, this is a matter of the respect and liking you feel for them, and which somehow they understand and feel towards you in return.[12]

Even in extreme situations, documentary photography manages to be a mutually agreed but unspoken contract between photographer and photographed; hence its distinguishing features of 'compassion' and 'dignity'.

Finally, and more exceptionally, the introducer may claim, or demonstrate, that the photographer is, by constitutional need, by psychological imperative, by temperamental predisposition, in short by existential persuasion, a documentarist. It would not matter what photos he took, the moral compulsions he lives by would require them to be documentary. John Le Carré's introduction to Don McCullin's *Heart of Darkness* (1980) is presented, quite literally, as a journey into that heart. Le Carré identifies McCullin's sense of guilt, insecurity, indignation, vulnerability (qualities he shares with Hitchcock's Jeff Jefferies, we might propose); and his photographic work is clearly an inevitable product of this particular moral and psychological mix:

I found them [the photographs] electric, I found them haunted and at times unearthly. I might not care that much for his confessions, but I could well understand that his work was the product of a restless and slightly puritanical nature, deeply ill at ease with the world's condition, and his own.[13]

Don McCullin grudgingly accedes to these autopsies on his living body.[14] For his part, he might want to attribute his love of photography to his alienation from text, to his dyslexia. At all events, text, in its minimal form, as title or caption, has much to teach us about the triangular relationship between photograph, photographer and viewer.

I have tracked particular photographs across three of Don McCullin's publications, the two albums entitled *Hearts of Darkness* (1980) and *Perspectives* (1987),[15] and his autobiography, *Unreasonable Behaviour* (1990). The formulation of their titles varies according to the stance of the book in which they appear, and they make it easy to understand how the titles of photographs become games of Chinese whispers, particularly when they escape from the jurisdiction of the photographer. One image, for example, is called

Battle-fatigued Biafran officer talking to a dead soldier, 1969 in *Hearts of Darkness, Captain Osadebe lectures a dead soldier about his sacrifice for the cause* in *Unreasonable Behaviour,* and *Mad Biafran captain lecturing his dead soldier on why he died, Biafra, circa 1968* in Jorge Lewinski's *The Camera at War* (1978).[16] Another is entitled *British soldiers dressed like Samurais charge stone-throwing youths, Londonderry, 1970* in *Hearts of Darkness, Men from the Royal Anglian Regiment in their samurai protective armour counter-attack in the Bogside* in *Unreasonable Behaviour,* and *Charge of the dreaded RUCs, Londonderry, circa 1971* in Lewinski.[17] Another is *Turks reaching out for the body of an old man shot during the battle for Limassol, Cyprus, 1964* in *Hearts of Darkness,* and *An old man gunned down by snipers in Limassol* in *Unreasonable Behaviour,*[18] but the photograph taken directly after this one is, in Lewinski, entitled *Wounded man carried to safety, Cyprus, 1963*; McCullin calls it *Turks dragging away the body of an old man, 1964* (*Hearts of Darkness*). The speed with which titles become unreliable is deeply disturbing. But in this section of my argument, I want to explore how even the slightest textual manipulation will alter our posture towards the photograph, and how the degree of a photograph's documentariness depends on textual formulation.

Some of McCullin's barest titles are to be found in *Perspectives: Destitute men, London; Lumb Lane, Bradford* (illus. 17); *Father and sons, housing estate, Bradford* (illus. 18). Not surprisingly, this gradual rendering down of the title is closely connected with the ageing of the photograph, its gradual accession to the status of icon, the broadening and dehistoricizing of its perspectives. It is as though the increasing abbreviation and impersonalization of the title were simultaneously processes of quintessentialization (isolating what endures, what survives), generalization and empowerment (registered in increasing speechlessness). The photograph gradually assumes an autonomy, speaking for itself, without the prejudicial intervention of a commentator, and becoming a more total account of a recurrent human condition.

Perspectives was published in 1987. The photograph *Lumb Lane, Bradford* was taken in 1978, and in *Hearts of Darkness* had the title *A man on crutches making his way home during a winter rain-storm, Lum [sic] Lane, Bradford, 1978*. This title points out the crutches and the rain and, in so doing, fixes the photograph's points of reference.

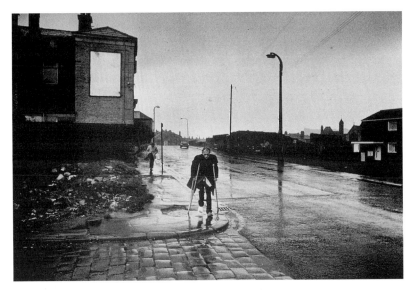

17 Don McCullin, *Lumb Lane, Bradford*, 1978.

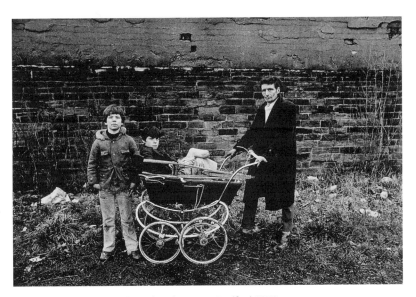

18 Don McCullin, *Father and sons, housing estate, Bradford*, 1978.

But this oppressed individual is not to be pitied just as a specific, historicized victim, but also as a metaphor of his environment – he gathers into himself the inability of the street-lamps to withstand the encroaching darkness, the crouching lowness of the buildings on the right, the overbearing facelessness of the building on the left, the waste, or rather wasted, ground, the sense of splintered community, the road that somehow goes *by*, rather than *with*, or *towards*, the cobblestones of a past and forgotten life. Similarly, *Father and sons, housing estate, Bradford* does not forestall, or pre-empt, our growing awareness of a truth, our having to admit to ourselves what it is we see. The title in *Hearts of Darkness*, *Bradford boy whose leg was mutilated in a scrap-yard accident and whose only mode of transport was a baby's pram, 1978*, tells us our responsibilities, our charitable duties, and blocks personal discovery, the engagement of the imagination, the challenge to unravel what we do not understand.

Indeed, the photograph's having-been-named absolves us from naming for ourselves. By putting the predicament into public words, the writer of the title takes away from us the responsibility of looking in order to see. But curiously, this *Hearts of Darkness* title is self-undermining: by its use of the simple past tense 'was', in both clauses (one might have expected *Bradford boy whose leg has been mutilated in a scrap-yard accident and whose only mode of transport is a baby's pram, 1978*), the image is tied into McCullin's autobiography, becomes a single encounter in the past to which we were not privy and from which we are further detached by the explicit barrier of intervening time. We cannot even look at this picture in a present of our own experience. And this is the curious thing about the documentary photograph: like all photographic images, it is necessarily taken in the past, but its power to generalize and quintessentialize gives it the capacity continually to reconstitute itself, to adapt to a changing present.

Finally, *Destitute men, London* is, in *Hearts of Darkness*, called *Down-and-out shouting confused political obscenities, Spitalfield market, London 1973* (illus. 19).[19] If I claimed that the words 'confused' and 'obscenities' were prejudicial to an appreciation of

19 Don McCullin, *Down-and-out shouting confused political obscenities, Spitalfield market, London 1973*.

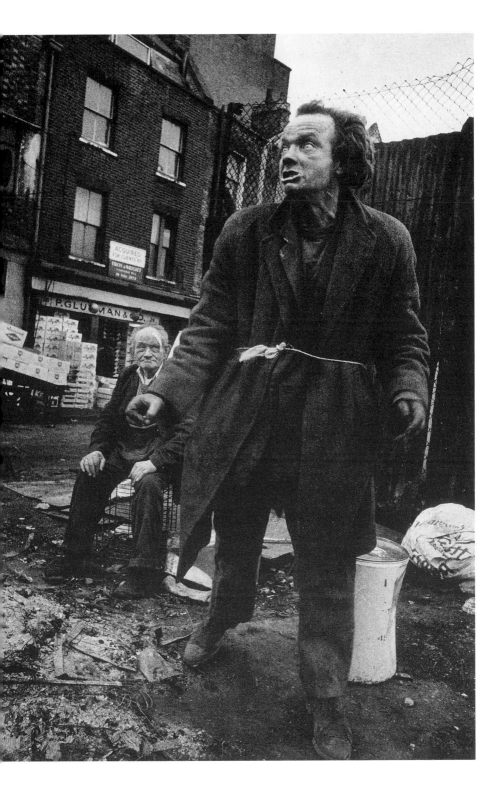

the image, one might justifiably retort: 'And quite rightly so, because that is what the photographer heard.' But is there not then a sense in which the viewer would have to prove himself/herself a worthy recipient of such information? Do not these words 'arm' the spectator against the image, provide him with ready-made levers and points of purchase? The eyes already speak confusion, the mouth already utters obscenity. But they may speak other things, too, which depend on a total and unconditioned assimilation of the picture. Let us not forget the underlying proposition of this piece: that in documentary photography the viewed is the viewer, and vice versa. At the very least we must meet the image half way. At the very least, we must ourselves be emotionally and psychologically inspected by the image.

Of course, in any circumstances, linguistic shifts will produce shifts in sympathy, focus and attitude. *Marines tormenting Vietnamese civilian captured during the battle of Hué, 1968* in *Hearts of Darkness*, becomes *A Vietnamese civilian tormented by his 'liberators', American marines* in *Unreasonable Behaviour*.[20] It is perhaps not surprising that sympathy should have drifted towards the Vietnamese between the publication dates of these two books, 1980 and 1990. But the recentring of the image on the Vietnamese civilian, the omission of any reference to capture and to the heat of battle as justification, and the ironic dubbing of the Americans not only as 'liberators' but as '*his* liberators', all make the photograph part of a completely different narrative.

Similarly, notice how much less reasonable, how much more inflationary, British responses have become in Ireland, between *British soldiers detain a young boy for questioning, Londonderry, 1970* of *Hearts of Darkness*, and *A young boy arrested by British soldiers on suspicion of causing riots* of *Unreasonable Behaviour*. More generally, we should also notice that, while the titles in *Perspectives* are largely substantival, made only of nouns without dates – *Bingley. Immigrant ironworkers; Homeless woman, London; Mother and child, Consett* – the irreducible and recalcitrant fact, stripped of explicit intention, and yet deeply, mysteriously intended precisely because of that, those of *Hearts of Darkness* favour constructions with a present participle – *American marine throwing hand grenade* [...] (illus. 20); *Army chaplain carrying old Vietnamese woman* [...]; *Shell-shocked soldier awaiting transportation* [...].

The characteristics of the present participle might be described

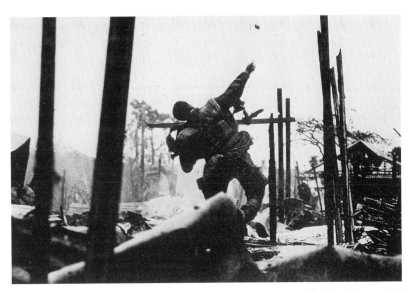

20 Don McCullin, *American marine throwing hand grenade during the Tet offensive, Vietnam*, 1968.

as follows. First, it is non-temporal, the time referred to being automatically that of the main verb. In other words, it is adaptable to temporal change, and when there is no main verb – as in photographic titles – it is available to all times, past, present and even future. Second, it depicts action in mid-stream, suspended in its happening, so that although the photographic image is wrenched out of a continuity, it re-establishes continuity in a time of its own. Finally, the present participle centres attention more on the agent than on the action. When we say 'American marine throwing hand grenade', we make the throwing a part of the marine, not necessarily an integral part, but an adjectival quality momentarily possessed by him. We notice, too, that the hand grenade has no article, no separate existence, no historical identity – it is a species, a category of armament, not one hand grenade as opposed to another, but rather hand grenade as opposed to stone, dagger or spear. This absence of article is a stylistic trait of *Hearts of Darkness*: *Marine with bullet wounds [...]; Grief-stricken woman and son [...]; Biafran soldier rushing wounded comrade from the front, 1969.*

If, on the other hand, the title had read 'An American marine throws a hand grenade', our attention would centre on the grenade and its effect, the action and its consequences. Who is he throwing it at? What devastation did that particular hand grenade cause? It is not

surprising, therefore, that the title of this particular image should, in *Unreasonable Behaviour*, concentrate on the fate of the throwing marine: *The athlete, moments before he was shot in the hand in the Tet offensive of 1968.*[21] This title throws one back to a passage in Swift's *Out of this World*; Harry Beech describes one of his war photographs:

> There is a picture of mine (one of the 'famous photographs') of a marine throwing a grenade at Hoi An. His right arm is stretched back, his whole body flexed, beneath the helmet you can see the profile of a handsome face. It's pure Greek statue, pure Hollywood, pure charisma. And it's how it was. It must have been. Because the camera showed it. A second later, that marine took a round in the chest and I took two more shots and then some more as they got him clear. I wanted the whole sequence to be printed. But you can guess – you know – which single shot they took.[22]

So Harry Beech's picture becomes a T-shirt and war totem, floating free from its context in lived history. This, then, we might summarize as the being of documentary photography, basing what we say on our observations about the present participle and the zero article: the documentary photograph draws our attention to the subject rather than the action, and the subject is presented as a category of human life, in a situation which is seen from the inside – action in mid-stream – in a temporality which is highly flexible, and for that reason durable. Photojournalism would, conveniently, be the opposite of these things. And the denuded language of the titles of *Perspectives* is the furthest language reaches in the withdrawal of the photographer, in the refusal to construct the picture. Beyond that lie the untitled images of, for example, Chris Killip's *In Flagrante* or Nick Waplington's *Living Room*.

Harry Beech deplores the removal of the grenade-throwing marine by photography from the context of both the marine's life and his own. The documentary photograph tells us everything as image and nothing as narrative. The instantaneousness of the photograph apparently gives it an inevitable irresponsibility, and acts as a licence for the photograph to be irresponsibly exploited. It is a shared narrative, on the other hand, that creates a fraternity between the photographer and the photographed. It is narrative that allows the photographer to participate in his own images. It is narrative that guarantees the activity of conscience. Narrative, and

particularly autobiographical narrative, puts the photographing self back into the image, and this is the final level of the verbalization of the image I want to explore.

In *Hearts of Darkness*, Don McCullin's image of a marine throwing a grenade is accompanied by a bare description: *American Marine throwing hand grenade, Tet Offensive, Hué, 1968*. But in *Unreasonable Behaviour*, even the caption provides a narrative reminiscent of Harry Beech's: *The athlete, moments before he was shot in the hand in the Tet offensive of 1968 – a turning point of the war in Vietnam*. The text elaborates further on the athletic grenade thrower:

> I took a picture of another black Marine hurling a grenade at the Citadel. He looked like an Olympic javelin thrower. Five minutes later this man's throwing hand was like a stumpy cauliflower, completely deformed by the impact of a bullet. The man who took his place in the throwing position was killed instantly.[23]

I would like to make three observations here. First, McCullin's use of the past tense – 'moments before he was shot' – ties the image, once again, not into extendable documentary time but into punctual photojournalistic time, or, more accurately, into the punctual time of the photojournalist – because the photographer reclaims his image as part of his own history too. He takes the image from us, tells us that we cannot be contemporary with it, that he was the only witness, and that we can only be witnesses by proxy. Second, in the full text, the 'throwing' of the title in *Hearts of Darkness* is replaced by 'hurling'. 'Hurling' is a bigger, more epic event than 'throwing'; it implies force, violence, anger. This kind of linguistic inflation is journalistic, of course; it justifies the telling of the story by narrative means alone. But it also expresses the excitement of the participant, and in this way, again, draws the photographer into his own image. Third, McCullin tells us that, shortly afterwards, the marine's hand was 'like a stumpy cauliflower'. In front of us we have a visual image, itself imaged in words, words of a common knowledge: 'like an Olympic javelin thrower'. Superseding this is another verbal image – 'like a stumpy cauliflower' – which cannot be checked against any visual evidence and which is notable by its uncommonness: the stump of the hand has been assimilated into what it looks like, and so we have a kind of visual coalescence: 'stumpy cauliflower'. The uncommonness is an index of the writer's involvement.

In *Hearts of Darkness*, we come across a photograph with the title *Christian militia mock the body of a young Palestinian girl killed in the battle of Karantina, Beirut, 1976* (illus. 21).[24] In *Unreasonable Behaviour*, it has the apparently unrelated caption *The mandolin player photographed despite a death threat to the photographer*. We notice that even in *Hearts of Darkness*, a present tense, 'mock', has been preferred to the more usual present participle, 'mocking', putting the emphasis on the act rather than on the agents, presenting the act as something pointed and recurrent, rather than as ongoing. The caption in *Unreasonable Behaviour* refers to the mandolin player by the definite article, assuming that we come to the photograph via knowledge already culled from the text. The photographer also appears in the caption, as an equal and opposite force to the mandolin player. The photograph itself shows, as McCullin puts it, 'carnival rejoicing in the midst of carnage',[25] and he adds: 'It seemed to say so much about what Beirut had become.' This is its documentary function. Nothing is said of mockery. But grafted on to this is a story about the photographer's chance encounter with the group, his fear of being shot, his subsequent anger, the death warrant put out on him. Did McCullin photograph a scene which summed up civil war in the Lebanon, or an episode in an almost personal vendetta? 'As we picked our way over the rubble on the way out I could hold it down no longer. 'The bastards. THE BASTARDS,' I yelled out loud. 'I'm going to get you bastards!'[26]

As a final example, we turn to *Hearts of Darkness*, to an image entitled *Albino boy, not only starving and at death's door, but ridiculed by fellow sufferers for skin pigmentation, 1970* (illus. 22).[27] In *Unreasonable Behaviour*, the same image is captioned *The albino boy clutching his empty French corned beef tin*, where, once again, the definite article expects us to be familiar with the accompanying text. The image's centre of gravity seems to have shifted from the double suffering of the albino boy to his corned beef tin. But the autobiographical text still insists on the boy's double penalty: 'Dying of starvation, he was still among his peers an object of ostracism, ridicule and insult.'[28] But this narrative has a more personal sequel:

I felt something touch my hand. The albino boy had crept close and moved his hand into mine. I felt the tears come into my eyes as I stood there holding his hand [...] I put a hand in my pocket and

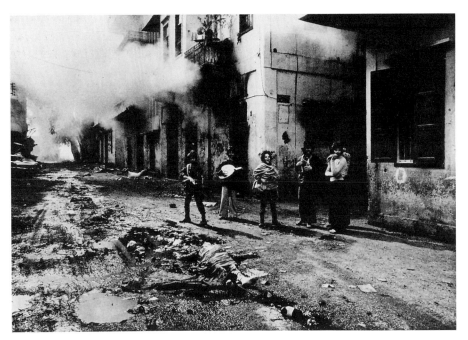

21 Don McCullin, *Christian militia mock the body of a young Palestinian girl killed in the battle of Karantina, Beirut, 1976.*

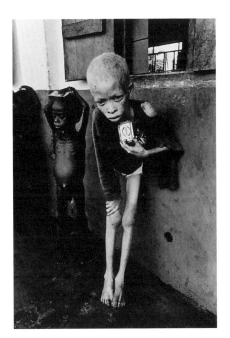

22 Don McCullin, *Albino boy, not only starving and at death's door, but ridiculed by fellow sufferers for skin pigmentation, 1970.*

found one of my barley sugar sweets. Surreptitiously I transferred it to the albino boy's hand and he went away [. . .] I noticed that he was still clutching the empty corned beef tin while he stood delicately licking the sweet as if it might disappear too quickly.[29]

And, in fact, the second title fits the image better: we do not see ostracism here; we see a child who looks like an adult, a black boy who looks like a white boy, clutching a Western product like a talisman, a dream of nourishment, a tin whose place of origin, France, was somehow too distant, too large, for its contents ever to reach this individual.

So, in this last example, the autobiography in a sense gives the image back to us, though the eloquence of the empty tin does not require the mediation of the photographer's narrative. The narrative supplied by the autobiography may push in directions which the photographs themselves resist. We have already explored the kinds of discrepancy that can occur between text and image, not only in McCullin's work, but in Emerson's as well. Nevertheless, a principal preoccupation of the photographer's autobiography is precisely the exploration of the ambiguities and contradictions which surround his relationship to his medium.

McCullin sometimes knows why he is taking photographs: 'What I hoped I had captured in my pictures was an enduring image that would imprint itself on the world's memory.'[30] And yet he sometimes feels that he should not be doing it: 'I stood there feeling less than human, with no flesh on me, like a ghost that was present but invisible. You have no right to be here at all, I told myself.'[31] Sometimes he seems to know what his photographs mean: 'I felt I had a particular vision that isolated and homed in on the essence of what was happening, and would see that essence in light, in tones, in details.'[32] And yet sometimes he does not know at all what they mean: 'I knew my pictures had a message, but what it was precisely I couldn't have said.'[33] What he does know is that his role is contradictory: 'I was, what I always tried to be, an independent witness – though not an unemotional one.'[34] These same uncertainties belong to the viewer. McCullin's comments bear out what we have already said about the peculiar importance of documentary photography: that it dramatizes our problematic relationship with photography generally.

Autobiography is the equivalent of entering the picture, of Jeff leaving his apartment and going over to beard Lars Thorwald in his den. If this option had been available to Jeff, what would have happened? Jeff would have been a prosecuting party, never the defendant that, briefly, Thorwald compels him to be. He would never have been confronted by his guilt, never ousted from his watch-tower, never asked why he was doing what he was doing. His predatory photographic life would have been fully vindicated. Instead, his image comes over to him, and looks at him, despite his efforts to blind it. The world of plights and conflicts must ask questions of the people who look at it, must be allowed to ask questions. These questions are the subject of documentary photography. The documentary photograph looks back at us and resists our attempts to slip it innocuously into some ongoing narrative that transcends and supersedes it. The real meaning of Don McCullin's encounter with the albino boy lies not so much in social ostracism, nor in the eloquence of the empty corned beef tin, as in the way in which the subject of the photograph comes up to him, and us, and demands satisfaction, accountability. In McCullin's account, this is expressed as a whole psychodrama: 'The boy looked at me with a fixity that evoked the evil eye in a way which harrowed me with guilt and unease. He was moving closer. I was trying not to look at him. I tried to focus my eyes elsewhere [...] He was haunting me, getting nearer.'[35] The albino boy refuses to stay in his own, framed territory and, like Lars Thorwald, steps up to the voyeur-photographer who, correspondingly, loses the power to look. The images of documentary photography are images that seek to haunt us, barely suppressed memories of, and fantasies about, our own capacity for cruelty, misanthropy, prejudice, condescension, violation. And less obviously, less problematically, perhaps, that is what all photography is.

Taking my cue from *Rear Window* and from McCullin's work, I have imagined documentary as something rather dark, a confrontational, almost fratricidal, psychodrama. In doing so, I have run the risk of overlooking encounters which are more balanced and collaborative. It is not unusual for the subjects of documentary photography to be posed; this is what establishes them as 'presences', as affirmed identities, and therefore as dignified and self-respecting. In this way, photographer and subject share the knowledge of their encounter, and indeed may share an ambition for the photograph's

future. Even where resistance between photographer and subject is at its greatest, there must be some room for this complicity, for these are the paradoxical combinations – resistance/complicity, wariness of the stranger/trust in the assimilated, fragility of the encounter/ aesthetic durability – that define documentary photography.

The Behaviour of Captions in the Press

Photographic genres – photojournalism, documentary photography, the family snap, the nude, etc. – may be said to exist, but photographs do not belong to them by any inherent right. Rather, a context is expressly created for the photograph, often and predominantly through language, which of itself assigns the photograph to a genre. No photograph is necessarily, say, photojournalistic; photo-journalistic photographs are photographs used by newspapers. A photograph of a row of new racing bikes – like any photograph of mass-produced objects, dear to the financial pages of the quality newspapers – might have been an industrial art photograph by another Rodchenko, or a film-still, or an advertisement, or part of a documentary photo-essay about the manifold potential destinies of a thoroughbred bike. Put it in a newspaper and it is a peg for a related event or trend: the increase in bike theft has produced a marked rise in insurance premiums ('Wheels of fortune . . . bike theft is big business', a photograph by David Sillitoe, *The Guardian*, 7 March 1992; illus. 23).[1] The photograph did not create the news, but was chosen for the news which was itself created by the newspaper. News photo-graphs are made and not born.

To understand photojournalism, therefore, we need to understand the photojournalization of photographs. We need to understand the psycho-perceptual triggers activated by the embedding of a photo-graph in newsprint, and particularly the linguistic features peculiar to the captions that project it. This chapter concentrates not on the activities of the newsroom, but on the newspaper's relation with the reader; it works from a limited corpus – issues of *The Times*, *The Independent*, *The Guardian*, *The Daily Telegraph*, *The Sun*, the *Daily Mirror*, the *Daily Mail*, the *Daily Express*, the *Daily Star* and *Today* for Tuesday, 13 July 1993 – and is thus inductive and speculative in nature, a beginning that invites elaborations.

23 David Sillitoe, Original photograph and cropped version, captioned 'Wheels of fortune… bike theft is big business', *The Guardian*, 7 March 1992.

We know very little about the psycho-sociology of newspaper reading. We know its classic sites – the breakfast table, the railway carriage, the waiting room, the factory floor – but we are much less sure of its functions. It alerts us to the day, makes national citizens of us, compels response to the world stage, supplies us with conversation fodder, distracts us in moments of tedium – but these different functions are not easy to separate, and are perhaps important precisely by the way they act together. The 'quality' newspapers, by virtue of the physical nature of the broadsheet format, can isolate the reader, justify incivility, make news-reading a private, silent and selective affair, involving a high degree of visual scanning and thus a greater readerly control of news-intake. Tabloids, on the other hand, pride themselves on generating a 'loud', corporate reading, on ease of access, on helping the eye to find something to latch on to, indiscriminately, whatever its import. *The Sun*, for example, boasts three readers per copy, and when it came into existence in its 'new' form in 1969, under Rupert Murdoch and Larry Lamb, it adopted state-of-the-art eye-catching techniques:

> The design of the paper was based on the *Mirror* with tabloid pages bristling with irresistible hooks for the eye – graphics, montaged photos and variable ('bastard') column widths, WOB

(white on black) and WOT (white on tone) headlines, underscores and overscores, rag-outs, starbursts, barkers and screamers.[2]

In any event, reading the newspaper is not a pure act. It is beset with context; it vies with, supplements and complements other activities, which often govern the reader's stance, or create incongruities between the reader's own physical situation and the situation of those he is reading about. This is part of Proust's concern in the wonderful analysis of newspaper-reading that he interpolates into 'Sentiments filiaux d'un parricide' ('Filial feelings of a parricide'). In this essay, he describes how he developed a growing acquaintance with, and deepening respect for, a certain Henri van Blarenberghe, only to read, one morning in January 1907, that this same Henri van Blarenberghe had killed his mother and then himself. Before stumbling across this horrifying news, the narrator treats us to an extended digression on the newspaper:

> [...] I wanted to cast an eye over the *Figaro*, to initiate that abominable and voluptuous act called 'reading the newspaper', thanks to which all the misfortunes and cataclysms which have occurred in the world over the previous twenty-four hours, the battles which have cost the lives of fifty thousand men, the crimes, strikes, bankruptcies, fires, imprisonments, suicides, divorces, the cruel emotions of statesman and actor, transformed for our personal use – we who are not involved in them – into a morning treat, combine excellently, and in a particularly exciting and invigorating way, with the recommended ingestion of a few mouthfuls of white coffee.[3]

We may not feel that reading the newspaper provides the physiological benefits Proust ascribes to it, but we should certainly take to heart his phrase 'transformed for our personal use – we who are not involved in them'. The newspaper transforms events in the world into news, pre-digests experience, makes it possible for us to communicate it to others in our turn. In short, the world is rendered down and funnelled into thirty-or-so pages of a newspaper, which we can possess, and in which we can keep our experiences of the larger world isolated, imprisoned; we can thus 'make personal use of it'. This physical circumscription of history-in-the-making is further aided by the photograph, which we are encouraged to treat as a window

looking directly on to the world. But we must remind ourselves again that the photograph does not come direct from the world so much as from the newspaper editor, and that, following the logic of this solipsistic circle, newspapers, and tabloids in particular, increasingly become their own news ('Sun Pic Finally Forces Sams to Confess' [*The Sun*, 13 July 1993, p. 1], 'Your super Daily Star racing service came up trumps yet again yesterday' [*Daily Star*, 13 July 1993, p. 1]).

The photograph is also circumscriptive, however, in its role as identifying agent. Many would argue that the news photograph, by virtue of its apparently reliable referentiality, closes down the operation of the imagination, acts as a substitute for, and thus releases us from, any implication in the news item. There may be much truth in this, but it should be qualified by two further observations. First, captions themselves may implicate us or otherwise compel response, as we shall see. Second, by acting as a focus, as the one piece of evidence available to us, the particular photo attracts to itself – in relation to a whole range of other possible photos – a disproportionate attention which transforms the one piece of available evidence into the whole evidence. The reader finds in the photograph a satisfying target for any emotional output. On this reckoning, the news photo does attract emotional discharge, but of a particular kind, the kind associated with the targeting of individuals: admiration, envy, pity, vindictiveness – but not, for example, hope, despair, determination. Graham Swift expresses it thus in *Out of this World*:

> People cannot comprehend large numbers or great extremes. They cannot comprehend a thousand deaths, or routine atrocity, or the fact that there are situations [...] in which life becomes suddenly so cheap that it is worth next to nothing [...] These things are pushed to the remote borders of the mind, where perhaps they will be wafted into someone else's territory. But they can contemplate one death, or one life.[4]

We can think the Holocaust, and war crimes, if we can think of bereaved individuals, trials and war criminals in docks.

So the news photo is a powerful weapon in that process of 'personalization', which is so important a factor in the assessment of news values. Roger Fowler, reporting these factors as formulated by Johann Galtung and Mari Ruge, glosses 'personalization' thus:

Presumably, its functions are to promote straightforward feelings of identification, empathy or disapproval; to effect a metonymic simplification of complex historical and institutional processes (Arthur Scargill 'stands for' a whole set of alleged negative values in trades unionism; WPC Yvonne Fletcher, shot dead from a window of the Libyan Embassy while policing a demonstration, is made to stand for 'Britain's moral superiority over Libya').[5]

The following trends in the tabloids are not, then, so surprising:

(1) The predominance of passport-size head-and-shoulders photographs,[6] without any indication of environment, and precious little language of stance, gesture, clothing. This is 'pure personality', operating without benefit of any circumstantial visual evidence, and for this reason, the photos may be noticeably inappropriate to the news item. These are photos from anywhere, designed to provide an optical 'fix' on the protagonist in question. The story in the *Daily Mirror* (13 July 1993, p. 10) that 'Comic Adrian Edmondson sparked a sea rescue drama when his dinghy lost a sail' is accompanied by a head-and-shoulders shot of a besuited, bespectacled, carefully kempt and smiling Edmondson, a photograph which might, for all we know, have been taken at a friend's wedding five years previously. These are photographs, without news value in themselves, of people in the news. But their photomat format – even the self-confessed murderer Michael Sams (*Daily Mirror*, 13 July 1993, p. 5) looks as though he has supplied his own photograph, one that catches him nicely in his checked cap and executive-frame glasses, with an open, half-smiling countenance – implies that the photographs are an affectionate gift from the subject, taken in a manner designed to please the reader and to capture the sitter's durable personality, impervious to the vicissitudes of the news, almost outside time.

(2) Tabloids also include head-and-shoulders photos of their correspondents, columnists, astrologers, weatherpersons, the stars of the evening's television viewing, those advertising sex-lines, and so on. This helps to foster the idea that the newspaper is generated by its own established personalities, that appearance in the newspaper confers personality, that, in a news-hungry world, personality is a key to, or result of, an instantaneous change of status. The quality papers have also espoused this habit. With attention span anticipated at a minimum, the photograph is less than an image or a piece of

information, but sufficient to warrant the ethos of first impressions and to anchor language in the identifiable and targetable.

(3) Relatedly, just as the newspaper becomes its own news, so the news item or feature becomes the writer. This is partly a result of visual connection: the photo of the reporter/correspondent stands in roughly the same relation to the written article as the photograph of the person-in-the-news. This absorption of the reporter into his own news, his ability to become his own news, is, of course, familiar to us from such films as Roger Spottiswoode's *Under Fire* (1983) and Oliver Stone's *Salvador* (1986), and from television reporting generally. There is also a noticeable shift of emphasis from the burden of what is written to the style or attitudes of the writer. This is obviously bound to happen at every level of reporting, but it is noticeably aggressive or brazen in the tabloids. In the *Daily Mirror* a forthcoming 'Woman' feature is advertised with the words 'New raunchy writers who will shock you'. In one of the paper's regular magazine spots, Marje Proops is permanently cast as 'The World's Greatest Advice Columnist', while, correspondingly, *The Sun*'s Deidre Sanders is 'The World's No.1 Agony Aunt'. And often, of course, the proprietary relationship between a correspondent and his or her news is visually expressed: the correspondent is presented as a banner headline for his/her own column (one thinks of Ross Benson and Peter Tory in the *Daily Express*, Roy Collins in *Today*, John Edwards and Nigel Dempster in the *Daily Mail*, Brian Hitchen in the *Daily Star*).

Before embarking on an analysis of the language of the photographic caption in newspapers, we should return once more to our original argument, namely that newspapers bring us the news and liberate us from it at the same time, by circumscribing it, by conventionalising it, in a set of known graphic and linguistic formats, and by reminding us that each issue of the newspaper is a perishable commodity and will be superseded in a few hours. The multitude of purposes to which a newspaper is put, the striking incongruities between the nature of news and the functions of the newspaper, between the extraordinary nature of news and our banality as readers, or the banality of the reading environment, produces the feeling either that we do not want the news we so avidly seek, or that we are not worthy to be privy to it.

Our reactions, however, are facilitated by the highly conventionalised nature of the news, of the paper's layout, of the reporting,

and so on. This has the effect not only of transforming the event, or person, into a stereotype, but also of stereotyping response. Like the drama, the news, already a category by virtue of its being reported – how much news do we have no news of? – comes to us as interpretation, and often as an interpretation of an interpretation, when the already implicitly interpreted is overlaid by an explicit interpretation, the editorial voice of the caption, intervening between the news and the reader, appropriating the news and passing it on with a gloss. These glosses, inevitably, are not so much real elucidations as ways of consolidating the readership, of urging a unanimity of response. The voice of the caption is the voice of the newspaper, not of the news; it transforms a 'real' event into a newspaper event, anticipates, provides a pattern for, our voice, is the voice of news-digestion. The process of reporting, editing, composing a newspaper, takes us progressively further from the news source. And with this recessive movement converges the equally recessive movement of the newspaper photograph. Like the newspaper column, the photo is framed, creating a particular effect described by Susan Sontag:

> A new sense of the notion of information has been constructed around the photographic image. The photograph is a thin slice of space as well as time. In a world ruled by photographic images, all borders ('framing') seem arbitrary [...] Through photographs, the world becomes a series of unrelated, freestanding particles; and history, past and present, a set of anecdotes and *faits divers*. The camera makes reality atomic, manageable and opaque.[7]

Framing persuades the reader that the news is encompassable, while the watertight separation that framing enacts reassures the reader, rather like territorial boundaries, that no disaster is in danger of spreading (this is not so true of the tabloids where the very style is invasive, and where, as we shall see, informational promiscuity is characteristic). The crucial paradox, in Sontag's words, is the conjunction of 'manageable and opaque', the conjunction of possession and incomprehensibility, implicit within which are the causal relationships 'manageable because impenetrable' and 'impenetrable because manageable'. The price we pay for the disempowering of news is its unintelligibility. Reformulating our previous assertion, we might now propose that the function of the caption is not to

elucidate news on news's own terms, but to transform the opaque of the news into another kind of transparency, the transparency of encapsulating judgement, expressed in summarizing shorthand, or as a summarizing pun, or both: 'Foiled: Dad Damon' (*Daily Mirror*), 'World-beater: Lys8-1, the first transgenic cockerel [...]' (*Daily Mail*), 'Degree of support: Nelson Mandela [...] saluting an audience [...] after receiving an honorary degree[...]' (*The Times*), 'Marching orders ... Orangemen commemorating the Battle of the Boyne [...]' (*The Guardian*).

If the manageability and digestibility of the news depend on the pursuit of framing – a sense of the world's radical discontinuity, both in space and time, the discouragement of moral, cultural, geographical interest – then we would assume that it is a peculiarity of news photographs to deny their own 'blind field', the extra-frame dimension. This is confirmed by the heavy cropping that photographs in the tabloids undergo, by the fact that, for many photos, there is no immediate 'blind field'. Photographs of figures in the world of finance, montages, and head-and-shoulders shots generally share a mode of presentation that makes the newsprint their 'blind field'. This last point deserves to be insisted upon: the newspaper generally wants the key to the photographs to lie not in an imagined extension of the photographers' field of vision, but in the adjoining reports, comments, etc. – this is how a newspaper monopolizes the news. A consequence of the eradication of the 'blind field' is the setting of the news in a median position – by that I mean that news's value as history-in-the-making, or indeed as *faits divers*, depends upon our not extrapolating from it into wider issues and questions, our not becoming absorbed by the ramifying and cir-cumstantial, the seductive detail which reorientates the story. History always take place in the middle distance; photos may be close-ups, but the effect of the whole story must be comfortably 'there', rather than 'here'. A final argument in support of the erasure of the 'blind field' is the fact that, in newspaper coverage of news, the next moment, the next position, occur the following day. The newspaper is, in effect, a time-lapse camera that presents the non-sequential as sequential, that slows reality down from the second-by-second to the day-by-day. Newspaper photographs are either photographs of the instantaneous, or photos from which, as we shall see, instantaneity has been cropped out.

Nevertheless, however true all this may be, we must beware of believing it to be categorically true. Sometimes photographs in the quality newspapers seem peculiarly to exploit our capacity for intra-frame fascination, with the 'speaking' or disorientating detail. Sontag herself associates the opacity of photos with 'mystery', with their ability to be 'invitations to deduction, speculation, and fantasy'.[8] Sometimes the photos of the quality newspapers invite us to extra-frame speculation about the news's contexts and environments; about, say, the street-life of Mogadishu, or the current notion of 'work' in former Yugoslavia, or the excitements and disappointments of the crowd at sporting events. This is the point at which the potentially documentary photograph seeks to shake off its manipulation by the newspaper, its subservience to 'hot news' interests, and re-acquire a self-sustaining and self-justifying independence.

For the tabloids, photos are only a part of the larger dynamic of the page, a kaleidoscopic construction in which our sense of borders and divisions and dimensions is thrown into disarray. Hence the rupture of the photographic frame by such devices as unframed images, the use of montage, the superimposition of part of one image on another, inset images, the projection of the image from the page by a three-dimensional frame, the invasion of the image by its caption, and 'loose' images, not squared up on the page but as if tossed on to it. These photos exist not so much to be looked at as to be encountered in a restive ocular relationship with the page, where the eye is constantly harassed by images lifting off the page, goaded into a promiscuous assimilation of the news. Promiscuity is perhaps a weakness of the tabloids, a failure to discriminate on the level of relative significance and in terms of news category (economic, legal, 'human', royal, moral). On page 10 of *The Sun* (13 July 1993), for example, the story of a nine-year-old stowaway jockeys for attention with a story of women prisoners setting up a cheese firm, the report of the mob-murder of photojournalist Dan Eldon in Somalia, a case of sexual harassment, a note about factory-gate prices, a report about 'inflation-busting' pay-deals, a 'Sun-Spot' about an appeal by a seven-foot man to shoe firms to supply him with size 18 shoes, and a colour-photo story about the official visit to Mongolia of Tim Lawrence and Princess Anne. Given that the language of the tabloids is suffused with a rhetoric of discrimination, this failure to discriminate becomes all the more ironic and morally incongruous.

On the other hand, one might propose that discrimination by significance and category (operated by the quality newspapers) is at best an unjustified rationalization of the way we actually relate to the world (which is disordered, anarchic), and at worst a form of predigestion which is no less prejudicial, though more covert, than the inflammatory discourse of the tabloids.

If the photographs of the tabloids gravitate towards 'functionalized' forms of photography (photomat, mug-shot, family snap), those in the quality newspapers, one might argue, gravitate towards the 'defunctionalized'. By this I mean that a photographic opportunity provided by the newsworthy (photojournalism) produces a photograph whose relative autonomy, or ability to cast the kinds of light on the item which cannot be reported as *news*, pushes it towards the documentary. In the Dan Eldon case, for example, five of the newspapers – *The Independent, The Times, The Daily Telegraph*, the *Daily Express* and *Today* – carry the photograph by Yannis Behrakis, distributed through Reuters, of Dan Eldon with Somali children in Baidoa, the previous December. Here Dan Eldon himself, rather than the situation in which he was tragically caught up, is the news item.

Several papers, however, in that photographic pursuit of the documentary beyond the photojournalistic, present us with photographic material that is not essentially the news. In order to be able to form opinions on more rounded evidence, the reader might want to know, for example, what kind of loss Dan Eldon was, not so much to his family as to our ability to see world events and situations. What kind of pictures were the photographers in Somalia taking? *The Independent* prints a photo of a UN checkpoint taken by Eldon the weekend before his death; and two newspapers – *Today* and *The Guardian* – present photos by the other identified fatality, Hansi Krauss, a German photographer working for Associated Press. Even though all these newspapers exploit the poignancy of 'their last photograph(s)', we begin, as readers, to piece together a way of life, an expanded environment. And *The Guardian*, which has no photograph of Dan Eldon, has instead, on its front page, one of the wounded, Mohammed Shaffi, Reuters Television's cameraman, being transported to an American hospital in Mogadishu (illus. 24).

What is striking about this photograph by Eric Cabanis is its graphic factor, by which I mean its ability to engage the eye despite

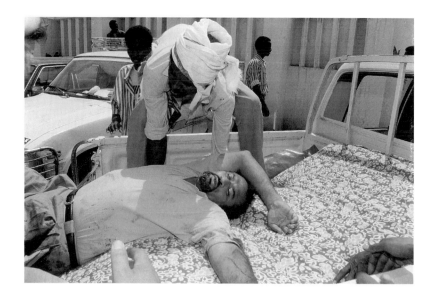

24 Eric Cabanis, Original photograph and cropped version, captioned 'Reuters Television's cameraman, Mohammed Shaffi, on his way to the American hospital in Mogadishu after being attacked by Somalis', *The Guardian*, 13 July 1993.

its ostensible message. What is curious about news coverage, as we have already noted, is that news occupies a peculiar middle ground between the over-particularized and the over-generalized. It wants its consumer neither to be distracted by the supererogatory, nor egged out of temporality by reflections on humanity at large. But the documentary photograph, which 'grows out' of the photo-journalistic one, does precisely that, polarizes and straddles *studium* and *punctum*, the culturally informative and the personally lacerating. The image of Mohammed Shaffi jolts us out of the newsyness of news by the informational extravagance of its depiction. Shaffi lies back, on what looks like a hastily commandeered mattress with a peculiarly insistent floral pattern; his right arm is flung back behind

his head, as if he were deeply asleep, or just emerging from sleep with a pleasurable stretch. Another, stooping figure is trying to make him comfortable in the Reuters' pick-up which serves as an ambulance. This figure is the dominant one, by virtue both of his solicitous activity and of his compositional importance: his bent body creates a central pyramid, and acts as a pivot for two bystanding figures, turned in opposite directions, while the bright sunlight, reflected from the bonnet of an adjacent car, is echoed in his head-dress. In short, this figure gives coherence to an image whose constituents gravitate around him, cling to him.

This coherence, centring, it should be emphasized, not on the off-centre news-subject (Mohammed Shaffi) but on a supporting actor, is constantly threatened by other intrusions: the floral mattress, a mysterious figure in the background, two fingers intruding into the picture-space at the bottom, the general indifference of the passers-by. All these elements are 'defunctionalizing', dispersing attention, providing a variety of disparate visual hooks. It is by virtue of the very randomness of these elements that, ironically, the photograph has a more intense temporality, registers time with greater punctuality, than a news photo needs or wants. The making of history (a string of causally linked events attachable to specific dates) is undermined by historicity (the haphazard confluences of people and objects in split seconds of time in a field of vision). How much of reality has to be thrown out before reality will make sense? But what is for the news photographer an embarrassment of competing detail is, for a documentary photographer, the source of circumstance, the very thing that produces fascination, curiosity, a complex syntax of expression, attitude, evidence, connection, by which we come to understand a way of life.

It is now our task to discover how photographic captions predispose us towards the image, how their syntax relates to the issues discussed so far. Do captions elbow images aside, or open them up? Do captions enjoin upon us a participation in the image, or, on the contrary, absolve us from responsibility? Do captions wink at us, or wag their finger, or plead? Where in time do captions locate their photographs?

Before addressing the syntactic structure of captions, I would briefly mention the function of names – briefly because this topic has been dealt with elsewhere and little needs to be added.[9] It is not

surprising that the self-confessed murderer Michael Sams should be referred to by his surname alone. This is not only a way of disowning him, of closing him off from sympathy, but also a convention of the thriller and detective fiction: the world of brutal acts, sadism and cynicism is a male world and maleness expresses itself in the guarded, unyielding aura of the surname. Correspondingly, the female victim, though a prostitute who might, in other circumstances, attract the opprobrium of a bare surname, is referred to by her first name, Julie (*Daily Mirror*). By virtue of the crime, the victim becomes the child of a mother (Lynn[e]), who can also be first-named since she is the persona of the parent-reader.

Meanwhile, the photograph of Henry Cooper, former heavy-weight boxing champion obliged to sell his three Lonsdale belts to offset losses in Lloyd's insurance crash, is variously captioned 'Champ Henry' (*The Sun*), 'Cooper' (*Daily Mirror, Daily Mail*), 'Henry' (*Daily Express, Daily Star*), 'Henry Cooper' (*The Daily Telegraph, The Guardian*). In such instances as this, where the accompanying text can draw a celebrated and popular Cockney sporting figure to the nation's bosom with references to 'Enery' or 'Our Enery', it perhaps matters little what telegraphic captions say. But as a point of first encounter, names create parameters of possibilty which the accompanying text may wish to explore. The bare surname assigns the boxer to the past, or presents him as uncompromising, or pushes him out of the circle of intimacy to fend for himself. The bare first name presents someone more vulnerable, less inscrutable, puts him among the newspaper's circle of acquaintance.

Television personalities, in the tabloids, have an almost exclusively first-name status, while with politicians, the opposite is true. Quoted in connection with a Norfolk Social Services adoption 'row', Virginia Bottomley, the then Health Secretary, has the following captions for her head-and-neck image: 'FED UP: Bottomley' (*Daily Mirror*), 'BOTTOMLEY: support' (*Daily Express*), 'Speaking out: Mrs Bottomley [...]' (*Daily Mail*). Whether this peremptory, undec-orated nomenclature speaks for Virginia Bottomley's ability to resist becoming an intimate of the tabloids, whether it bespeaks an unthinking sexism – females are all right as females, but there is something wrong with women who have gone into politics – or a distrust of politicians generally, it hardly predisposes the reader to give much time to her words. The only politicians who escape this

fate are those who are members of the family ('Maggie' Thatcher),[10] or those who have kinship with other members of the family: Michael Heseltine's journalistic name, 'Hezza', is a re-modelling of the nickname given to the footballer Paul Gascoigne ('Gazza'). And it is another indication both of a latent sexism and, more importantly, of the newspaper's news-making, news-shaping capacities, that the multitude of appellations which the Princess of Wales attracted – the Princess of Wales, Lady Diana, Lady Di, Diana, Di, Princess Diana, Princess Di, the Princess – far from celebrating her own mastery of a gamut of roles, and of ways of relating to the public, reveals the range of manipulations practised on her by the moulders of public images.

Naming in the quality newspapers is governed less by expressive considerations than by a set of decorums. For larger photographs, first name and surname, without reference to marital status unless it is part of an official title – Mrs Gandhi, Mr Heseltine, President and Mrs Clinton – (there is, however, a tendency for reference to marital status to increase with the increasing age of the subject); for small photographs, surname alone; and for photos of any size, first names alone only in the captioning of children, and surnames alone on the sports pages.

If naming is what insinuates an attitude or set of attitudes towards the 'personality', verb forms orientate readerly response towards the action. We now turn to the two 'tenses' typical of the photographic caption in newspapers, the present tense and the present participle.

Let us begin with a photograph from *The Guardian* (13 July 1993, p. 9; illus. 25), which marks the end of General Morillon's term of office as UN Commander in former Yugoslavia. It is captioned as follows: 'General Philippe Morillon salutes before leaving Sarajevo yesterday as Belgian General Francis Briquemont, left, takes over UN command in former Yugoslavia.' An obvious feature of this caption is its length, and two points should immediately be made. First, photographs are often the totality of the news item, and indeed newspapers must cater for those 'easy-route' readers who read by photographs alone. The Yugoslavian story attached to this photograph is not about General Morillon at all, but about the brain-drain sparked by the troubles. Second, we have already referred to the 'shallowness' of a photograph's ability to narrate (see Chapter 2). The photograph actually shows General Morillon

THE GUARDIAN
Tuesday July 13 1993

General Philippe Morillon salutes before leaving Sarajevo yesterday as Belgian General Francis Briquemont, left, takes over UN command in former Yugoslavia PHOTOGRAPH: ANJA NIEDRINGHAUS

25 Anja Niedringhaus, 'General Philippe Morillon salutes before leaving Sarajevo yesterday as Belgian General Francis Briquemont, left, takes over UN command in former Yugoslavia', *The Guardian*, 13 July 1993.

standing in front of a screen of sand-bags, his arm raised in salute (to what? to whom?), and the image itself tells us nothing about his being on the point of departure, nor does it imply that General Briquemont, who stands to attention on the left, is in the process of taking over (a process which is hardly as instantaneous as the photo suggests). The caption, however, by using an imbricated syntactic structure of temporal phrase ('before leaving [...]') and temporal clause ('as Belgian General [...] takes over'), is able to 'deepen' the photograph's narrative and to suggest that the act depicted (a salute) is in fact the trigger of, and key to, other significant events, and is therefore significant in itself.

The truth is, of course, that many news photos are not significant in themselves but are emblematic, or representative: they have the task of establishing a news item, authenticating it rather than depicting it. We can read the sequence of photographs in a newspaper as a shorthand or *aide-mémoire* for the current state of the news, which we have probably seen more fully reported in pictures on the television the previous evening (do we yet know how the advent

of television has affected the nature of news photos?').[11] This representative function of the photograph can be put to good use in 'longer-term' news items, where the photograph must stand for a whole period of activity or must accompany a pondered general assessment of a particular situation. For example, in *The Times* (p. 9), a report by Anatol Lieven on the conflict in Nagorno-Karabakh is accompanied by a photograph bearing the caption 'Back from the front: Armenian fighters carrying weapons after an engagement with Azerbaijanis near Gadrut, where fighting has continued in recent days'; and Robert Fisk's exploration of the dream of Bosnian unity (*The Independent*, p. 11) is 'illustrated' with a photograph by Mark Milstein encaptioned 'A Bosnian army soldier runs for cover in the Sarajevo suburb of Hrasno. The destruction wreaked on the area bears witness to the ferocity of the fighting' (illus. 26).

But even if the available photos can only show us the prelude or aftermath of a particular event, they have one huge advantage over the column: they preserve the present by assimilating it in their own 'thereness'. 'A Bosnian army officer runs for cover' – this is not a description of an actual event, which happened long ago, but a description of an image, which refuses to stop happening before our eyes. The photograph compensates for that crippling condition whereby the latest news is always stale, whereby we are always too late to participate, prevent, or indulge our voyeuristic urges in the actual. In fact, the newspaper photograph seems to reverse the sentence that hangs over all photography: namely that the photograph puts in front of us what has already been taken away from us, what must be past in order to have been 'taken' at all. But what kind of present is the news photograph? Or, more particularly, what kind of present tense is the 'salutes' in our Morillon example, and how can it be combined with 'yesterday'? (Compare *The Daily Telegraph*, p. 2: 'Dan Eldon is greeted by children [...] last December').

The present tense of the photographic caption is odd in several respects. It replaces what we might normally expect to be a continuous tense – 'What is General Morillon doing?' 'He is saluting.' We cannot explain this by saying that 'salutes' describes an instantaneous action (though the taking of the photo is). Even if it did, the usage would be unacceptable. What uses of the present tense do depict actions of short duration? The present tense of commentary: 'Joe Biggs pokes out a left, crosses with the right ...' (i.e. reporting

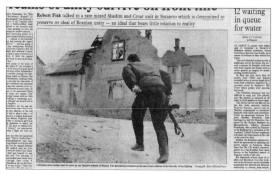

26 Mark Milstein, Original photograph and cropped version, captioned 'A Bosnian army soldier runs for cover in the Sarajevo suburb of Hrasno. The destruction wreaked on the area bears witness to the ferocity of the fighting', *The Independent*, 7 July 1993.

the usually non-visible present). The historic present, for real or fictional events: 'And in walks Joe, as bold as brass ...' On the other hand, what might be called the image-descriptive present – 'In Manet's *Luncheon in the Studio*, a young man stands in front of a table, while, to his left, a bearded man smokes a cigar' – has more affinities with the omnitemporal present of permanent fact or truth (e.g. 'snow melts when warmed'; 'the National Gallery overlooks Trafalgar Square'). What is peculiar about the present tense of the photographic image is that it participates not only in the omni-temporal present of the fictional/painted image, but also in the

instantaneous present of the commentary, thanks to its actuality. And thanks to the possibility of a temporal modifier of past time – 'yesterday', 'last December' – it participates also in the historic present. The present tense of the photographic caption is thus a 'compound' and fairly complex tense (it even has affinities with the lyric present – 'The curfew tolls the knell of parting day').

'General Morillon salutes (before leaving) yesterday.' 'Yesterday', too, introduces special elements into this mix. To make the use of the word 'yesterday' possible, two closely related consequences must be accepted: the speaker's point of view must be today (with the implication that we know what today is, its date, what day of the week); and the speaker (and reader) must, therefore, be temporally implicated. Compare: 'Jack told me that Bill came to see him yesterday' (I am located in today, with Jack, and Bill went to see him the day before) with 'Jack told me that Bill came to see him the day before' (Jack himself might have said 'yesterday', but the 'today' in which he said it is already past; I am no longer part of Jack's temporal perspective).

The fact that 'yesterday' puts us into the narrative sequence, implicates us in the temporal environment in which an action has taken place, is, of course, hugely important. It reaffirms that old, but false, equation between unfolding temporality and meaningful plot – that days are a series which add up to a serial (what would be our view of the world, of the processes of history, and of the continuity of causality, if our newspapers were published erratically – Monday, Wednesday, Thursday, Sunday, Monday, Friday, Saturday ...?). It also makes us participants not by virtue of belonging to the action, but by virtue of belonging to the time in which the action took place. Newspapers make us answerable to the news, albeit at the same time making it 'safe' for us. And perhaps we buy newspapers with nervous frequency, not because we wish to keep abreast of the news or to have something to while away tedious time, but because we feel ourselves to have become distant, bit-part players in a whole host of ongoing narratives/soap operas/tragedies. Temporal implication makes us part of a ubiquitous, bystanding crowd.

We have already made several observations in the previous chapter about the nature of the present participle in captions: it is non-temporal, or omnitemporal, in the sense that the time it refers to is automatically that of the main verb. Thus, it is adaptable to temporal

change, and where there is no main verb, it is available to all times, past, present and future. Furthermore, it depicts an action in mid-stream, in suspended animation. Even though the photograph may refer to a 'yesterday' or a 'last year', the deictic nature of the caption creates a presentness out of the photograph itself: the present participle may be temporally flexible, but its 'present' dimension will predominate. We should add that the present participle has several adverbial/prepositional substitutes: 'X on her way to ...', 'X during the ...', 'X with ...' We have also remarked how the present participle serves the 'personality' orientation of the news. It centres attention on the agent rather than on the action, and itself assumes an adjectival role: 'Doctor's orders: Diana Maddock, the Liberal Democrat candidate, camp-aigning in Christchurch yesterday' (*The Times*, 13 July 1993, p. 2).

There can be no doubt that the present participle serves pathos more effectively than the present tense. In the *Daily Express*, we find 'POPULAR: Newsman Dan Eldon shaking hands with smiling Somali children in Baidoa last December' (13 July 1993, p. 10; illus. 27), and, in a report of the kidnapping of David Rowbotham and his cousin Tanya Miller by Kurdish guerrillas, 'GREAT BRITON: David setting off on his trek with Tanya (above) and holidaying with his parents in Turkey (left)' (p. 13). The durational aspect of the present participle, its imperfectivity, endows it with a melancholic aura. This imperfectivity has, it seems, two central effects. First, it affirms that human activity is embedded in a continuity, when the reader knows that fate has already decreed otherwise. Here, the present participle seems to negate both what we already know, and the nature of the photograph itself, which has been snapped out of time and space as a random, mercurial fragment. At least the present tense implies that reality might proceed in a sequence of discrete acts, unpredictably, as a curious series of potential finalities, so that the tragic event, when it comes, at least fits into the pattern and does not *gainsay* the pattern of the past. The present participle, on the other hand, seems to provide a guarantee, to give an undertaking, which the tragic event cruelly disappoints, betrays. Second, as we have already proposed, the present participle, by shifting the focus from the act to the agent and by making the act itself temporally indeterminate, condemns the protagonist to a kind of passivity, an embroilment in the act, rather than allowing him/her to perform

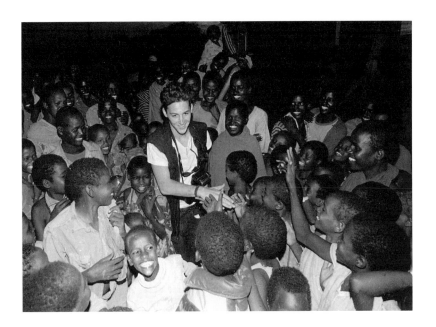

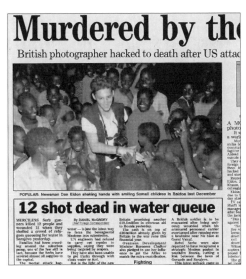

27 Yannis Behrakis, Original photograph and cropped version, captioned 'POPULAR: Newsman Dan Eldon shaking hands with smiling Somali children in Baidoa last December', *Daily Express*, 13 July 1993.

it. The longer the act lasts, the less one is able to exert one's authority over it and the more one is monopolized by it.

The format of the photograph, too, plays an important part in the play of temporality. One might note, for instance, that the tabloids, and indeed *The Daily Telegraph*, resort to the kinds of coding more at home in the strip cartoon to diversify the temporal reference of

the photograph. To mark a photo as belonging to a past prior to the past/present of the 'current' photographs, it is given a jagged frame. More importantly, perhaps, the conventions that govern the size of the strip cartoon's vignettes apply equally to newspaper photographs. The large, panoramic vignette – often used, for example, as the opening 'shot', for its informational capacity – has more spectatorial duration in it (though it often has more event duration as well) than the smaller vignettes, which diminish in proportion as the pace of the action quickens. The larger the photograph, the more (though instantaneous) it supports the durational character of the present participle. It is no surprise, therefore, that the photomat-size, head-and-neck photograph of the other identified victim of the Somali riot, Hansi Krauss, is captioned minimally and with a past participle: 'KRAUSS: Killed'; all contributes to the peremptory irrevocability of the event. And the size of the photograph operates in another way too: the reader's participation in Dan Eldon's destiny, partly activated by those elements of poignancy we have already discussed, is denied to Hansi Krauss, almost by virtue of the size of his photograph alone. The cropped image is as if caught in a process of inevitable diminution, of erosion of memory. It is a last glimpse of someone who, because he has no context and no duration, is fast becoming a statistic.

One final remark should be made about the present participle of the newspaper caption, a remark which also applies to the use of the present tense. When a present participial construction occurs with a main verb, it may express one of several things: simultaneity ('looking rapidly both ways, he crossed the road'), causality ('feeling cold, he shut the window'), concession ('seething with anger, they let him pass through'), or condition ('they would fare better taking another course of action'). As a caption of an image, the present participle simply tells us what is happening: 'Virginia Bottomley, Secretary of State for Health, holding a giant shoe at the launch yesterday of an anti-smoking campaign aimed at teenagers …' (illus. 28); 'Andrew Lloyd Webber and his wife, Madeleine, arriving at the Adelphi theatre for last night's opening of "Sunset Boulevard"' (both in *The Independent*, 13 July 1993). The photographs tell us these things too; and if the caption were restricted to what the participle tells us, to what is visible, they would be absurd: 'Virginia Bottomley holding a giant shoe'; 'Andrew Lloyd Webber arriving at the Adelphi'. In terms of images, only additional photographs could make clear

28 Edward Sykes, Original photograph and version captioned 'Virginia Bottomley, Secretary of State for Health, holding a giant shoe at the launch yesterday of an anti-smoking campaign aimed at teenagers', *The Independent*, 13 July 1993.

what the story was about. But the caption goes beyond the visible and thus appears to save the photograph from gratuitousness. In other words, the 'verb' (present participle, present tense) is (in) the visual (describes rather than explains it), while the rest of the caption fills in the unseen and invisible circumstance.

In a peculiar sense, therefore, the power to define lies not in the news (the photograph) but with the newspaper (the caption), and

the apparent dynamic of the news (the explicit or implied verb form of the caption), which the photograph cannot really supply, is both made redundant by the photograph, once uttered, and superseded, in terms of newsworthiness, by the circumstances that motivate it (the remainder of the caption). In other words, the source of both the dynamism of events and their scope is, in a very literal sense, the newspaper, which does not gloss the news but supplies it. The newsphoto is as if projected by the newspaper on to reality and then reclaimed by it from reality. It is thus not a quotation from the world,[12] but a point of contact with the world, a kind of feeler put out by a newsman. We shall continue to look at the structure of captions as an expression of this relationship, as we proceed to examine how punctuation is used to create a captional syntax.

The ubiquitous colon creates around it a whole range of potential relationships, which we must assume operate subliminally at the very least. The habit the colon has of introducing a quotation, or key, or conclusion, gives a peculiar authority to what succeeds it. It has the force of a revelation. *The Daily Star*, for example, presents the pre-colon material as a mystery to be solved, as something which awaits its cause or solution: 'POT LUCK: Diana dishes out a generous portion of stew.' But although the first element may seem to be projective, something which discharges the news, engenders its realization, the truth of the matter, we quickly perceive, is that the pre-colon material, when not simply a name, is a judgement or summary already arrived at, that it is, in fact, nearer to us in time, more immediate, than what it appears to beget. The post-colon material, as we might after all expect, is something which comes after only in a verbal sense. In temporal terms, it precedes the colon which introduces it. This chronological reversal pre-empts sense-making (even as it seems to make it available to the reader) in order to generate it. And perhaps we come to realize an important, if obvious, condition of newsmaking: the existence of the newspaper can be more confidently predicted than the existence of the news. There is, therefore and inevitably, a sense in which the news is subsequent to the uses made of it.

Photographic captions seem to fold together two contradictory functions of the colon: presenting words from the horse's mouth (direct-speech quotation, primary evidence), and exemplifying or substantiating the already ascertained. Of course, these functions

are not always combined; sometimes the colon does introduce a quotation – 'Tully: "The journalist is not the hero"' (*The Times*, p. 3); sometimes it does set up a substantiation or illustration – 'Embracing the disadvantaged: Princess Diana at an old people's home in Zimbabwe' (*Daily Mail*, p. 8). But with equal, if not greater, frequency there occurs something akin to the fusion of the two: '"TERROR TARGET": Major's four-bedroom home at Great Stukeley' (*Daily Mirror*, p. 2). What is the target? The colon explains. But at the same time, the explanation is not so much evidence produced as the originating cause of the pre-colon material, which is itself an explanation. The quotation is a quotation and not a quotation – it is a telegraphic summary of the written account of the reporter. The colon, then, is a kind of copula about which its different functions pivot or revolve. Jacques Drillon, in his analysis of the roles of the colon in his *Traité de la ponctuation française* ('Treatise on French punctuation'), provides an apt commentary: 'The colon is a mirror in which the two parts of the sentence look at themselves. Modern linguistics calls this "an adjacent assertion."' [13]

In the telegraphic style of the newspaper caption, the colon acts as an abbreviation; not, in the above example, of a form of subordination, but rather of co-ordination which allows reversibility: 'X:(is) Y' and 'Y:(is) X.' This identification of the colon as a syntactical device compels us to qualify what we have said, by returning to what we have already suggested. In the 'colonized' caption, pre-colon material has a natural predominance over, if not anteriority to, post-colon material. This would seem to derive in large part from the relationship between transitivity and word-order, from the apparent syntactic control exercised by the head of the sentence. When we read 'KENNY: No to stripper' (*Daily Mirror*), or 'BUSH: Banned advert' (*Daily Star*), or 'BASSEY: May take her fight to the Lords' (*Daily Express*), it is natural for us to read the pre-colon material as the subject, and the post-colon material as the predicate, often containing a grammatical object (direct or indirect), the person or thing acted upon, or affected by, the subject's action (as here 'stripper', 'advert' and 'fight'). The 'colonized' caption can thus make personalities the makers of news, the protagonists in newsworthy events, simply by assigning them to the pre-colon position.

By the same token, of course, the personality in the post-colon position becomes the patient, the person affected by the news:

'FOILED: Dad Damon' (*Daily Mirror*), 'VICTIM: Dan Eldon – "an outstanding person"' (*Daily Mirror*), 'FED UP: Bottomley' (*Daily Mirror*), 'STABBED: Stefan Beck' (*Daily Star*). We immediately notice that a pre-colon past participle is, in such structures, a 'natural' choice: the individual is a victim of a completed, past action, about which nothing further can be done. We will note equally that the agent is not identified, for three reasons: it has dramatic impact (the mystery element to which we have already referred), it encourages the reader to turn to the accompanying report, and it implicitly casts the newspaper as the agent. It does not matter, therefore, that the patient, the person affected, the caption 'object', is the subject of a sentence in the post-colon position. That sentence will demonstrate, either by voice (passive) or modality (obligation), that the apparent agent is still a patient: 'WARNED: Luciano must lose weight' (*Daily Star*); 'ROYAL REIN: Anne is led round the desert' (*Daily Star*). Alternatively, the very fact that the apparent agent appears in the post-colon position is sufficient to confirm his/her 'real' function as object or patient: 'FIERY EXIT: Hill, right, watches in despair as his engine goes up in flames at Silverstone' (*Daily Express*); 'DEBT TRAP: Laura nearly didn't graduate' (*Daily Mirror*); 'POT LUCK: Diana dishes out a generous portion of stew' (*Daily Star*); 'HELPING HAND: Di serves precious food to a hungry African boy yesterday' (*Daily Mirror*). While the first two instances here might present no problems – Hill and Laura are the agents of passive or negative actions – the two Princess Diana captions are rather more problematic and, indeed, rather more revealing. We can explain them in two ways, neither of which excludes the other. First, we may suppose that there are individuals who, by virtue of their status or position, are always cast as patients – royalty, and feminine royalty in particular, are those who undergo their daily diary of events, their obligations, their picture-worthiness. Second, and more importantly, we should recall an underlying theme of this enquiry: the newspaper/caption-writer is the agent, and the news is the patient; photographs are linguistically dominated by their captions, the language of the editor governs the actions of those in the news. This is true not only of the tabloids, but also of the quality newspapers: 'Cutback query: the Liberal Democrats' Mrs Diana Maddock talks to student Daniel Warner, 21, at Brocklehurst station' (*The Daily Telegraph*); 'Breeding new

diseases: New York's vicious cauldron of wealth and misery fosters mutant strains of bacteria' (*The Times*). The pre-colon material becomes the agent of the caption's syntax by its snappiness, its wittiness, its ability verbally to control the news situation, seemingly to generate news. Pre-colon slogans and catch-phrases compel the world to respond with the appropriate news-items.

Occasionally the patterns outlined above seem to be contradicted: (i) 'Krauss: Killed' (*Daily Express*); (ii) '"I'M GUILTY": One-legged killer Sams' (*Daily Mirror*). These particular captions have, I believe, an explanation. Caption (i) uses the reversed pattern to take Krauss's life in the very course of the caption, for expressive reasons; Krauss is the agent and then suddenly, fatally, the patient. Additionally, by using his name as its 'agent', the caption memorializes Krauss, allows him, dead, to dominate that death. In (ii), the murderer Sams must be transformed from agent into patient, not only by the law, but by the judgement of the newspaper. The quotation, therefore, is not so much confession as verdict, not so much uttered by Sams as demanded by the prosecutors of justice, among whom we count the readership.

Before leaving this analysis of the colon, we should make one final observation. The colon signals a range of potential relationships between the caption's two elements and acts as an abbreviated form of syntax. This kind of abbreviation is desirable in terms of the dynamic of the caption and the authoritative peremptoriness of its judgements; but it is also necessary, given that the 'colonized' caption is the staple diet of diminutive photographs, of the head-and-neck, head-and-shoulders variety. And, of course, there is a natural relationship between the small-format photograph and the snappy caption: 'BLAMED: Terry Dunning' (*Daily Express*); 'Sir Dudley Stamp: Pioneer' (*The Daily Telegraph*); 'BAN: Father James' (*Daily Star*). The curtness of these captions has a transfixative power which accords well with the mug-shot. True, *The Times* sometimes minimizes the criminalizing and incriminating nature of the postage-stamp snapshot by extending the caption (e.g., 'Tapie: his presidential ambitions are no secret', 'Bush: poll win set pace for fishing village boom'), and the quality newspapers avoid the declamatory slogan-style use of upper case. But this does not change the fact that these forms of caption, allied with the small photo, produce a singularly demeaning and inculpatory image of the person.

These photographs and captions are among the condescensions of the newspaper, which looks upon newsworthy figures, whether public or private, as hired actors in its own drama, actors who are two a penny, interchangeable, and whose only claim to fame is their capacity to be pointed at and labelled by the newspaper.

Punning is another of the ways in which newspapers may establish pre-colon agency. The pun is a way of summarizing and activating the news; it is both a point of departure, whetting the appetite, and a point of arrival, witty encompassment. As the caption's agent, it provides the lens through which we view the news. Of the quality newspapers, *The Guardian* is perhaps the most consistent in its use of puns: 'Marching orders ... Orangemen commemorating the Battle of the Boyne' (illus. 29); 'Bite size ... Designer Nimba Ali at work on the head of a life-size Tyrannosaurus rex'; 'Down but not out ... Henry Cooper'; 'Troubled outlook ... Leeds youth worker Paul Auber, who cites the dangers of the "me-first" mentality' (illus. 30); 'Shopping for votes ... Diana Maddock, the Liberal Democrat by-election candidate, out and about in Christchurch yesterday'.

Two things are immediately noticeable: the punning mechanism operates regardless of the relative gravity of the news; and *The Guardian*, like *The Sun*, favours *points de suspension* (suspension points) over the colon as its mid-caption articulation. Actually, it may be misleading to speak about suspension points as an articulation. We do not read them as an abbreviated syntactic code, as a shorthand sign of a set of possible connections. Suspension points certainly indicate a relationship, but one which is as visible as it ever will be, and one which is not syntactic so much as psycho-associative.

29 'Marching orders ... Orangemen commemorating the Battle of the Boyne', *The Guardian*, 13 July 1993.

30 John Angerson, 'Troubled outlook ... Leeds youth worker Paul Auber, who cites the dangers of the "me-first" mentality', *The Guardian*, 13 July 1993.

The pun and the straight photodescription operate on two different levels of verbal interpretation, the pun being a symbolization of the photodescription. Punning runs risks in that it seems to be an essentially patronizing activity, more interested in its own achievement than in its raw materials, lifting the reader out of a language of concern into a language of play. The pun in the caption, in effect, works something like a cryptic clue which is then solved by the photodescription. In other words, the caption relates more to its own play of meanings than to those of the photograph it accompanies; or, more accurately, the pun is built on the photograph and the photodescription, for its part, solves the pun. 'Troubled outlook' is the pun generated by the image of a black youth-worker looking skywards through a window or glass door, with an apprehensive expression. The photodescription that follows – 'Leeds youth worker

Paul Auber, who cites the dangers of the "me-first" mentality' – indicates how we can understand the figurative nature of the 'pun', which is a pun precisely by virtue of its being a translation of the literal (the literal photographic image) into the figurative.

The pun is dangerous in its tendency not only to trivialize but also to insinuate, and in its inability to control its insinuations. The caption 'Marching orders ... Orangemen commemorating the Battle of the Boyne pass under the gaze of soldiers as they go through nationalistic Dungannon' raises a whole set of questions about the implications of the pun. Who exactly is issuing the marching orders and to whom? Are the marching orders orders to march out or orders to march in? Or are we to understand 'order' solely in the sense of 'a group bound together by oath, or common purpose, or shared belief'? These questions are not a playful luxury, but the key to attitude, prejudice, 'soft' indoctrination, the complacencies of reading. It is not difficult to see how the pun can become incendiary.

This potentially incendiary nature of the pun is activated, I would suggest, by the punctuation. Suspension points do not function grammatically but rather temporally and expressively. They create an undefined pause, undefined because the pause does not relate to the nature of the syntactical relationship between clauses or phrases (as with the full-stop, comma, semi-colon). Although suspension points frequently occur at the end of clauses or phrases, there is nothing to prevent them from occurring at any point in the syntactic chain, e.g. 'I ... meant ... to tell you.' Thus the pause or drawl or phonemic protraction, encoded by suspension points, is not grammatical but expressive – it is the pause of provoking or taking thought, and hence the pause of innuendo, portentousness, digestion of message, the working out of difficulty (in this sense, suspension points increase reader participation, but not so much in the news as in the verbal play); it is also the pause of suspense and anticipation.

This last function is the one which predominates in *The Sun*. Although *The Sun* indulges in the punning caption – 'Rhyming couple ... Linda and toyboy love John', 'GREY RIGHTS ... but pensioners are facing a tough future' – where anticipation centres on the solution of the cryptic clue, it more frequently uses suspension points where other papers would use a colon, to amplify the drama: 'Confession ... Sams was haunted'; 'Grief ... this photo of Lynn beside Julie's grave prompted killer to tell all'; 'Survivor ... Bruce'

(Bruce Forsyth's TV 'Generation Game' survives BBC programme cuts); 'Prisoners of crime ... Phil and Jackie with Kit, James, Emma and Philip' (a couple afraid to leave their house because of a spate of thirteen burglaries). The impatient peremptoriness of the colon gives way to the 'build-up' of suspension points, to the news we have to wait for, or reach for.

While the 'colonized' caption emanates entirely from the paper, as curt announcement, the caption with suspension points, while still an utterance of the newspaper, makes room for the reader, for greater participation, and in so doing, once again consolidates the corporate commitment of its readership. Suspension points are part of a process of withholding, postponing the pay-off. In situations already fraught with drama, this can add to the tension. But *The Sun* uses suspension points conventionally, automatically, in all those situations in which, in other dailies, we would expect the colon. Many of these situations are completely without puzzle or drama: 'Hezza ... dynamic speaker', 'Minnie ... penfriend bride', 'Frisked ... TV star Patrick', 'DISHY ... the glamorous Diana'. Here the suspension points must pay with either increased meretriciousness or with devalued expressivity. Unless, of course, we believe that suspension points also supply a subtext of disbelief in one's own words. But after all, perhaps the most significant function of suspension points, as of the colon, is simply to indicate, as we have already discovered, that the newspaper is not only the source of utterance (caption or report), but that its 'word' (whether it be pre-colon or pre-suspension-points) is also the agent in the utterance, both transforming text into metatext (text about text), news into comment on news (where the comment is the new and newest news), and implying that its 'word' actually produced the news.

The Penguin *Wordmaster Dictionary* reminds us of some of those lexical items characteristic of journalese: 'blaze' (fire), 'row' (dispute), 'rap' (charge), 'riddle' (mystery), 'pit' (coal-mine), 'attack' (criticise), 'hit' (affect), 'key' (important), and so on.[14] It also reminds us of those grammatical elements most usually omitted in the telegraphic style favoured by newspapers: article ('dollar plunges'), 'be' as main verb, 'be' in passive constructions ('four men accused') and in constructions expressing plan or intention ('Pope to visit Leeds'), prepositional phrases (replaced by noun modifiers − 'city fire death probe shock').[15] There have been numerous studies of the

languages of journalism, their construction and transmission.[16] Tony Trew, Bob Hodge and Roger Fowler have examined journalese as it relates to the construction of news, ideology and the exercise of power.[17] Photojournalism has been treated historically, and professionally, and the relationships between photo and newsprint have been examined.[18] The influence of individual pictures has been traced.[19] Most recently, John Taylor has investigated all the issues – censorship, 'civility', moral responsibility, compassion fatigue, optical racism, optical morbidity – associated with the photojournalism of horror.[20] But our understanding of the 'performance' of the newspaper photograph still has a long way to go. As does our understanding that performance necessarily involves understanding the performance of the caption, since the two are so closely wedded and yet so curiously divorced.

The Language of Fashion Photography

While concentrating in this chapter on the language of fashion photography, I should say at the outset that I will not be directly confronting two of the issues that recur in discussions of fashion photography: the relationship between model and photographer, and the role of the model in relation to the reader.[1] The former of these will certainly be present by implication, however, and the latter will be featured inasmuch as it is visible in language. For the moment I limit myself to two broad observations.

While some argue that all fashion photography, necessarily and by definition, transforms woman into object and promotes an imagery of woman that excludes swathes of the world's female population, others base their sexual reading of fashion photographs on a prior knowledge of the sex of the photographer. Nowhere is this latter approach more awkwardly apparent than in Val Williams's survey of women fashion photographers of the 1990s ('Agenda Benders', *The Guardian Weekend*, 4 September 1993, p. 24).[2] Speaking of a set of photographs by Andrea Blanche, Williams writes:

> Although one of the photographs shows a naked model covered in glutinous seaweed body cosmetics, when we know that the photograph is by a woman, its menace and objectification disappears, leaving in its place a wonderful female comedy, wittily satirising the absurdity of the beautification process. As the model holds up her hands and grimaces to the camera she seems to be asking: 'Why do we do this to ourselves?'

This argument is too convenient, partly because it implies that the semantic values of photographs, being completely reversible, can only be stablized by the sex of the photographer; partly because, in favouring the dialogue between the model and the photographer, it overlooks the dialogue between the model and the reader, and more

importantly perhaps between the magazine and the reader — what copy was this series of photographs accompanied by? Val Williams's remark only confirms what we are reluctant to believe, namely that the photograph has great difficulty in projecting an intended meaning, and that our interpretation of photographs is activated not so much by the image itself as by circumstantial evidence (who took it, when, where, in what conditions, for what purpose, its context of publication). That Ellen von Unwerth and Corinne Day were models before they were photographers, or that Deborah Turberville and Manuela Pavesi were fashion editors before they were photographers, is no reason to suppose that they wanted to get their 'own back by subverting the semi-pornographic poses associated with much fashion photography' (p. 24).

This leads directly into our second observation, about the role of the model in relation to the reader. Is the model intended as a figure with whom the reader can identify positively? (How then is this empathy to be created? Sexually? By narrative? By mood?) Or is the model an empty space, a shop window mannequin, a clothes hanger? (How is this neutrality, this zero-presence, to be created?) These questions cannot be answered until we know the reader's motives for wearing and 'reading' clothes.[3]

For many — we will call this category (0) — clothes are the means to prevent 'cultural lock-out'; vestimentary conformity is a way to social acceptance, and, it can be argued, conformity makes us socially more competitive and enlarges our choice of relationship. For the individual haunted by fear of eccentricity, stereotyping is therapeutic. And yet clothes, too, are bought for the purposes of individualization.

The individualizing nature of clothes works in four possible ways. (1) Clothes help to construct identity, an identity which the wearer then seeks fully to inhabit (i.e. clothes are a shorthand for self, a quick-fix identity.[4] (2) Identity is separate from clothes, is already possessed by the wearer; clothes do not have identity-value, but temperament-value (i.e. we change our clothes as our moods change; different occasions — dinners, walks by the sea, parties — are essentially exercises in different moods). In a world-view that fully accepts relativity, this 'modal' variability may replace identity:

Perhaps style becomes a substitute for identity, perhaps its fluidity (in theory it can be changed at will) offers an alternative to the

stagnant fixity of 'old-fashioned' ideas of personality and core identity, perhaps on the contrary it is used to fix identity more firmly.[5]

(3) Clothes bring out, complement, enhance and dramatize physical qualities one already has: 'Natalie entered, a glass of wine in her hand, a smile on her face. She was wearing a cashmere jumpsuit in a shade of emerald green that complemented her eyes, made her skin glow, and brought out the gold in her hair.'[6]

And if (3) is a physical equivalent of the psychological or emotional values of (2), then the psychological impulse towards conformity, and assimilation (category [0]), has its physical equivalent in (4), the ability of clothes to compensate for, or conceal, 'eccentricities' of the flesh. Clothes are solicitous companions designed to distribute the viewer's attention to the optimal advantage of the viewed. For example,

(a) Longer jackets which cover the hips are very flattering. But beware of adding fussy tops – they can ruin the smooth line and make you look bulky.
(b) A long shirt tied at the front draws attention away from the bottom. And slim trousers flatter without emphasizing any lumps and bumps. (*Clothes Show*, July 1992, p. 60)
(c) She was wearing a long-sleeved white blouse with a ruffled neckline, a peasant skirt, a wide belt, and soft suede boots, a simple outfit but one that flattered her, emphasizing her height and flattering her figure.[7]

About these extracts two things should be said. First, the clothes are quite clearly agents, usually allies, occasionally enemies ('fussy tops'). Even where humans appear to be the agents, their verbs – 'adding', 'wearing' – are not activities in themselves, so much as activators of activity (the activity of the clothes), ways of becoming patients of action, handing over responsibility. And the fact that it is the clothing which 'draws attention' or 'flatters', while the wearer remains, it seems, sublimely unaware, creates a lasting, conspiratorial relationship with clothing. Clothes may well be merely adorning, but they are more important perhaps as unobtrusive aesthetic engineering.

Second, the term apparently inextricably linked with (4) is 'flatter'. Looking at its trajectory across these quotations, its obvious advantage

is its ability to turn (4) into (3). In (a), 'flattering' would seem to mean 'to make appear more attractive than they (the hips) in fact are'. In (b), it means partly as under (a) – this is why it is contrasted with 'emphasize' – but partly also 'to show to advantage' (i.e. the [3] meaning, 'to enhance a beauty which is already there'). And in (c) it is exclusively 'to show to advantage'; this is why, here, it *can* be combined with 'emphasize'.

All these categories – (0) conformity/assimilation, (1) construction of identity, (2) expression of mood/temperament, (3) self-enhancement, (4) compensatory mechanism – with the occasional exception of (2) perhaps, presuppose a copresence, a viewer. Our final category, (5), is that of fashion for the solitary person, who has only herself to please or impress. Now the relationship between self and clothes does not develop into a self/world exchange, but stays with questions of ease, comfort, adaptedness to climatic conditions. The same considerations apply to the garment which is being sold *for itself*, in solitude, not as already part of a combination, but as a potential combiner. Such a garment needs to be attractive to the largest possible audience for the largest number of possible occasions, and it does so on the comfort/adaptability (+ inbuilt economy) ticket (illus. 31):

> Feelgood fabrics are back this autumn, and silk is the queen of them all. This washed silk shirt is the ultimate in wearer-friendly fashion. It's cream so it teams with every colour and pattern; it's light and roomy so it can go over or under jackets and sweaters; it's hand washable [...] (*Madame Figaro*, 16 October 1993, p. 30)

A number of terms in this extract require closer analysis. First, 'feelgood fabrics'. Where fashion's authority comes from we do not know, so it can never be taken to task. But textually, its permeating presence can often be felt in /f/: fashion, fabric, feelgood, friendly, soft, floating, flared, feminine, floral, ruffle, full, etc. 'Feelgood' begins to sound like a fabric, like lurex or viscose or organdie. There are some fashion descriptions that produce a kind of verbal euphoria, so that we can no longer distinguish between facts and qualities, materials and virtues. We put on a shirt to put on the headiness of its words. Paul Theroux (*The Observer Magazine*, 26 September 1993, p. 34) sees this as part of the credulity of fashion language:

31 Martin Gardner, 'Get shirty' fashion ad, 1993.

Get shirty

French Connection silk shirt for £39.99

Feelgood fabrics are back this autumn, and silk is the queen of them all. This washed silk shirt is the ultimate in wearer-friendly fashion. It's cream so it teams with every colour and pattern; it's light and roomy so it can go over or under jackets and sweaters; it's hand washable; and, at £39.99 including post and packing, it's a veritable bargain. Turn to page 98 for the order form

Skirt by Nicole Farhi
Belt by Jacqueline Rabun

Photography: Martin Gardner
Stylist: Liz Thody
Hair & make-up: Mary-Jane
Model: Tamsin

Fashion description is so credulous and uncritical, so precious and pseudo-technical, that it remains as obscure as that of art criticism and (as with art criticism) merely to quote it is to ridicule it. Consider the leggings 'in smoke-toned gossamer organza' worn with a 'Versace bustier' [...] or the 'moulded leather bodice', 'chunky shoes' and 'distressed velvet frock over matching knickers and rhinestone buckled court pumps' [...]

Theroux does not sufficiently allow for the knowing ironies and arch self-intoxications of fashion copy, for the express blurring of the boundaries between fashion and art photography, thanks to an esoteric language and the image's aspiration to a non-product-governed autonomy.[8] But since the clothes are agents, it is not surprising to find anthropomorphism, and indeed its reverse, 'sartoromorphism'.

Second, 'This washed silk shirt'. What might one mean by 'sartoromorphism'? (a) The model becomes the clothing: 'this washed silk shirt'; 'A glimpse of navel and frilled edging: the pretty details that soften a sexy look' (*Vogue*, November 1993, p. 202). (b) Words shift from cloths to people and their institutions: 'fashionable', 'chic', 'shirty'. 'Get shirty' is the heading for this advert – puns and other metaphorical devices are ubiquitions in fashion-speak, but extremely weak in semantic charge. Here, no idea of annoyance or anger breaks the surface, no justification for the pun is forthcoming. In those metaphors and puns which might change the world of clothes into a world of human emotions, such a change does not take place – the vestimentary connection remains predominant. Why? Because this is a caption for a photograph whose evidence constrains our thought processes. Because the pun is not important as pun; it is important as a communicative device; it indicates a certain attitude to life and clothing: improvising, playful, chummy, the sacrifice of long-term meaning for immediate effect (and its economic equivalent in the imperative form: buy now, pay later), the reminder that it does not matter after all: 'Fashion is both *too* serious and *too* frivolous at the same time.'[9]

Third, 'it's light and roomy ...' Barthes lists four possible relations of clothes to the world: purposive ('These shoes are made for walking'), causal ('This hat is young because it shows the forehead'), transitive ('Accessories make the spring') and circumstantial ('Pleats are for the afternoon'). This particular advert/offer starts

off in the transitive mode, and moves into the purposive. Ultimately Barthes's opinion is that the distinction between different kinds of relation is unimportant:

> ... the relation being constant and its content varied, we see that the structure of written clothing is concerned with the constancy of the relation, not its content [...] structurally it is nothing but an *equivalence*: accessories are *good for* the spring, these shoes are *good for* walking, prints are *good for* the races.[10]

No doubt Barthes is right, in that clothing, first and foremost, must activate the wearer's relationship with the world, or negotiate it, or impose it. But differences of reason do matter from an advertising point of view. Our offer makes two simple statements: (a) 'This shirt is fashionable' (you wear it and are assimilated; you are back in fashion); and (b) 'This shirt is useful' (and economical), because it combines so well, not only in juxtaposition (alongside), but 'in depth' (over and under).

We shall have more to say about combination. For the moment, I would like to pause over the structure 'it's light and roomy so it can go over or under ...', for two reasons. The causal structure: 'it's ..., so ...' scores over 'because it' ..., it can ...', because this alternative structure is excessively purposive, the manifest function, the primary reason for buying, the revelation of utilitarian attitudes to clothing. None of these can be fully admitted. Clothing is bought for self-expression, or comfort, or as a luxury, not because it was a bargain or because it could be put to several uses. These latter advantages must be afterthoughts, fringe benefits, unforeseen pluses: the 'it's ..., so ...' structure expresses this perfectly. Even the added causality of 'that' would be ill advised: 'it's ..., so that ...'; as it is, 'so' follows on, as a surprise discovery, from qualities that are already virtues. 'So' is a consequence of something which was not a cause, 'so' is a conjunction of result rather than of purpose.

What is also odd about this clause is the use of 'roomy' to describe clothing. One might think of using this adjectives for cars, or even shoes, but a shirt? The correspondence between the adjectives and prepositions would seem to be 'roomy' therefore 'over', 'light' therefore 'under'. But the elements are arranged chiastically so that the adjectives retain an expressive freedom over and above their functional aspect. 'Roomy' may reach towards a market of the

larger-sized, but it also adds to the purely material meanings of 'light' ('thin', or 'not heavy') more suggestive connotations, namely 'airy', 'light-filled', 'allowing its wearer to get by with few other furnishings', 'inducing lightness of spirit'.

The photograph itself is expressively minimal and expressly 'amateurized'. The lighting is flat and non-differentiating; the figure's shadow is no more than a dark stain; the pose, with the hands pressed self-consciously to the sides, does no more than stabilize or immobilize the figure. The earnest gaze creates no dialogue with the camera, but submits to it, tries to please. And because the pose does not belong whole-heartedly to the genre 'fashion photography' (as opposed to 'photographs to market clothes'), so the standard fashion framing – cut close to the head and close to the feet – looks more accidental. This is quite literally an offer; the model, or rather the person modelling, offers the garment for purchase, does not provoke the reader to purchase. The very wording of the sub-heading – 'French Connection silk shirt for £39.99' – with the inclusion of 'for', directs the reader to the notions of both value and monetary exchange, in a way that the more non-committal details usually found in fashion magazines – 'Silk shirt, £39.99, French Connection' – do not. The sub-heading here is a sales pitch, a speakable declaration, while the bare, alternative version (without 'for') has no voice in it, is a written tag turned to for identification and information. Moreover, the inset photograph insists on the fashion catalogue nature of the image: postal transmission must be undertaken with the maximum of visual information about the product; and the ordinariness of the photograph must directly acknowledge and endorse the ordinariness of the buyer. For a fashion photograph to do this would be an insult, since Fashion offers that self-identity which transcends the ordinary, the mundane, the boring, the socially and professionally imprisoned. Fashion offers access to essence, to the unalloyed expression of oneself.

For this photograph, then, what transcendence there is must remain in language; the photograph refuses to supply it. And as the purchaser wears the garment, which threatens to fulfil its function only too well, so she will be dependent on a language to speak about it, to replace it, as it were, in its magazine origins. Indeed, for all fashion, the magazine is both the point of departure and the point of arrival; its purpose is to maintain this circle of self-insulation.

But in most 'straight' fashion photographs, language is 'layered', so that its relationship with the photograph, and the relationship of both language and photograph with the reader, is an unfolding and changing one. Looking at a fashion photograph is a complex process in which language provides, ensures, a duration in the looking, which is made of varying perspectives and modulating interactions. It is this complex process which now calls for our attention.

The image we begin with (illus. 32) is the first of a sequence in which a mobile, hand-held camera captures roughly focused and spontaneously enframed moments of temperamental variation: exhilaration, reflectiveness, absorption, despondency (i.e. category [2]). But the text, at a purely vestimentary level, reinforced by the photographic image (solitary girl, unobserved, amuses herself on the beach), concentrates on the comfort/adaptability syndrome (i.e. dress in solitude – category [5]), while nonetheless alluding to individual mood *and* to social conformity ('the casual look'), and thus making room for a potential spectator: 'A carefree, girlish mood influences the casual look for wet and windswept climes. Throw on loose layers of oversized, soft cotton jerseys and sweatpants; combine with waterproof textures and long, cosy socks' (*The Observer Life*, 28 May 1994, p. 41).

32 Julie Sleaford, 'Wet wet wet' fashion ad, 1994.

The puzzles we encounter in this copy, if we stop to ponder it, concern the order of transitivity and the word 'influences'. First, we have to blend 'carefree, girlish' (= effervescent, exuberant = youth) and 'casual' (= relaxed, studied = adult), and understand how, despite the irresistible spontaneity of the girlish mood, and the activity-centred notion of the 'casual look', the 'wet and windswept climes' can remain the primary motivators of choice ('for' = 'for the purpose of', 'if these conditions obtain'). In fact there are, in this situation, apparently two overriding considerations, wet weather (meteorological) and girlish mood (emotional), which logically have nothing to do with each other and which might be in competition for clothing choice, were it not for a potential connotative connection ('singing in the rain', bad weather releases inhibitions, turns us into primitive and wild beings), and for the mediating power of 'casual look' (carefree = casual, casual = clothing for weather in which fine dressing is wasted and inappropriate).

What we have said so far might suggest that the first and last elements of the sentence dominate the middle one:

2	1	2
carefree, girlish mood	casual look	wet and windswept climes
category (2)	category (0)	category (5)

But this is too overlook 'influences'. You only need to influence someone who has more power than you; and you need to influence that person to intercede for you with an even greater power. This produces a sequential power-progression that looks like this:

1	2	3
carefree, girlish mood	casual look [for]	wet and windswept
[influences]		climes

The 'wet and windswept climes' dictate 'the casual look', which in turn might be slightly adjusted to suit a 'girlish mood'. The very fact that we have reverted to the definite article for 'the casual look' gives it a substance, a recognizable familiarity, an 'already-thereness', which the other nouns, with their indefinite and absent articles, do not have. Before it rained and before a girlish mood came over the model, 'the casual look' was an already constituted notion, which the model could not appropriate for her own individual uses and

needs, but could only 'influence'. On these grounds we might argue for a power-structure which looked more like:

<div align="center">

¹ ³ ²

carefree, girlish mood casual look wet and windswept climes

</div>

Furthermore, the double adjectives echo each other ('carefree, girlish'/'wet, windswept'), while the difference in structure ('carefree, girlish' co-ordinated by a comma, 'wet and windswept' co-ordinated by 'and') indicates that the mood is improvised, changing, multidimensional, while the climes are more or less clichéd décors, true to type (reinforced by the alliteration). 'Climes', however, transforms climate into something poetic and exotic/far away ('distant climes') and is a long way from 'weather'. This, together with the absence of a grammatical article, takes the photograph out of itself, out of the possibility of deixis, as it takes the clothing into itself. This is not a girl flying a kite on Morecambe sands; this is a mood temporarily inhabiting a look in a multipliable set of beachscapes. Consequently, this is not a sentence with clear patterns of transitivity and agency, or a clear division between essence and circumstance. Its ingredients seem constantly to shift and realign themselves, and exchange values. It is a mobile structure that creates not so much a pattern of meaning as a display case. This is indeed the kind of rhetoric and syntax to suit the photograph, which itself has a similarly fluid syntax. The model's upheld arm points to the main text, for which the kite and its tail act as an 'umbrella'. The 'footnote' of dress details at the bottom right, however, eludes the composition, while the direction of the model and the kite – towards the left – pulls against the direction of reading – towards the right – helping to make the eye restive. The image is a fashion photograph flirting dangerously with the family snap. The unusually realistic background threatens to assimilate the model and endow her clothing with reality, rather than the more usual pattern of fashion photographs, which is the reverse: the reality of the model's clothing, the only element in the photograph with referential reliability, endows an often stagey setting, when defined at all, and the expressly 'imported' model, with a potential for a real, fully integrated existence.

A fashion statement has been made. The model has been alluded to ('girlish mood', 'casual look') without being there, in the words.

What is there is a fashion statement, which the model in the photograph illustrates, almost in the abstract, but which she does not aspire to realize (since she already illustrates it). This is the first of three possible layers of language/text: a fashion statement which takes place in the world of edicts and absolutes, and to which women, photographs and all else must submit.

However, in order to gain admission to this fashion statement, to deserve it, as the model in the photograph has, the reader must undertake certain actions (acquisition, dressing), although in fashion photographs the natural order is usually reversed: dressing precedes acquisition. This is the second layer of the text, and involves the fashion editor in addressing the reader directly: 'Throw on loose layers of oversized, soft cotton jerseys and sweatpants; combine with waterproof textures and long, cosy socks.'

This layer of language is a curious mixture of teasing and frustration for the reader, for two simple reasons: (a) the reader does not yet have the clothes, and (b) the level of reference is vague, confined to plurals ('cotton jerseys and sweatpants', 'waterproof textures'). So what exactly should the reader buy? The mode of address at this layer is characteristically the imperative − 'Throw on' (already the way you put clothes on is part of the dress − 'carefree, girlish'). This imperative hovers uncertainly between the speech-acts of command, advice and appeal. Contact is established, pressure is introduced, and more specific definition is provided. Not surprisingly, the utterance is still highly rhetoricized: acoustic echoes and pairings in /s/,/l/ and /ʧ/; adjectives with multiple associations ('soft', 'cosy'); manipulative word-order. These last two elements work closely together.

The rules and principles governing the order of premodifying adjectives are complex and not easily isolated,[11] but several are particularly relevant to our purpose:

(i) Information provided by a premodifying adjective ('soft') is felt to be more temporary, or subjective, than a noun premodifier, which usually immediately precedes the noun, or 'head', and which is, correspondingly, more permanent or objective ('soft *cotton* jerseys').

(ii) There is a natural order of 'recursive qualification': i.e. an object can only be one thing if it is already another, and the thing that

it already is goes nearer the head. In the sequence 'gold brocade hourglass fitted jacket', the jacket can only be hourglass in shape because it is fitted.

(iii) There are considerations of rhythm and euphony. For example, short terms precede long: not 'Pistachio strappy high slingbacks', but 'High, strappy pistachio slingbacks'.

(iv) Common items precede rare ones: 'white silk crepe palazzo pants'.

(v) As an extension of (i), adjectives nearer the head are more intrinsic, permanent, verifiable, objective, while those further away are more relative, contingent, temporary, subjective, etc.

In our example – 'oversized, soft cotton jerseys' – therefore, (i) is applied; (ii) is inapplicable; (iii) is transgressed; (iv) is inapplicable; and (v) justifies the transgression of (iii) – cotton jerseys are more inevitably soft, more intrinsically soft, than they are oversized. Two further factors should be considered, however. First, the positioning of 'soft' variously means that a 'vulnerable' monosyllable is placed at the centre of a string of polysyllables, the 'soft' heart of the phrase; that its /ɖ/ assonates more directly with that of 'cotton'; and that 'soft' is framed by pauses, the comma preceding it, and the need to pause after it, to negotiate the two consecutive stressed syllables: 'soft • cotton'. Second, 'soft' is one of those simple but malleable adjectives used in fashion-speak to construct bridges between garment and feeling, material and mood, the literal and the figurative (cf. 'light', 'dark', 'smooth', 'loose', 'flowing'). Inasmuch as it is an essential feature of the material, it will gravitate towards the head; but fashion-speak is so designed that the subjective, connotative and contingent should also gravitate towards the head, should become intrinsic characteristics of the garment. It is Fashion's intention to make clothes essentialize inner qualities, to make the subjective and objective coincident, to turn objectively verifiable material into an equally verifiable and reliable subjective experience, to marry the temporary and the permanent. These remarks largely hold true for our other adjectival combination 'long, cosy socks'. 'Cosy' buries itself between the assonating 'long socks', its two syllables foregrounding it against its flanking monosyllables. Though the order here fulfils (iii), it runs, if anything, against (ii). These socks are 'cosy' because they are 'long' (not because they are, say, 'woollen' – we have no information about material). Unlike 'soft',

'cosy' is already a transformation of terms that might have doubled as both subjective and objective (e.g. 'warm' or 'thick' – giving warmth, security) into an exclusively connotative and subjective term (receiving, feeling warmth, security and also intimacy, comfort, etc.). As with 'soft', however, the positioning of 'cosy', satisfying (iii), is an attempt to reverse (v), an attempt to make the evaluative into the factual, the accidental into the essential.

Our other specific concern here is that, although the reader has been called to action ('Throw on ... combine ...'), the proffered garments remain stubbornly plural and zero-articled, as if the reader were throwing open a wardrobe and being paralysed by an *embarras du choix*, or no choice at all. And I think that the editor's intention was indeed to produce this uneasy blend of impulse and interrogation, the desire to dress and the need to be guided towards a purchase. But it is not the fashion editor who provides the answer, it is the photograph. Whereas, in relation to the editor's edict, the photograph was only a generalized illustration, a convenient reference, something in the direction of which to wave one's hand, in relation to the reader's desire it becomes a crucial authority and source of first-hand information. The model ceases to be a woman modelling (i.e. a referentially minimized individual, an iconic representation, a vehicle of the imagination, an individual who lends her reality to a fiction, at the expense of *her* reality), and begins to recover the indexical, to become the target of identification, to regain the circumstantiality of her own being. But she only begins to do these things. Why? Because the fashion photograph must avoid the 'that-has-been' of the purely indexical photograph, must convince that the clothes are still purchasable, are not already *démodés*.

Fashion photography achieves this end in two ways: most obviously by making the model herself recurrent, albeit differently dressed (this is one function of the photographic series); but also by reminding us, even as we look to the photograph to provide a proof of the real, to bear out the claims of a necessarily unprovable language, that the photograph itself is partly unreal. Most often, its backgrounds are theatrical (décors and settings – the model does not inhabit the background but is montaged on to it); the clothes are all brand new with no signs of wear; the model is standardized in respect of youth and beauty;[12] the model is posed, in a set of poses peculiar to fashion modelling (*déhanchement*, pointing of the feet,

floppy doll, contrapposto; sulky, pouting, enigmatic, or reflective facial expressions).[13]

This 'absence-of-reality' factor can be explained by the fact that the fashion photograph must not present its image as reality, but rather negotiate between the image's origin in (false) reality and its future in (real) possibility. In other words, the element of unreality is part of the photograph's investment in the future, part of its projective ambitions. The fashion photograph has been taken, but its image is the servant of fantasy. The model did wear the clothes, was a dressed woman, but just before she could step off the stage, out of the dress, reclaim her full indexicality, she was re-suspended by the reader's need to see her not only as someone else but also as just some-one, to see her both as some (particular) one and as some (possible) one. But just as the model does not quite manage to achieve indexi-cality or literalness, so the reader, looking at the photograph, does not quite manage to see or know the clothes. This is what necessitates the third layer of language. But before we move on to this, we might quickly verify the first two layers by drawing on other examples.

The first layer of language maintains only a tenuous link with the photograph, through some deictic element which may point as much to a familiar reality beyond the photograph as to the photo-graph itself. In our original example, the definite article before

33 Andrew Dunn, 'one good tweed deserves another' fashion shot, 1993.

'casual look' performed this deictic function, as it does in 'The new girly look needs no accessories' (*Elle*, December 1993, p. 134) or in 'A gently burnished colour code – from toffee and taupe to dark chocolate – emerges as a powerful presence in the autumn collections' (*Vogue*, November 1992, p. 170). But deictics of time may serve this function just as well, as 'suddenly' does in 'Tactile, textured pure new wool tweeds suddenly give an added dimension' (*Cosmopolitan*, November 1993, p. 183; illus. 33).

After the first layer's tenuous link with the photograph, as general reference or exemplification, the second layer moves into the imperative and indefinite (characteristically plural), and leaves the reader to interrogate and explore the potential relationships between text and photograph, photograph and reality: 'Take a holiday from city chic. Exchange wristwatch and pearls for bangles and beads. Swap heels for thongs and put away pinstripes and tailored skirt. Replace with some bright colours and a sarong. Then break out of the concrete jungle!' (*Cosmopolitan*, June 1992, p. 173; illus. 34). There are other ways, too, of expressing indefiniteness: collective nouns ('the choice', 'a mix') or inclusive adjectives ('catholic', 'eclectic'): 'Capture the look from the choice of diffusion and high-street ranges, adding an eclectic mix of jewelled accessories and Chinese silk shawls' (*Marie Claire*, June 1992, p. 102).

The order of the first and second layers is occasionally reversed: 'Slip into someting more sensuous ... Luxury chiffon and velvet are the stars of understated glamour' (*Elle*, December 1993, p. 122). Often the one occurs without the other. In some magazines, this latter characteristic is an identifying class feature, as we shall see.

By opening up a critical gap between text and photograph, by compelling the reader to seek sanctuary in, and specific advice from, the photograph, the second layer seems to mark language's withdrawal from the operation, so that the reader is left with a dialectical relationship with, and the dialectical movement within, the photograph. But the photograph is dumb and its informational powers turn out to be both considerable and severely limited. It can say much about 'the look', much about 'the mood', much about 'the occasion', but about the clothes themselves – their materials, their colours, their styles, their cuts, what they look like from the back –

34 Richard Imrie, 'going native' fashion shot, 1992.

Take a holiday from city chic.
Exchange wristwatch
and pearls for bangles and
beads. Swap heels for thongs
and put away pinstripes
and tailored skirt. Replace
with some bright colours
and a sarong. Then break
out of the concrete jungle!

going native

Above: Black bikini top,
£29.99, Next Directory
(M85324). Georgette floral
pleated skirt, £25,
Marks & Spencer. Multi-
strand coloured beads,
£89, Art of Africa. ▶

and the accessories, about what we should ask for by name, to try on or buy, they can tell us surprisingly little.

While the photograph expresses a renewed need of language, therefore, it must not surrender the ascendancy which it has won for itself. So language at the third layer is without rhetoric (or apparently so), without voice (it lists) and almost without syntax. The information it provides is 'what', 'whose, by whom', 'where' and 'how much' (the final three of these elements may appear in a different order: there may be no second element): 'Cotton shirt, £27.99, by Esprit at 6 Sloane Street, SW1 [...] Shorts, £14.99, at Miss Selfridge [...] Leather boots, £80, by Blundstone at Shellys, 266–270 Regent Street, W1 [...] Kite, £9.50, from the Kite Store, 48 Neal Street, WC2'. Of these elements, the directions of referentiality are caught nicely between reference out of the photograph to reality (place and price) and reference into the photograph (garment, accessories, etc., and designer). It may be odd to propose that the designer belongs in the photograph, but it is only in the magazine photograph that the style is shown as style, the design as the design. It is doubtful whether the ordinary wearer is fully capable of wearing a garment in a way that optimizes its aesthetic appeal. In the photograph, it is the very fact that the model has the world to herself and any setting or pose at her beck and call that allows the aesthetic to be maximized. One must suppose that the fad for designer labels is intended to indicate not only the source of the garment but also the wearer's ability to wear it as it was designed to be worn – without the label, on me, I am not sure that an Armani jacket would look like an Armani jacket.

Listings such as the one just cited move through a certain hierarchy in which footwear comes after bodywear, and in which other accessories – the kite, for example – come after footwear. This hierarchy is misleading; but to correct this misconception, and qualify our assertion about the non-rhetorical nature of identifying lists, we need to move upmarket, and return to the adjectival string. Where nothing but neutral descriptive terms are invoked, one might expect a sequence something like:

> colour > superficial > cut/style > material > garment
> length decoration
> (beaded, embroidered etc.)

This is fair enough, and is often enough borne out: 'Cream ribbed cotton vest'; 'Air Force-blue wraparound wool cardigan'; 'tailored single-breasted wool gabardine overcoat'. We need to bear two things in mind, however.

(1) Fashion is the displacement of material by style or cut. This is partly a necessary direction of Fashion, as the designer displaces the dressmaker, as individual materials lose their cachet (cotton may be as stylistically expressive as silk), as new synthetic materials require style to lift them out of the tacky and downmarket. Accordingly, the material concedes its position next to the head to the essential design feature: 'white marabou feather buttonless jacket'; 'white stretch cotton bell-bottom trousers' (both *Vogue*, November 1992, p. 128); 'suede wrap-over trousers' (*Harpers and Queen*, November 1993, p. 163); 'Black wool crepe Nehru-collar jacket'; 'Burgundy angora mix crossover sweater' (both *Vogue*, November 1993, pp. 177 and 201).

(2) Language is rhetoricized particularly in the choice of colour words, and by the presence of exotic vestimentary terms, particularly French ones. The latter are easy to deal with: faille, faux-coral, distressed velvet, dévoré, pareo, peplum waistcoat, cropped silk, ecru cuffs, grosgrain, ruched bustier, etc. The former have multiple functions, including: the naturalization of colour (not artificial dyes, but environment-friendly); the suiting of colour to class (upmarket colours have more 'cultured' names); the encouragement to discrim-inate between those fine nuances which makes all the differ ence; the creative use of language to transform dress into image. Colours encountered in a brief trawl include: burnt tangerine, fuchsia, butterscotch, oatmeal, ivory, bitter-chocolate, mushroom, chestnut, strawberry, vanilla, banana, aubergine, caramel, cinnamon, olive, champagne, damson, forest green, honey beige, citrus, and raspberry. What the trend in colours seems to suggest is that adjectival strings in fashion listings are working to reverse the fourth principle of adjectival ordering, namely that common terms precede the rare ones – oatmeal may be common on the breakfast table, but in the world of clothes and colours it assumes a studied distinctiveness.

One factor which makes this destruction, or reversibility, of adjec-tival hierarchy possible is the transformation of the clearly adjectival into the substantival, so that either the attention becomes more evenly distributed along the string, or one begins to apply our first

principle – noun premodifiers are closer to the head than adjectival premodifiers – in which case all premodifying material appears to gravitate urgently towards the 'home noun', the head, claiming a priority. 'Burgundy angora mix crossover sweater': a description such as this tends to militate against any suggestion of 'recursive qualification' and we read these words not as an ordered sequence, but as a cumulative combination.

This trend has other consequences. One can still recognize adjectives by morphological form – past participles (fitted, tailored, double-breasted), certain suffixes (buttonless, strappy) – or by the practice of hyphenation (wide-leg, drape-front, bias-cut, bondage-belt, full-length, flower-pot, side-split). But the presence of these indicators is not sufficient to withstand the cumulative, synthesizing dynamic, a dynamic positively aided by hyphenation, since the hyphen itself is a sign of compounding, fusion, combinatory activity. 'Blanket-weave cashmere dressing-gown-style coat'; 'Banana chiffon long-sleeved, waisted, button-through top'; 'Wool crepe fret-worked column dress'. In the end, one begins to feel that everything should be hyphenated, or nothing at all. And this feeling is reinforced by an increasing haphazardness of punctuation. When does one use a hyphen (halterneck/halter-neck; wrapover/wrap-over; angora mix/angora-mix; floral print/floral-print)? And while several magazines avoid commas other than between phrases and clauses, some retain commas in their adjectival strings, creating a curious randomness, thus: 'Banana chiffon long-sleeved, waisted, button-through top'. The confusion in these matters becomes a positive sign of euphoria created by this heady mix of fashion elements.

The adjectival string galvanizes colours, cuts, materials, decoration into concerted activity, as noted by Barthes:

> In the vestimentary code, inertia is the original state of those objects which signification will seize upon: a skirt exists without signifying, prior to signifying; the meaning it receives is at once dazzling and evanescent: the 'speech' (of the magazine) seizes upon insignificant objects, and, without modifying their substance, strikes them with meaning, gives then the life of a sign.[14]

Language does this above all by the principle of combination. We have already met the lexis of this combinatory imperative: mix, combine, match, team, eclectic, layer – 'A glamorous shirt becomes

doubly luxurious when contrasted with workwear cottons'; 'Let urban and rural influences crossbreed' (*Vogue*, January 1993, p. 93). We have already encountered some of the linguistic devices which subliminally promote notions of combination: alliteration and assonance ('loose layers', 'wet and windswept', 'soft cotton', 'long socks'), and hyphenation. And now the adjectival string, by making the directions of reading reversible and/or by distributing attention and status equally among the constituents, allows the reader almost to recompose the outfit. It is in the nature of Fashion itself to turn the conferred into the inherent, the accidental into the essential, and combination is the way it achieves this. Items lose their accidentality through their assortedness; different aspects of the outfit, interacting with each other, produce a reciprocal inherence.

Vestimentary combination ensures combination on two further levels: the body and the personality. Women's magazines are in the habit of disaggregating the female body into its component parts, so that each part can be dealt with separately and intensively – health hints and beauty tips select the eyes, the stomach, the legs, the hair, the breasts, the skin, the feet for separate treatment. But what aesthetic assessment puts asunder, garments bring together: this is an *outfit* (a totality) which *suits* the woman. And while it emphasizes some features, it masks others in an overall, integrative strategy.

Barthes argues that moods, qualities of personality, are also treated discontinuously in fashion-speak, but that they can, for that same reason, also be put together, even if the result is a compound, an aggregate, rather than real synthesis:

> ...the Fashion personality is in effect a quantitative notion, it is not defined, as elsewhere, by the obsessional force of a feature; it is essentially an original combination of common elements, the detail of which is always given; personality here is *compound*, but it is not complex.[15]

This is certainly a tenable point of view, but the answer probably lies somewhere between the complex (a simultaneous conjunction of different qualities) and the compound (an aggregational, consecutive juxtaposition of different qualities). In other words, when we read 'A carefree girlish mood influences the casual look' or 'Let urban and rural influences crossbreed,' we have available to us both an

achieved synchronic synthesis and a developing, diachronic, modal modulation (i.e. both of our categories [1] and [2]).

But the reversibility of our adjectival string reveals also the need to transmute the detail into the origin, the apparently decorative into the intrinsic, the frivolous into the serious:

> The 'detail' involves two constant and complementary themes: tenuousness and creativity [...] a 'morsel' of 'nothing', and suddenly we have the entire outfit permeated with the meaning of Fashion: *a little nothing which changes everything* [...] *the details ensure your personality*, etc.[16]

As the sequence of adjectives lengthens, moves further away from the head, the garment, or as the sequence of items in third-layer listings moves from the cotton shirt to the kite, or from the hound's-tooth wool jacket to the faux-pearl and gilt filigree earrings, we seem to move in the direction of the superficial, the transient, the unnecessary. But this is profoundly to misread fashion, for three reasons.

First, as Luther observes, the model or buyer must not become subservient to a single design or designer:

> Women are now told by designers as well as editors to express themselves in their clothes, not to wear one total look by one designer. Paris designer Emanuel Ungaro actually defined a fashion victim to *Women's Wear Daily* as 'a woman dressed head-to-toe by one fashion house'.[17]

This policy necessarily multiplies and diversifies the elements of dress. Second, in order to express oneself, one needs to intensify the variant factor provided by accessories. While the 'central' garment (shirt, coat, skirt) is the gesture of conformity, the instrument of the wearer's social assimilation, accessories allow the wearer to find her way back to that eccentricity and individuality she has momentarily sacrificed. Third, reading through the listed vestimentary ingredients of the photograph, one may feel one is moving from the central to the peripheral, from the more important to the less important. But in the adjectival string the contrary seems to be the case. Once again, the Fashion experience as a whole encourages us to lose our sense of the significance of direction. But the fact remains that in a process of spectation which in fashion photography might be mapped as model > dress/style > highlight (accessory), the last perceptual

move, towards the accessory, becomes a kind of destination, the key to the combination, the synthesizing nub and thus the visible epitome of the underlying coherent self. As the garment itself may move, via the designer label, from material to author, so it equally moves, via the particular combination and the choice of accessories, to the other author, the wearer.

Before leaving this discussion of Fashion's layers of language, we should point out that in several magazines, particularly upmarket ones, the second layer (imperative and plural) is omitted. It is not difficult to imagine why. The Fashion ethos would want to suggest that clothes are not sold (hard-sold) to buyers, but rather select their wearers. The reader of the fashion magazine must feel chosen by clothing as much as choosing it, so that the symbiotic relationship with dress – and through dress with the world, which is Fashion, is *mondanité* (a word significantly without an English equivalent) – can be achieved. According to one statistic, only 2,500 women in the world are purchasers of *haute couture* products. This is credible; for the vast majority, the *haute couture* product is the fashion magazine and its photographs. Wearing is transferred to looking. Not surprisingly, therefore, both for the select few real buyers and for the window-shoppers, an imperative would be either tasteless or irrelevant. The imperative is the photograph itself, and the intensity of this subtextual imperative is in the quality, glossiness, archness, self-consciousness, of that photograph. The photograph, not the voice, is the agent. For the window-shopper reader, the essential encounter is with a photograph, and the stages of looking must somehow parallel, imitate, the stages of acquiring and wearing. We shall shortly return to this proposition .

Correspondingly, with the second layer removed, the first layer relocates itself as part of the third. Although a first-layer formulation may occur as an introduction to a whole photo-sequence – 'Gossamer light, black chiffon reveals a sensuous streak in longer evening lengths. Shot with a shimmer it's a SHEER INDULGENCE' (*Vogue*, November 1992, p. 151) – each third-layer listing has its first-layer set-up: 'Swirling, twirling chiffon, slashed for maximum movement'; 'The slip-off shoulderline'; 'Lace toughens up, losing its twee tone in bold, boyish cuts.' The benefits seem to be reciprocal: the listing is not only an identification of what is in the photograph, but an immediate putting into practice of the revealed truth of the first

layer. The first layer's adjacency invests the listing with rhetorical force and removes some of its potential arbitrariness.

In this respect the punctuation between the first and third layers is important. Sometimes there is a full-stop, but more frequently there is no punctuation, or the usefully exemplifying, or explanatory, or disclosing, force of a colon: 'Instead of a dress that binds the body, this season chiffon competes with wool for an altogether new approach: wool knit and chiffon dress (opposite), £593 […] etc.' (*Harpers and Queen International*, November 1993, p. 158). The return advantage is the consolidation of the relationship between the first layer and the photograph: while the listing tells us what the ingredients of the photograph are, the first layer tells us of its style, its way of life, even of its compositional choices. In short, the aesthetics of the clothing becomes indistinguishable from the aesthetics of the photograph: 'So close for comfort' (close-up of hand on girdle); 'Sparkling reflections at dusk' (soft-focus sequined dress, so that sequins look like multiplied lights); 'Strategically positioned gilt buttons attract the eye to wider lapels and a fitted waist.' This device gives further authority to the photograph: although the photograph still only illustrates the first-layer formula, the reverse is also true, since, crucially, the photograph now seems to precede the caption. Deictics such as 'here', or the definite article, a lexis of looking ('Heads turn …', 'on closer inspection', 'in detail', 'First seen'), a frequently notational style ('Delicate scoop on a shoestring strap', 'Cascade of spangles'), descriptions of pose or posture ('Swathed in pearly smoke', 'Taking it easy, with hot coffee and cream silk'), all imply the temporal and indeed representational priority of the photograph, as though Fashion could exist, spontaneously, involuntarily, without prescription and diktat. Of course there are other patterns of language layering: *Clothes Show*, for example, characteristically combines all language layers together, in the same printed space, and if a layer is omitted, it is usually the first.

Photographs become an evidential demonstration of Fashion. Fashion exists unequivocally, reliably, only in the fashion photograph. In language, Fashion's meaning must remain implicit, because while the conditions of its existence can be defined, its specific vestimentary constituents cannot. Additionally, the achievement of Fashion does not depend on garments alone, but on the model, the wearer, who must have the necessary personal qualities for the clothes to fulfil themselves. Clothes can only become fashionable if

they can draw the proper sustenance from the wearer. This mediating process is often overlooked, because, following on from Barthes, one begins to think of the codes of fashion as polarized between Fashion (implicit) on the one hand, and clothes (explicit) on the other. This is to overlook the function of both the fashion photograph and the wearer in that middle ground occupied by terms both human and vestimentary: elegance, glamour, sophistication. While Fashion remains resistant to definition and curiously independent of human agency ('this season chiffon competes with wool for an altogether new approach'), 'glamour' and 'sophistication' are more accessible to human habitation. Martin Harrison is both right and wrong when he asserts: 'Where previously formal values, or less readily defined qualities such as *elegance* or *glamour*, had been paramount, the shifts in fashion photography after 1945 are due principally to the increased awareness of its psychological dimension.'[18] He is certainly right to stress the shift from the social to the psychological, from class consciousness to the individual psyche, a shift after all responsible for the decline in fashion drawing, in which fashion imagery could still be used as a vehicle for light social satire. As William Packer observes:

> None of that survived the sudden shift, away from the old stabil-ising, comfortable, hierarchical assumptions and social attitudes, towards the excitement and the supposed freedom of the cult of youth [...] No longer would *Vogue* ride to hounds, and only the seasonal diversions of sea and snow would be admissible as *Vogue* sought actively to identify itself everywhere with a neutral, affluent new class.[19]

While fashion drawing tends to integrate the figure into an envi-ronment in which it must naturally belong, the photographed model is, as we have already noted, essentially montaged, a figure in an available décor, or no décor at all, a transferable, mobile, free figure, without the constraints and responsibilities imposed by an environment, and for whom opportunism can be a way of life.

But Harrison is wrong to say that 'elegance' and 'glamour' have ceased to be paramount or, as he implies, are antithetical to a psycho-logically orientated fashion industry. It is the very transferability of these terms between the vestimentary and the psychological, the fact that they are both anthropomorphic and sartoromorphic, that has

made them durable. If we look for a dictionary definition of 'sophistication' (of which 'elegance' can be considered an aspect) and 'glamour', we shall be disappointed, particularly because such definitions tell us so little about the relationship between 'sophistication' and 'glamour' as two competing options for fashionable living. *Collins Cobuild English Dictionary*, for example, defines 'glamour' as 'the charm and excitement that seem to surround an interesting, fashionable and attractive person, place, or job';[20] the *Longman Dictionary of Contemporary English* defines 'sophisticated' as 'experienced in and understanding the ways of society, esp. showing signs of this by good taste, clever conversation, wearing fashionable clothes, etc.'[21] Such definitions beg questions and overlook crucial factors.

My own differentiation between 'glamour' and 'sophistication' would be as follows: 'glamour' is youthful, dynamic, pleasure-seeking, extrovert, voluble, short-term, gregarious, uncultured, volatile, public (and thus downmarket), while 'sophistication' is mature, poised, restrained, introvert, taciturn, long-term, solitary, cultured, controlled/severe (and thus upmarket). Because of its culturedness, 'sophistication' often has a social pedigree which 'glamour' can function without. *Prima* (November 1993, p. 6) defines this difference in its review of Christmas party wear: 'We've combed the high street collections to bring you lots of ideas for every look. From elegant dinner party separates to a show-stopping sensation for that big occasion, there's an outfit for everyone.' The Hollywoodian, entertainment aspect of glamour is equally in evidence in a *Clothes Show* feature on sunglasses (July 1992, p. 37), as is its instantaneousness: 'Beloved by pop stars, models and starlets, they spell instant glamour.' The sophisticated, on the other hand, oscillates between the truly luxurious and the undemonstrative, in a noticeably educated language: 'The opulent synthesis of sinuous curves and cascading jewels is couture's most potent weapon. Here, pictured in the Duke and Duchess of Windsor's Parisian villa, are perfectly proportioned clothes distinguished by their superlative wit and splendour' (*Vogue*, April 1990, p. 200). It is often the undemonstrative that triumphs, however. For if glamour is instantaneous and requires constant revitalization, sophistication remains quietly confident in the stability of its acquiredness: 'This season's suits focus on relaxed tailoring – wide pants and loose-cut jackets worn with a simple polo-neck or the perfect silk shirt' (*Elle*, December 1993, p. 112).

'Perfect' is the word of tranquil achievement, for sophistication, like fashionability, once possessed cannot be improved upon; and in this world, 'simple' is a superlative, a marker of extremity, like 'superlative' or 'perfect' or 'purest'. Where glamour's exhaustibility might drive it to the faddish, sophistication begins to operate at a different speed, on a much slower, longer time-scale: 'Rotary is well known for the quality of its design but you won't find any fashion fads here: Rotary watches can always be distinguished by their sophisticated styling and timeless elegance. In fact, they are designed to last a lifetime, (*She*, December 1993, p. 21). This sense of sophistication as something assured because achieved, is conveyed by its cultivation of past participial forms. In this passage 'well-known', 'distinguished', 'sophisticated', 'designed', belong to a family of *faits accomplis* like 'tailored', 'refined', 'tapered', 'embroidered', 'encrusted', 'waisted', 'draped', 'ruched', which justify a certain passivity, a certain supple lethargy, in the wearer. The ongoingness of glamour, the sense that it lasts only as long as it is actively sustained, demands the busy importunity of the present participle – 'sizzling' 'glittering' 'dazzling', 'stunning', 'eye-catching', 'sparkling', etc. – and the mobile, reflective surfaces of disyllabic adjectives ending in -y: 'sexy', 'glossy', 'glitzy', 'snappy', 'sassy', 'splashy', 'showy', 'sporty'.

Few magazines, however, can afford to keep the sophisticated and glamorous entirely segregated, not only for reasons of audience, because these terms represent different age-ranges and economic strata, but because sophistication, being already possessed, is a quality of the model and the 'reader-as-model', while glamour, being unpossessed and desired, is a quality of the reader and the model-as-reader. The perfect circle thus contains both. Some magazines, however, particularly the upmarket ones, try to control the dosage of glamour in sophistication: 'Slip into something more sensuous … Luxury chiffon and velvet are the stars of *understated* glamour' (*Elle*, December 1993, p. 122 [my italics]; illus. 35); 'Heels and sheer black tights give a working woman's wardrobe a *touch of* glamour' (*Marie-Claire*, June 1992, p. 84 [my italics]). Others let them interfere with each other and consort together without restriction: 'Ever since sunglasses first became a style item back in the 1930s, they've denoted sophistication and cool, importing instant glamour to the wearer' (*Clothes Show*, July 1992, p. 37); 'For elegant and easy-to-wear glamour choose one of the new glitzy knits; 'Team a sparkling

SUNSET STRIP

SLIP INTO SOMETHING MORE
SENSUOUS...LUXURY CHIFFON AND
VELVET ARE THE STARS OF
UNDERSTATED GLAMOUR

35 Neil Kirk, 'Sunset Strip' fashion shot, 1993.

sweater with chic black trousers for a relaxed party look' (*Prima*, November 1993, p. 12; illus. 36). This last pair of quotations reveals all, for what could be more ideal in fashion, the art of self-expression through combination, than the *teaming*, the *matching*, of the glamorous with the sophisticated, and on fashion pages devoted to that euphemistically entitled age-range '16+' (i.e. anyone between 25 and 55).

The transformation of glamour into sophistication seems part of that larger desire to escape the destiny of fashion through fashion itself. It is the destiny of fashion to suggest that all is transient, changing. This is why, as Barthes points out,[22] in fashion magazines, age matters more than sex (age is threatened by time, whereas sex is a given). It is the destiny of fashion to suggest that essences, personality, psychological features, are as temporary and contingent as the clothing that draws them out. As Harry Callahan points out, photography seems to be a part of this fashion conspiracy:

> Fashion isn't just surface. It's only surface [...] Fashion is thin [...]
> And nothing is better, or more appropriate, at portraying fashion
> than photography, a process of capturing light in impossibly thin

36 Paul Viant, 'Just dazzling' fashion shot, 1993.

Team a sparkling sweater with chic black trousers for a relaxed party look.
Lurex knit sweater, £22.99, Etam. Cotton/viscose trousers, £24.99, BIB. Scarf, Accessorize. Jewellery, Savvy. Watch, H Samuel

The black sweater is classic with sequins for party glitz, right.
Acrylic mix sweater, £29.99, C & A. Crushed velour viscose trousers, £69.99, Viki Pola. Necklace and earrings, Val D'or. Bangle, John Lewis

Rich gemstones gleam on this black tunic to stunning effect, set off by soft silky pants.
Acrylic mix sweater, £34.99, Empire. Silk trousers, £67, Jacques Vert. Earrings, Val D'or. Shoes, Faith

Just dazzling

For elegant and easy-to-wear glamour choose one of the new glitzy knits

slices of time. Photography reduces all it sees to a thin emulsion of light and shadow, colour and hue. Fashion and photography is an arranged marriage and one that really works.[23]

But just as fashion can redeem fashion (by the wearer's achieving the stable state of the 'fashionable'), so photography can redeem photography – by the indexical's achieving the stable state of the iconic. As we have already indicated, however, the fashion photograph, thanks to our awareness of montage, pose, décor, and other elements of unreality, can only ever forge a tenuous link with the indexical. It is true that the photograph of the glamorous is nearer to the indexical than the photograph of the sophisticated because, as we have been at pains to claim, the glamorous is instantaneous, changing, dynamic, out-turned, gregarious (anxious to relate to the viewer). But even here the iconic is already installed and the photograph already an art-object. It appears in a journal, is large-scale, is high-gloss, has a model (already more than a mannequin), and usually has the kind of selective focus that, even in outdoor settings, puts model and garments in a space of their own (oddly, they benefit from real atmosphere without our being able to reconstruct the sources of that atmosphere – light, wind, heat, humidity, etc.). And as we have also pointed out, such photographs allude to a past while projecting the reader and themselves into possible futures, into fantasies and fictions. For this reason, fashion photographs resist the instantaneous and offer to become part of a life, part of narrative. Indeed they will only become so if the reader can imagine it for herself with sufficient conviction to become the model and/or purchase the dress. But this already takes us in another direction, the direction of photography's relationship with narrative, with duration and sequence. This direction might free photography from its dependence on language – if only photography could manage to do its own telling.

Photography and Narrative

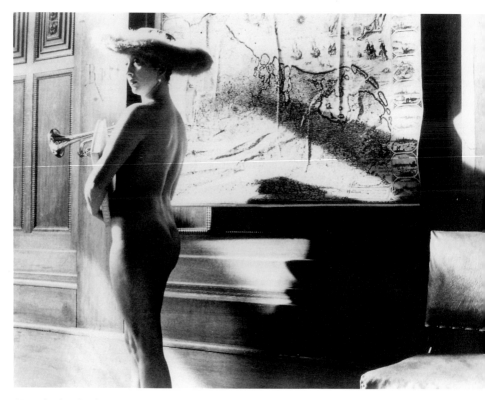

37 Production shot from Peter Greenaway's *A Zed & Two Noughts*, 1985.

Narrative and Time-lapse Photography in Peter Greenaway's *A Zed & Two Noughts*

It may seem odd to begin a consideration of photography's relationship with narrative with an extended analysis of a film. But the photographic and the filmic are intimately interwoven: the photograph is an isolated image inviting, through its 'blind field', its re-installation in a history, in a passage of time and a sequence of images. The film is a continuity forever carried away from itself, from the meanings it would make available as a set of stills, from the dramatic, expressively structured photographs that make up its every frame and that do not stay to be digested. The opening freeze-frame sequence of Roger Spottiswoode's *Under Fire* (1983), set in war-torn Chad in 1979, eloquently makes the point, even suggesting that narrative is inimical to the photograph's power to discharge compressed visual energy, to transcend sequence in epitomization, expectancy in arrested fascination. The particular film that forms this chapter's point of departure, Peter Greenaway's *A Zed & Two Noughts* (1985; illus. 1, 37),[1] sets still photography against film and involves painting as a third party in the debate. And, as so often happens when still photography appears within a film, we can sense that the medium as a whole – photography – is testing its assumptions, investigating the ways in which it can create sequence, transform sequence into consequence, construct teleological patterns which would explain, and be explained by, beginnings.

In a sense, still photography is continuously present in *A Zed & Two Noughts*, not only cinematographically but also musically. Among the cited sources of minimalism, besides Ravel (*Boléro*), Satie (*Vexations*) and Copland (Clarinet Concerto) are Baroque ground basses and chaconnes, with which Michael Nyman's music is particularly familiar. In his sleeve note (1982 Charisma Records, 1989

Virgin Records CASCD 1158) to *The Draughtsman's Contract* (1982), Nyman tells us that he used Purcell's ground basses for three reasons: because they brought the best out in Purcell, because they were closest to the 'infinitely repeatable/variable/recyclable/layerable harmonic structures that I customarily work with', and because these closed harmonic systems 'could be interpreted as making a musical parallel with the organisational and temporal constraints that the draughtsman Neville imposes in the Herbert household'.

For the photographer, the insistent beat of Nyman's music echoes the clicks of the shutter and the synchronous flashlights of the time-lapse camera or the camera of the chronophotographer. It is no accident that, early on in the published script of *A Zed & Two Noughts*,[2] Greenaway should refer to Eadweard Muybridge: 'The photos he [Oswald] is taking will record the animal's movement in a collection of Muybridge-like stills which will be seen later in the film' (p. 19). Similarly, it is no accident that Philip Glass should choose Muybridge as the subject of his music/theatre piece *The Photographer* (1982). Muybridge's work in animal locomotion, where the locomotion is supplied by the zoopraxiscope, reveals movements and processes invisible to the naked eye, and is the converse of time-lapse photography, which allows one to see the invisibly slow changes, collapsing days, weeks, months years into seconds and minutes.[3] Minimalist music, however, serves both kinds of chronophotography: the clarity of its elemental motifs allows the listener to register those minimal variations built into the musical structure over a long period of time, and which otherwise would be inaudible; at the same time, the same structural clarity lays bare the different harmonic layers and displays their synchronous action.

There is a further sense in which we should make a parallel between Nyman's minimalism and Greenaway's visual strategies in *A Zed & Two Noughts*.[4] Returning to the sleeve note of Nyman's music for *The Draughtsman's Contract*, we find him referring to his *In Re Don Giovanni* (1977). He goes on: 'For *The Draughtsman's Contract* score a not dissimilar process of reconstruction, renovation, renarration, refocussing, revitalisation, rearrangement – or just plain rewriting – would be applied to a carefully sifted, narrow range of Purcell material.' This statement squares particularly well with Greenaway's summary of the intended effects of his plotting and cinematography: 'Thus all events are open to re-interpretion

[*sic*], re-appraisal and re-interpretation.' Film has the desire of the zoopraxiscope: to restore movement and meaning to the discontinuous, dislocated, instantaneous. But the variety of materials, the absence of 'fit', the discrepancies and reversibilities, open the pattern up again, throw it into question, so that the task of re-weaving must always recommence. Greenaway's view of narrative seems very similar to Benjamin's view of history: the past is a detritus of images, fragments, quotations, made intelligible in the present by a process of montage, of semantic construction. But making intelligible is a constantly repeated process, as the fragments are reassembled to form new wholes, potential lessons or allegories:

> ALBA [to Oliver]: You are already beginning to build yourself a case for the supernatural – another set of details from the same crash could produce something completely different.
> (p. 65)

The reader of narrative has as many keys as Alba Bewick has for L'Escargot (p. 71). The important thing is that the more keys the reader has, the more constructions he can make; and the more the elements of the past are wrenched out of a fossilizing tradition, the more the power-base of tradition is subverted and its aura dissolved. The zoo is the image of tradition and of power through taxonomy. The film, the Deuce twins, take on the zoo, in order to remotivate the past (history and narrative) for the present. Greenaway affirms: 'I would like a cinema in which it would be normal to view films several times over … I like a cinema which, instead of pretending to give answers, asks questions … Nothing but questions …'[5]

The camera is peculiarly inimical to tradition, to a standard view, because it refuses to discriminate:

> The camera retains, like the draughtsman in the film [*The Draughtsman's Contract*], a steady, uncommitted, observant, uncritical eye as interested in the texture of a fabric, the gloom of candlelight, the wind in elm trees as in the demeanour of a corpse or the discomfort of the victim of a sexual coercion. (Peter Greenaway, sleeve-note to music of *The Draughtsman's Contract*)

Perhaps Greenaway's choice of the word 'uncritical' is inapt; even the most disinterested perception creates the *inescapable*, since the

photographic image is not just registered but offered, and therefore implicitly has a message, whether it belong to Barthes's *punctum* or to *studium*. A photograph offers all its evidence to view, apparently without discriminating between its parts, and it does so immediately. But although the photograph may, in this way, seem to be totally visible, the spectator's knowledge can never be equal to this visibility. We suspect that the real meaning of appearances lies somewhere in this disproportion between visibility and knowledge, in something we caught a glimpse of but did not 'see':

> OLIVER [watching 'Life on Earth', to Fallast]: I'm going to take it in stages, it needs absorbing. I'm sure I must have got it wrong before, and I'm on the look-out for clues.
> FALLAST: What sort of clues?
> OLIVER: I need to separate the true clues from the red herrings.
> (p. 29)

The incoherence of the single photographic image largely derives from the fact that it has lost the purposefulness, the 'plot', of its taking, of continuity in time. The photographic image is the epitome of evidence, not so much because it bears witness to something known to be significant as because we can return to it when we do know what to look for; or because we come, by chance or patience, to see in it what we always overlooked, a key to its mystery.

Time-lapse photography promises a way out of this predicament. The photograph becomes an element in a sequence, a sequence made cohesive, consecutive, by the filmic collapsing of time between separate shots. Time-lapse photography also makes the action of chronometric time available to perception, that is, the action of a time which is an autonomous, external force, acting on humanity like a destiny. The staccato breaks out of the continuous duration of the filmic, where time is absorbed into movement and spectatorial experience, and in so doing is able to dramatize, to 'image', time. Time-lapse photography accelerates the action of time, so that we actually pass through time, rather than, as in the filmic, merely keeping pace with it. Time-lapse allows the spectator to explore time and to grasp the fourth dimension. And of course, it is by reconstructing our passage through time, by tracking the tiny metric changes, by means of the staccato and minimalist, that Oswald and Oliver hope to uncover the forces that have produced their wives' deaths:

OSWALD: I'm trying to work it out.

ALBA: What out?

OSWALD: Why we've come all this way – slowly and painfully – inch by inch – fraction by fraction – second by second – so that my wife should die by a swan.

(p. 70)

Oswald, in his exasperation, or as he more closely approaches his target, the human corpse, introduces more exact measuring equipment into his time-lapse experiments. The decaying crocodile is the first animal to have the benefit of a 'graph-board' (p. 84).

Not surprisingly, in view of the cognitive, clinical, perceptual stance shared by photography and minimalism, Oswald distinguishes himself, initially at least, from Oliver,[6] by the studied restraint, precision, cleanliness, of his approach to grief; he wants to understand it by understanding his wife's death and decay. Oliver, on the other hand, takes the untidy and bloody way of experiential immediacy, consuming the glass fragments from the car's shattered windscreen, multiplying copies of the same photograph of the crash, gathering newspaper cuttings.[7] As one might expect, it is Oliver who expresses himself through nakedness and enters the tiger's cage. The initial complementarity of the twins, to which we shall return as theme, is evident in their bouquets at the funeral: 'They both have bunches of flowers on their laps – each bunch is different. Oswald's bunch is discreet, neat and wrapped primly in cellophane; Oliver's bunch is untidy, poorly wrapped, the brightly coloured flowers large and overblown' (p. 23). While Oliver watches David Attenborough's TV nature series 'Life on Earth' in the public auditorium of the zoo theatre, in colour, Oswald watches it in the privacy of his apartment, in black and white – and often the empty screen is tracking, as though reality could not be framed or caught up with. Fittingly, too, Oliver is the custodian of the snail, the very agent of decay. If the lick and the kiss are the vehicles of the bacteria *bisocosis populi* (p. 24) – and we think of those kisses exchanged between Alba and Paula, Alba and the twins, Adam and Eve – then the snail is the lick/kiss embodied. Alba loathes the snails of L'Escargot because 'if you left a bicycle by the back door while you went indoors to use the toilet – when you came out – the saddle was covered in snails – licking up your sweat' (p. 71). The snail's sexual

intimacy with decay is complemented by its own sexual immunity, since, as Oliver points out, it is hermaphrodite (p. 36).

But if time-lapse photography seems to engage peculiarly with Oswald's chronometric view of grief and decay, as opposed to Oliver's durational approach, we should not suppose that relativized versions of temporality are eschewed by the time-lapse camera. The script keeps careful track of the reduction times of the time-lapse footage: the 10-day decay of the prawns becomes 60 seconds of film, the 4-week decay of the crocodile becomes 25 seconds of film, the 4-week decay of the dalmatian becomes 20 seconds of film, and so on. But all history is time-lapse, since that is the only way to wring a development and a continuity out of the imperceptible pace of aeons. David Attenborough's voice-over creates a time-lapse perspective for life on earth, by compressing history into 365 days. This compression maintains some of the relative durations of ages, but threatens to create unidirectionality and implicit purposiveness. Oswald's time-lapse laboratory, too, registers the variety of the life and death speeds of different species, in the counterpointings of flashing lights and clicking shutters: 'In the time-lapse laboratory, there are at least a dozen cameras staggered across the large spaces – alternately light and dark. Each set has different characteristics – each flickers with a regular flash – some at eight, some at ten, some at twelve seconds' (p. 89). Elsewhere, more poignantly, Oswald describes the flashlights as 'lighthouses giving you a bearing on lost spaces of time'. It is only natural that a chronometrist should use this phrase. Oliver, for his part, would argue that the syncopated rhythms of the flashlights give us bearings on lost spaces of different times, different time-scales.

But the creation of narrative out of history, a continuity out of the disjointed, a singleness out of the multiplex, is the only way that Oswald will be able to see his wife's death as determined, as something that can be accounted for. While Oliver's untidiness is that of unreconciled lamentation, Oswald's smartness and control identify him as someone who looks for consolation in comprehension, assimilating the anarchic and contingent into the ordered and general. But zoology is as fraught with fictionalization as fairy-tale; Van Hoyten remarks that Oliver will not find an answer to his wife's death in 'Life on Earth' because it is 'just a straightforward account' (p. 44), and adds: 'Darwin was a good story-teller' (not in

published script).[8] Contingency is Van Hoyten's refuge; he knows of the displacements, discontinuities, overlappings in unmediated existence, and this is what gives him his bargaining power, the capacity to be inconsistent. But we did not need the maladjustment of different kinds of time – chronometric, durational, relativized – to warn us that categories/species do not occupy watertight taxonomic spaces, but run into each other and permutate endlessly, to make a Babel of classification and truth; the very title of the film tells us that.

Greenaway himself supplies a short commentary on his title:

> The archetypal pair of twins, Castor and Pollux, the astrological Gemini, born out of an egg from the union of a swan and a god provide *A Zed & Two Noughts* with its central pivot, the two brothers Oliver and Oswald Deuce, the two letter O's, the two noughts, the two zeros of the film's title – put together to make a spectacle of themselves.
>
> (pp. 14–15)

This title takes us through the alphabet, but only by deletion/omission: 'A Z(ed) ...' A–Z promises comprehensiveness, but the Roman version has none of the metaphysical resonance of the Greek alpha to omega. One of the reasons for this is that the twenty-six letters of the Roman alphabet (what an ironic etymology this word has!), unlike the twenty-four letters of the Greek (wrongly identified as twenty-three by Oliver [p. 32], presumably to create an equivalence with Vermeer's paintings: 'twenty-six paintings – and three of those are dubious' [p. 45]), have no names. 'Zed' is a sorry-looking exception, to put alongside 'aitch', 'kay' (?), 'em', 'eff' (?). But how do you spell 'q'? While Alba (white, dawn, alb, alpha) gives her children the names of the Greek alphabet, her daughter reconstitutes the Roman alphabet as a zoology, and perhaps as a new evolutionary sequence, running from angel fish to zebra. Next to 'zed' stands not 'and' but an ampersand, which has a name, it is true, derived from the pleonastic etymology 'and per se and', but which pushes the language further in the direction of pure graphism,[9] reminding us that Z, as a grapheme, is a pictogram of 'swan', just as the O's are pictograms of 'eggs'; these O's reappear, as a decorative motif, in the bedstead of Alba's hospital bed, occasionally supplying her with a halo and thus adumbrating her drift towards the biblical. But the O's do not have names either, and to be represented in

language they must become numerals – zeros, nils, noughts, loves.

The title, then, is peculiarly promiscuous and non-categorial, crossing the boundaries between the graphic and the orthographic, the graphemic and the phonemic, the Roman and the Arabic, the Roman and the Greek, the written out and the abbreviated. Some of the elements in this blurring of taxonomies are pointed out by Greenaway himself:

> Darwin's Eight Evolutionary Stages of Natural Selection, the seven days of Genesis, the Greek Pantheon, the twenty-six letters of the alphabet, the diminishing number of authenticated Vermeer paintings ... and so on [...] What about mermaids, centaurs, the Sphinx, the Minotaur, werewolves, vampires, and that proliferating zoo of contemporary hybrids [...] Is classical Venus the biblical Eve? Is a zebra a white horse with black stripes, or a black horse with white stripes?
>
> (pp. 14–15)

To this list might be added the evolutionary pattern outlined in Beta's naming of the alphabet, already alluded to, and the developmental string that runs from Catarina Bolnes's red hat to the teased-up hair of Alba Bewick, marked out by the sequence of cited Vermeer paintings, which include: *The Lady/Girl with the Red Hat, The Lady standing at the Virginal, The Allegory/Art of Painting, The Concert, The Music Lesson, Mistress and Maid,* and *Woman in Blue Reading a Letter, The Astrologer* and *The Geographer.*

Greenaway's question about the zebra, echoed by Van Hoyten (p. 28), indicates that the underlying schema of the film is to be found in reversibility, the non-scientific, biblical finding: 'How decay becomes life, and becomes decay again after life'.[10]

> ALBA: Good Lord, Oswald, what's this?
> OSWALD: Prawns on their way back.
> ALBA: Way back?
> OSWALD: To where they came from. Ooze, slime, murk.
> (p. 45)

We see this principle of reversibility in the film's title: the end is in the beginning, not only because of 'A Z(ed) ...', not only because the zebra is the first animal – its head is in the tiger's cage – and the last, but also because the O's are eggs and omegas, and because they

are eggs/Deuces/noughts that come to nought. The final words of the script are: 'The final experiment requiring the brothers' personal self-sacrifice comes to nought' (p. 110). Even the title as sign is reversible: the normal order of its letters in the opening shots (ominously extinguished one by one in Shot 6 [p. 21]) is reversed in Shot 78 (p. 107), when Milo finally surrenders to her desire for the zebras. The beginning is also in the end in the sense that the script's epigraph – 'you are the last and we are already finished' – is a self-quotation, taken from its own closing pages, where Oswald says to Alba, where omega says to alpha: 'If you are the last, we are already finished' (p. 108). Furthermore, the period of decay for human beings is the same as the period of gestation: nine months (given as ten in the published script [p. 91]). And on their first visit to Alba in the zoo's hospital, Oswald and Oliver each, symmetrically, pick up an object, Oswald an apple, and Oliver a toy zebra.

But this circular structure, presided over by the snail which is first found in Shot 12, in the flowers laid by the brothers at the scene of the crash (but not mentioned in the published screenplay's account of Shot 12), and last seen bringing the twins' experiment to nought, is countered by a movement of progression:

OSWALD: Reptiles didn't die out. They grew feathers and became birds.
(p. 70)

Nowhere is the dialectical relationship between the circular and the progressive more succinctly put than in the two words used in Shot 67, when the twins visit Van Meegeren's surgery to arrange to be joined together:

VAN MEEGEREN: Why do you want it done?
OLIVER: Completeness.
. . .
VAN MEEGEREN: Do you envisage taking your photographic experiment to completion?
(pp. 96–7)

Alongside the desire for completeness, for existential wholeness, the stasis of achievement, is set the progressive principle of completion, the teleology of scientific investigation. The desire for completeness belongs, fittingly, to Oliver, while completion is the

goal that Oswald has set himself. The goal of the 'plot' would seem to be the convergence of the two principles, expressed in the repeated, symmetrical patterns of complementary couples.[11]

It is here that we might propose that Oswald's films are time-lapse films within a time-lapse film, just as Vermeer's paintings are *tableaux vivants* within a series of *tableaux vivants*. As in Oswald's time-lapse laboratory, the film itself operates with experimental/clinical/artificial conditions:

> My underlying design is to make resolutely cinematic, that is to say artificial, films. And one of the strategies I use to achieve this end, is to set up scenes which develop rather like scenes in theatre or opera [...] Similarly, the dialogue is 'written' and the actors speak it without trying to 'naturalize' it ...[12]

Like the time-lapse film, Greenaway's is also an exercise in temporal compression. Sacha Vierny, the director of photography, tells us: 'Z.O.O., which now lasts only 1hr 50, was originally 3hr 30. He abbreviated the shots and yet used all the material. He just compressed it.'[13] Like the time-lapse laboratory, Greenaway's cinematography capitalizes upon the staccato, the discontinuous, in order to activate cognition and reveal invisible continuities; not unnaturally this strategy extends to the music:

> Usually, montage tries to conceal itself, the progression of images must seem 'natural'. I, on the other hand, want the audience to clearly perceive the montage, the shift from one scene to another [...] It's rather the same with the music: it's not at all my intention that it should be 'forgotten'.[14]

Thus we might track both the complementarity of the twins and their growing convergence. Equally we might trace the increasing intrusiveness of Catarina Bolnes, first seen as a head-and-shoulders mirror-image, a faked Vermeer picture, in Shot 7 (p. 21), and Felipe Arc-en-Ciel, first glimpsed as an insignificant presence in Shot 16 (p. 27); the latter will go on to oust the twins in Alba's affections. Ultimately Catarina Bolnes will gravitate towards Milo, offering herself to the twins for money, but without the dirty stories thrown in (p. 67). They also share a sexual fondness for zebras, if only expressed, in Catarina's case, through her underwear. Milo herself is a complement to Alba Bewick, black to her white, pregnant, like

her, by two fathers (Van Meegeren, Van Hoyten), having her work published through the good offices of Felipe Arc-en-Ciel, Alba's 'husband'. While Alba, in actuality, has no legs, but in fiction has (as a Vermeer model), Milo has arms in actuality, but none in fiction (the statue of Venus de Milo). Alba is the woman of legitimate entry, but with too many keys for the one lock; Milo specializes in illicit entry (Oliver's apartment, the gorilla house, the zebra enclosure), using the same tools for every door (a flat piece of plastic and a sharpened pencil – a pair of assets whose significance needs no labouring). It is the possession of these latter assets which differentiates Van Hoyten from Oswald, but both are slaughterers of animals. Van Hoyten shares with Van Meegeren an onomastic particle and, as already mentioned, the claimed paternity of Milo's child. Both men also offer Oswald Milo's corpse (complications arising from abortion, mishap with the zebras) for his final experiment. And as the film progresses, so the mark on the wall made by Oswald, as he paces like the tiger (the animal initially associated with Oliver), becomes more accentuated.

In the course of the film, the zoo is increasingly amplified, to become a microcosm of all modern social spaces: hospital, apartment, cinema/theatre, laboratory, hotel, café/restaurant, art gallery, zoo (circus). And yet, is the film sufficiently compressed to make all these movements of convergence and relationship visible, in a true epitome of time-lapse? Or are we as aware of the continuities we cannot manage to create as of those we can? Are we aware how much has escaped our notice, how much the time-lapse technique has not been able to isolate?

This last question should perhaps be emphasized because the discrepancies between the published screenplay and the film script point up what is accidental about knowledge, and how haphazard are the bases upon which we build it. To take one example: Greenaway mentions the Greek Pantheon in his introductory note, but it is the Roman version, as degraded as the Roman alphabet in relation to the Greek, which the film employs. How aware are we that the zoo is as much Olympus as a microcosm of modern society? And even if we are, can we tell whether the film is a mock-epic (vulgar humans speaking like gods) or a burlesque (gods speaking like vulgar humans)? We are back in the reversible world of black and white. At all events, (Venus de) Milo and Ford Mercury are

only two of the heavenly company; Van Hoyten, the published screenplay tells us, wears a 'Walt Disney Pluto badge' (p. 27), while Fallast 'wears a thunderbolt tie-pin: the Emblem of Jupiter'(p. 29); the hospital bed of Alba Bewick, who is already, in some sense, both Leda and Jupiter, is surrounded 'by screens – richly patterned with peacocks – the emblem of Juno' (p. 30) and she 'looks like a mature Juno by Titian' (p. 30).

The simile in this last observation begins to tell us that the screenplay is both a script for the film and an interpretation of it; it both precedes the film and somehow comes after it. Were these things which Greenaway put into the film? (He has already mentioned that the Deuce brothers are the Dioscuri, Castor and Pollux, or, in Greek, Castor and Polydeuces, the sons of Zeus [Jupiter] and Leda.) Or did he imagine them out of the film, as he seems to have done the animal measurements of the opening – 'The letters Z, O and O dominate the front entrance gates of a capital zoo. They are made of glass and they tower up 2 giraffes high. They are the width of one elephant and the colour of bottled blue ink' (p. 17) – or the number on Oliver's 'tiger-counter' – 'Already the tiger-counter shows the number of 676, the square of 26' (p. 18)? Do grids, and frames, and cage-bars measure animals, or is it the other way about? Is this film a fable (animals acting like humans) or the opposite? If all these things were made visible in a still photograph, or a time-lapse sequence, how would meaning, or the distribution of meaning, change?

But do these patterns of symmetry and convergence, complementarity and growing together, produce a completion which is completeness? The answer is 'no', for three reasons. First, when the complementary elements in this film are put together, there is still, as with any photograph, either a shortfall or an excess of meaning/knowledge. Put Oliver and Oswald, the two zoologists, together and there is still a lacuna, still some knowledge that slips away:

OLIVER: So you see that between us, we know everything.
BETA: You don't know everything.
OSWALD: Between us we do.
BETA: All right then ... You see that woman over there. What colour knickers is she wearing?
(p. 65)

But even when Beta's knowledge is put together with that of the twins, Catarina Bolnes's knickers still remain elusive. The discovery of her nakedness beneath the dress quite properly costs Oliver a slap in the face. Similarly, although Milo finally gets into print (p. 100), her published story, 'The Obscene Animals Enclosure', is, like Greenaway's story of the same name,[15] something we never manage to see into: in Greenaway's version, we are regaled with circumstantial evidence without managing to penetrate the enclosure itself.

By 'excess of meaning', I mean the pattern on the zebra. David Attenborough's voice-over commentary tells us that 'both the tiger and the zebra carry their own prison bars'; but he also adds: 'Whereas the tiger's stripes undoubtedly serve as camouflage, the stripes of the zebra are now no longer believed to be protective colouring.' The question about the zebra (white horse with black stripes or vice versa?) arises partly because the stripes have passed beyond functionality, beyond the rationalizations of selection and survival. The stripes of the zebra are the enigma of a decorative margin added to the functional. We, of course, meet other forms of these stripes throughout the film: in the traffic barrier at the crash, in the black-and-white photograph of the dead wives, in the dalmatian, in the zebra crossing, in the panda, in Alba and Felipe (white) v. Milo and Van Hoyten (black), in Bolnes's knickers, in the angel fish, in Van Meegeren's slashed Vermeer costume, and in room décors. The zebra is the film, in which we can never tell whether what we see is too much or too little, whether real zoology or art. The zebra is also the crash, either determined by the concerted progress of history through time, or belonging to the accidental fringe of purpose, the zone of the arbitrary and inexplicable:

> ALBA: Look, it was an accident. Five thousand accidents happen every day – bizarre, tragic, farcical … they're Acts of God fit only to amaze the survivors and irritate the Insurance Company. (p. 47)

Is the zebra question a question whose answer would take us beyond the zoology of causality and into its metaphysics? Or is it a question whose answer is as meaningless, as free, as subjective, as the answer to the question 'Why is cut-glass cut?' As with Greenaway's favoured time of day, we are caught 'entre chien et loup' (i.e. in the twilight).

The second reason the answer might be 'no' is this: as Greenaway tells us, 'as single beings, we are incomplete and looking for our "other half."'[16] But this gravitation towards the other half may be a drift towards a central sameness, rather than a fruitful conjunction of complementarities. Oliver and Oswald lose the multiform relatedness of brothers to become twins, and finally indistinguishable Siamese twins. We have cited other examples of convergence. Does the fact that, from the time of her arrival in the zoo hotel, Alba Bewick frequently wears red, express a complicity between her and Catarina Bolnes which nullifies their differences? And what are we to make of the expertise in stitching shared by Milo and Van Meegeren? Van Meegeren amputates in order to sew,[17] while Milo sews to conceal amputation. Van Meegeren sews up the twins and Milo sews the suit to put them in. Does the film find a solution to its own problematic, not in a marriage of alternatives, but in an increasing erasure of difference, which disempowers interrogation and encourages connivence in a cover-up?

But complementarity can also end in stand-off and stalemate. This is the third reason an answer might be 'no'. Rather than achieving fusion, complementarity generates an unresolvable dialectic, which leads to a kind of Manicheism, which in turn adds up to reversibility. It may be that 'Nature [...] has a predilection for symmetry and things in pairs,'[18] but symmetry is a spatial rather than a temporal notion, non-dynamic and unresolved. It is another point at which the functional tips over into the aesthetic, as interrogation is replaced by another kind of satisfaction. The play between colour and black-and-white might also seem to promise a Manichean lack of resolution.

The dialectical conflict between colour and black-and-white is acted out in many ways in *A Zed & Two Noughts*, as already indicated. But the two principal protagonists, given that the medium is film, are the black-and-white newspaper photograph of the dead wives and the colour photo of L'Escargot. The former photograph, taken through the windscreen of a Ford Mercury with the letters B/W on its number-plate, is both a summation and a prefiguration of destiny: 'twins' joined in death. It is a photograph which symbolizes the photograph: a field of visibility which we scan for evidence, the evidential which we do not know how to interpret, the framed space which is incoherent with information. And the frame itself is the instrument of enigma, an obstacle to the unfolding of a 'blind

field', to context and explanatory circumstance. The picture of Alba's birthplace, L'Escargot, on the other hand, a picture of a gate/fence and lush vegetation, is an invitation into the 'blind field', is all 'blind field', the expanding landscape and riverside scenery which the twins will come to know. The evidence that might allow a reading of the crash photograph is all in fragments – the pieces of cheap Delftware, the fragments of shattered windscreen, the newspaper cuttings – and, while this photograph cannot be entered but only, frustratingly, duplicated, the photo of L'Escargot is a real threshold, and Alba has all the necessary keys. It is a photograph that is hardly a photograph at all.

The juxtaposition of colour and black-and-white also encourages a conflictual reading of their expressive values and associations. Anne Hollander, for example, describes the difference as follows:

> The black-and-white mode remains the vehicle of a truthfulness that is temporally conceived and notated, and that deals with the drama of subjectivity. Color, working directly on the senses, affects independent responses of mood much more than it urges sympathy or promotes thought. However important its sensory impact is, color is unnecessary to significant narrative, as comic strips show. In colored popular art, the color serves the interests of pleasure, not meaning.[19]

Colour in photography is associated, through adverts, fashion photos and family snaps, with enjoyment, illusion. Black-and-white is serious, dissociated, controlled and unnatural, that is to say coded, conventional, a message to the mind as well as the eye.

It might be argued, however, that the film does indeed have a direction, a plot, which can be summarized as: 'Black-and-white gives way to, is superseded by, colour.' From the newspaper photo of death and enigma we move to an image of life-affirmative invitation and fertility; from the prison-house of the zoo we move to open landscape and freedom; from the place of isolation and mutilation we move to the mixing and multiplying of unconstrained nature; from the scientific taxonomy of the official zoo we move to Beta's capricious colour zoo, in which the laws of survival are acted out at first hand rather than through the mediation of film:

OLIVER: Only an innocent would put a spider and a fly in the same cage because they were both brown.

OSWALD: Putting them together will probably tell an innocent more about spiders and flies than keeping them apart.

(p. 103)

From a pantheon of fallen pagan gods and sexual promiscuity emerges the family restored and the biblical post-diluvial promise: Felipe Arc-en-Ciel, the multi-coloured Father. From the world of the zebra, and the metaphysical uncertainties of its hide, we move to the comfortable world of the snail, the mollusc that embodies unthinking natural process. In short-circuiting the twins' final experiment, the snails replace the artifice of studio lighting with the natural light of dawn.

But this narrative progression is only seeming, and far from an unmixed blessing. Felipe Arc-en-Ciel is not the natural father of the new twins, who have usurped the place of Oliver and Oswald – for, as we have already intimated, Oliver and Oswald *are* marginalized, ousted. The plot begins to look like a conspiracy to suppress the questions. Oswald and Oliver are pushed aside by the young pretenders, their experiment is smothered by snails, they are isolated by the increasing solidarity of the others. And the others are happy enough to accept that the crash was an Act of God, whose solicitude is now guaranteed by Felipe Arc-en-Ciel. For their part, the Deuces have been made unreliable by grief (p. 104). But just as time-lapse photography interrogates, quizzes, the film, so in the

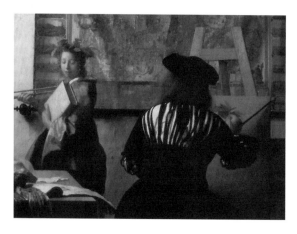

38 Johannes Vermeer, detail from *The Art of Painting*, c. 1666–7, oil on canvas. Kunsthistorisches Museum, Vienna.

world of still photography, black-and-white interrogates colour and destabilizes its easy assumptions and its acceptance of the world as it is. This is nowhere better represented than in the *tableau vivant* of *The Allegory/Art of Painting* (illus. 38), created by Van Meegeren and Catarina Bolnes, where the painter, wearing his zebra-striped slashed doublet, visually interrogates the red-hatted figure of his model. Nor is it at all surprising that Van Meegeren is wielding a camera rather than a paint-brush: 'He takes flash-light pictures reminiscent of Oswald Deuce's time-lapse camera when he films decaying animals' (p. 73).

To understand the further significance of this last observation, we need, finally, to put Vermeer into the picture.[20] Why was Greenaway drawn to Vermeer? Because he was filming in Holland (Rotterdam Zoo). Because Vermeer painted only twenty-six pictures, three of which are of dubious authenticity. Because female legs are peculiarly absent from his canvases. Because Greenaway wants to use Vermeer's characteristic lighting from the left. But most especially because Vermeer is a photographer *avant la lettre*: 'I am convinced that Vermeer used an optical device, rather like the one which appears in *The Draughtsman's Contract*, but in a more perfected form. A sort of primitive "camera"…'[21]

> The overall visual master-of-ceremonies of the film was to be Vermeer – adroit and prophetic manipulator of the essentials of cinema – the split-second of action, and drama revealed by light. It cannot be proved that Vermeer's 'Milkmaid' is a painting representing one twenty-fourth of a second of seventeenth-century time, exposed at f8, but the direction of the light is certain: always from the left of frame, coming from a source four and a half feet off the ground.
> (p. 14)

Greenaway's sense of the cinematic in Vermeer's work is endorsed by Anne Hollander:

> The quality of movement in Vermeer's still kitchen is carried not in the rendering of arrested human action – it is in the surge of feeling that attaches to the perception of light's motion. In a picture, the offer of light's action to the gazing eye is like an offer of enlightenment: the picture is a discovery. But at the same time, the still image is a lesson in contingency. The discovery is

not one instant, but a dip into a flow of light that must keep changing, that shows both what is and what is not a present moment, a moving present that is always full of both hope and loss. And so the Vermeer is like a sequence of movie frames, not like a photograph that tries to freeze the light. The still image is laden with constant shift, like still moments in life itself.[22]

If we consent to these views, then Vermeer uses the frame like a photographer rather than a painter. As we noted in Chapter 1, photography generally distinguishes itself from other visual arts in deriving its *cadrage* from the perceiving mechanism rather than from the image's support. *Cadrage* from the support affirms the autonomy of the picture space in painting; we expect the image to grow into the frame of its support, and this, in itself, is an implicit guarantee of 'composition' and coherence. The imposed *cadrage* of the perceiving mechanism, on the other hand, invites reality to make sense, constantly re-views reality and its varying potential compositions. But most important of all, photographic *cadrage* transfers the image from the support to the viewer, gives back to the motif its sense of the thing surprised in a moment of existence. The image is no longer the ready-made picturesque offered to the viewer, but part of the problematic of the viewer's comprehension of reality, part of the constant urge to look in order to see, to see the pattern and the direction. Concomitantly, therefore, photographic *cadrage* has a natural tendency to imply a 'blind field'.

But Hollander is wrong to suppose that Vermeer's work has more affinity with cinema than with still photography. Vermeer's pictures share, it seems to me, all the ambiguity and paradoxicality of the photograph. While the film continually moves into its 'blind field' and thus creates the illusion of ongoing reality, the photograph both implies a 'blind field' and reveals the illusoriness of its reality. In this sense, photography is the narrative equivalent of indirect speech, while the film is direct speech. The photograph, as Barthes tells us,[23] is the 'that-has-been', the irrecoverable, the unretrievable, whose 'blind field' is promised but no longer available, the possible that cannot be explored. We could only explore its meaning if the single photograph were to become an Impressionist series or a sequence of time-lapse photographs. The pastness of Vermeer brings this home to us; Van Meegeren's attempt to 'fake' Vermeer, to

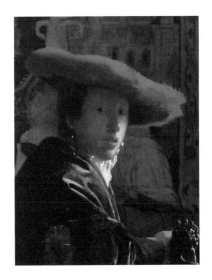

39 Johannes Vermeer, *Girl with a Red Hat*,
c.1665, oil on canvas. National Gallery of Art,
Washington, DC.

re-establish contact with what his images propose, with their 'future',
with their unfolding narrative, is the equivalent of Oswald's
attempt to reconstitute the process of decay through time-lapse
photography, or Oliver's attempt to reconstitute the past through a
careful viewing of 'Life on Earth'. What is it that Vermeer's *Girl
with a Red Hat* (illus. 39) knows and might tell us? What are her
half-opened lips about to offer or utter? What more will the moving
light reveal about her? What drama do the highlights enact or
represent? We can never know. The 'blind field' is withdrawn, the
image retires into its frame. History becomes a litter of fragments,
quotations, glimpses.

This other side of the paradox, the withdrawal of the image
from the viewer into the support, and the corresponding shift of
the *cadrage* from the perceiving mechanism back to the canvas, is
further underlined not only by the frequency of framing devices in
the film – doors, windows, hatches, grids, bars, gates – but also by
the effects of *mise en abyme*, particularly as they relate to Vermeer.
We have already mentioned that the film is about sets of time-lapse
photographs within a sequence of time-lapse shots. One pair of twins
begets, is duplicated in, another. Van Meegeren is not the faker of
Vermeer pictures; he is the cousin, or nephew, of the faker (film and
published script disagree [p. 46]), that is, a fake of the faker, just as
Catarina Bolnes is not a modern-day Catarina Bolnes, but someone

who has changed her name to become one. The truth recedes in this sequence of mirrorings, of dilutions of substance. And yet those very displacements that take the truth away are the processes that create continuities: what makes truth recede is what creates the paths for us to pursue it. This is the paradoxical mechanism of time itself. This is the mechanism of Vermeer's *trompe-l'oeil* painting, so evident in *The Allegory/Art of Painting*, where the curtain drawn back on the left both tells us that the image is theatre, artifice, and establishes a continuity between the viewer's space and the space of the image. Of such paradoxes zebras are made.

The photograph is thus similarly a paradox, able simultaneously to enjoy two forms of *cadrage*, and both to offer and withdraw a 'blind field'. The two elements of this paradox are separated out, as we have seen, in the still photographs of the dead wives and L'Escargot. The photograph of the dead wives belongs to a mute past; the image shrinks, with its meaning, back into the frame, away from us. Its frame is not our frame, but the frame of a picture. The photograph of L'Escargot, on the other hand, opens up a future, an environment, something which can be given meaning; the frame belongs to the viewer looking at a reality which he/she can complete. In Vermeer's painting the two elements of the paradox co-exist, just as they do in time-lapse photography, which can only create a continuity by elision and deletion, can only narrate by destroying the 'blind field'. But we must always suspect that what has been omitted is what was crucial, that the answer is not in the clinical concentration on the subject, but in the wayward circumstantiality of the erased 'blind field'. And the film itself is a twin of time-lapse photography.

As can be gathered from the quotations from the script, the film is not the location where the narrative takes place, but just one of the instruments – along with painting, the photograph, time-lapse photography, the film script[24] – whereby access to narrative is sought. In this sense, the language of both film and script is meta-narrative rather than narrative. Speech does not create or negotiate relationships, make plans, reveal motives. Instead, it interrogates events, envisages the possibility of narration, comments on the narrative potentiality of its images. Language in this film relates to the filmic/photographic narrative in the same way as Oliver's remarks relate to Milo's attempts to tell an obscene animal story: as objection, qualification, question, interruption:

MILO: [...] A circus owner in Anchorage kept a polar bear called Fairbanks to entertain Eskimo wives ...

OLIVER: Unlikely ... and how come you know about Alaska?

MILO: I was attentive in geography ... The bear had a narrow snout, a sweet nature and ... a rough and probing tongue. It also liked honey.

OLIVER: It's beginning to sound like a bedtime story.

MILO: Isn't that just what you wanted?

OLIVER: ... and there are no bees in Alaska.

(p. 36)

Language is a disruptive resource, no more able to string together a dialogue than images can string together a plot, indeed less so. Photographs at least hold out the possibility of constituting new continuities, whole stories (of decomposition; of 'life on earth'). Words, for their part, wander like lost souls in limbo, trying to get their bearings. They often seem to be full of intent, but motives are never yielded up, and so there is nothing to plot with.

Just as Hitchcock's *Rear Window* might be regarded as an allegory of documentary photography, so Greenaway's *A Zed & Two Noughts* provides an allegory of narrative photography, raising and dramatizing issues centrally connected with the relationship between various kinds of photographic image and the formation and perception of sequence, continuity, purposive narrative. It is particular narrative issues raised by the film – circularity and progression in the photo-sequence, the single photograph's narrative potentialities, the proposition that film gets closer to a (post)modern mode of narration than still photography ever can – which I wish to explore in the following chapters. first, I turn to a 'primitive' form of the photo-narrative, the photo-story or *roman-photo*, which, like time-lapse photography (and as itself a form of time-lapse photography), has tried to occupy the ground between the photographic and the cinematographic.

The Magazine Photo-story:
The Rise and Decline of a Genre

The *photo-roman, roman-photo* or *roman-photos*, in Britain called
the 'photo-novel' or 'photo-story', depending on its length ('photo-
story' is the standard term for the magazine format),[1] owes its origins
principally to the cine-novel.[2] The cine-novel first came into exis-
tence as early as 1913, when William Selig used film script and
film stills to create a serial in the *Chicago Tribune*. But it was in
the 1920s, '30s and '40s that it flourished, and best served its social
purpose of bringing the cinema to communities, particularly provin-
cial or rural ones, which did not boast a cinema. After the arrival of
the photo-novel, the cine-novel survived simply as a published
film-script, accompanied by a selection of 'key' shots. Alain Robbe-
Grillet, however, attempted to reconstitute it as an independent
genre, in cine-novel versions of *L'Année dernière à Marienbad* (1961),
L'Immortelle (1963) and *Glissements progressifs du plaisir* (1974).
In his preliminary notes to *L'Immortelle*, Robbe-Grillet summarizes
the nature and function of the cine-novel:

> The book, then, may be regarded as an exact description of the
> film, a detailed analysis of an audio-visual whole that is too
> complex and too rapid to be studied very easily during the actual
> projection. But the cine-novel can also be read, by someone who
> has not seen the film, in the same way as a musical score; what is
> then communicated is a wholly mental experience, whereas the
> work itself is intended to be a primarily sensual experience, and
> this aspect of it can never really be replaced.[3]

A crucial difference between the film and its cine-novel, implied
in Robbe-Grillet's final sentence, is that while film always takes
place in *the* present (tense) (i.e. 'what we see on the screen *is in
the act of happening*)',[4] the still photograph, though it retains the

immediacy of a present, belongs necessarily to the past, that is, it can narrate but it can also be narrated.

One might argue that, like the cine-novel, the photo-novel was born of a privation. In the austere post-war years, people, and women in particular, needed not only to rebuild relationships but to feel that narratives, of a utopian kind, might be put together, which would erase the discontinuities and fragmentations of the war. These consumers of the photo-novel were working women, often of little education, often with little reading time at their disposal, who wanted to be reassured that a traditional moral order had been restored, and that loyalty, honesty, etc. would be rewarded with happiness.

Growing out of graphic novelettes of increasingly realistic style, the first photo-story appeared in Italy in 1947, in the pages of *Il Mio Sogno* ('My Dream'), produced by Stefano Reda and Giampaolo Callegari. One of the principal actors in this first example was Giana Loris (later Gina Lollobrigida). Shortly afterwards, two further photo-stories by Damiano Damiani, the future film-maker, appeared in *Bolero Film*. The most popular of the romantic-story weeklies, *Grand Hotel*, launched in June 1946 by Domenico and Alceo Del Duca, turned to the photographic medium in 1950. And it was their brother Cino Del Duca, exiled in France since 1932, who created Les Editions Mondiales and launched the French equivalent of *Grand Hotel*, namely *Nous Deux* (first appeared 14 May 1947), under its imprint. *Nous Deux* actually introduced photo-stories only in August 1950, about a year after its sister magazine, *Festival*. The graphic story-strip finally disappeared in 1962. When Cino Del Duca died in 1967, his wife Simone took over the publishing enterprise. After Simone's retirement in 1981, Monique Pivot became the editor of the two flagship publications *Nous Deux* and *Intimité*; and in 1986, the year in which *Intimité* became *Le Nouvel Intimité*, colour was introduced. The other principal publisher in the history of the photo-story is Lancio Publications, important because of its wide translation and distribution network. Lancio entered the photo-story market in 1960 with *Letizia*, the first magazine with photo-stories produced in the Lancio Group's own studios. Its subsequent operations have included versions of its magazines translated into French, English, German, Spanish, Portuguese, Norwegian and Dutch; in France, for example, Lancio publishes at least twelve titles (*Lancio Color, Lucky Color, Charme Color, Riviera Color, Monte Carlo Color*, etc.).[5]

It is generally supposed that the photo-story found it difficult to take root in the Anglo-Saxon world because its place was already occupied by a medium that had arrived from another direction, the comic. This undoubtedly has some truth in it, but would not, for example, account for the fact that in France, even given the popularity of the *bande dessinée* over the last three decades, *Nous Deux* and *Intimité* have maintained their market share (670,000 copies for the former, 350,000 copies for the latter). Besides, as we have already pointed out, the photo-story does not occupy a place which has a comic-strip equivalent; it relates to the cine-novel, to the romance and to the graphic novel/story, which always had a high degree of realism in its draughtsmanship. But it has made use of narrative techniques and stylistic devices to be found in the comic strip.

Moving from the Continent to Britain, one finds that the area of operation of the popular photo-story becomes much more limited. Magazines such as *Oh Boy* (*and Photo-love Monthly*) (launched 1976) and *MG* (*My Guy*) (launched 1978, colour 1985, all colour 1988),[6] both originally of IPC Magazines, and *Jackie* and *Blue Jeans*, both of D. C. Thomson, have catered for teenage girls.[7] The actors are all of very much the same age and social group, and the sexual interest does not touch on current issues (homosexuality, AIDS, adultery). However, the British photo-story has had a more educative orientation; it depicts those typical emotional and moral problems which beset the teenager, and often strikes the reader as an agony column or problem page acted out (when it is not already, and explicitly, just that).

This last point touches on one of the underlying objections to the photo-story, that its narrative is too obtrusive and demonstrative. According to John Berger, this nullifies what might be peculiarly photographic about it:

> Supposing one tries to narrate with photography. The technique of the *photo-roman* offers no solution, for there photography is only a means of reproducing a story constructed according to the conventions of the cinema or theatre. The characters are actors, the world is a decor.[8]

There are several strands woven into this argument. The first implication is that there is too much story-line in the photo-story, too much conventional cause-and-effect sequence. Several things

might be meant by this. Possibly the photo-story is simply overdetermined, by pedantic dialogue and by narratorial interventions (the *récitatifs*, to borrow a term from the *bande dessinée*), such as 'And Rod was an expert at getting round people' or 'Their lips met, but it was a kiss full of pity, not passion,' or the simple articulatory moves 'So ...', 'But ...', 'And –', 'Then' It might also mean that there is no background environment, nothing that makes the image expandable in the reader's mind, no strata of 'issue', 'symbolism', 'theme' or 'social reverberation' to create friction for the reading eye as it glides easily over the repetitive imagery; or that, as Berger implies, the photo-story depends too heavily on the cinema, or rather on a view of the cinema which believes that the camera sees continuously and therefore should narrate continuously and sequentially.[9]

But one does not derive a 'story', a 'plot', from indiscriminate narrative. So the art of cinema enters, the art of cutting, jump-cutting, montaging, fades, etc., in which narrative continuity is interrupted, the better to narrate, the better to establish contact with the inner experience of the viewer:

> Everyone knows the linear plots of the old-fashioned cinema which never spare us a link in the chain of all-too-expected events: the telephone rings, a man picks up the receiver, then we see the man who is at the other end of the line, the first man says he's coming, hangs up, walks out of the door, down the stairs, gets into his car, drives through the streets, parks his car in front of a building, goes in, climbs the stairs, rings the bell, someone opens the door, etc. In reality our mind goes faster – or slower on occasion. Its style is more varied, richer and less reassuring: it skips certain passages, it preserves an exact record of certain 'unimportant' details, it repeats and doubles back on itself. And this *mental time*, with its peculiarities, its gaps, its obsessions, its obscure areas, is the one that interests us since it is the tempo of our emotions, of our *life*.[10]

Here, Robbe-Grillet asks for a filmic art which will do justice to every spectator's inner duration, the Bergsonian 'deep self', where the different configurations of individuals' memories and experience mean that each spectator makes different choices, works with different perceptual frames, derives different benefits. It is this same concern that drives Eisenstein's advocacy of montage (different

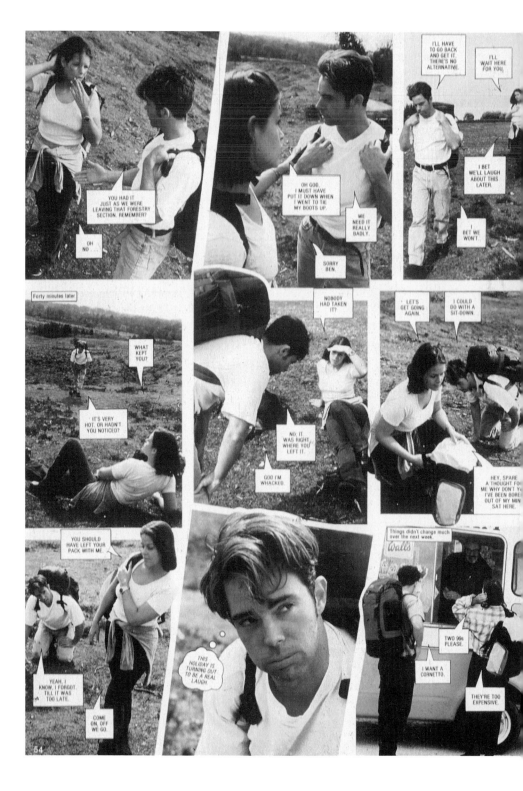

images in juxtaposition produce a higher-level thematic synthesis), quite apart from its political usefulness. Montage obliges the spectators themselves to create, and thus achieves the power of inner creative excitement.[11] In the photo-story, this potential ability to reach into personal experience and inner time can be achieved not only by montage, or cutting techniques, but also by the constructive use of the space between images, the *entr'images*. Indeed, one might argue that the latter is the expressive resource that most clearly marks the photo-story off from cinema and the cine-novel, an expressive resource that the photo-story shares with the comic strip.

If, however, we compare a photo-story page with a comic-strip page, we discover a vast difference in the function of the *entr'images*. When I look at the photo-story page ('My Little Pony', *MG Holiday Special*, 1994, p. 54; illus. 40) merely as a set of images, it seems to depict no more than a couple's walk, across heathland, to an ice-cream van (the ice-cream van, it turns out, belongs to another occasion – note the different clothing and the boy's different back-pack). The communication of this piece of visual information takes a whole page (nine vignettes). The photographs fall victim to the conventionality of their size and shape – even though the edges are tampered with, even though there is some tilting, our over-riding sense is one of homogeneity, of the standard photo; and if the photographs are the same, the spaces between them are too. Indeed, if anything, the photo-story is embarrassed by these spaces, tries to nullify them either by allowing the image to overflow the frame, or by various jigsaw arrangements. The impulse seems to be away from the comic strip (separate images compiled) towards the cinematic (uninterrupted sequence). The narratorial notation in 2.1 (second row down, first image) – 'Forty minutes later' – bears no relation to our visual experience (and what an odd time span to have to imagine!). And the attempt to suggest time shift by shift of camera position (the switching of figures from right to left of the image and back) is undermined by the fact that the angle of vision (downwards from eye-level, on down-sloping terrain) remains the same, while the dialogue itself is strikingly continuous.

In the Tintin example (*The Broken Ear*, 1975, p. 27; illus. 41), on the other hand, although the vignettes are standard in height, they

40 'My Little Pony', from *MG Holiday Special* (1994).

vary in width as time accelerates and decelerates, as the reader's impatience to find out intensifies or rests for a moment. But the *entr'images* is consistently maintained. What functions does it fulfil? Much of the action, for example Tintin throwing rocks, takes place beyond the frames, out of vision (how often does this happen in the popular photo-story?), so that the *entr'images* is a permanently available 'blind field', or invitation to imagine a 'blind field'. Frustration and curiosity are essential ingredients of narrative interest, and this is what the *entr'images* can create.

The *entr'images* also reminds us of the elasticity of time in narrative, in imagined narrative: how much time elapses between 3.1 and 3.2, if 3.3 follows on almost immediately from 3.2? Tintin must have had time to take refuge in the rocks and to have found suitable projectiles. And while 4.1, 4.2 and 4.3 are pretty much consecutive, 4.4 must be at least half-an-hour later, the expansion of time confirmed by the relatively larger size of the final vignette. The *entr'images* is also a space for emotional response; in our example, the build-up of apprehension – thunder, fireball, Tintin's disappearance – is followed by momentary relief (2.1), return of apprehension (pursuit) mingled with levity (we have time to enjoy the incongruity of the man's suit so neatly half-blown-away in the explosion, a fact we might not really have noticed in 1.4, where our attention is on the empty, smoking stool), and positive, relieved pleasure as Tintin ties things up. The invitation to respond emotionally is often in the wordlessness of the image, the fact that we can simply look and do not have to read. Why, in our photo-story, does 3.2 need its speech-bubble ('This holiday is turning out to be a real laugh')? Could not the reader be relied upon to interpret the facial expression?

But we should be careful not to condemn the photo-story's method too quickly. We should remember that it is in the nature of the British photo-story to be exemplary, that is to say, to have a shared validity, so that the heroine's problem can be properly educative. In our particular example, a camping holiday in the New Forest enables Ellie to test her relationship with Ben and reassure herself that his feelings are not simply motivated by sexual opportunism. Unfortunately, it turns out to be 'a test till breaking point'. Another story in the same issue shows how appearances can deceive and pride

41 Hergé, *The Broken Ear* (1975), p. 27.

can lead to missed opportunities. In the *MG* of 18 June 1994, 'Staying Mum' explores the viability of a relationship when the girl has the responsibility of looking after younger sisters, while 'On the Rebound', not surprisingly, considers the emotional vulnerabilities of a couple who have just split up. Narratives like these must have a strong 'third-personness' about them if they are to function effectively as case histories, test cases or demonstrations. And the standardization of the size of photograph and page layout have the effect of reassuring the reader that no liberties are being taken, that the presentation of the evidence is straight. In fact we might suggest that standardization of layout has three consequences or implications:

(i) the narrative is traditional, straightforward, has a consistent story-line;

(ii) the 'narrator' or the narrative is morally 'straight', serious, purposive and not showy or meretricious. Photo-stories and comic strips which experiment tirelessly with layout (*Captain America*, the work of Philippe Druillet) create narratives which are difficult to 'read' and seem to activate deviant behaviour and moral ambiguity;

(iii) the temporality of the narrative is external or chronometric (i.e. made up of homogeneous moments which can be separated from each other like seconds and minutes on a clockface), a conventional time (clocks, diaries, calendars) shared by us all, rather than internal and experiential time (i.e. elastic, continuous, qualitative, heterogeneous), varying from individual to individual.

This last consequence may, of course, also be imputed to the magazine's policy as a response to its readers' age. The magazine must operate with social conventions, must suggest that authority is external to the reader and that moral truths are quantifiable and universal. This is a very different aim from that of the high-culture photo-novel and presupposes, among other things, that the teenager's reading does not engage memory, and involves concerns about personal destiny rather than experience. The characteristic question that the heroine of a romance asks herself is 'Does he (really) love me?' ('Do I love him?') and not 'What is love?' The strategy of using relatively standardized layout to insinuate narrative honesty and straight progressivity (one thing *does* lead, logically, to another) relies, therefore, upon the conventional 'realism' of the photograph to endorse its impartiality and authenticity. The emphasis falls

squarely on action and its inevitable consequences, not on the quality of lived experience, or the problematics of a relativized perception of the world. As one moves up the age scale, to the Continental photo-novel which is a small part of the *presse du coeur* (romantic magazine industry), one discovers a slowing of pace. Lancio Edition publications, for example, tend to have five or six vignettes to the page as opposed to the eight or nine of British magazines – a more insistent invitation to inhabit the narrative (greater use of large-format photos) and a greater willingness to break the horizontality of page/narrative (the consistency of the height of the images), so that the reading eye circulates on the page, rather than reading through it, constantly modifying its perceptual speed, perspective, point of focus. In short, the narrative mode is altogether more 'engaging' (illus. 42).

A further issue raised by Berger has to do with the artificiality of the genre: the characters are actors and the background is a décor. Lancio publications continue the Italian tradition, the cine-novel habit, of prefacing their stories with credits, and the principal actors are also announced on the cover. In the British photo-story, every effort is made to 'naturalize' the narrative: there are no details of participants, the story is unauthored, and it frequently assimilates itself, either implictly or explicitly, to the true-life mode. However, as we have already pointed out, it is possible to argue that photography naturally gravitates towards montaged effects,[12] by its polarization of far and near, by its differential focusing, by its two-dimensionality, and by its bleeding out of foreground atmosphere (grainier printing papers, faster film, might help to restore this). Photo-stories concentrate unremittingly on a foreground occupied by the principal characters, and this natural 'lifting out' of the figures is only emphasized further by pose (i.e. by stances, postures, gestures which are not integrated into, or necessitated by, the environment). Indeed, those natural elements which disregard pose and should help the process of integration – wind and light – have a contrary effect: the natural on the unnatural becomes doubly unnatural. The device of allowing figures to break the frame increases the montaged effect, and the superimposition of the speech bubbles implies that the whole image is a set of superimpositions, figures superimposed on backgrounds, speech superimposed on figures.

It is easy to tax the photo-story with being technically primitive,

with being a medium that apparently denies 160 years of photographic history, and particularly and perversely disregards all those devices which might allow it to create and support narrative dynamisms, by a cultivation of visual dynamics. But we could also suggest reasons for this peculiar resistance. It is important that the photo-story maintains its connections with the family snap, because, for the teenager, the situations depicted are domestic, because the family snap *is* the reader's mode of photo-graphy, and because the family snap fits in with the class identity of the readership. And the montaged effect of figures against a décor visually dramatizes the whole problem of social assimilation both for teenagers and lovers. Indeed, one might go as far as claiming that the photographic awkwardness of the photo-story has an existential value: social awkwardness is the cross to be borne by all those passing into adulthood, and awkwardness is the principal risk to burgeoning relationships with the opposite sex (this again coincides with the embarrassments so frequently evident in family snaps).

But looked at from the other side, the lifting out of the figures may be a way of implying that backgrounds need not be constrictive, that autonomy is available, that personal relationships are a key to that autonomy, and that they have more potential significance, greater value, than backgrounds. Backgrounds, then, become no more than vague topographical reference points. We identify the context of dialogue as indoors or outdoors, house or hospital, street or beach. But beyond this, backgrounds are inert, utterly banal and non-distractive, arousing no curiosity and thus refusing, as we have said, to supply the story with any thematic or symbolic subtext or co-text.[13] The very characterlessness of the background, made more so by any loss of focus, may, however, like montaging, have a positive function: it privileges the act of recognition over the act of interpretation as a reading mode. This may be psychologically reassuring in that it presupposes that the reader is already in possession of a body of knowledge; it also implicitly reminds the reader that she is indeed the targeted reader, that it is highly appropriate for her to read the photo-story, that she is the one who can peculiarly make sense of it.

But if Berger's remark challenges us to decide how true or untrue

42 From *Charme* (1991).

to photography the photo-story really is, we may, in reading Barthes, begin to feel that we are asking the wrong question:

> There are other 'arts' which combine still (or at least drawing) and story, diegesis – namely the photo-novel and the comic strip. I am convinced that these 'arts', born in the lower depths of high culture possess theoretical qualifications and present a new signifier (related to the obtuse meaning). This is acknowledged as regards the comic-strip but I myself experience this slight trauma of *significance* faced with certain photo-novels: '*their stupidity touches me*' (which could be a certain definition of obtuse meaning). There may thus be a future – or a very ancient past – truth in these derisory, vulgar, foolish, dialogical forms of consumer subculture.[14]

What Barthes proposes is that the 'obtuse meaning' (see the discussion of this notion in Chapter 1), that which escapes the process of signification, resists interpretation, resists translation into another medium (here language), is the element which epitomizes generical specificity. The obtuse meanings recuperable from a film, for example, are what peculiarly constitutes the 'filmic'. Translated into other terms, experiences of *punctum* in a particular genre, or medium, double as the *punctums* of generical or medial specificity. To experience *punctum* in reading prose is to experience what is peculiarly 'prosaic' about prose. Similarly, *punctum*/obtuse meaning in a photograph attaches itself to a detail that expresses photography's inability to leave things out, what the photograph offers in excess of its meaning. So the real question to ask about the photo-novel (or photo-story) is: How photo-novelistic is it? For Barthes, the obtuse meaning that represents the 'photonovelistic' is the very stupidity of the genre. How seriously should we take this, given that Barthes's contempt for the genre is so patent? What might he mean by 'stupidity'?

We have already mentioned some of the ways in which the photo-novel seems to deny itself the expressivity of the comic-strip (size of image or vignette, [non]use of the *entr'images*, montaging of the figure). I would like to mention some other instances of this perverse refusal to learn lessons from the graphic counterpart, other instances of the self-defeating, and ostensibly crass.

1 *Naturalness*. We have already dealt with this topic in relation to pose and atmosphere. In the presentation of speech, things are no better.

(a) Shape of speech-balloon. The rectangularity (geometricity) of the speech-balloon (thought-balloons are generally cloud-shaped) relates more to the shape of the page and vignette (i.e. to the printed, written, mechanical) than to the notion of utterance (i.e. inflation, the balloon filled by the air of the speaking voice). This sense of the speech-balloon as something inflated by air is borne out, in comic strips, by the way the speech-balloons tend to drift to the top of the page. In the photo-story they as frequently appear below the mouth of the speaker, at the bottom of the page.

(b) The *appendice* or speech-balloon attachment. In comic strips the *appendice* is frequently used to express speech-impulse, and the variety of *appendices* used conveys something of the variety of the speech tones (urgent, languid, fearful, etc.). Neither the shape of the speech-balloon nor that of the *appendice* convey, in the photo-story, any paralinguistic information (tone, loudness, tempo, intonation, etc.). Instead, the *appendice* merely attributes speech to the speaker, indicates *who* speaks the words (and not how they are spoken).

(c) The typography. In the comic strip, there is a natural continuity between image and speech, plot and dialogue, because they are both products of graphism. One might argue that image and speech enjoy the same 'logical' link in the photo-story: both derive from mechanical modes of production. But while the handwritten text – unless it has the copperplate regularity of Hergé's work – preserves something of the unevenness of speech in its own unevenness, is characterful, is humanly motivated, the printed text is without human agency, more obviously written than spoken.

2 *Narrative energy*

(a) Atmosphere. About this feature we have already had something to say. But there are two further observations to be made. First, the comic strip has very specific languages of predicament and reaction at its disposal. At one extreme, there is a non-realistic, symbolic set of graphic signs (stars = consternation, concussion, etc.; sweat-drops = panic, anger, surprise; spirals = emptyheadedness, intoxication; signs of resonance, atmospheric turbulence, speed, etc.). At the other extreme, in more realistic narratives, there is the

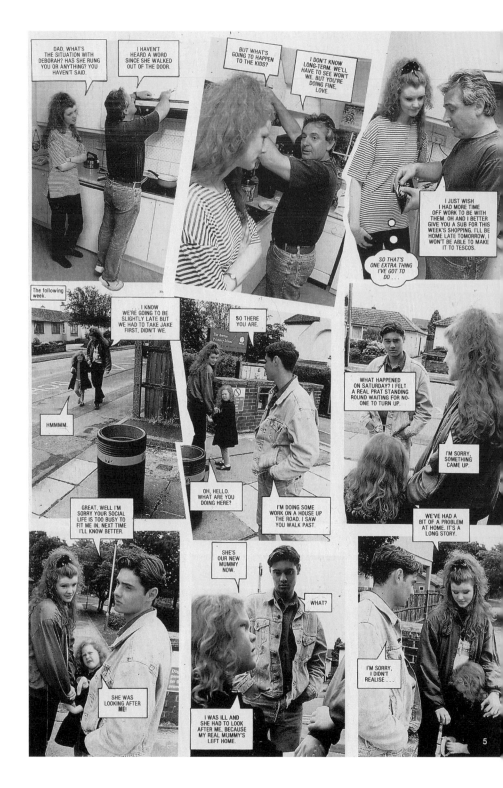

exaggeration of gesture and facial expression (furrowed brow, staring eyes, the hollowing of cheeks, etc.). Between these two, a whole array of onomatopoeic terms is available. Comic strip is, by nature, caricatural. The photo-story, for its part, is aimed at a realism it cannot sustain. It does not justify its artifices by appealing to a willing suspension of disbelief, and the slow-movingness of its plots produces only minimal variations in posture and expression: in 'Staying Mum', for example (*My Guy Magazine*, 18 June 1994; illus. 43), Mark, the boyfriend, stands with his hands in his pockets for a sequence of five vignettes. No attempt is made to lift internal feelings out of the figure represented into the mode of representation (under- and over-exposure, double exposure, sandwich printing, filters, etc.).

(b) Narratorial dynamism. In cinema, the camera becomes the 'narrator', by panning, zooming, intercutting close-up with long shot, exploring the field of vision, and so on. Similar effects are achieved in the comic strip, and indeed in the televised photo-novel. But what is remarkable about the magazine photo-story is its habit of cutting only when a new episode begins, and of maintaining the same, or relatively the same, position of shot (distance from the protagonists). It favours the so-called *plan américain*, the knee-length or thigh-length shot, or head and torso (*plan rapproché*). This habit of sustained equidistance over shot-sequences might seem to promote neutrality, that narratorial 'third-personness' to which we have already referred. But unfortunately it is not long before one begins to associate it with the camera's lack of interest in the scene depicted.

(c) Narrative dynamism. This aspect is closely connected with (b). For example, the cropping of the actors' legs and the habitual immobilization of the arms by the sheer constrictedness of the photographic space both minimize the figure's gestural opportunities. As a result, the face is required to bear too much of the expressive load; and a striking feature of the popular photo-story is the ill-adaptedness of the face to the words spoken. This may, of course, be attributed to the inexperience of the actors, or the crude editing made possible by an uncritical audience. But it can also frequently be ascribed either to overlengthy utterances for which an unchanging facial expression is inappropriate – 'Of course, Becky! To tell the truth, I

43 'Staying Mum', from *My Guy Magazine* (1994).

know you've been feeling low since Dave left the shop. D'you want me to talk to Dad? I might be able to make him change his mind about Dave' (*Oh Boy*, February 1992, p. 44) – or, similarly, to the fact that the same face makes two speeches in a single vignette: Mark: 'So there you are'; Carly: 'Oh, hello. What are you doing here?'; Mark: 'I'm doing some work on a house up the road. I saw you walk past' (*MG*, 18 June 1994, p. 5).

We have already spoken both of the inertia within the vignette and of the lack of readerly stimulation between vignettes (the *entr'images*), suggesting that the photo-story wishes to maximize continuity between vignettes, by minimizing spectatorial 'input' at the transitions. Perversely, the photo-story seems then to jeopardize this wished-for continuity by its arrangement of figures within the vignette. While the comic strip habitually increases its propulsive power by ensuring that its figures are either facing, or moving, in the direction of the oncoming vignette, the photo-story yields to the intimate, dialogic nature of its encounters, and frequently has its figures on either side of the vignette both facing inwards (e.g. *Oh Boy*, February 1992, p. 36; illus. 44). What then facilitates the movement of the eye from vignette to vignette in the photo-story is the consistency of the camera's distance from the figures. The reader is not propelled from vignette to vignette by the impatience of the characters themselves to move, or look, out of the vignette.

The drive from vignette to vignette is also activated in the comic strip by the frequent use of suspension points at the end of the final (or only) speaker's utterance; everything is maintained in an unresolved state. The photo-story does have recourse to this device, but only intermittently. The comic strip also standardizes the use of the exclamation mark as a generalized indicator of excitement, tension, drama, etc., relating either to the loudness of the voice or to an exclamatory syntax. Often in the comic strip, exclamation mark and suspension points are combined: '!...' The question mark, too, has an obvious narrative value, expressing indecision, uncertainty, dangerous ignorance, curiosity: it can be combined both with exclamation marks, '!?!', and with suspension points, '?...' In short, the punctuation of the comic strip is to do with narrative dynamics (suspense, curiosity, surprise, decision) and expressivity (i.e. features of voice such as

44 'Here is my Heart', from *Oh Boy and Photo-love Monthly* (1992).

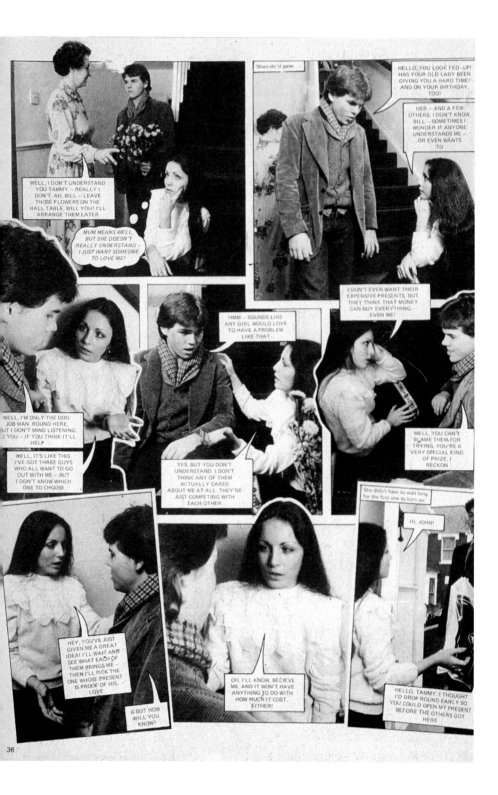

WELL, I DON'T UNDERSTAND YOU TAMMY – REALLY I DON'T. AH, BILL – LEAVE THOSE FLOWERS ON THE HALL TABLE, WILL YOU? I'LL ARRANGE THEM LATER

MUM MEANS WELL, BUT SHE DOESN'T REALLY UNDERSTAND – I JUST WANT SOMEONE TO LOVE ME!

'When she'd gone...'

HELLO, YOU LOOK FED-UP! HAS YOUR OLD LADY BEEN GIVING YOU A HARD TIME? AND ON YOUR BIRTHDAY, TOO!

HER – AND A FEW OTHERS. I DON'T KNOW, BILL – SOMETIMES I WONDER IF ANYONE UNDERSTANDS ME – OR EVEN WANTS TO

I DON'T EVEN WANT THEIR EXPENSIVE PRESENTS, BUT THEY THINK THAT MONEY CAN BUY EVERYTHING – EVEN ME!

HMM – SOUNDS LIKE ANY GIRL WOULD LOVE TO HAVE A PROBLEM LIKE THAT –

WELL, YOU CAN'T BLAME THEM FOR TRYING. YOU'RE A VERY SPECIAL KIND OF PRIZE, I RECKON

WELL, I'M ONLY THE ODD-JOB MAN ROUND HERE, BUT I DON'T MIND LISTENING TO YOU – IF YOU THINK IT'LL HELP

WELL, IT'S LIKE THIS. I'VE GOT THREE GUYS WHO ALL WANT TO GO OUT WITH ME – BUT I DON'T KNOW WHICH ONE TO CHOOSE –

YES, BUT YOU DON'T UNDERSTAND. I DON'T THINK ANY OF THEM ACTUALLY CARES ABOUT ME AT ALL. THEY'RE JUST COMPETING WITH EACH OTHER –

She didn't have to wait long for the first one to turn up.

HI, JOHN!

HEY, YOU'VE JUST GIVEN ME A GREAT IDEA! I'LL WAIT AND SEE WHAT EACH OF THEM BRINGS ME – THEN I'LL PICK THE ONE WHOSE PRESENT IS PROOF OF HIS LOVE

B-BUT HOW WILL YOU KNOW?

OH, I'LL KNOW, BELIEVE ME. AND IT WON'T HAVE ANYTHING TO DO WITH HOW MUCH IT COST, EITHER!

HELLO, TAMMY. I THOUGHT I'D DROP ROUND EARLY SO YOU COULD OPEN MY PRESENT BEFORE THE OTHERS GOT HERE

intonation, urgency, hesitation, faltering fearfulness, etc.). On the whole, the photo-story does not avail itself of these resources to nearly the same degree: instead of emphasizing the spokenness of the dialogue, its punctuation pays just as much attention to the writtenness of the communication, that is to say, to its syntactical structure and correctness: 'Let's face it, if I can't convince her in ten minutes, I never will!' (*Oh Boy*, January 1992, p. 51). The characters apparently produce language without hesitations, interruptions, changes of mind, pauses, discourse particles. They are, to all intents and purposes, correctly speaking a written script; their speech is learned. As a result it has no dynamic, no movement, but emerges as a set of staccato sentences, useful phrases for describing your former boyfriend (make your own combinations): 'I wouldn't go back out with him if you paid me. I'm glad he's gone. He was getting to be a real pain. He is so conceited. He thinks the world of himself' (*Oh Boy*, January 1992, p. 51).

Finally in this connection, we might mention something already alluded to: the positioning of the speech-balloons. In the comic strip, inflated speech-balloons rise to the top of the vignette, allowing an adequate proporton of unoccupied graphic space. In the photo-story on the other hand, speech-balloons are given free range, the only out-of-bounds area being the faces of the characters. Quite apart from the implication that speech has all but absolute priority, this can lead to the virtual masking of the whole of the shot. The cluttered image is thus, in one sense, full of information, but the kind of information designed to produce an unproblematic, 'univocal' reading, and the kind of speed that results not from visual dynamism but from a story which is exceedingly easy to read. These are stories whose very layout tells us that we are not meant to 'get into' them, stories that belong to someone else and affect us only in their exemplarity.

If, then, we had to offer a definition of the photo-story's 'stupidity', it would relate to those contradictions almost inherent in the medium. For example, because the visual is mechanically produced, so, too, must the speech be; speech, which lasts in time, is attached to instantaneous snapshots (which means that the mouths of all the speaking characters have the same indeterminately half-open look); so-called photographic realism is used to endorse palpable artifice; photo-stories about modern youth use a photography remarkable

for its primitivism; efforts towards continuity are undermined by equal and opposite devices apparently designed to emphasize the static and inert; and so on. And yet this simple self-contradictoriness has a certain power ('touches me'). Why?

We have suggested that the 'awkwardness' of the teenage photo-story may serve the existential and sociological contradictions of its readers. But the source of this awkwardness is to be found in the semiological discrepancy which exists between the photograph (index/icon) and language (symbol). While a photograph may at least seem to provide the evidential, to supply the matter of fact, language is the medium of concealment, half-truth, decorative embroidery, etc. While 'if their "truth" quotient weren't so high, [photographs] could not deceive as indiscriminantly as they often do',[15] we are used to treating language with more circumspection, and more adept at understanding its pragmatics. In the teenager's world, in the world of lovers, the photograph (the look, the moment of privacy, the moment of togetherness) often reveals a 'reality' that the lovers are struggling towards, but for which they cannot find the adequate language. Equally often, however, a situation seen, without the benefit of explanations or reassurance, is misinterpreted and itself becomes an obstacle to the kind of verbal exchange that might put everything right. The trajectory of the two lovers, then, is towards that situation in which the visual and verbal are in unison, that is to say, in which the lovers feel that they at last possess the visual, that it is their servant and not someone else's, and that the verbal is purely confessional, not self-protective or self-projective. The huge relief of a reciprocated love (as perhaps its subsequent danger) is that you do not have to try any more, to put on airs, to make the effort to impress.

I would not want to suggest that the photo-story as a medium/genre is an allegory of love, or that the lovers allegorize a 'love affair' between the visual and verbal, which after the usual obstacles and misunderstandings, achieves its consummation. But I do think that this is what makes the medium's stupidity 'touching'; the photo-story is already, as it were, a dramatized relationship. And, equally, this is what makes the photo-story instructive, although once again I would not want to claim that the educational usefulness of the photo-story lies in its showing its readers how to negotiate between two very different sources of knowledge, the visual and the verbal, or

how to orientate themselves on the different points of the semio-logical progression we outlined in Chapter 1. But undoubtedly it does provide a glimpse of the problematics of the differential relationship with truth enjoyed by the visual image on the one hand, and by the verbal account on the other. But if this is how photo-stories end, in convergences of various kinds, how do they begin?

It is habitual for comic-strip narratives to begin with a large panoramic drawing, which has several functions. It has a phatic function, establishing the narrative communication, settling the reader; it may sketch in an environment, suggest a background; it may prolong the process of looking while the narrator (*récitatif*) provides some exposition, or link-up with previous episodes; it usually depicts a scene of narrative quietness, ordinariness, a normality which can be broken dramatically and almost immediately as we move, without further ado, into the action. Customarily, the char-acters remain silent while the narrator speaks. In the popular photo-story, the initial, large (half-page, full-page) photograph may be an out-take from the crucial episode of the story, a kind of trailer or guarantee of drama; or it is a lead-in shot.[16] The *récitatif* is not narrative in nature, so much as a tantalizing glimpse of the crux of the story, usually accompanied by suspension points – 'Late at night the agony in Peter's heart echoed through the cold, lonely house – and Lynn could do nothing to ease the pain that tormented him …' (*Oh Boy*, January 1993, p. 36); 'All Ellie wanted to do was see the New Forest ponies. All Ben wanted to do was visit Ellie's tent …' (*MG Holiday Special*, 1994, p. 50) – or the posing of the central problem, usually interrogatively – 'How could Carly have a boyfriend when she had two kids to look after?' (*MG*, 18 June 1994, p. 4) – or a statement about a narrative situation, often involving an antithetical structure and an exclamation mark – 'Her smile was a dentist's dream … that was fast turning into a nightmare!' (*My Guy Monthly*, February 1992, p. 8); 'Love brought them together – but the world tore them apart!' (*Oh Boy*, January 1993, p. 16). Sometimes the title of the story itself is one of these options: 'In for a penny…' (*Jackie*, 30 April 1988, p. 8).

What is common to these options is that they relate directly to that kind of title explored in Chapter 2, which we identified as a rebus, a puzzle looking for a solution. In other words, we know from the outset that these are not 'free' narratives, which give the

impression that they are creating themselves as they go along, which might convince the reader that she had a constructive part to play in them. From the outset, we are assured of firm narratorial control, of an outcome which at once justifies the rebus and provides an answer. It is no accident that many photo-stories are, quite explicitly, the acting out of a problem-page scenario, eg. *My Guy's* 'One from the Heart' series ('He's trying to change me!'; 'I can't face dates alone') or 'Problem Story' series:

Name: Pat Simpson

Problem: Simon's the nicest guy Pat's ever met — but is he too nice for her?

The emphasis on solution, the sense of there being a way out, may, contrary to the general drift of the arguments that tax the photo-story with its banality, its redundancy, its peculiar narrative poverty, dramatize, and give a symbolic role to, those very 'shortcomings': 'While in the comic-strip each utterance is operational, that is to say informed by a narrative or humouristic function, the photo-novel is prodigal with the trivialities and prattle which pervade daily encounters.'[17] Looked at existentially, the prattle and triviality of the photo-story, the endless verbal transactions, the gossip, are a Gordian knot waiting to be cut. Just as the agony aunt is able to lead the correspondent out of the dilemmas of contradictory advice and divided loyalty, so the story promises a similar release from the social and psychological labyrinth of uncertainty, conflicts of evidence and impulse, dramatized by a plot which is suffocating in its redundancy and slow-movingness.

What might lend credence to an interpretation of this kind is the very nature of the photographic sequence. Monique Pivot is, I think, wrong to propose for the photo-novel the kind of explanation we have already met in Robbe-Grillet's justification of the cine-novel, namely: 'Where the cinema image is transient, indeed fleeting, that of the photo-novel persists and constitutes a point of reference. It is irrefutable.'[18] This may have some truth for the Continental photo-romance, but the photo-novel in general, and the British teenage photo-story in particular, tend, by their consistency of viewpoint and the redundant nature of their language and of the physical presence of their protagonists, to make the sequence of

photographs constantly self-superseding. In other words, each photo-graph positively takes the place of, replaces, the one before it (which does not survive).

This has two very different consequences. The first is that the narrative is constantly being assigned to the past, even though at a slow rate. If we take seriously the suggestion that redundancy (repetition, overlap) and triviality are the ways in which the life of the teenager manifests itself, if redundancy and triviality are experienced as suffocating, as a kind of viscous, enveloping fluid, then getting out, putting all this behind one, if only step by step, is a significant achievement. The teenage photo-story would in this sense enact the process whereby a self, in creating a viable couple, disen-gages itself from the 'normality', from the web of obligations (about attitude, behaviour), of the parental home. Geeta, in the penultimate photograph of 'If I can't have you' (*Oh Boy*, January 1993, pp. 16–24), tells her father: 'Oh father, thank you! You've made me so happy'; but in the final photograph, she tells Trevor, her new boyfriend: 'But I have the feeling Trevor is going to make me happier still.' In these two short speeches, we find that pattern of generational overlap and supercession which is the very principle of the photo-sequence.

The second consequence concerns visual aesthetics and informa-tion. The habits of cutting and montaging (between vignettes), to be found in the comic strip, ensure that the individual page (*planche*) builds up into a total narrative design, in which no single element is supplanted by, or interchangeable with, another. As one looks at the page as a whole, it creates a certain design from which one can deduce narrative patterns – new episodes, changes of fortune, the diversity of elements involved in a particular stretch of narrative. Colour makes its own contribution and allows the reader to pick out immediately changes of clothing and location, time of day, and so on. If, on the other hand, one is reading through sequences of images which merely confirm one another, and can therefore be serially discarded as the written narrative proceeds, then the page as a whole will have little significance; it will, in fact, be something which progressively disappears. Our earlier example, the page from 'My Little Pony' (illus. 40) in which Ellie and Ben *seem* to walk across a heath to an ice-cream van is a case in point.

45 'My Little Pony', from *MG Holiday Special* (1994).

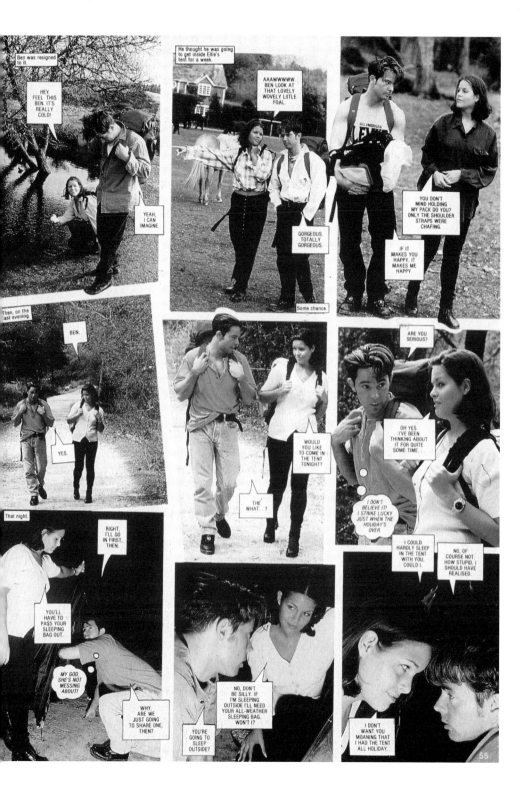

55

This seeming destination of the page is a consequence of reading the page as a narrative totality. It clearly is not a narrative totality, however, since one has to negotiate the narrative vignette by vignette, forget about what one has seen, and build up no expectations about the narrative progression, apart from that of an instructive, and usually happy, outcome. But the potential advantages of this kind of narrative short-termism, namely the delivery of surprise, shock, and the inculcation of an enquiring, alert mentality in the reader, who can take nothing for granted, are nullified by the visual overlaps, repetitions and redundancies, and by the consequent univocality of the narrative's meaning. And because the photo-story is not rich in codes or code-variables – the protagonists, for example, are always in the foreground, which creates the montaged effect of the individual photograph – we hardly notice changes when they do occur.

In the page following the one just referred to, three changes of clothing occur in the first three vignettes (illus. 45), but it is unlikely that the readers will experience any shift in the narrative, will not read these vignettes as temporally consecutive, because the *récitatif* make no reference to temporal change, because the photo-story does not alert us to slight changes of background; because the modes of presentation are so consistent with each other, and because the vestimentary has so little significance:

> Accessories and clothing, although indispensable to the representa-tion of the characters, never stand out on the surface of the image, since any symbolic or expressive value they might have is sacrificed to the strict normativity imposed by their naturalist aesthetic.[19]

From the last point one might conclude that the teenage photo-story precedes any developed fashion consciousness, and that clothing, therefore, provides no access to autonomy and identity, no language of mood and temperament, to which the boyfriend, and the world at large, might be expected to be sensitive. On the contrary, clothing comes to represent that depressingly undifferentiated milieu from which the characters find it so difficult to disengage themselves. And the readers' own generalizing vision of dress both confirms assent to the prevailing situation and, ironically, makes dress-change equally ineffective on a narrative level.

The sense of a narrative continually being thrust into the past is heightened by the feeling that we are confronted by text and images

which have emerged not only from the past, but from a past which is, in fact, doubly past. The presence of a narrator in the *récitatif* reminds us that the direct speech that takes place between the characters is in fact reported direct speech. The photographs give us the illusion of the 'thereness' of the characters, but we are immediately conscious that these are photographs that have been taken. In these respects, the vignettes of a photo-story, like the stills of a cine-novel, narrate and are narrated. The relative unobtrusiveness of the *récitatif* in the photo-story helps to keep the 'being-narrated' slightly further forward in our perceptual awareness than the 'having-been-narrated'.

However, the past of the 'having-been-narrated' is doubly so; the Lancio Edition photo-stories make quite clear that the characters are actors playing out a scenario. And the British photo-story cannot hide this origin: the writtenness, the printedness of the dialogue, the posedness of the shots, the lack of co-ordination between facial features and dialogue, constantly remind us that a script is being acted out, in other words, that the photographs are enactments of actions which have already, textually, in the shooting script, taken place. Similarly, the actors are speaking words which already exist, have been uttered. The photo-story already has built into it that mechanism which allows it to be consigned to the past; it easily constitutes itself in the minds of both protagonist and reader as the bad dream, the potential scenario in whose playing out they have been either the willing or unwilling participants. The very artificiality and awkwardness of the photo-story tells us that this is action of an action, a realization of a fiction, a narrative as much experimented with as actually undergone. The photo-story intends itself as a fantasy (the dream come true) and as a dry-run or rehearsal (the dream is not true, *this time*), each one being a potential opt-out from the other, or each being intricately woven into the other. And the principle that must be grasped here — namely that a comic-strip's inbuilt fictionality (iconicity) means that it cannot be artificial (i.e. unnatural rather than non-natural), while a photo-story's realism (indexicality) means that it can be artificial, and that artifice, within the frame of realism, may be a sign of fictionality — is one that may generate more tolerance of the photo-story's artificiality.

The cinematic film is a process whereby continuous 'reality' is broken down into a sequence of frames in order to be reconstituted elsewhere, in an equivalent form; the discontinuous part of the

operation – the film in frames – remains invisible. The mediational stage – the filming – not only allows the filmed 'reality' to be transported elsewhere, it also allows its temporality and sequencing to be tampered with (slow motion, cutting, etc.). Time-lapse photography allows an ongoing, invisible process to be transferred from one time-scale to another, so that the process itself becomes visible. Film stills and the photo-story are different inasmuch as they make the discontinuous part of the operation the *raison d'être* of the undertaking, ostensibliy because this allows the recuperation of images (which the film does not), and creates more space and time for the viewer to exercise his/her imagination. In fact, if our arguments are correct, the photo-story does not achieve (does not seek to achieve) either of these objectives. It seems to fall awkwardly between the two stools, in the intervening space between a still photograph which has recovered a certain degree of autonomy, and a still photograph which has been reassimilated into a dynamic continuity (whether that continuity involves cutting and montaging or not).

This is, by most accounts, the definition of an aesthetic failure. But if, as previously, we regard it as a metaphor for the existential, then at least we can claim that it makes sense. The teenager is caught in an in-between, in which neither personal autonomy (the self as innately interesting) nor personal relationship (the validation of self by another) has been accomplished. The final photograph promises the attainment of either one, or simultaneously both, of these objectives (we should not forget that photo-stories by no means always end in a union of lovers; sometimes they are tales about the girl who has managed to fend off unwanted attentions, or who has successfully broken with a boyfriend who turned out to be a mistaken choice). The adult romance, more than the teenage story, tends to identify successful relationship with the psychological autonomy of the partners: if self is the confidence to be self, if the mirror that casts back one's reflection must be transformed, from an agent of self-destructive narcissism into an expression of social appreciation (the 'other' reflects the self), then the loving relationship is the route to self-belief. In other words, the ambiguous, between-two-stools status of the photo-story's photographs is the expression of an existential predicament and, at the same time, the bridge between two states, autonomy and relationship, which is precisely the plot of the photo-story, precisely the sense in which the photo-story is as much passage as stasis.

These kinds of argument do not change the fact that the teenage photo-story, unlike its continental adult counterpart, is in decline. *Oh Boy* ceased publication in the early 1990s, as did *Jackie*, and *MG* (now published by Perfectly Formed Publishing) is virtually going it alone. It is true that the photographic conventions and formats of the photo-story continue to inform the communicative use of photographs in other teenage magazines (e.g. *Mizz* [IPC Magazines], *Shout* [D. C. Thomson]), and that photo-stories are to be found alongside graphic strips in magazines for sub-teenagers (e.g. *Bunty, Animals and You* [D. C. Thomson]). But the writing is on the wall.[20] *MG*'s stable companion from Perfectly Formed Publishing, the once-yearly holiday special *Loving*, is more adult, each of its stories illustrated by a single, provocative photograph, usually placed liminally.

The principal reasons for the teenage photo-story's decline are that the medium has been genericized (i.e. that medium and genre have become indistinguishable, that the medium is the instrument of a single genre) and that the genre concerned — romance — is a popular one, that is, consumer-driven and thus valued for the consistency of its observance of a set of visual and verbal etiquettes. These include no swearing, no nudity, no sexual contact other than kissing, parental presence but of a non-interfering kind, non-exotic locations, the family snapshot as visual model, movement to be conveyed by posture rather than by, say, blurring, or suspension in the air, no homosexuality, and no drugs. Many feel that, consequently, the photo-story has become trapped in an anachronistic time-pocket (hence, for example, the parodies in the satirical, often scurrilous, adult comic *VIZ*), its cultural and aesthetic currency constantly devalued by televisual competition, the 'soap opera'. In what direction is the photo-story to turn?

The photo-story should perhaps develop its instructive, didactic character, its ability to *show* social, psychological and moral problems, and their solutions, by playing a greater part in educational textbooks:

> I think besides that the so-called educational slot is an interesting, because innovative, way forward. It is an effective way to communicate a message. Nowadays comic strips are increasingly linked with the content of school textbooks. One might seriously envisage combining comic-strip illustrations with photo-stories which, I am convinced, would strike pupils as more lifelike and appealing.[21]

" Quel choc, mes amis !... Terrible premier conta qui mérite votre enthousiasme ! Vous semblez croire en la victoire de Yuko... mais n'oublions jamais que l'issue reste incertaine jusqu'au bout

" Nicolas est en difficulté... Il ne tient pas toutes ses promesses... Une fois encore, la preuve est faite... Il y a loin de la salle d'entraînement à l'arène... Comme vous, je suis un peu déçu... "

The photo-story already has an instructive part to play on the problem pages of the tabloids (e.g. 'Miriam's Photo Casebook' [*The Mirror*] and 'Deidre's Photo Casebook' [*The Sun*]).

The photo-story manages to be a realistic parable, manages to achieve the status of an edifying demonstration, because of its cohesiveness. Cohesiveness is a term drawn from discourse analysis and text linguistics, and refers to the practice whereby sequential units, whether they be phrases, clauses or sentences, are linked by back-referencing or cross-referencing, usually of an explicit, overt kind (personal pronouns, conjunctions, adverbs). In terms of the photographic sequence of the popular photo-story, cohesiveness is provided by visual repetitions, overlaps, redundancies, as well as by verbal back-referencing. The emphasis on surface cohesion certainly provides narrative with continuity; but it does not necessarily guarantee underlying coherence. By drawing attention to the mechanics of narrative progression, and by doing so on an essentially short-term basis – cohesion concentrates attention on the step-by-step, on the close at hand, not on larger panoramas or underlying patterns – the photo-story draws attention away from coherence, from the more covert, more inferred, the more interpreted patterns of meaning, which might include psychological predicament, social conditions, thematics and symbolic structures.

Usually, of course, cohesion and coherence are part and parcel of one another. But there may be some narratives in which one exists at the expense of the other. And we might suggest that, in the photo-story, cohesion exists at the expense of coherence, that attention is drawn to the narrative surface, to a personal dilemma, which is shown to have a solution, a reassuringly achievable outcome, rather than engaging with the other, subtextual 'plots', which are social and psychological in nature, and which are not half as responsive to treatment, or amenable to resolution. In educational contexts, the favouring of the cohesive over the coherent has obvious advantages, and gives direction and purpose to the learning process. The instructive photo-story operates like the proof of a theorem, and the solution arrived at provides all the intellectual satisfactions and psychological rewards of a Q.E.D. But one must not forget that cohesiveness is a rhetoric, and serves ideologies both social and

46 Christian Bruel and Xavier Lambours, *La Mémoire des scorpions: Photo-Roman* (1991).

pedagogic. One ousts the coherent at the risk of forfeiting a pondered and interrogative style of judgement. Besides, I have tried to indicate that such subtextual 'plots' do occur in the photo-story, and that the low esteem in which the photo-story is held is to be largely ascribed to the fact that neither readers nor critics see these underlying coherences. But we must also insist that if these other 'plots' are overlooked, it is, ironically, the fault of the photo-story itself.

Another way forward for the photo-story is one that has already been canvassed, in indirect ways, by Robbe-Grillet and Monique Pivot. Hubert Serra reformulates the proposition:

> It seems to me that an important aspect is being neglected: the pleasure of reading, the pleasure of revisiting the same image several times. The televisual image exerts a fleeting power, while the reading of a photo-novel, with a high-quality production, beautiful locations, attractive actors, remains a permanent pleasure, which we can renew whenever we wish.[22]

The popular photo-story seems, perversely, to deny itself this justification for its necessary discontinuities and its static nature. The picture space is obscured by the *récitatif* and speech balloons, or it is arranged, repeatedly, according to a fixed code of receding planes; the discontinuity is not exploited, but minimized, by various devices of continuity and impulsion – the reader is not encouraged to dwell because the verbal and visual meanings are equally univocal and unarresting. The possibility of making the photographic image paramount in expressly narrative contexts has only been explored in the high-culture photo-novel (e.g. Hervé Guibert's *Suzanne et Louise* [1980] and *Le Seul Visage* [1984]; John Berger and Jean Mohr's 'If Each Time ...', in *Another Way of Telling* [1982] [see Chapter 9]; Marie-Françoise Plissart and Benoît Peeters's *Fugues* [1983] and *Droit de regards* [1985]; and Christian Bruel and Xavier Lambours's *La Mémoire des Scorpions* [1991]; illus. 46). But this has occurred only because the makers of these novels have believed that coherence in the photographic sequence could be achieved without cohesion, and that the individual photograph has an inbuilt potential for narrative, just waiting to be released by other, juxtaposed photographs.[23] It is to the narrative resources of the single photograph that we shall direct our attention in the next chapter.

The Narrative Resources of the Photograph

In the previous chapter, we saw how a medium/genre was able to capitalize on our natural need to read series as sequence, and sequence as consequence. In the popular photo-story, this consequence is, more often than not, the solution to a problem/dilemma. The narrative works at the level of a schematized plot, which the actors act out without ever becoming characters in the story or acquiring a symbolic resonance. And the unintended montage effects within individual photos prevent the actors being integrated into their background, so that the sociological value of the narrative is minimal. I have tried to show ways in which the popular photo-novel might indeed conceal a 'deeper' narrative, about the existential and social predicaments of the teenager, but these have required fairly strenuous exercises of interpretation, with an uncooperative medium. The photo-story sacrifices coherence, with its promise of a meaning operating at deeper levels, to cohesiveness, where meaning is consecutive and univocal; this is borne out by the high incidence of repetition and redundancy, and by the minimization of the *entr'images*.

In Greenaway's *A Zed & Two Noughts*, we can see the drama of coherence and cohesiveness played out in the film's parallel plotting. The plot of the time-lapse photography is the plot to reconstruct a plot, which will tell the Deuce brothers the why of their wives' deaths and trace decomposition with sufficient continuity to allow the brothers to live out their grief. Unfortunately, time-lapse moves too far in the opposite direction and, like the photo-story, destroys the *entr'images* entirely, leaving a cohesiveness which does not add up to a coherence, a sequence which has a beginning and end but no internal design. The parallel plot, within which the time-lapse plot takes place, is the plot of the film as a whole, taking us from the deaths of the wives to the deaths of the husbands. This plot activates too much coherence without sufficient cohesion. It provides us with

a set of structures – mythology, alphabets, numbers, colours, etc. – and many ways of inter-relating them; but what is sequential in them seems arbitrary, and forward momentum has constantly to yield to diversion, ramification, potential and suspended connections.

Cohesiveness in the popular photo-story is provided as much by the verbal as by the visual. But a problem of movement, as well as of pictorial credibility, is created by the discrepancy between the temporality of the photograph (instantaneous) and the temporality of speech (durational): one facial expression has to cover a whole verbal string. No doubt this nervousness about the photograph's inability to hold ongoing time is what drives the photo-narrator further towards the cohesive, towards the goal of consecutive sequence. But it seems silly that photography, faced with this crisis of faith in its capacity to encompass process, should resolve it by gravitating as far as possible towards cinematography. The chronophotography of Muybridge and Marey is not a model for photographic narrative, since its intention moves in a direction contrary to that of narrative. Muybridge and Marey were looking to analyse process by breaking it down into its constituent intervals and moments – only thus could the camera see what the eye could not. By restoring the frames to movement, to the filmic, we merely restore what the eye can already see. It was this analytical fragmentation of movement and time that the Italian Futurists objected to in chronophotography. The 'photodynamism' of the Bragaglia brothers, Arturo and more especially Anton Giulio, was intended to introduce time and movement into the single frame, but to make it visible *in its passage*. Chronophotography left the Bragaglias dissatisfied because it immobilized movement, reduced it to split-second intervals, the equivalent of translating the ongoing inner time of experience into the quantitative, measured time of the clock-face, with its divisions into minutes and hours:

> We are certainly not concerned with the aims and characteristics of cinematography and chronophotography. We are not interested in the precise reconstruction of movement, which has already been broken up and analysed. We are involved only in the area of movement which produces sensation, the memory of which still palpitates in our awareness.[1]

47 Anton Giulio Bragaglia and Arturo Bragaglia, *The Roses*, 1913.

In order to produce a photography which was at once an analysis and synthesis of movement, which moved on from the chronophotographers' concern with the mechanics of locomotion to an attempt to capture the psychic and emotional impulses expressed in movement and intuited by the spectator, the Bragaglias had to develop techniques able to register the 'intermovemental' passages of movement:

> To put it crudely, chronophotography could be compared with a clock on the face of which only the quarter-hours are marked, cinematography to one on which the minutes too are indicated, and photodynamism to a third on which are marked not only the seconds, but also the *intermovemental* fractions existing in the passages between seconds.[2]

The Bragaglias were looking for a photographic space between the consecutive frames of the chronophotographers, which destroyed the sense of overall movement but preserved its moments, and the blurred photograph, which maintained the sense of a whole movement, but at the expense of any detailed perception of it. The answer, arrived at in 1912, was a photograph with a long exposure, in which the subject performed a movement in staged sequence, so that continuity of movement was combined with the perceptible 'anatomy of the gesture'.

Anton Bragaglia's ambitions were too specific – to imprison time in the photograph in the form of gestural movement (a woman smelling a rose [illus. 47], a salutation, a slap, a violinist playing) – and his photographic means too limited, to supply photography with a ready-made solution to narrative. But, importantly, he did engage with the problem of synthesizing duration, the sequence of images, into a single photograph. And he did, like other Futurists, explore movement as the physical trace, or actualization, of psychic and emotional impulses – in other words, he asked himself how the photograph could register, and communicate, the inner life of its subject. The popular photo-story, deprived of duration, is unable to project 'character' or inwardness; it relies on conventional signs of character (facial expression, posture) without being able to individualize those signs, other than through the realism of the medium itself; the 'realisticness' of the image is the only guarantee that the character-signs have indeed been individualized. But Bragaglia,

in attempting to reconcile the synthetic and the analytic, the essentialist and the relative, in attempting to capture the very sensation of movement, was equally attempting to install in photography the Bergsonian thinking by which so much Futurist work was informed: inner experience, or duration, *is* both heterogeneous and continuous, motivated by the drives of the deep self.

If Anton Bragaglia is the epitome of Futurist photodynamism, the photographer of Cubism is, perhaps oddly, David Hockney.[3] His quarrel with photography coincides with his belief that we have yet to learn properly the lessons of Picasso and analytic Cubism. Prior to his experimentation with different kinds of photocollage, Hockney considered photography to be a 'small medium', largely because of its temporal stinginess. The photograph's temporal limitations are, in Hockney's account, two-sided: the photographic image is without time, because its taking is instantaneous; and the viewing of a photograph is without time, because the image does not have the temporality necessary to engage the eye:

> You can't look at most photos for more than, say, thirty seconds. It has nothing to do with the subject matter. I first noticed this with erotic photographs, trying to find them lively: you can't. Life is precisely what they don't have – or rather, time, lived time. All you can do with most ordinary photographs is stare at them – they stare back, blankly – and presently your concentration begins to fade.[4]

We might wish to argue with Hockney's easy assimilation of the time of viewing to the time of taking/making, and with his restriction of the notion of photographic time to the transfixative/transfixed mode. More fundamentally, however, he attributes much of this impotence of the photograph to its inability to generate ambiguity, as in the following passage quoted earlier:

> However good the photograph, it doesn't haunt you in the way that a painting can. A good painting has real ambiguities which you never get to grips with and that is what is so tantalizing. You keep looking back. A single-eyed photograph can't have that quality: when you look back, it's the same.[5]

Again we might object, this time in the name of John Berger's 'language of appearances', which provokes the viewer to ever-renewed speculation.[6] At all events, Hockney's polaroid photocollages

are still very much about the object, are in fact narratives of the object, inevitably: because they maintain the frame of the window-aesthetic, and because their standardized square prints, laid out gridwise, make uniform the temporality of discrete perceptions. What the window-aesthetic does, among other things, is consign the image to the past in a quite explicit way: the subject is over there, we are cut off from it by an intervening wall – and it is over there in time, too, and its space cannot be re-inhabited.

Our second point – the homogeneity of perceiving time – refuses the viewer in the sense that it seems to consign all viewers to the same temporal experience of the object, as if there were only one, universal mode of looking. But of course temporality, in its hetero-geneous and unpredictable patterns of glancing here and gazing there, is the way the viewer engages with the object; the flexibilities of time solder the relationship between ourselves and the world, and without these flexibilities we are likely to shut out the uneven, varied movements of inner duration. Thus although these polaroid photocollages allow diversification of viewpoint, which may well imply temporal shifts, the homogeneity of segments in the visual field tends to interpose between us and that field a barrier of conven-tionality, or a space emptied of atmosphere and time, as though the image were an autopsy.

And yet, there are counter-pulls. The uniform squareness of the images allows the eye to move in any direction with absolute freedom, a mobility further facilitated by consistencies of tone or tonal echoes. And even though there is no experience of 'blind field' (simply because the picture-space is so strikingly discontinuous), and thus no possibility of inhabiting pictorial space, we can fictionalize and narrate it. As with the Cubist picture, there is no sense of physical co-presence with the 'scene' depicted, but there is much ocular activity and involvement.

Hockney's *Yellow Guitar Still Life, Los Angeles, 3rd April 1982* (illus. 48), for example, is both peculiarly inanimate and animated, even animistic, as if the objects depicted were struggling to express themselves, to create a varied life for themselves. The floor at the foot of the picture consents to be stood on by the table-leg at 8.1., affirms its autonomy at 8.2., and then, as the perspective grows steeper, gathers momentum, and races off to the right, to find other places for itself. The wine-bottle, seen from above, in 4.2., as no more

48 David Hockney, *Yellow Guitar Still Life, Los Angeles, 3rd April 1982*.

than a paperweight for the *Los Angeles Times*, asserts its formal likeness to the guitar in 5.2., and then, in 6.2., proudly displays its pedigree (label); otherwise it acts as a backdrop for the pear (5.1., 6.1., 7.2.), itself a 'necked' fruit echoing the shape of the guitar and wine-bottle. The guitar is centred on its sound hole (4.4.), an eye which constitutes the image as seeing as well as being seen, and which provides a circular form about which other objects in the picture can revolve. But the guitar itself peculiarly denies the fixity and fixatedness of the sound hole/eye at 4.4.; it quite literally resonates, in a series of vibrations, across the upper right-hand side of the image, formally as elusive as the music it potentiates. And just as the yellow/orange colouration of the whole – provided by the artificial light – seemingly emanates from the guitar, enveloping the other objects in its warmth, so the 'vibrations' of the guitar reverberate through what should have been a still life and communicate a dance of changing relationships. This analysis should make clear what the polaroid 'joiner' can do for portraiture, and particularly for double or group portraits: it not only explores the changing moods of the subject(s) (as any multiportrait or sequence of portraits might), it *simultaneously* explores relationship, through its choreography of sympathies, empathies and distances.

Hockney's polaroid collages use conventional perspective in each individual image in order, collectively, to shatter conventional perspective, and to release the image from the immobilizing grid that perspective imposes. As we move from the polaroid collages to the SLR collages, we have to add to the presence of Picasso that of the Oriental pictorial tradition, in two important features: the breaking of the frame and the reversal of perspective. In contemplating Chinese scrolls, Hockney saw a route out of the window-aesthetic, a way of instituting an image which could unfold before the inquisitive eye. While the polaroids animate the frame by intensifying the play of the *entr'images*, the SLR collages 'perambulate', by overlaps usually, but also by spatial jumps, the layout corresponding not to the imperatives of a support (canvas, photographic paper) but to the caprices of the investigating observer. Equally, instead of the area of vision being subject to a force outside the spectator – the vanishing point on the horizon – reversed perspective situates infinity in the spectator himself, so that the visual field seems to expand out of him.

49 David Hockney, *Hitch-Hiker, Hollywood Steering Wheel, L.A. 1985.*

In the polaroid photocollages, narrative was in the subject, albeit a narrative created by the ocular activity of the spectator. The SLR collages complete this shift of the narrative from the subject/motif to the viewer, simply by insisting that their formal composition is dictated by, and radiates from, the viewing eye. Hockney's Grand Canyon panoramas quite literally fan out from the viewer. In other images, the spectator is present at the 'threshold' of the shot: the driver's hand and legs in *Hitch-Hiker, Hollywood Steering Wheel, L.A. 1985* (illus. 49), the walker's feet in *Walking in the Zen Garden at the Ryoanji Temple, Kyoto, Feb 21st 1983*. Of course the subjects may still enact their own narratives, whether because they are in movement (e.g. *The Skater, New York, December 1982*) or because they are engaged in a longer, more complex event (e.g. *Photographing Annie Leibovitz while She Photographs Me, Mojave Desert, February 1983*; *Luncheon at the British Embassy, Tokyo, February 16th 1983*). But the photographs clearly track the time and attention of the viewer, recount the way in which the viewer relates to the motif. This narrative of the viewer has all the whimsicality of any first-person

50 David Hockney, *The Desk, July 1st 1984*.

narrative, and like the first-person narrative, it tells of the self through the other. But it is a peculiarly modern first-person narrative inasmuch as the narrator is not a resistant person but a transferable point of view. It is extremely difficult for the photograph to transform the subjectivity of seeing into the subjectivity of being, unless that being is, as it were, transferred to the motif. In *The Desk, July 1st 1984* (illus. 50), for example, self-portraiture is achieved in traditional ways, by the inclusion in the image of characteristic, characterizing objects: Picasso's *Guitar* collage of 1913, Cosima Wagner's *Diaries*, William Prescott's *History of the Conquest of Mexico* and *History of the Conquest of Peru*, and a carton of large dog biscuits. But it is also achieved through what Hockney sees as drawing techniques, this analysis of one's own vision, the narrative, in traced lines, of looking.

Drawing/photocollage takes you closer to the motif, but draws the motif closer to you, so that drawing/photocollage is a process of reciprocal becoming: 'A drawing is an autobiographical record of one's discovery of an event – seen, remembered or imagined.'[7] The spectator enters into a gradual, staged possession of the desk, where the individual, constitutive photographs operate as units of ocular or pedestrian movement. The progressive aspect of the image is countered by the fact that the overlapping photos also introduce a visual unsteadiness into the image when it is seen, simultaneously, in its entirety – J. G. Ballard went so far as to say: 'Gazing at these jittery panoramas one sees the world through the eyes of a concussed bumble bee.'[8] In narrative terms, this double perspective means that one operates in linear duration, following paths of investigation and description, but that one cannot put the elements together in such a way that the picture will be stilled: the story can only be told and retold with incessant variation.

In attempting to break the 'one-eyed' tradition that has dominated photography, Hockney does not introduce the stereoscopic. His are flat images, and the insertion of time into his photographs derives not so much from the insertion of space, of a third dimension, as from the cultivation of ocular labour; and this labour leads to no stable construction. Looking at *The Desk*, or, say, Theresa Russell as Marilyn Monroe in *Nude, 17th June 1984* (illus. 51), we are permitted by the Cubist techniques to see a more complete picture, but only on condition that we admit contradictions, repetitions and incongruities. This is a photography of modern narrative, in which

story-telling is not an explanation, but an obsessive recounting, not a consistent description but a series of impressions, polarizing coherence and cohesion.

In *Nude*, repetition (of hands, mouth, feet) produces visual oscillation and flickering. We realize that the fixations of pornography are no longer visually available to us; the image, paradoxically, preoccupies the eye, increases the eye's investigative activity, and yet does so in such way that the image becomes an optical illusion, a mirage, on the run from the eye. The connection between analytic Cubist photocollage and 'depornographization' ironically relates to the fragmentation of the image; where we might expect a fetishization of body parts, we find that each part is visually undermined, has its free-standing credibility removed, by the immediately contiguous, but discrepant, image fragments. The navel acts as the still centre of a body constantly receding from the eye's inspection.

When Hockney declares that photocollage is inappropriate for a subject such as Nick Ut's napalmed Vietnamese girl because 'the portrait would be far too strong,'[9] he is certainly right to assume that collage, even though visually evasive, produces obsessive inspection. But one should add that, at the same time, the 'joiner' deconstructs reality and, in so doing, fictionalizes it. 'Joiners' are not optimistic, as Hockney claims. They suspend reality in order to embroil the spectator in a labyrinthine act of looking which can never come to an end. Similarly the *nouveau roman* suspends 'reality' (referentiality) as it becomes obsessed with the act of narrating; it loses its sense of scale, proportion, relation, and narrates so much, that narrating itself is undermined. Robbe-Grillet's narrator in *In the Labyrinth*, analyzing a fault in the ceiling, is as if analyzing modern narrative and the photocollage:

> ... the crack, thin as a hair, just slightly winding, it too so precise and complicated in shape that one would have to follow it with great attention, concentrating hard on its bends, its curves, its wobbles and uncertainties, its sudden changes of direction, crooks, straightenings, slight retreats, but one would need more time, a little time, a few minutes, a few seconds, and it is already, now, too late.[10]

51 David Hockney, *Nude, 17th June 1984*.

We always need more time for putting the facets together, for tracing the visual route, and we need more time because we shall never come to an end, and that is why it is already too late.

The double perspective we have identified in Hockney's photo-collages – a sequence of separate glances, a synthesizing totalization – combines two models of seeing explicitly canvassed by him. On the one hand, he argues that photocollages are much truer to our cumulative way of seeing than conventional photos: 'But, more importantly, I realized that this sort of picture came closer to how we actually see, which is to say, not all-at-once but rather in discrete, separate glimpses which we then build up into our continuous experience of the world.'[11] On the other, he argues that conventional photographs falsify the naturally inclusive, if 'edited', way in which the human eye absorbs the world. Speaking of his *A Diver, 1978* (*Paper Pools*) in a 1981 interview, Hockney claimed that the painting gives us the whole dive, the splash and the body gliding away under water, where a series of photographs could provide only isolated and imperceptible instants extracted from the whole event. These two models of vision appear in different mixes in other para-narrative forms which relate closely to Hockney's concerns, the family snap – Hockney's photographs belong essentially to the genre of the family snap – and the photomontage.

The family snap has many reasons for existing, among which we might mention those cited by Kenyon:

> One thing we use domestic photography for is to signal to ourselves (whether knowingly or not) certain experiences as important. This importance can be personal or cultural, and these aspects may be reinforced by virtue of being different to the everyday, or by being the underlying dependables of our lives. Such photography celebrates our successes. It also helps make our emotional lives tangible, and combats the psychological effects of distance and passing time, bringing us closer together and sustaining our fleeting pleasures.[12]

The psychological drives to which this quotation in part refers – the use of photographs to create a sense of intensified emotional experience, or of the palpability of one's existence, as *aides-mémoire* to combat the erosions of time, as evidence of relationship or communication with others, as evidence of power over, or possession

of, people or places – are sublimated in the photograph's social functions, in its transition from private to public status.[13] Family snaps are forms of social engineering undertaken by parents in the interests of the family's standing. The democratization of art that the snap should represent paradoxically surrenders to totalitarian conformity:

> In fact, while everything would lead one to expect that this activity, which has no traditions and makes no demands, would be delivered over to the anarchy of individual improvisation, it appears that there is nothing more regulated and more conventional than photographic practice in amateur photographs.[14]

There are two senses, however, in which this underlying truth should be qualified. First, instead of speaking of the democratization of art in relation to family snaps, we should rather speak of the domestication of art. The presence of the family-snap mode in tabloid newspapers, or indeed in fashion magazines, banalizes the extraordinary, brings it within reach of the quotidian and demythicizes photographic 'reality'. By the same token, these generical interferences allow the family snap to invert the process and make claims of extraordinariness for the banal, a strategy which informs pub-table narrative art. But while the pub anecdotalist has the rhetoric of hyperbole at his disposal, the family snapper must rely on the rhetoric of voluntary and involuntary editing – captions, selection, survival – which endows the photograph with an implicit prestige.

Second, we should recognize that, in ritualizing family life, by limiting the categories of its photographable activity, the family snap, nonetheless, has a wide range of categorial options. Kenyon lists 55,[15] though several of these may fall within the same occasion, such as Christmas (women's photos, parties, presents, Santa). The family snap is frequently thought of as a distinct photographic genre, as limited as other genres. But it is, in effect, defined not so much by its subject, as by the status of the photographer and the function of the photograph. The family album contains the amateur, or domesticated, equivalent of a whole host of 'art' genres – still life, portrait, landscape, reportage, documentary.

The transition from private to public is, for the family snap, entirely a matter of storage and presentation. The family album is, precisely, a form of publication, consecrating and enshrining family memory and family history, for the benefit of the larger community.

An album is essentially a book, implying thereby that the contents can be read, that they are ordered, unfold in time, have no loose ends, and that their significance is guaranteed by the narrative they can tell. Because the book necessitates (number of prints per page, size of prints, number of pages), so it implicitly optimizes its contents (the question is 'From whose point of view?'). Traditionally, a father produces the contents, and a mother edits and captions them.[16] This, then, is a repeat procreational act, a new making of the family, but in terms less of personal relations than of social expectations. The family album is a key to social acceptability and its narratives accordingly require certain biases (towards conventional gendering, towards the bourgeois, towards the competitive, towards the productive use of leisure). Inasmuch as the family album is *family* narrative, it militates against alternative social narratives and against personal narratives (in favour of role narratives). The function of the publicization of the album is thus to claim a comparability – this is what makes looking at family albums potentially so boring for the outsider – and to confirm the in-placeness of the proper kinds of censorship. That family albums edit and omit is not the only sin; it is also that they do it with the knowing connivence of every other album-maker.

The purpose of Jo Spence's 1979 exhibition 'Beyond the Family Album' was to put her own record straight:

> In my early photographs there is no record of my appalling health (or the many doctors who fobbed me off with undeveloped medicines because of my unseen 'social problems'); no record of the pointless years shunted around schools inside formal education (where I was downgraded for 'unruly behaviour', constantly evaluated and eventually crushed into the mould of 'typist'); no record of a broken marriage and the havoc this so-called failure caused me; no record of hard work done for countless employers.[17]

There are several senses in which these remarks can have only limited validity: (a) because such photographs would deny the function of family photographs, and family photographs cannot be disqualified for not being what they did not design to be (i.e. for not being documentary photographs of family life of the kind to be found in Nick Waplington's *Living Room* [1991]);[18] (b) because, as Jo Spence herself says, all photographs are, to a greater or lesser degree, 'fictions', subject to visual rhetoric, and we constantly re-think the past; and

(c) because photographs simply cannot say what we might want them to: '[...] the image was totally inadequate. A photograph of my parents or my father doesn't tell me for a second what I thought of my father, which for me is much more important than what the man looked like. So I then had to evolve into writing' (Duane Michals interviewed by Marco Livingstone).[19] But it is not difficult to understand Jo Spence's need to retrieve herself as a child and as a woman, to cease being a protagonist in someone else's narrative and become the protagonist in her own.[20] To do so, she also had to 'evolve into writing'.

The family album takes control of one's image. While apparently providing a continuity for the subject, it in fact engineers a sequence of images each of which is intended as complete and self-justifying. Selfhood is sacrificed to the 'integrity' of the photograph. The narrative shallowness of the single image and the constrictive influence of the caption act to reduce the subject to appearances, to the visible. The caption does not extend the image but installs the adult's frame of reference, designs the image for the consumption of a public assumed to have no personal interest in it. 'Such a lovely little girl, doesn't she look like Shirley Temple?'[21] is a caption not about Jo Spence but about an image, not about character but about photogenia. The transference of identity (to Shirley Temple) merely underlines that principle of comparability to which we have already alluded. Additionally, it reveals how the family album seeks to re-infantilize its children, and constructs narratives which are in effect sequences of moments of control, moments when, precisely, there is nothing to say, nothing to explain (away).

Ironically, however, the family album carries within it the mech-anisms of its own deconstruction. Photographs fall out or are replaced; the narrative threatens to ramify or begs questions; we become aware that the album cannot iron out the elasticities of time: three pages devoted to the holiday in Majorca of 1983, only one photograph, following on, records the building of the house-extension two years later. The fruitful discrepancy between the *temps de l'histoire* (the time of actual events, *erzählte Zeit*) and the *temps du récit* (the time of narration, *erzählende Zeit*) is one that the still camera can construct only quantitatively. While, in cinematography, the camera can diversify time by cutting, panning, tracking, reversing, accelerating, etc., the still camera can saturate an event

with photos, or economize, but these are really the only devices available for varying temporal experience. Most frequently, the still camera is seen to belong to the *temps de l'histoire*, while the *temps du récit* must be supplied by the viewer and/or accompanying text. The real question confronting the subject of family snaps is how to re-insert his or her *temps du récit* into them, how to break the 'conspiracy' of the album which implies that its contents have the cohesive purposefulness of a *temps de l'histoire* without a *temps du récit*.

This way out of the traditional family snap, by the suppression of the *temps de l'histoire* and the appropriation of the *temps du récit* by the photograph, is evident in an image by Anna Bardwell-Dix of her two daughters (illus. 52). Here, the visual space is controlled by the two girls, looking down into the hollow which contains the viewer; and we become subject to the time of their looking, to the predominance of their being. Backed by the tracery of branches against the sky, they are as if fabulating the scene, spirits of place beyond the reach of the camera's peremptory 'instants', enquiring about our role in an image invented, imagined, by them. And their 'at-homeness' is expressed quite literally: the girl on the right leans on the sill of a tree-window, while her sister is a tree-incorporated hamadryad.

A way out is also to be found in the dismantling of the album itself, achieved, as one might expect, by changing habits of storage and presentation. Already the flip album destroys the narrative of the page, by removing the need to order and edit to the same degree, and by allowing greater variation in viewing speed. The photographs are no longer consecrated by 'mounting'; respectfulness is no longer inculcated through the measured rhythms of page-turning. But even the flip album constructs itineraries and implies that the subject is, willy-nilly, subject to the remorseless passing of the *temps de l'histoire*.

A step further on lies the photomontage of snaps (illus. 53) of a particular event or period. The photographs from consecutive reels of film are mounted kaleidoscopically, often with radical cropping, on another support. This permits one's relationship with the snaps to remain associative, improvised, synthesizing rather than successive. It allows patterns of metaphor and symbol to emerge; it allows temporal manipulations of experience (in the varying size of the

52 Anna Bardwell-Dix, Photograph of her daughters, 1998.

image, for example – compare the *bande dessinée*). But it remains bound to a life's chronology, to a life unfolding in stages.

It is with the accumulation of family snaps in shoe-boxes and drawers that the viewer can take, or be compelled to take, any number of a-chronological journeys through his/her past, not following, for the nth time, that track beaten out by the album, but surrendering to chance encounters with prints which he/she must shape into narratives – not narratives of external time but narratives of inner duration, memory, resurrected illusion; in short, narratives of the narrator (*temps du récit*). So our past is restored to us in a form that requires constant reinterpretation, with the result that we are never done with exploring ourselves.

There is plenty of evidence to suppose that people look upon their photographs as evidence of their living, as the sources of their narrative (photobiography). In the first of a set of Channel Four programmes entitled 'Opening Up The Family Album' (1989), one woman wished to have her photographs scattered over her at her death, wanted the ultimate photograph to be taken of her, the photograph of her with her photographs. Others spoke of the loss of photographs as a taking away of their history, a loss of the richness of identity; even the damaging of photographs was regarded as an emotional or psychological wounding. For many commentators this is an investment of self which deeply detracts from the quality of life. Sontag has indicted the tourist mentality generated by photography, whereby photographs become substitutes for experience, create the illusion of participation, take the place of response.[22] Instead of being a trace, an evidence, of a reality which must be reconstructed elsewhere, in the self, photographs have gathered truth into themselves. Instead of being *aides-mémoire*, triggers of memory, they have become the memories themselves. For both Proust and Benjamin, photographs are the enemies of involuntary memory (the past relived – as if by a gift, by the grace of chance encounter – in all its expanding, self-narrating fullness) and the instruments of voluntary memory (the past conjured up by an act of mnemonic will, revived as event, fragment, as something identified rather than relived). When Marcel stumbles on the uneven cobblestones, Venice is given back to him, unbidden, without intellectual labour, complete:

53 Clive Scott, Family snap collage, 1994.

And almost at once I recognized the vision: it was Venice, of which my efforts to describe it and the supposed snapshots taken by my memory had never told me anything, but which the sensation I had once experienced as I stood upon two uneven stones in the baptistery of St. Mark's had, recurring a moment ago, restored to me complete with all the other sensations linked on that day to that particular sensation.[23]

For Benjamin, the camera extends the range of voluntary memory, that is to say, of the archival memory; but the price we pay for the efficiency of the archive is the loss of imaginative play in remembering. In fact, the archival memory preserves the past for us by dispossessing us of it, by taking away our indispensability in its recovery. Many recent photo-narratives, as we shall see in the chapters that follow, work to put the 'reader' at the centre of a reconstructive process, where what seemed a given has to be radically reimagined.

In order to be reinhabitable as a site of constructive memory, of imaginative and experiential repossession, the photograph has, in the view of some analysts, to be discrepant, incongruous, ill-fitting, in order to deactivate that feature which seems to be the very principle of photography, likeness. Likeness, similarity, truth to appearances, lifts being to the surface and becomes an adequate objective. As viewers, in acknowledging likeness, we absolve ourselves from having to define, identify, characterize — the photograph does it for us. Those who need a truth deeper than similarity ('he is himself' rather than 'he is like himself') will need to avoid the illusoriness, the blinding, which likeness produces, and approach their prey through the 'unlike like'. Barthes finds the truth of his mother in a photograph of her as he never knew her, as a young girl:

> Likeness leaves me unsatisfied and somehow skeptical (certainly this is the sad disappointment I experience looking at the ordinary photographs of my mother — whereas the only one which has given me the splendor of her truth is precisely a lost, remote photograph, one which does not look 'like' her, the photograph of a child I never knew).[24]

Sometimes, it is true, photographers themselves are able to release this truth in their subjects, this 'air', as Barthes calls it. But the significance of Barthes's route to the truth *is* its indirectness. We

achieve the experience of involuntary memory, we find our way back into ourselves, when we look at other people's photographs, not our own. While our own photographs tend to limit us to externalized and archival memory, to what we recognize, other people's photographs, whatever their date or location, may act as the trigger to a memory whose eruption we cannot control, a memory which we may not, indeed, at first recognize, but can only inarticulately experience. Real memories are those we are shaken by before we can properly identify them. Looking at the portrait of a black family by James Van der Zee of 1926, Barthes has an experience of *punctum*, which he associates first with the sister's (daughter's?) low belt and then with her strapped pumps. Only later does he acknowledge that the laceration of *punctum* in fact derives from the sister's necklace, which has discharged in him an involuntary memory:

> ... but this photograph has *worked* within me, and later on I realized that the real *punctum* was the necklace she was wearing; for (no doubt) it was this same necklace (a slender ribbon of braided gold) which I had seen worn by someone in my own family, and which, once she died, remained shut up in a family box of old jewelry (this sister of my father never married, lived with her mother as an old maid, and I had always been saddened whenever I thought of her dreary life).[25]

Much of the value of photography lies not in a documentary showing of the seen, but in an unforeseen, uncontrollable activation of the unseen, the recovery of a privacy through a medium which seems intent on making us public. This happens more frequently for us when we contemplate unfamiliar photographs, an implicit assumption of John Berger and Jean Mohr's *Another Way of Telling*, and particularly of their photonovel 'If Each Time ...', as we shall see in the next chapter.

But the fact remains that many of our emotional and psychological drives, anxieties, etc. are locked in our own photographs. We have submitted to the camera, been possessed by it, and the resulting images focus our self-love, self-hate, our alienation from past images of ourselves. The camera has required of us a coherence we have not got, a control of self we have not got. We may feel violated, the victim of a theft; we cannot change an image we did not consent to; we involuntarily connive in the reinforcement of stereotypes and roles.

But if it is through photographs that we have been condemned to neurosis, alienation, insecurity, then it is through photographs that the curse must be lifted, that the psychic and the social can be re-engineered, and that we can find our way back to a representable self, or a self properly represented. This can be done in two closely related ways, by phototherapy or by photobiography.

Rosy Martin and Jo Spence explain how their own brand of phototherapy works:

> Drawing on techniques learned from co-counselling, psycho-drama and the reframing technique borrowed from neuro-linguistic programming therapy, we began to work together to give ourselves and each other permission to display 'new' visual selves to the camera. In the course of this work, we have amply demonstrated to ourselves that there is no single self but many fragmented selves, each vying for conscious expression, many never acknowledged.[26]

Phototherapy thus conceived indicates the way in which photography might generate new kinds of narrative. Far from bemoaning the fact that the photograph wrenches moments out of continuity, we should recognize that the photograph is the source of a narrative that destroys the meaning of the consecutive, that sets at nought the responsibility of the subject to maintain a consistency, that makes available the dream of continual self-invention (which fashion photography puts to its own uses). The moments of the past are not discarded as one proceeds (as in the photo-story), they are held, along with all other moments, in a state of suspension, of potentiality, so that the synthesis that emerges is neither constrictive nor definitive. Thus the past is neither determining nor dispensed with. Where chronophotography and cinematography try to sew up gashes in time, phototherapy believes that time must be held open to allow the self to re-insert itself, rearrange its photographic molecules, pursue other narratives.

The concern to take over the narrative of one's own existence at the earliest possible point has particularly preoccupied women, simply because the family album demands so insistently to be re-gendered. The projects of women photographers have been very similar to phototherapy: to escape identification through self-multiplication, which itself becomes a route back to identity. Marcia Resnick, for

instance, declares: 'My work attempts to consider the peculiar ways in which I related to myself and my world while growing up.'[27] She supplies her photographs in this 1978 collection with a third-person narrative commentary which, however, takes us into the subject (e.g. 'She scotch-taped her nose up before dates hoping it would stay that way') while concealing her visual identity. Just as Jo Spence recovered freedom in those sets of contact prints which make her as elusive as she is self-exploratory, so, for example, Friedl Bondi has created day-by-day diaries of self-images, which leave narrative open, the being made and always to be made, and which allow the self to relate not only to itself in its diversity but also to the medium, photography, with a variety which prevents it from adopting a consistent mode of definition. Photography cannot be permitted to develop an authority of its own; it must remain a product of our attitudes towards it: 'From March 1977 to March 1978 I completed another one-year self-portrait which shows my different attitudes towards photography and myself. I intend to continue doing one-year self-portraits in five-year intervals until the end of my life.'[28]

Women have been among the most active of contemporary photographers in creating images of images, images of meta-phors or objective correlatives, whereby unusual angles, subject-combinations, lighting, etc. signal an entry into the psycho-symbolic (a realm which Brandt's nudes already begin to explore). Jo Alison Feiler puts it like this: 'I try to express in depth some of the truths of my own existence and I search for correlations in the physical world which can adequately describe and map my interior visualizations.'[29] Typical of this current of feminine self-portraiture is recourse to costume, make-up, montage, double exposure and sandwich printing, in order to enact those self-transformations necessary if the femi-nine psyche is to relocate itself.[30]

In this process of self-telling, the portfolio inevitably becomes the photosequence, or the photosequence becomes a set of diptychs, or triptychs, as in Nancy Honey's *Woman to Woman* (1990), where the provocative juxtapositions project narratives of questions and ambi-guities, where images can stand in literally conflictual relationships with each other (Nancy Honey's own photos may, for example, vie with male-constructed media images: fashion, rock music, cinema, advertising, pornography). 'Rhymes' of colour and form here invite us to reorder our patterns of association, or map out new itineraries

through feminine experience. These techniques suggest indirection, evasion, deviousness even, but as Spacks points out, such strategies can be 'a mode of enlargement and inclusion that implies a refusal to rest on limiting definition, awareness of precisely what such definition involves'.[31] The multiple narratives of photomontage or photosequence transform the fugitive into the pursuer, and tell us how highly 'feminized' the postmodern is.

The examples of photography we have considered so far all tacitly acknowledge that the single photograph is incapable of opening up any more than an extremely limited narrative space, because the time inscribed in it is of too short a duration (this is not to make any presuppositions about the duration of looking). The solution has been seen to lie in the directions of either the compound single image (montage, collage), or the photosequence (family album, self-portraiture). Montaging, in the form of combination printing, already existed in Pre-Raphaelite and Pictorialist photography of the latter half of the nineteenth century, not as a device for multiplying temporality or point of view but as a means of increasing aesthetic control of composition, and of producing a higher standard of visual experience (overall focus, consistent exposure levels). But why did the single-image narrative photographs of the late nineteenth century fail, and in what ways could twentieth-century photomontage compensate for that failure?

As far as the worlds of the historical and legendary are concerned, we have already had occasion to see how photography's indexical nature turns historical subjects into anachronisms. And one must further add that the photograph's constricted duration leaves little room for imaginative inhabitation, does little to promote the willing suspension of disbelief. If photography falls short of what painting can achieve in narrative, in creating space for the imagination, it is because photography has within it none of the elasticities which characterize narrative painting. Here I do not refer merely to the factor of time – moment v. instant, iconic v. indexical – but also to access to symbolism. Of course photographs may generate symbolic readings, but they will tend to do so only if their primary justification cannot be found at the indexical and iconic levels. If historical or legendary or literary topics strike the spectator as illustrations, then indexical considerations will predominate and the reader will feel, given the weak intentionality of the photograph, that further

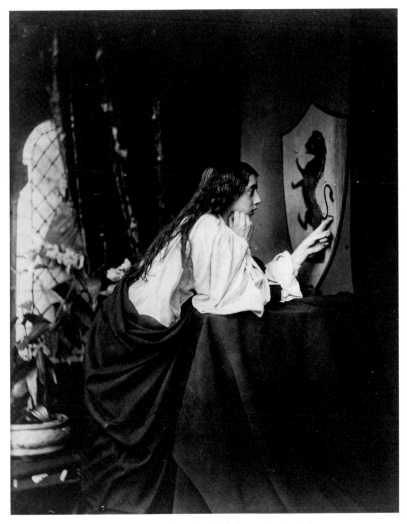

54 Henry Peach Robinson, *Elaine Watching the Shield of Lancelot*, 1859–60.

interpretation is uncalled-for. Looking at H. P. Robinson's *Elaine Watching the Shield of Lancelot* (1859–60; illus. 54), we ask how much of Tennyson's account, or indeed of any other account, is here, and what can be identified. We do not ask what kind of 'reading' it is, or what it means. The narrative is outside the photograph, the photograph is a window into the narrative, or an *aide-mémoire*, or, as we have said, a photographed version of a *tableau vivant*.

When Moholy-Nagy, on the other hand, tackles the mythological story of Leda and the Swan (illus. 55), he initiates a new narrative, the myth reversed ('Der umgekehrte Mythos' is the subtitle of his photomontage of 1925). The swan does not swoop down on Leda, Leda dives down in the direction of the swan. But Leda is also Zeus disporting him(her)self in an upper realm towards which two figures are climbing, up a web-like radiation of lines. But the two climbing figures may be a single figure seen from different perspectives – on the back of the original photomontage, Moholy-Nagy noted 'Der Kletterer und Jupiter oder Leda und der Schwan' ('The Climber and Jupiter or Leda and the Swan'). The space of the photograph is a free space, a space of free invention, a space that can be invested with new geometries, infinitely deep and infinitely available for free-standing figures. Different histories intermingle, and levels of meaning are visually connected: the original myth, a timeless swan, a modern diver, what the myth enacts (the aspiration towards the godhead, the web of destiny), the modern uses of the reversed myth (feminism, a sports ethos – the climbers are also mountaineers). Photomontage of Moholy-Nagy's 'photoplastic' kind works to repotentiate images, to undo the photograph's imprisonment in the 'that-has-been': 'The job of the narrative photographer is to suspend our sense of the irreversible lateness of our arrival at the scenes depicted; and to try to resituate viewers within an apparently emergent process, still unconsummated at the moment of perception.'[32] The narrative photographer must recover from the photograph, by whatever means, this element of the unconsummated, of which Moholy-Nagy's photomontage is the sexual metaphor. All photographs are taken in the past, a necessary condition of their existing at all. But equally intrinsic to them is their discontinuity, or their having only momentarily touched a continuity; they are unfulfilled. We have already seen something of the way in which fashion photography activates this sense of potentiality, of futurity. Photomontage, in exploding the photograph without sacrificing the photographic, attempts to win photography for the projection of possible futures, and for reinterpretations, rather than for re-presentations, of the past.

When Pictorialist photography engages with allegory, it again does so in the guise of a charade, of 'acting out' the idea. How would

55 László Moholy-Nagy, *Leda and the Swan*, 1925.

you represent 'Patience' or 'The Artist Listening to the Muse', or 'Dawn and Sunset'? For the photographer it seems to be a problem of modelling and props and arrangement, and for the spectator one of recognition, of being able to approve the appropriateness of the image to the title or caption. The title defines the photograph's aspirations, which the viewer translates back immediately into the title – a small self-fulfilling circle. Allegory, of course, uses narrative as its argument, as its discourse of cause and effect. But while the painting can spatially unfold time, so that, for example, a background might represent a past, a path the future, the photograph finds it difficult to escape the 'simultaneity' of its taking, manifest in the focus. Thus, while it may be possible for the photograph to progress from the indexical to the symbolic (via the iconic), a leap at the symbolic without the preceding moves will end in the symbolic's being sucked back into the indexical and nursing its own pretentiousness; the photograph is not given 'entitlement' by its title alone.

In the photomontage, on the other hand, the pull of the indexical has already been nullified. The photographic elements can now be used in an exploratory fashion: 'Montage offers a kaleidoscopic expanded vision which, by collapsing many views into one, suggests an experience of unfolding time.'[33] Moholy-Nagy's *Jealousy* (1925; illus. 56), for example, is a complex interaction of forms of being (silhouette, absent silhouette, shadow, negative) and of gender (the absent/white silhouette has a woman's legs and a woman – if the 1927 variant of this image is anything to go by – firing a gun, as its heart; the black silhouette is the shadow of the principal female). The only positive existences in this image are the two women, but only the bathing-suited one apparently has a literal function. If the 'other woman' is the vengeful force at the man's heart – the male images are derived from a photograph of Moholy-Nagy taken by his wife Lucia – then her murderous intentions will murder him too. In this conflict, even though he is 'possessed' by the other woman, he is a bystander, haunting the consciousness of the two other protagonists. In this triangular situation, the man loses his being and becomes subject to a multitude of kinds of half-being. And yet his repeated image is also an image of obsession, haunted as well as haunting, fixated on the targeted but carefree and smiling bather.

56 László Moholy-Nagy, *Jealousy*, 1925.

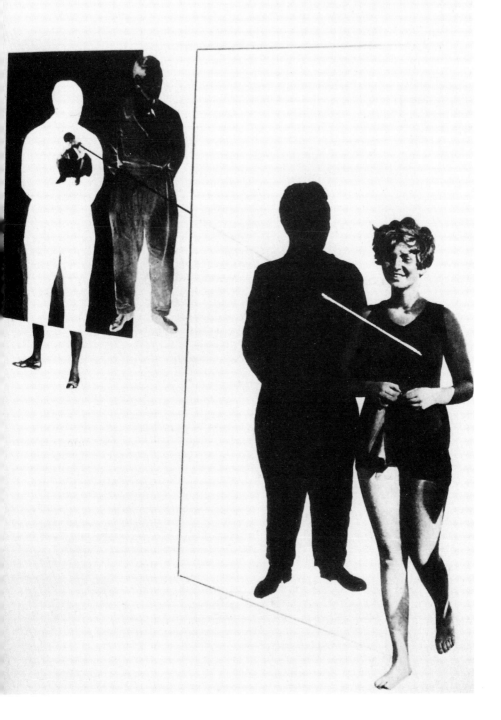

She alone, as if carefully stepping round the foreground frame, freely occupies the photograph's space, while the man finds it impossible to extricate himself from the frame, which is partly an index of his personal fixation, partly an indication of the way in which unruly feelings make specimens of us, partly a construction of a narrative of recession, of that fictionalizing process whereby we see images within images within images, often in dialectical relationships. Indeed, *Jealousy* does not represent jealousy, as if it were some stable concept, but investigates it as a geology of existential

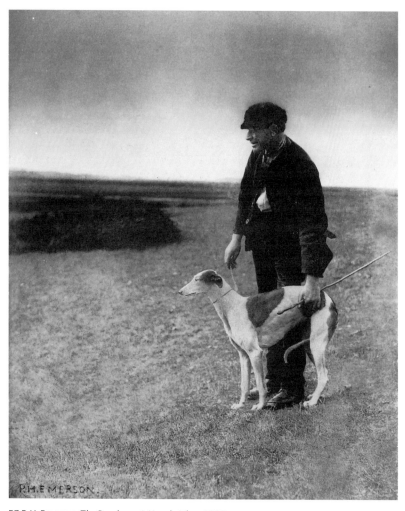

57 P. H. Emerson, *The Poacher – A Hare in View,* 1887.

THE SPOKEN IMAGE

strata – envy, anger, neurosis, love, possessiveness, feelings of inad-equacy – which form an unstable pattern of reversibilities (black to white, positive to negative, female to male, etc.). In other words, narrative, by means of dialectical and reversible relationships, acquires infinite extendability, unfolding through the recessive planes of the picture, of consciousness, of reality, so that the spatial does acquire temporal multi-dimensionality. In other words, jealousy realizes, and is realized by, a model of narrative.

Finally, we should consider the 'contemporary' narrative offered by Pictorialist photography and activated by the substitution of caption for title. Although we may associate self-ingratiating captions with the 'picturesque' of photographers such as Rejlander and Robinson, even Emerson's naturalism makes room for this habit of Victorian sentiment. The stern and uncompromising nature of many of his images is often belied by the participatory impulses in his captions. *The Poacher – A Hare in View (Pictures of East Anglian Life*, 1887; illus. 57), for example, is a curious blend of a title ('The Poacher'), which asks us to interest ourselves in a typicality (of pose, character, occupation), in an extended time-span, and a caption ('A Hare in View'), which asks us to involve ourselves in an imminent event, to look at the image with some excited anticipation. As we shift from title to caption, so we shift from the definite article (permanent type) to the indefinite (random event), from critical scrutiny (third-person relation) to participation (first-person relation), from self-defining image (the poacher) to the intervention of a narratorial voice (a chase is about to begin).

But, as we have already argued, the narrative that can be sustained by an 'ordinary' photograph is extremely shallow. We are locked into the given data, we undergo the constraints of the frame; the frame, for all the possibility of a limited 'blind field', produces a kind of narrative claustrophobia, which allows only unavoidable choices – '...the frame paralyzes action. I can no more intervene into the single picture than I can come back to it and find it something else'.[34] So the poacher will slip the whippet's leash and a hare will be caught, or not, and the poacher's belly, and the bellies of his family, will be filled, or not. Ideologically, Emerson undermines his own naturalism: because the confrontation with the type (the poacher) is diluted by a narrative which takes us away with the dog and into the photo-graph's 'blind field'; because this narrative itself is shallow and takes

us only to the end of an event, and not into the poacher's life. What is confrontational and attention-focusing by nature – a title – is replaced by what is diversionary and compromising and attention-absolving – a caption.

The political photomontage, on the other hand, sacrifices nothing ideologically in its captions, because its captions, besides having a double function as image-caption and placard-slogan, are attached to the kind of image that can reach beyond its frame. Where the captions of the Victorian photographers provide paternalistic reassurance and pinpoint the petty concerns of their social inferiors, the political photomontagist is an agitator, challenging his peers (the politically and socially inferior). John Heartfield's celebrated photomontage on the Hitler salute – *The Meaning of the Hitler Salute/Motto: Millions Stand Behind Me!/Little man asks for great gifts* (1932; illus. 58)[35] – by collapsing a distance (between Hitler and big industry), which usually makes relationships of cause and effect invisible, creates a sinister narrative. But the incongruities of scale, the cropping of the image, the relative positions of the figures, allow the narrative to expand without losing its political punch – in the end, Hitler is a 'small man', a pawn, receiving tips from a large, well-fed body which cannot be identified. Nazism may be about the creation of a master race, but which is the master race? As Hitler receives his backhander, we follow the diagonal of hands and faces, the descending parallels of industrialist's arm, jacket-bottom, and Hitler's belt, down beyond Hitler, to an implied, unending sequence of similar relationships. And because of the pun in the caption – 'Millions' – we can translate this money into people and see a slave trade.

Photomontage does not, as Berger claims,[36] always turn continuities into new suggestive discontinuities. It both creates unexpected continuities out of apparent discontinuities and creates discontinuities out of symbolic incongruities of scale, meaning and origin. The continuities allow the photographic medium to maintain its referential, indexical validity, while the discontinuities release narrative into symbolism and extend its range. As Berger puts it: 'We are still looking first at *things* and only afterwards at symbols.'[37] The doubling of meanings ('millions', 'great gifts') means that the photomontage *commits* Hitler to a revelation of purpose which, like some incompetent servant from farce, he does not intend to give away.

Photomontage releases photography into fiction and alternative time by making its realism serve fantasy and abstraction: 'Roh described montage as a precarious synthesis of the two most important tendencies in modern visual culture, extreme fantasy and extreme sobriety – or, put another way, the pictorial techniques of modernist abstraction and the realism of photographic fragment.'[38]

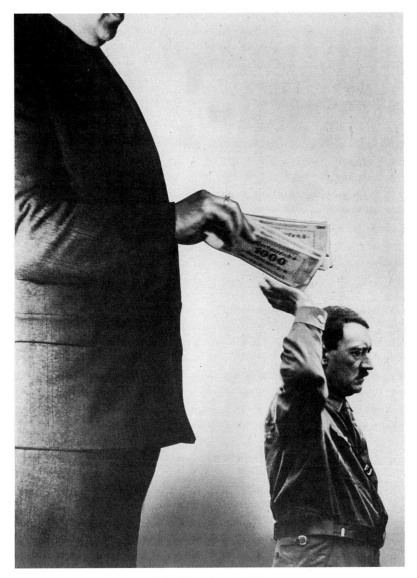

58 John Heartfield, *The Meaning of the Hitler Salute...*, 1932.

Photosequences, meanwhile, make possible a documentary mode whereby juxtaposed photographs can be used to interrogate each other, to penetrate, as it were, each other's surfaces. This was the purpose to which John Berger increasingly put the photosequences of his collaborative work with Jean Mohr, so that together, as writer and photographer, they could delve into the social and psychological selves of the culturally deprived, and into the vagaries of communal and private memory. But, initially, as we shall see in the next chapter, they felt that the supplement of language was still indispensable to an understanding of such sequences.

The Other Way of Telling
of John Berger and Jean Mohr

John Berger and Jean Mohr's *A Fortunate Man: The Story of a Country Doctor* (1967)[1] opens with a double-page panoramic shot of a car wending its way along a country lane. A couple of pages further on, we find a double-page image of two men fishing on a lake and the words: 'Landscapes can be deceptive. Sometimes a landscape seems to be less a setting for the life of its inhabitants than a curtain behind which their struggles, achievements and accidents take place' (p. 13). The photograph peculiarly designs landscape/environment as a setting: its two-dimensional compression of space produces a set of overlapping and receding planes, likes pieces of theatrical scenery, subject to the tonal differentiations created by aerial perspective; and one only has intimations of the space between these 'flats', a space one cannot see into. Berger and Mohr's 'portraits' of the culturally deprived, be they peasants or migrant workers, are investigations of lives, which, for the outsider, have been 'flattened out', whose third dimension is no longer visible, either because the rituals of existence have produced a deceptive homogeneity (the peasant), or because market forces have acted to anonymize the individual (the migrant worker). Berger's effort in his photo-essays is to get behind these flats, to reveal not only a hidden or suppressed life but also a realm of unexploited possibility. In both *A Fortunate Man* and *A Seventh Man* (1975), he seems to be of the conviction that language alone can open out the constricted, presentative (rather than inhabitable) space of the photograph, largely by the resource of metaphor. But by the time he and Mohr come to put together the photographic sequence of 'If Each Time ...' in *Another Way of Telling* (1982), the photograph has become the adequate instrument of its own exploration.

In *A Fortunate Man*, the photograph is as much a symbol of a certain way of perceiving reality as it is evidential illustration, and

that in two principal senses. In his early years of practice, the country doctor John Sassall is compared by Berger to a Conradian Master Mariner who confronts the unimaginable by blocking out imagination:

> It is almost as though the sea is the symbol of this contradiction. It is to the imagination that the sea appeals: but to face the sea in its unimaginable fury, to meet its own challenge, imagination must be abandoned, for it leads to self-isolation and fear.
> (p. 52)

One might propose that the photograph blocks out the unimaginable/imagination in rather the same way, by its very focus, by its ability to make its own version of the world the viewer's objective, by representing the world with a certain clear-sightedness. The medical equivalent of the photograph is the 'emergency', i.e. that which makes non-negotiable demands, the *fait accompli*, a reality simplified (two-dimensional, framed) and made dependent on the viewer (photographs plead their case). The viewer of a photograph is someone who does not need to examine his own motives. Ultimately this code of conduct proves inadequate for Sassall. The imagination needs to be more liberally admitted, the whole, rather than the localized, crisis must be taken into account, and an exchange between doctor and patient, viewer and photographer, must be installed, involving a reciprocal investigation of motive. Doctor, in healing others, heal thyself; the doctor must learn to 'recognize' his patient, both psychologically and physically. This shift between differing perceptions of responsibility is explored, or at least conveyed, through differences in photographic format, to which we shall return.

The second point at which the attitudes of protagonists coincide with the photographs which present them is to be found among the community of the doctor's patients, the 'foresters'. Sassall has come to master the art of recognition, vital to the 'foresters' because they lack the ready means of self-recognition. This kind of cultural deprivation, in which knowledge exists, but does not generate the capacity to think about it, in which knowledge cannot be verbally clarified and thus has to remain unnamed, manifests itself in habits of speech which are preoccupied with the external and practical. This kind of mental set is also embodied in the photograph. The

photograph, as a form of expression and representation, is culturally backward, primitive, depending for its persuasiveness on confusions of fact and truth, appearance and truth, and on the belief that the essential can be pictured and requires little by way of explanation.

In *Another Way of Telling*, Marcel, the owner of fifty cows, has his photograph taken, and far from undergoing the psychological crises which frequently beset more sophisticated sitters, he has every confidence, having chosen the photograph's constituents himself, that 'now my great grandchildren will know what sort of man I was'.[2] It is curious that those with the greatest faith in photography's ability to speak their truth should be those who do not take photographs. And there does seem to be some connection between our own tacit faith in the greater authenticity of documentary photographs (as opposed to other kinds) and the frequency with which their subjects are the culturally deprived. We ourselves, as sophisticated consumers of photographs, subscribe to the idea that photographic simplification and externalization can do justice to the conditions and interests of the underdeveloped:

> The greatest stumbling-block to accepting this [the social reality of the 'foresters'] is the false view that what people cannot express is always simple because they are simple. We like to retain such a view because it confirms our own bogus sense of articulate individuality, and because it saves us from thinking about the extraordinarily complex convergence of philosophical traditions, feeling, half-realized ideas, atavistic instincts, imaginative intimations, which lie behind the simplest hope or disappointment of the simplest person.
> (p. 110)

Mohr's photographs, by their variations of format, compel us to inspect our perceptual assumptions. The photographs themselves become a critique of the way we use photographs to make our thinking comfortably preordained.

But there is a third way, too, in which photography is powerfully appropriate to Berger and Mohr's purpose. Between pages 113 and 124, Berger meditates on anguish, exploring its connections with childhood and, particularly, with the child's perception of time. For Berger, what makes the child's life adventurous is a vivid sense of time's unfolding, that is, of time as irreversible, set on a course from

which it will never waver. This powerful awareness of time moving on and away is smothered in adulthood by patterns of recurrence and habit; but it may be released in the adult by loss, a loss which conjures up all other, irrevocable losses. But where, for the child, loss participates in a certain necessity, and where, for the child, the lamentation of loss can be dialogic, an appeal to others, loss, for the adult, is absurd, gratuitous, and begets a grief which is self-directed. The adult's experience of anguish, in other words, relates directly to the experience of the photograph, for the photograph, unless installed immediately in a narrative, has both a peculiar gratuitousness, relating to its relative instantaneousness, to its narrow historicity, and a profound irrevocability. By contrast with the child, the anguished adult suffers from the conviction that what has happened is absurd, or is at best without sufficient meaning. That is to say, the meaning which remains cannot possibly balance what has been lost. We have, then, a strange paradox, whereby that by which the culturally deprived express themselves, the photograph, is equally the proof of an anguish, and a further paradox, whereby that by which they express themselves, the photograph, diminishes the amount of meaning they have available for themselves – as if each photograph of them reduces their potentiality to be more or other.

Sassall's sense of inadequacy is connected with his patients' subjection to the 'photographic', in its metaphorical as well as literal dimensions. As Berger explains it, Sassall's disquiet grows from the discrepancy between the realistic expectations of his patients (as far as their lives are concerned) and his hopes for them (p. 141). These realistic expectations are an extension of our second point: the 'foresters' work to a foreseen minimum, not so much a material minimum, as an emotional, intellectual, spiritual one:

> It almost empties of content such concepts (expressed in no matter what words) as Renewal, Sudden Change, Passion, Delight, Tragedy, Understanding. It reduces sex to a passing urge, effort to what is necessary in order to maintain a *status quo*, love to kindness, comfort to familiarity.
> (p. 142)

Berger refers to *A Fortunate Man* several times in the text as an 'essay'. The book is dedicated to John and Betty 'whom it concerns'. And although the case histories mentioned do not refer to particular

persons and are compounds of several cases, the book is clearly a documentary work in the tradition of the photo-essay. But there are senses in which this a rather special documentary.

To begin with, it is double in nature: while Berger/Mohr document Sassall, Sassall documents his patients, he is the 'clerk of their records' (p. 109), both imagining the 'foresters' and speaking for them. Our argument about documentary photography in Chapter 3 suggested that the viewed becomes the viewer, that the subject invades the space of the spectator with questions that cannot be answered. We have already mentioned the sense in which the 'foresters' confront Sassall with his own inadequacy, his inability to improve the social/psychological 'health' of his patients, and the sense in which the process of curing others is a programme of self-cure. The point needs no further labouring, and John Sassall's suicide subsequent to the publication of the book seems to bear out what one might also trace in McCullin's work: the degree to which the need to get closer to those who are culturally alien, in order to represent them, produces a much profounder existential alienation in the documentarist:

> Some may now assume that he has taken over the role of the parish priest or vicar. Yet this is not so. He is not the representative of an all-knowing, all-powerful being. He is their own representative. His records will never be offered to any higher judge. He keeps the records so that, from time to time, they can consult them themselves.
>
> (p. 109)

As happens literally with the defenestration of Jeff in *Rear Window*, the documentarist is 'squeezed out' of his own existence, begins to operate in a twilight zone, a borderland, 'from whose bourn/No traveller returns'.

As the above extract indicates, much of the reason for this alienation lies in the doctor-documentarist's inability to inhabit a third-person, or a first-person, narrative position with any consistency. A third-person perspective would allow the documentarist to say 'this is how it is', to be the spokesman of 'truth', or of a government, or an international agency — to be an anthropologist or sociologist, in short. A first-person perspective would allow the documentarist to be an autobiographer (as McCullin in *Unreasonable*

Behaviour), to turn the evidence, which draws us all out of ourselves, into the experience by which we are justified in returning to ourselves. The whole point of Sassall's education, his complication of the originating Conradian ideal, lies in the itinerary which takes him from a resolvable I/it, or I/him, or I/her, relationship to an unresolvable you/me, from one in which the 'other' is something to be worked on and put right by a self in command, to one in which the 'other' is someone to be worked with, brought on, by a self which has yielded the initiative to this 'other'. We shift from the self who has knowledge to the self who recognizes.

Berger, as the documentarist of Sassall, operates in the same fluid and ambiguous space, negotiating between evidentiality and involvement, and the different roles of the first person:

> What I am saying about Sassall and his patients is subject to the danger which accompanies any imaginative effort. At certain times my own subjectivity may distort. At no time can I prove what I am saying. I can only claim that after years of observation of the subject I believe that what I am saying, despite my clumsiness, reveals a significant part of the social reality of the small area in question, and a large part of the psychological reality of Sassall's life.
> (p. 110)

The particular historical conjuncture in which he finds himself disqualifies Berger, too, from judging his subject by the choices he makes. Just as earlier in his practising career Sassall relished the crisis, the medical problem which could be isolated, which stood off from him, and could be dealt with once and for all, Berger would similarly have been able, had circumstances been right, to summarize Sassall's moral value, to assign to him an historical role, to uncover his moment of truth. But Sassall belongs to a time which is 'an exact and prolonged antithesis to a moment of truth' (p. 162), and in which no choices have been exercised. Like Sassall, therefore, Berger must bear the cross of the recognizable but unknowable, must cast himself as documentarist/narrator, in the role of one who lives with his subject in a relationship of sympathetic alienation and Faustian dissatisfaction; the fraternity of recognition is undermined by the discrepancy of perspective.

What material consequences does this have for Berger? Quite simply, he cannot conclude. Generically he has forgone the easy options of fiction (ability to construct a moral universe as desired), autobiography (complete control of one's own life), biography (significance already ascribed to the life by implication) or the obituary essay (the subject is 'framed', 'definitive', and the author is clearly the 'protagonist'). He is left 'at the mercy of realities [he] cannot encompass' (p. 159). And, in terms of moral judgement, he cannot say what Sassall's life is worth in any particular sense. He can only affirm Sassall's value in its non-assessability, in the way that his practice resists society's gradual devaluation of social interaction, in the stoicism with which he struggles against death's determination to diminish him.

If it is true to say that Sassall undergoes a conversion, the same might be said of our narrator(s). We have suggested that the photo-graph is an equivalent of the emergency, the crisis, single and simplified. The documentarist must evade this lure, which is, in fact, the currency of the photojournalist (the photojournalist relates to the event itself rather than to its circumstances, is able to localize/ locate the 'problem' of a total situation, by focusing on a particular symptom or detail). But photojournalistic intentions are sometimes diverted into documentary ones: the patient becomes more inter-esting than the illness, the illness can only be remedied through the patient, the photographer becomes not only affected but implicated (psychologically or physically). He feels increasingly like a repre-sentative and less like a messenger. Suddenly the summary/ resolution provided by the single photo is insufficient – only the sequence will do. In *A Fortunate Man*, after the isolated single images which accompany the selection of cases described, up to page 41, the book engages with grouped photos. In these groupings is enacted the documentarist/doctor's true desire: that a careful diagnosis will itself constitute the therapy, in part at least, since no radical solution, no revolutionary change, is to be expected. But even this is inade-quate. To become a witness rather than an arbiter requires more than recognition; it requires expression, too:

> There are large sections of the English working and middle class who are inarticulate as the result of wholesale cultural deprivation. They are deprived of the means of translating what they know

into thoughts they can think. They have no examples to follow in which words clarify experience.

(pp. 98–9)

It is in consultation with his patients, it as the clerk of their records, that John Sassall can begin to bring language to the 'foresters'. But he remains painfully aware that whatever new light his own expressed thought may shed on their lives, his intellectual persuasions – the Faustian seeker, the Universal Man – cannot displace their own, that his speculative language will not oust their proverbial utterances, the lapidary voice of common sense. Sassall will not, in short, displace their photographs with words; the photograph will continue to exert its power of confirmation, its constraining focus, its two-dimensionality behind which it does not pay to look, behind which much pain is stored, a pain, however, which can produce nothing, no psychological enlargement or social change.

For Berger looking at Sassall, on the other hand, language is what releases comparison – Conrad, Faust, the medicine man, Yeats, Gramsci – comparison which widens reference as it aids comprehension. Language produces that proliferation of role and association which gives the documentarist a route back into his own society, the society of readers, away from the trauma of bare evidence, of the photograph. Sassall is caught in a vicious circle: he is the doctor of the community which provides his subjects – they are his patients not his examples, they are his brothers not his case-histories; they must learn from what he learns from them. For Berger, on the other hand, the readership is the community, which is cured by his diagnosis of Sassall; and however deep his fraternity with Sassall, it is not in relation to Sassall that he will find his justification. Sassall's presence among the 'foresters' only exacerbates their regionalism, only produces photographs of what is already there. Mohr's photographs are made to serve much larger issues by the flexibility, the 'deviousness', the 'looking behindness', of the language they come to complement. Berger himself makes no bones about the inevitable rhetoricity of language; the important thing is not that language is rhetorical, but that it displays it and sets our imaginations to work with it. Photography, too, is rhetorical, but covertly so, and in such a way that even by deconstructing it, we will not make ourselves privy to a greater truth about its subjects. Berger's admission comes like this:

I am very well aware that there is a certain clumsiness in my metaphorical devices. And what do they matter? On the one hand a sociological survey of medical country practice might be more useful: and on the other hand various statistical analyses of the degree of satisfaction expressed among patients after different forms of treatment might be more revealing [...] But what I am trying to define here are relations which cannot yet be reached by a question-and-answer analysis.
(p. 110)

At the outset of this account, we quoted the 'epigraph' on the second double-page landscape photograph. This first epigraph is developed by another, on the third double-page landscape: 'For those who, with the inhabitants, are behind the curtain, landmarks are no longer only geographic but also biographical and personal' (p. 15). Implicit in these epigraphs, it seems to me, are two related convictions about photography: that photography cannot, like language, 'look out of' its subject, adopt his/her/its perspective; it can only 'look in'; and that it cannot, like language, 'look into' its subject in a penetrative way, cannot exploit the Bragaglias' intersticial movement or Benjamin's optical unconscious, *unless the photograph is part of a narrative* (Benjamin's photographic analyses are usually narrative in nature).[3]

A Seventh Man: The Story of a Migrant Worker in Europe (1975)[4] presents itself as an attempt to enact a Brechtian interruption in the dream/nightmare of the migrant worker's submission to the capitalism of developed economies:

In a dream the dreamer wills, acts, reacts, speaks, and yet submits to the unfolding of a story which he scarcely influences. The dream happens to him. Afterwards he may ask another to interpret it. But sometimes a dreamer tries to break his dream by deliberately waking himself up. This book represents such an intention within a dream which the subject of the book and each of us is dreaming.
(p. 7)

And the overall method of writing is an interruptive one. The reader is not given the opportunity to identify with a principal protagonist, because there is only the unnamed, multiform 'he', whose mooted nationality and social background shift. The reader is not treated to

a narrative submissively unfolding for his own convenience, for the basic narrative structure – 'Departure' > 'Work' > 'Return' – ramifies, is intercut with documentary information, poems, a range of photographic modes. We proceed by leaps, by fits and starts, so that critical spaces – the urge to question and ponder – are constantly being opened up, so that we are constantly faced with the task of connecting the unlike, the particular with the general, the regional with the global.

As a psycho-socio-economic enterprise, *A Seventh Man* is more methodical, more explicit about its means, than *A Fortunate Man*, but the relationship between text and photos is much the same. In his 'Note to the Reader', Berger makes clear that images and text should each be read in their own terms, the former only occasionally illustrating the latter. Each medium creates its own sequence and therefore its own narrative, although one might argue that the verbal narrative imitates the visual one in preferring coherence to cohesion, in trying to release narrative from its dependence on temporal unfolding (the photographs, for example, were taken over a period of years). This resistance to consecutive time is important for two reasons.

First, it is part of Berger's pursuit of a social realism which has a content rather than a plot, which reveals historical forces as much as individual destinies, which dialectically oscillates between a third-person and first-person modality. Social realism is an implicit rejection of the naturalism of the photograph, that apparent devotion to appearances, that positivistic belief in the reliability of the visible evidence, which, in effect, confirms and promotes the status quo. Second, it allows the reader to come to an understanding in a time of his own making, so that realizations are not compelled, but arrived at. In this sense, social realism shows itself to be closely affiliated with the avant-garde. We make 'difficult' works more difficult for ourselves by continuing to apply the rules of the cohesive; but if we approach such works in a state of suspended availability, they become remarkably easy, the more so because they seem to speak directly to a flexible, heterogeneous inner duration rather than to a rigid and conventionalized external schema.

It might, however, be fairer to say that, in Berger's writing, the avant-garde is more characteristic of a method than of a tone, for there is no doubt that the structural openness is not matched by a corresponding non-tendentiousness of voice. Berger's magisterial,

'secularized millennial'[5] tone is not as obtrusive in *A Fortunate Man* as in *A Seventh Man*, where, significantly, the photographs are entitled (or 'captioned' as Berger has it): 'When documentary information makes it easier to look into a picture, the picture has a caption beside it. When such information is not immediately necessary on the page, the caption can be found in the list of illustrations at the end of the book' (p. 7). It is as if Berger willed his voice to his migrant workers, at least allowing them to say who they are and where they come from. The 'foresters' of *A Fortunate Man* may have lacked voice, but they had not been uprooted; they retained identity in community, and Sassall became their clerk. The migrants, however, are dispossessed of voice and identity, an ironic fact given that photographs, the standard proofs of identity, are the only communicative instruments they have left. Berger, then, must become their Sassall, which he does, not only by statistical diagnosis (the crisis, the 'external' case) but also by metaphor, the leap at recognition, the speculative instrument, about which we shall have more to say later: 'Yet necessarily the language of economic theory is abstract. And so, if the forces which determine the migrant's life are to be grasped and realized as part of his personal destiny, a less abstract formulation is needed. Metaphor is needed'(p. 41).

The book opens with a short disquisition on the photograph: 'A friend came to see me in a dream. From far away. And I asked in the dream: "Did you come by photograph or train?" All photographs are a form of transport and an expression of absence' (p. 13). The photographs carried by the migrant attest to the absence of the person photographed. For us, the readers, as Berger acknowledges, it is the other way round: the book's photographs conjure up presences. But there is another difference: 'He puts it [the photograph] immediately back in his pocket without glancing at it. As if there were a need for it in his pocket' (p. 16). We do not look at, scrutinize, inspect, photos of the ones we love, because we do not require knowledge of them and because the photograph is only a temporary substitute, a pledge with only fiduciary value; to look too closely might be to break a spell. But as readers, as outsiders, we examine these photos, looking for information, possible situations or narratives; our critical gaze is likely to take us dangerously out of empathy. So both these differences have to be bridged, have to be held in metaphorical tension with each other: absence/presence; empathy/scrutiny.

In these opening pages, Berger makes one further observation about the function of the photograph for the migrant: 'It holds open, preserves the empty space which the sitter's presence will, hopefully, one day fill again' (p. 16). Much later in the text, Berger looks at the lifetime of the migrant worker in relation first to bereavement, and then to absence. In the normal way of things, the present enters the life's time, and the past (memories) and future (hopes, fears), free and unfixed, continually adapt themselves to it. In bereavement, the past of the life's time becomes temporarily fixed (fixated on the deceased) and the future withdraws, no longer a possibility. Absence (imprisonment, migration) is potentially even more destructive: the prisoner/migrant experiences absence doubly – as something missing from his life, and as something continuing without him:

> Increasingly he may begin to live by way of memory and antici-pation, until the two of them become indistinguishable, until he anticipates his release in the future as the moment when he will rejoin all that was left in the past. Imprisonment is designed as the categorical denial of the present.
>
> (p. 178)

Accordingly, past and future have become static, and the future is merely the past projected forward to the point of the prisoner/migrant's return. The present cannot be made use of in this pattern: leisure-time, time not filled with anticipating the future (past) in work, weighs heavily on the migrant's hands. The present remains external to the migrant's life's time, is something possessed by the metropolis in which he works, or which works him. Even the pornographic photographs round his clock – photographs which theoretically offer instant sex and make a kind of relating available – even these act as cold-storage units, as repositories, or pledges, of a virility which will only be activated on the migrant's return. Ironically, these photographs have almost the same function as those of his nearest and dearest: they are the only present he can live with, the present which both defines the absence he is orientated towards, and holds it open, suspends it, so that the past may be rejoined in the future without the present having interfered with it. Curiously, for the migrant worker, the photograph is both the guarantee of a life, a life dormant and anticipated, and a guarantee

of a death, the death of a present which does not belong to the worker. The photograph, as it were, kills the present by ostensibly substituting itself for it, even though it belongs itself to the past.

This contradiction is the source of the worker's tragedy, of the failure of migration. Time, after all, has not stopped, and will inevitably frustrate any attempt to reinstall the past. When the migrant finally gets home again, it is too late: one half of the reason for returning (the enhanced prestige, the purchasing power) effectively destroys the other half (the recovery of the past as it always was): 'Unchanging as the village is, he will never again see it as he did before he left. He is seen differently and he sees differently [...] An assured place for him no longer exists in his village' (pp. 220 – 21). But once he has returned, the photographs will have no role to play ('For a whole month now the photographs will become redundant' [p. 215]), because this is a culture for which the photograph is only a repository of the known, not an instrument of knowledge. The migrant worker does not take photographs, does not work to buy a camera; his attitude to the world is passive rather than inquisitive. For the reader, however, as already noted, the photograph gives access to the 'other', however imperfectly. Even though no dialogue with the image can be instituted, it can be interrogated and we can make our own sense of it. The photograph for the migrant is an anachronistic, or a-chronological, moment, a way of stepping out of time. For us, it is part of a lived present, changing our posture towards the past and the future, however much we may need language to negotiate its significance in our life's time.

The migration of the migrant worker involves the sacrifice of language. Temporarily his language hibernates, and an intensified vulnerability, both spiritual (he is open to exploitation, he cannot make his wishes known) and physical (he cannot read warnings on machinery), results. Because the host nation does not have to come to terms with the worker's language, it does not have to come to terms with the worker's being, and thus cannot envisage the worker as an equal ('Equality has nothing to do with capacity or function: it is the recognition of being' [p. 141]). But a language, too, is a whole system, whose parts cannot be understood separately or without a knowledge of its pragmatics ('He learnt twenty words of the new language. But to his amazement at first, their meaning changed when he spoke them' [p. 118]). The wholeness of language is a

prerequisite for a wholeness of being and thus for equality ('The principle of equality is the revolutionary principle, not only because it challenges hierarchies, but because it asserts that all men are equally whole' [p. 141]).

Reading this text, then, becomes a peculiarly disorientating experience for us. We are the owners of the language of this text; the migrant workers are migrants in our textual reality. We judge them, like the immigration officials, by appearances, by their photographs; we verify identity, we examine them physically like doctors. Photographs are the way they communicate with us; photographs are the way they hand themselves over to us. And our language, the language of the text, envelops them, and, in the 'captions', 'entitles' them. But with these 'captions', too, as we have said, Berger wills them a voice, for he is their Sassall, and the text which we might believe was exclusively ours, begins to become theirs. The questions that Berger really asks in *A Seventh Man* are questions directed at the reader. Are you prepared to accept these migrants into your speech community? Are you going to expel these workers after they have served their turn in the text? Are you going to send them home again when you close the book? Our response will depend on two things perhaps: whether we have managed to empathize sufficiently with the migrants to view their photographs in the same way that we would view photographs of those close to us — not clinically and evaluatively, but with that set of glances which is like a re-establishing of contact or the affirmation of relationship; and whether we have read ourselves into this text, with sufficient imaginative energy, through the constructivist possibilities and metaphors offered by montage.

By and large, the photographs in *A Fortunate Man* and *A Seventh Man* constitute the muteness, the anonymity, the entirely pragmatic 'language' of the culturally deprived. It is through these two-dimensional representations that the subject is made accessible, vulnerable, manipulable. But Berger has been anxious to encourage us to 'look behind' these photographs, to adopt towards them the kinds of attitude and response which they might have aroused in their possessors and subjects. We should not, however, allow ourselves to believe that the photographs constitute a simple, homogeneous language. Let us remember that they are not autonomous images, but images presented. They now have a textual existence; like direct speech in narratives, they are reported direct speech. They certainly

preserve a degree of autonomy, but even when they occur without captions or textual comment, they are subject to, and diversified by, the rhetoric of the page, by layout and framing.

In *A Fortunate Man*, for example, all photographs, up to the explicit introduction of Sassall on page 44, are full-page (either double- or single-page) images of landscape, containing different signs of human habitation (car, houses, telegraph wires). The 'grammar' of these images is that of the zero/indefinite article. In other words, the image is random, generalized, 'spontaneous', but also, crucially, enveloping and proximate. We are taken to the heart of a country without knowing why we are there or who we will meet, without preconceptions or briefing. And these photos have the light tones and the grainy mistiness of enlargements, characteristics which prevent them from belonging entirely to the external world, which suggest that they are imaginable, the stuff of memory or dream.

Once Sassall has been introduced, photographs framed by white borders of varying sizes make their appearance. Their grammar is that of the definite article; we are, in a sense, removed from them, they have a greater degree of intentionality and focus. We look at them, as through a window, inquisitively, voyeuristically, critically. These are the kinds of image out of which one would want to make a sociological narrative; these are not images of uncontrolled personal encounter. But these framed photos do not supersede the unframed, full-page ones, and as one shifts from one type to the other and back

59 Jean Mohr, Untitled photograph, from *A Fortunate Man: The Story of a Country Doctor* (1967), p. 90.

60 Jean Mohr, Untitled photograph, from *A Fortunate Man*, p. 92.

again, one undergoes kinds of psycho-perceptual shifts which enrich one's relationship with the subject. Let three short examples suffice.

Between pages 90 and 96 occur seven images of local inhabitants. None of these are studies of individuals in working contexts; they are personal portraits. The first is a full-page head of a man wearing a woollen hat (illus. 59), not looking directly at the camera. We do not have his attention; he lives past us, in a space which is as large as ours, which we have not made. He is, in a peculiar way, being coterminous with the page, coterminous with the book; his 'blind

61 Jean Mohr, Untitled photograph, from *A Fortunate Man*, p. 114.

62 Jean Mohr, Untitled photograph, from *A Fortunate Man*, p. 118.

63,64 Jean Mohr, Untitled photographs, from *A Fortunate Man*, pp. 169, 171.

156

65 Jean Mohr, Untitled photographs, from *A Seventh Man: The Story of a Migrant Worker* (1975), pp. 156–7.

One tunnel was to run for five kilometres under the town and would collect all the rain and gutter water of the right bank and discharge it into the Rhone below the lake. A second tunnel was to run parallel with the first for more than half the way, and would carry electricity and telephone cables and water mains for the new buildings and the new offices in which so many plans on a world-scale were being drawn up. The diameter of each tunnel was to be 3.6 metres.

Tunnelling began in June 1971 and will continue until 1976. In tunnelling space restricts the amount of labour that can be used. Even with three faces being worked simultaneously, there is work for only a hundred men. Most of the men now working are Yugoslavs. There are also Spaniards and some Italians from South Italy. On the many building sites in Geneva most workers are migrants. In the tunnels they are one hundred per cent migrant. The two engineers and one of the foremen are German.

field' is not the white of a surrounding page but the space we occupy. We must thus come to terms with him in a way that other photographs in the sequence, the last five of which all have subjects addressing the camera, do not require. We have to accommodate him, make room for him, react to the pressing demands his expression and proximity make on us. We are his doctors in open consultation; he is our patient and responsibility. The framed photos which follow (see illus. 60) – there is one further full-page image – are like cases already treated, cases of clinical or historical, rather than of diagnostic or personal, interest. These framed photos already belong to a past, while the initial full-page image belongs to an inescapable present, requiring a future of us.

Berger's reflections on anguish are accompanied by a sequence of five photographs (pp. 114–18), four of which depict a weeping woman and an elderly man, a comforter. The first three images are framed, and are, in this sense, illustrations of Berger's thesis about anguish. The final two are full-page images which convey something of the changed temporal scale that anguish produces ('Such awareness of irreversibility slows down time. Moments can "seem like years" because, like a child, one feels that everything has changed for ever' [p. 124]). The zero/indefinite article removes objects from history, from passing time, while the definite article firmly locates things in history. Another effect produced by the full-page image is something like the personification of anguish. Where the earlier, framed images depict a woman feeling something which might well be called anguish (illus. 61), the final photos amplify the state (see illus. 62), so that it occupies the total available space and thus makes it seem that Anguish has visited itself upon this woman, as an encompassing, atmospheric presence.

Finally, the last two images of the book are of Sassall climbing a steep slope towards a cottage; at the top of the slope a family waits. But whereas in the first of these images, full-page, we see the whole picture, in the second we see only the climbing Sassall, isolated in a sea of blank space (illus. 63, 64). This ending has something cinematic about it: the camera's lens screws down to our last view of the doctor as we leave him to go about his continuing daily business. But more than that, the final framing of Sassall leaves him imprisoned in his community. He arrived as a go-between, as someone endowed with the freedom of outside, and, by dint of acting for the 'foresters', he

has cut off his own avenue of escape, back to the world of the reader. The previous, full-page image has the heroism of an allegory: the doctor scales the steep slope of human tribulation, hears the cry of those marooned and in need of succour, and with a firm tread and unflinching steadiness of purpose, he not only cures them but reconnects them with the rest of the community. As with another character from Conrad, Lord Jim, Sassall's commitment to a community allows him to discover freedom of action, to fulfil his potential, to achieve mythic status, but the price he has to pay is the non-transferability of these benefits; he must live himself out in the same narrow, non-expanding circle.

A Seventh Man employs the same techniques but, not surprisingly, extends them: the multiple media of the metropolis, the many countries included, require a wider range of visual reference. To the framing devices already explored, Berger and Mohr add the photograph with the thin black border. This not only insinuates a funereal note, but increases the image's fixity, finality, finish – such photographs have a peculiar self-consciousness, a certain exhibitional quality, which removes the image further from the viewer, tempts the viewer to replace a social concern with an aesthetic appreciation.

In terms of photographic material, Berger and Mohr add posters, a page from an instruction manual, a painting, a magazine cutting, a photograph from a book, and four sets of contact prints (illus. 65). These last occur in the description of migrant labourers' work on the drainage system under Geneva. Their expressive effects are manifold: laid out horizontally, they are themselves tunnels of images; they insist on the repetitive nature of the work and the

66 Jean Mohr, Untitled photograph, from *A Seventh Man*, pp. 158–9.

lodging rooms; they positively 'reduce' the subject, not only in size, but by constantly replacing him with another image. They invite the same selective processes in the viewer which the immigration officials have already exercised; they quite literally produce a fragmented and topsy-turvy world (some images upright, some on their side, depending on how the camera was held). But in a moment of visual drama, one of the contact prints is blown up into a double-page (full-page) print (illus. 66); this a moment of reclamation, when one of the hitherto undifferentiated Hadean souls is resurrected, restored to self-imposing consciousness.

The reading of these photos is thus far from having a cognitively homogeneous nature. We are required continually to adopt different perspectives and perceptual modes, and are encouraged to relate the images to each other in a variety of different manners. The narrative capacity of a photograph in a text depends a great deal on factors of typography and layout. That is to say that in some sense the page itself narrates, is the narrative viewpoint on, what the photograph presents. But if part of the heterogeneity we have been speaking about is temporal, temporality has a much more complex part to play in the photographic sequence.

The issue of time in the photograph has been much muddied by the same misconception that has bedevilled the perception of time in Impressionist painting. Impressionist painting, like photography, is reckoned to capture the instant, the fugitive, the transitory. This instant may be an instant of revelation, a 'decisive' moment, an epiphany, call it what we will. But the epiphany may have two very different sources: it may be that the split-secondness of the instant has revealed one of those intersticial spaces, that optical unconscious, normally invisible to us (Muybridge, Marey, Benjamin, etc.). On the other hand, the instant may be significant because it synthesizes a variety of different temporalities. Impressionism is important for depicting not the transitory but the relative. What is arrested in the instant is a whole gamut of different time-scales, and what is revealed to us is their interaction.

These differences of time-scale/temporality are produced, broadly, by four factors: (a) an object's innate durability (a rock is 'slower' than a peach); (b) an object's posture or position and the way in which this relates to stability, to the pose which can be held (a book laid square on a table is 'slower' than a book laid crooked; a closed

book is 'slower' than an open one); (c) the composition of the whole image and, again, the way in which this relates to stability (an image constructed on a diagonal is less persistent than one constructed on a horizontal; asymmetry is more dynamic, more time-filled, than symmetry); (d) in photography particularly, focus. High focus will tend to historicize the motif, to draw it more firmly into circum-ambient time. Photographs with softer focus (calotype, pinhole, gum bichromate, vaseline, etc.) tend to fictionalize the image, i.e. to make it available to a wider range of temporal possibility (to a range wider than that of its taking). The taking of a photograph (its indexical dimension) may well be instantaneous; but this is a mechanical matter and need not affect the temporal potentialities of the motif. The image itself (in its iconic and symbolic dimensions) is inevitably time-filled, and, what is more, filled with different times.

I would like to relate this proposition to a sequence of four photographs that occurs on pages 172–5 of *A Seventh Man* (illus. 67–70). This sequence centres on the image of three migrants in a lodging room (barracks, in fact), whose walls are covered with soft-porn photos of women. Dyer explains the difficulty:

> Berger and Mohr wanted to use the photo as an 'indirect index of the sexual deprivation suffered by these men' but the problem was how to use it without appearing either to approve the 'virulent sexism' of the images or to reduce it to simple evidence of the migrants' misogyny.[6]

Their solution was to preface the above image with two images of maternity, one real (a photoportrait of a Greek peasant woman at a market), the other idealized (a Madonna by Perugino), and to follow it with a photograph of a peasant girl (a girlfriend? wife?). The sequence is commented on by Berger and Mohr in *Another Way of Telling*:

> Photographs can relate the particular to the general. This happens, as I have shown, even within a single picture. When it happens across a number of pictures, the nexus of relative affinities, contrasts and comparisons can be that much wider and more complex.
>
> The following sequence, taken from the book *A Seventh Man*, was intended to speak about a migrant worker's sexual deprivation. By using four pictures instead of one, the telling, we hoped, would

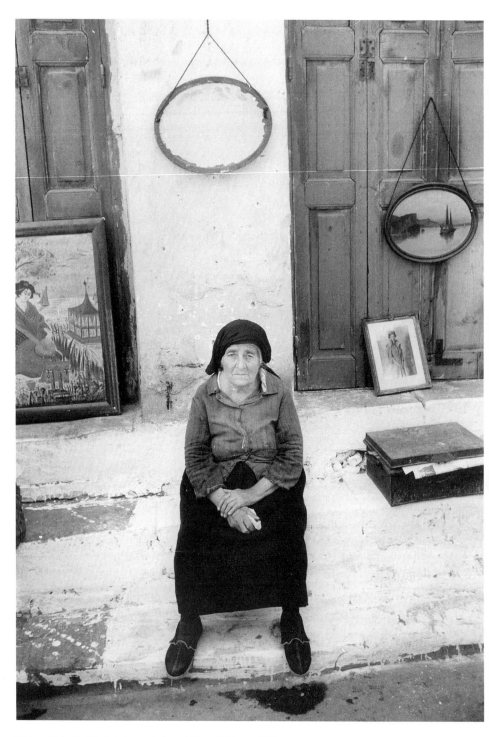

67 Jean Mohr, Untitled photograph, from *A Seventh Man*, p. 172.

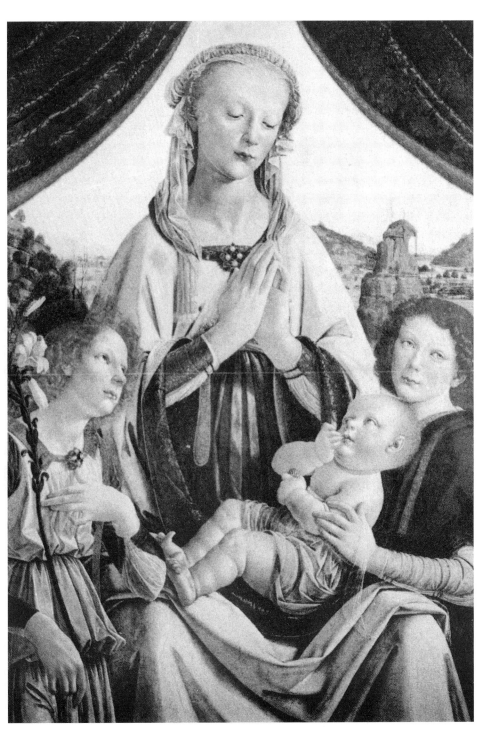

68 Madonna by Perugino, from Jean Mohr, *A Seventh Man*, p. 173.

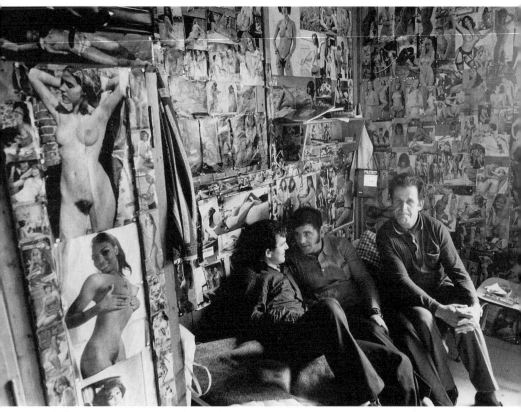

Wall above bed in barracks, Switzerland

69 Jean Mohr, Photograph, from *A Seventh Man*, p. 175.

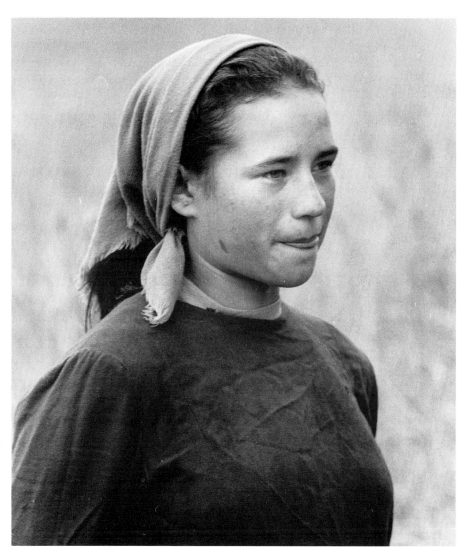

Peasant girl working in field

70 Jean Mohr, Photograph, from *A Seventh Man*, p. 175.

go beyond the simple fact — which any good photo-reportage would show — that many migrants live without women.
(p. 281)

Berger and Mohr are wrong to assume that a wall plastered with soft-porn photos will be read as a declaration of misogyny or 'virulent sexism': this practice is a social commonplace which indicates (a) that the place is generally unvisited by women, and (b) that it is communal rather than private (the pictures belong to nobody in particular). Besides, Berger has been at pains to argue that the present of the metropolis, which these photos represent, does not impinge on the life's time of the migrants. These photos are an index of a cultural alienation, not of a cross-cultural sexual complicity.

However, it is certainly true that meanings multiply when we add the three other photographs. Currents of oedipality or matricidal sacrilege become available. The repeated figures of the naked women, thrown into relief by the solitude of the old woman and the peasant girl, echo the more general experience of the metropolis: proliferation of the same. The four images create two diptychs: the mother becomes increasingly unreal and culturally removed, while the peasant girl is redeemed from the sexually indiscriminate, from the appetite for proximity.

But we should not overlook the temporal complexity of this sequence either. The image of the old woman/mother enacts a process of temporal deceleration and relocation: a fixed facial expression, a comfortable posture, hand laid on wrist, the relative symmetry of the image, all these things combat the element of instability introduced by the shallow diagonal. The woman is surrounded by framed images, and the mirror above her is as if waiting to receive her image in its turn. And then the time which she inhabits will have been located elsewhere, will have become the time of fictionality, of eternity, the time that belongs to our understanding and imagination of her, rather than to her being. This mother is already half into this other sphere: the closed shutters, the small box of wares/belongings(?), her eviction from the familiar interior. This mother, dispossessed of her family, is returned to a familial plenitude, interiority, in the Perugino painting. But the time of the painted image ousts the photographic time of its reproduction, the real time that clung on, like a farewell, in the previous photo-

graph, of the old woman. This image of reassurance (Perugino) is in fact, within the sequence, an image of something unattainable, locked in a temporality to which the camera, the instrument of the workers' memory, cannot gain access.

The third image, that of the three workers and the pornographic images, throws us into a complicated, restive time, differentiated, difficult to organize. The images within the image, now no longer coterminous with the photographic frame, do not offer temporal oases, escapes from the headlong and anarchic times of the metropolis. These 'pin-ups', as if multiplying before our eyes, are the creased debris of self-replicating magazines, and the nudity of the women is not a nakedness of self but a nudity of anonymity, the selling of body-parts. Within the incomprehensibility of this disorientating plethora of images, in which the repeated instants of photographing have become dizzying,[7] masking the sharp contours of space (how is this room laid out?), the workers reconstruct a temporality of their own. The man on the right (the older? the slower?) clutches his knee, poses, smiles for the camera, tries to affirm an identity with its own time. As for the other two, the camera, unnoticed, intervenes in a conversation, with its unstudied postures. But those who do not vie for our attention capture it. While the man on the right, ironically, with his sense of occasion, competes with the pin-up girls in the struggle for acknowledgement, we find our interest settling on the conversationalists. And as this happens, so the initially invisible structuredness of the picture becomes manifest. The image acquires a stability, slows down again, becomes less hectic – the older man parallels the girl holding up her breasts, and these figures frame the two inturned, conversing men. The line of heads creates a gently rising diagonal which leads out of darkness into the light falling on the side of the older man's head, which itself echoes the light falling on the face of the left-hand conversing man. The other focus of light, the older man's hands, lies at the end of another gentle diagonal, leading from the pin-up's breasts and across the knees of the three men. This strong pull towards the right is countervailed by the fact that four of the five principal heads (three workers, two larger pin-ups) are turned to the left.

The different and changing temporalities of this photograph enact a drama in which we are pulled roughly into conflicting timescales and then released from this conflict as the image composes

itself, and in its composition finds some temporal equilibrium. This prepares us for the final image, the peasant girl, who, in herself, synthesizes a certain temporal complexity. In place of the 'slow', primitive frontality of the old woman, we have the less stable, more 'refined' three-quarter view. While the old woman's hands and feet are visible in their plantedness, the girl's extremities belong to the 'blind field' and its unpredictabilities. Where the old woman's expression is set and melancholy, the girl's face is on the edge of a smile, which her tongue, caught momentarily between her lips, is trying to suppress. While the old woman looks to decelerate, and even deny, time, while the pin-up models surrender to a time which is not their own, but the time of the appointment, the time of the photographer, the erratic timetable of the voyeur's desire, so the peasant girl gathers up her own time, a time, however, which she shares with others. While the old woman attracts time to herself, in order to take it elsewhere, to frame it, so the peasant girl affirms the 'blind field', that public space/time within which her own time finds its place. The time of the rural does not need to withdraw into itself; it can, and should, envisage a future, an expansion. It is the peasant girl who demonstrates how wrong we might be when we say that the instantaneousness of the photograph interrupts a continuity. The photograph does not interrupt, but is, for an instant, copresent with continuity.

The temporal complexity of the photograph and *a fortiori* of the sequence of photographs, and the way in which a sequence of photographs can construct a narrative of temporality, are exploited in *Another Way of Telling* (1982), as is the language of framing. But before we proceed to a consideration of this text, we should say a few words about the relationship between the stranger and metaphor.

One of the distinctions that Benjamin makes between painting and early photography on the one hand, and post-industrial photography on the other, is that while the former generates distance, the respectful assimilation of the image's aura, the latter aims at proximity, reaching into event, intensifying actuality. Criticism has found the two aspects of this duality co-existent in the figure of the stranger. Summarizing the work of Georg Simmel, Papastergiadis writes: 'Appended to the group "inorganically", the stranger can maintain the synthesis of nearness and remoteness which also secures his position as an organic member.'[8] This is equally the double

perspective of the storyteller, who is both 'stranger and witness' in the community about which he writes: 'The act of approaching a given moment of experience involves both scrutiny (closeness) and the capacity to connect (distance).'[9] Photography (proximity) is not the adequate vehicle for telling, these two Berger/Mohr texts seem to insist; the distance created by verbal metaphor is equally important. But metaphor itself combines exile and empathy, distance and proximity, dissimilarity and likeness: 'Exile and empathy could be seen as analogues to the dual co-ordinates of near and far, as well as to the twin forces of approaching and retreating that are constitutive of metaphor.'[10]

And so there are two senses in which we must understand metaphor, as an integral part of the methodology of these two texts. First, verbal metaphor is the force which complements the photograph, in a dialectical fashion. While the photograph fragments, appropriates and exploits, language is the home and the only site of potential totality, of things seen whole:

> The boon of language is that potentially it is complete, it has the potentiality of holding with words the totality of human experience – everything that has occurred and everything that may occur. It even allows space for the unspeakable. In this sense one can say of language that it is potentially the only human home, the only dwelling place that cannot be hostile to man.[11]

Second, 'metaphor' is that figure one of whose terms is the photograph, the other of which is language. And we should not understand this schema in purely spatial terms, because it is ongoing process as well. While language is the past and the future ('everything that has occurred and everything that may occur'), the photograph is the present which constantly inserts itself into language and changes its configurations, its reading of the past, its predictions for the future. 'Metaphor' in this sense combines Benjamin's notions of *Erfahrung* (= language) and *Erlebnis* (= photograph), interpretation/association with trauma, the durational with the instantaneous (see Chapter 1).

In *Another Way of Telling*, Berger and Mohr seem to arrive at the conclusion that the expressive resources of the photograph are sufficiently sophisticated to generate a narrative without words, namely the story 'If Each Time ...' The titles for the photographs

of this story are supplied as an appendix; the only other verbal aid is a brief introductory note warning against linguistic interference:

> We are far from wanting to mystify. Yet it is impossible for us to give a verbal key or storyline to this sequence of photographs. To do so would be to impose a single verbal meaning upon appearances and thus to inhibit or deny their own language. In themselves appearances are ambiguous, with multiple meanings. This is why the visual is astonishing and why memory, based upon the visual, is freer than reason.
>
> (p. 133)

This crucial declaration merits an extended gloss.

'Yet it is impossible [...]' In fact, Berger and Mohr do supply a storyline. The protagonist is a peasant woman, a spinster, who has worked briefly in the metropolis and then returned to her village in the Alps. The sequence of photographs 'attempts to follow, for a few minutes, the mind of an old woman considering her life' (p. 133). This last explanation is misleading. First, 'for a few minutes' corresponds to no meaningful reading framework; external temporality is quickly made irrelevant by the elastic internal time not only of the remembering woman but also of the 'reader', who both identifies the associative mechanisms, memories, fantasies, operating in the mind of another and enters his own experiential duration. What is the reader's duration made of? It is made of the temporal perspectives connected with the size and framing of the images; of the undefined and heterogeneous temporal spaces of the *entr'images* and page-turning (a temporal experience not shared by the old woman); of images not included in the sequence but triggered by the sequence's images (intertextuality); of subjective connections made between the images offered; of the way he remembers the sequence of images as he reads them; and of the input of the reading context.

Second, we need to understand 'the mind of an old woman' in broad terms. As Berger and Mohr point out, they are documenting neither the physical life of the woman nor even her subjective life: many of the photos depict an existence beyond her ken (Yugoslavia, Istanbul, Romania, Palermo). The 'mind of an old woman' is both a generalized psychic space, the space of any ageing individual reflecting on life in general, and an intersubjective space, the space

where an old woman's projection of a set of images intersects with a reader's interpretation/counter-projection of the same set – an intersubjective space in which intentionality is minimized and reception has no obligation to specific interpretative models.

'To do so would be to impose [...]' Intentionality and interpretative models make us blind to the 'language' of appearances, to which Berger addresses himself in the essay which precedes the photo-novel, entitled simply 'Appearances'. As we have already noted, Berger proposes that photographs quote from appearances, while paintings translate them. Berger's confidence in making this affirmation derives partly from his belief that no systems for interpreting appearances, and particularly no semiological systems (sign-languages of clothes, gesture, posture, etc.), can exhaust what appearances express for us. Berger's underlying premise in his developing argument is that appearances cohere – through visual affinities, visual imitations, visual 'intertexts' (i.e. visual memories). While the emergence of visual/physical similarities relate appearances to evolutionary processes, that is, to the future, visual intertexts relate appearances to the past. Not surprisingly, then, Berger concludes that: 'The apparatus with which we deal with appearances is identical with that with which we deal with verbal language' (p. 114). Not surprisingly, because his account of appearances coincides with his textual methodology of the metaphor. Like metaphor, appearances deal in similarity and difference, association and memory, the past and the future ('everything that has occurred and may occur'). Like metaphor, visual appearances reconcile proximity and distance, empathy and exile, and because the language of appearances derives from juxtaposition rather than consecution, from metaphoric impulses as much as metonymic ones, the structure of appearances is coherent – a montage principle – rather than cohesive.

Two related shifts, then, have taken place between the essays on Sassall and the migrant workers, on the one hand, and 'If Each Time ...', on the other: (a) the authors now believe that photographic images do not need to be supplemented by language, that language is not the only repository of metaphor, that photographs can function like language; (b) correspondingly, the belief that language is necessary to photographs, so that we can 'see behind' appearances, falls away. This belief, that photographs are opaque and deceptive, and thus need to be dissected, is a Cartesian one; in

fact, appearances speak, and all we need to do in order to hear them is to establish a dialogic relationship with them.

Berger, however, still has an awkward question to ask himself: if appearances are a language, who wrote them? But the logic of the question does not bear out the reality of our relationship with appearances. While the question takes us back to intentionality and interpretative models, our experience tells us that our response to appearances is constantly changing and depends very much on the colouring our perceptual stance projects into them. In this sense, it is the perceiver who authors appearances.

'In themselves, appearances are ambiguous [...]' This sentence is very much a consolidation of the previous one. Having warned against using language to impose unequivocal meanings on appearances, Berger here makes mention of the ambiguity of the visual. Here, too, a caveat is needed. The first subsection of 'Appearances' is entitled 'The ambiguity of the photograph', which in turn begins with a consideration of a photograph of a man with a horse. Berger plays with the possible meanings of this photograph, and out of this grows his proposal that photographs are ambiguous. This ambiguity is engendered by the 'abyss between the moment recorded and the moment of looking' (p. 89). But this ambiguity is founded entirely on ignorance; the instant of the photograph is discontinuous only if ignorance is the originating premise. We have already suggested an alternative formulation: the instantaneous photograph is not an instant wrenched out of continuity, but an instant of copresence with a continuity. The subject knows what this continuity is. The photographer may do, too. But if we cease to put a premium on the image's intentionality and allow photographs constantly to re-insert themselves into our lives with a changing appropriacy, then even the ignorant future spectator may make meanings which relate not to factual truth but to personal value. Despite the earlier stages of his argument, this appears to be the conclusion that Berger himself wishes to reach. By removing words, with their pre-emptive interpretational drives, from images, photographs can recover their real expressivity: 'Yet it might be that the photographic ambiguity, if recognized and accepted as such, could offer to photography a unique means of expression. Could this ambiguity suggest another way of telling?' (p. 92). What the ambiguity of the photograph might uniquely express – it transpires in Berger's argument – is the social

function of subjectivity, the refusal, by ordinary folk, of history's monopoly of time. To use the terminology we developed in Chapter 1, we might say that the instant (historical) of the photograph's taking captures a moment (anti-historical or a-historical) of deep human being. But we might develop this a stage further and propose the following: the photograph which is more or less instantaneous and thus historical (an instant in a sequence of instants) paradoxically negotiates between the temporal relativities (variable durations) of the subject it depicts and of the viewer;[12] it creates a meaningful relationship between these two relativities. Berger includes the teller/photographer in this dialogue:

> The discontinuities of the story and the tacit agreement under-lying them fuse the teller, listener and protagonists into an amal-gam. An amalgam which I would call the story's reflecting subject. The story narrates on behalf of this subject, appeals to it and speaks in its voice.
>
> (p. 285)

'This is why the visual is astonishing [...]' Berger's initial analysis of the ambiguity of the photograph concerns the single photo-graph. The wealth of its meanings is proportional to the 'length' — 'breadth' might have been clearer, since time is not involved — of its quotation from appearances, the number of cross-connections and correspondences its constituents generate, not only among them-selves, but also intertextually. This purely synchronic coherence, which makes a virtue of the image's discontinuity, has as its outcome a general but complex idea. In other words, single photographs, according to Berger, do not narrate; they instigate ideas. In 'Stories', the essay that acts as an epilogue to 'If Each Time ...', Berger describes the kind of narrative that a photo-sequence might consti-tute. The version of narrative he has in mind draws much of its sustenance from memory and differs markedly from the reportage photo-story. The following tabulation is an extended, interpreted version of Berger's own differentiations:[13]

Reportage photo-story	*Berger's photo-narrative*
1. an outsider's point of view (what the photographer saw and experienced)	an insider's point of view (what the subject has experienced)

2. more cohesive than coherent	more coherent than cohesive
3. uses words to overcome ambiguity	maintains ambiguity by dispensing with words
4. realism of recognitions, of wholes in parts (its 'blind field' is a 'blind field' of extending reality)	poetry of appearances (its 'blind field' is a 'blind field' of multiplying meanings)
5. it quotes from reality: its quotations are evidence of the actual	it quotes from reality: its quotations are allusions to what reality makes possible
6. its images are remembered scenes – voluntary memory (metonymic); they must be replaced in their original continuity in order to mean	its images are triggers of memory – involuntary memory (metaphoric); they create their own continuity and generate their own meanings
7. each photo points towards the next, i.e. like film, this is an anticipatory narrative, concerns adventures/suspense	each photo points backwards as much as fowards, i.e this kind of narrative is anti-filmic, retrospective, concerns memories and revelations

About memory, we must always remember the following: memories are not things we have to create and remember by acts of will, or things we return to. All our lived experience naturally becomes memory as it shifts into the past, but it continues to inhabit us in our present:

> Both the photograph and the remembered depend upon and equally oppose the passing of time. Both preserve moments, and propose their own form of simultaneity, in which all images can coexist. Both stimulate, and are stimulated by, the interconnectedness of events. Both seek instants of revelation, for it is only such instants which will give full reason to their own capacity to withstand the flow of time.
> (p. 280)

'If Each Time ...' is composed of 153 images. 'The reader is free to make his own way *through* these images,' stopping, reviewing, skipping, etc. The sequence was constituted as a narrative (not as a box of random photos), but the strictly linear and consecutive story, the story which thrives on the single-minded drive of a plot, on suspense, on the sense of an imminent destination, is a 'modern invention'. More traditionally, stories have had to find their way, have been made up of discontinuities and things left unsaid, of montages in short. In montage-construction, the images either side of the cut are drawn to each other by a mutual attraction whose energy can 'take the form of contrast, an equivalence, a conflict, a recurrence' (p. 288).

The two juxtaposed images in a montage act like the two terms of a metaphor, or the interdependence of two memories, freed from the disqualifications of chronology, hierarchy, durational difference. And indeed we do not read the photo-book from page to page, but from two-page spread to two-page spread; so, to speak of the photo-sequence itself as a sequence is misleading. This anti-sequential impulse is also evident in the story's two epigraphs. The first is a remark made by an old Savoyard peasant woman – 'If each time I had milked a cow somebody had given me a penny, I'd be a rich woman' – and tells of a life which is a cumulative superimposition of similar ritual acts, not unfolding, but as it were getting denser, more stratified. There is presumably, in these words, also an allusion to the phrase 'A penny for your thoughts'; the old woman is certainly rich in the thoughts a metaphorical penny might have purchased. The second epigraph, a quotation from Mandelstam's *Entretiens sur Dante*, speaks of the peculiarly poetic reality of impulses, aims, oscillations. These features of existence are poetic because they become visible to us in variations on a paradigm, in the subtly changing nuances of a refrain, in patterns of parallel and echo. And these are the kinds of device that characterize 'If Each Time ...'

'If Each Time ...' resists the consecutive, that is, resists the temptation to do the narrative work for us, by drawing on devices which seduce us, as readers, into the shifting landscape of combining, associating, remembering, forgetting. Quickly we become the narrators of the old woman's story, and through hers, of our own. As we proposed in the previous chapter, on the basis of Barthes's testimony, our involuntary memory is more directly engaged by

other people's photographs than our own. Besides, this distribution of subjectivity is already available in the pedigrees of the photographs. They are images of an old woman's subjectivity, but she did not take them. This is the story of her mental activity, but she does not tell it, we do. The woman's psyche is the site of a set of memories which belong to us all.

What is important, then, in this 'sequence' of images is not the narrative as such, but the narratology; not the story, but the mechanisms which make it narratable and diversify its manners of being told. For example, photographs are repeated, but sometimes the image increases in size and sometimes it diminishes, sometimes the proximity of the image increases as the size increases, sometimes it does not, sometimes the larger version precedes the smaller, sometimes vice-versa. Thus are enacted the processes of remembering and forgetting, the clarifications or growing uncertainties, the inflation of a detail or the taking of distances, anticipations and recollections. These processes are given another dimension by the distance, in pages, between the occurrences of the same image. The greatest of these distances is between pages 155 and 274/5 (the narrative's final image), an image of cottage doors, which undergoes enlargement, as if the whole sequence of photographs were necessary for the reader finally to gain access to the natal home. Sometimes the distance is much shorter, operating like a mental double-take, as a glimpsed image is hauled back from the brink of disappearance. Sometimes it is difficult to recognize the repetition – a dark panoramic shot of a village dance (p. 234), for example, returns as a much lighter detail (p. 245) – so that the quality and accuracy of memory are themselves explored and exploited. Sometimes the repetition is immediate, from one page to the next, as if the image were peculiarly urgent or impatient to be unravelled.

Throughout the text, we are encouraged to organize the images in a whole set of possible metaphorical relationships: similarities and dissimilarities of theme (hands, slaughter, celebration, work, laughter, shops, dolls, death); similarities and dissimilarities of specific activity (cheese-making, knitting, hay-harvesting); similarities and dissimilarities of visual association (piles of cut timber seen end-on > stacked skulls in a charnel house; pigs' intestines > tree roots; bespectacled farmer > bespectacled fox; upturned head of a laughing woman > upturned head of a slaughtered pig; dead

rabbits > cows' legs > cow's udder > clouds); metonymic associations (darning socks > schoolchildren); patterns of oscillation (the initial dialogue between water and wool; flesh and wood). Governing these specific forms of relationship are the more general recurrent techniques: variations in framing; position of the image on the page; size, age and quality of the photograph; the intercutting of photographs with photographic reproductions (posters, paintings, manuals); the double page as stationary diptych/triptych in tension with the progressive impulse of page-turning; proxemics (varying distance of subject from viewer); angle of vision; etc.

We have already had occasion to identify Berger's work as a peculiar mixture of the avant-garde and the traditional. While his narratives, with their montage techniques, their pursuit of the metaphorical, their interest in multiple authors/narrators, their assimilation of the narrative into the narratological, point to an aesthetic of the provisional, the speculative, the improvised, the deferring, the relative and so on, his voice employs the rhetoric of the magisterial and his sympathies seem anything but futuristic and metropolitan. He is at home in rural communities; with the expanded life's time of the child. His politics are the politics of a romantic Marxist. Photography in his work remains marked by the scepticisms of Baudelaire and Benjamin, and yet, like Benjamin, he sees photography as a means of democratizing art, as the new literacy that gives those without access to a verbal power-base a chance to express themselves. These paradoxes do not, I think, offer themselves for resolution, and we must accept that Berger is something difficult to imagine, but palpably there: a nineteenth-century postmodernist.

In Conclusion: Modern Narrative in Photograph and Film

As Berger and Mohr's work progresses from *A Fortunate Man* and *A Seventh Man* to 'If Each Time ...', we witness a severance of language from photographic image. But however much we may feel that their joint enterprise — to provide the culturally deprived with the literacy of the image, to free photography into its implicit ambiguity and thus to make it effective in the struggle against history — does involve the relinquishment of their own authorship, of their own authority, which has hitherto been maintained by language, the fact remains that the liberated language of photography is still justified by the principles of verbal language that Berger himself has developed.

Berger tacitly rejects the pleonastic relationship between the image and text. A photograph without definition is without intentionality, has a negative ambiguity; but once defined by words, image and text repeat what is obvious in the other. From being reciprocally dependent, they become reciprocally superfluous. Instead, and explicitly in *A Seventh Man*, Berger seeks a complementary relationship in which each medium can tell its own story and supplement the other. Ultimately, however, he seems to find that the paths of the two media run parallel and that one can be amalgamated with the other, since they share the same underlying (linguistic) structure. And yet he has been at pains to imagine photography as 'another way of telling', as a medium which can tell radially rather than linearly, which can tell intersubjectively, which can be read as improvisation. This, in turn, has meant that Berger has been able to situate photographs, as well as text, between the documentary and the fictional. Photographs are sequenced in such a way that they both refer to a past actuality and project potential narratives, lives that have been lived and lives still available to inhabit. Berger also sees the dangerous political reversibility of the photograph's

function. We have spoken of the photograph principally as an interactive access point to the culturally deprived. In the same social situations, however, the photograph is no less a possible weapon of a dominant capitalism, inasmuch as it can brand its subject with past-ness, inasmuch as the weak intentionality of the photograph can itself represent the weak social impetus of its subject, and inasmuch as photography genericizes its subject and thus categorizes it within a power hierarchy.

Michael Messmer gathers together the contradictory attitudes to Berger's work – is he a postmodernist or is he not? – and comes to the only reasonable conclusion: 'Berger's work [...] is an ambiguous signpost standing at the junction of modernism and postmod-ernism, pointing in both directions.'[1] But if one wanted to identify a feature of postmodernism not to be found in Berger's work, it would concern, precisely, the relationship between text and image. In post-modernism, this relationship is one not of mutual complementarity but of mutual corrosion, as each medium throws the other into question and makes it problematic. The 'father' of the narrative photo-sequence, Duane Michals, himself belongs to a modernist world, since he found writing necessary to supplement what was missing in the picture, not to cast doubt on the image's function (see quotation above, p. 231). Michals takes photography further into the world of fiction than Berger does; his subjects are the products of neurosis, fantasy, daydreaming. But although Michals speaks of his photo-sequences as haikus, and although they are indeed suggestively brief, they usually work with perfect narrative consecutiveness (without cutting, without an active *entr'images*), and witty fables of the modern condition are what emerge.

The Michals photo-sequences, however, do undermine the index-icality of the photographic image (in the way that a photomontage does). And if the photograph no longer insists on the origin of its taking, its function changes radically. It no longer authenticates or confirms a reality external to it, but floats in a semantic no man's land. As John X. Berger and Olivier Richon observe, it becomes a free image able to relate to any number of different experiences of image:

> ...if the origin is a fiction, a construction, then the image refers to other images: an intertext, a displacement. The image is charac-terized by allegory and parody. In this sense, the term analogy

may be transformed, leaving behind its naturalist implications. It then becomes 'the demon of analogy' – the expression is from Mallarmé: a chain of associations, displacements, condensations. Analogy ceases to propose a happy marriage between sign and referent, emphasizing instead a difference: the image becomes other than itself.[2]

'The image becomes other than itself.' What is important in this formulation is the choice of 'other than itself' rather than 'something else'. 'Something else' would suggest that the signified had merely been displaced as in allegory, would imply that there was something else, another solution to be attained through decipherment. In speaking of photographic meaning under postmodernism as allegory and/or riddle/rebus, Berger and Richon mislead. Postmodern photographic meaning is not a unicursal labyrinth, with a centre still to be reached, albeit with difficulty. It is a multicursal labyrinth in which the multiplication of signifiers from different epistemological categories produces a refusal of meaning, a state of permanent semantic latency. Postmodern meaning is not a displaced or relocated signified but an occlusion of the signified by displacement, by the elusive dance of categorially incompatible signifiers, as Berger and Richon make clear in their description of Victor Burgin's *Office at Night*:

> The pretended transparency of the photograph and the coded clarity of the pictogram do not provide a relation between signifier and signified. Instead, their juxtaposition provides a relation of signifiers, an ongoing substitutive chain without an originary signified – the demon.[3]

Linda Hutcheon may be right to identify photography as the postmodern medium[4] – its acute problematization of the relationship between evidence and truth, its semiologically multiform existence (see Chapter 1), its generical instability and vulnerability to language, all these things make it supremely unreliable and elusive. But photography is postmodern not perhaps because it is, in itself, the site of many paradoxes but because, being as much without a code as with a code, it is highly parasitical on other codes and suspended between different media. It is, in short, in constant flight from

itself. What John X. Berger does in his nine-photo sequence *Details from Hawthorne* (1989; illus. 71–9) is to set this medium in flight from itself against a text which is 'other than itself', the relationship between them creating a multi-layered perceptual experience impossible to resolve. But as one might expect, from the discussion of his theoretical comments above, John X. Berger still allows relationships of complementarity, of reciprocal aid, to exist between text and image. I will use an analysis of the first image/text of the sequence as a means of exploring the nature of this protean narrative, and of gaining access to the sequence as a whole.

Image. The first image is of a deserted life class. All the images are virtually devoid of human presence. There is a small figure waiting at the bus-stop in exposure 6, and the head and shirt of a man are just visible in exposure 9. This emptiness is crucial to the photograph's potential fictionality. They may be images of Newcastle and its environs, but this is a Newcastle waiting to be inhabited by a nineteenth-century American text, Hawthorne's *The Blithedale Romance* (1852), not as a stand-in décor but as an environment with the ability to refictionalize Hawthorne, by becoming the frame of the text, by assimilating the text into itself, and by visually commenting on a text which exists outside it.

The empty life class 'translates' the text in the sense that the absent model has ceased to be the spectacle of only a few and is now in an elsewhere which is everywhere. Or the empty room, with the mattresses as focus, is a visual equivalent of a present woman 'seen' with closed eyes, or in a drawing. But the empty life class also relocates, or renarrates, the text in the sense that it dramatizes the femininity and feminism of Hawthorne's Zenobia: she is someone who has been scrutinized, depicted, but has maintained a multiformity (see the images of the nude in very different styles on the wall). She has escaped, but her absence means that nothing can take place. The male gaze feeds on the feminine and makes the feminine its theatre and the symbol of its own theatricalization of life (voyeurism and peepshow), and in doing so, it deprives the feminine of protagonistic status. The life class is empty, a theatre without actors. We preserve the privacy of the feminine against all, apart from those with a professional interest – here the student of anatomical drawing – and yet the paper-covered windows leave

Zenobia was truly a magnificent woman. It was wronging the rest of mankind to retain her as the spectacle of only a few. Her womanliness incarnate compelled me sometimes to close my eyes, as if it were not quite the privilege of modesty to gaze at her.

71–9 John X. Berger, Photographs from *Details from Hawthorne*, from *Other Than Itself: Writing Photography* (1989).

Hollingsworth was fast going mad. It required all the constancy of friendship to restrain his associates from pronouncing him an intolerable bore. His specific object was to obtain funds for the construction of an edifice devoted to the reform and mental culture of criminals.

One always feels the fact when one has intruded on those who love, or hate, at some acme of their passion that puts them into a sphere of their own. The intentness of their feelings gives them the exclusive property of the soil and atmosphere, leaving one no right to be there.

Priscilla produced from a work-bag some little wooden instruments and proceeded to knit a silk purse. I remembered having been the possessor of just such a purse. Its peculiar excellence lay in the almost impossibility that any uninitiated person should discover the aperture.

The pathway of that walk still runs along, with sunny freshness, through my memory. I know not why it should be so. My mental eye can even now discern the September grass, bordering the pleasant roadside with a brighter verdure than while the summer heats were scorching it.

Priscilla had been brought up in some inauspiciously sheltered court of the city, where the uttermost rage of a tempest could not shake the casement of her little room. A little parallelogram of sky was all that she had known of the awfulness of nature's limitless extent.

It is not a healthy kind of mental occupation, to devote ourselves to the study of individual men and women. If we take the freedom to put a friend under a microscope, we magnify his peculiarities and thereby isolate him from many of his true relations.

Her manner bewildered me. It struck me that here was the fulfillment of every fantasy of an imagination revelling in various methods of self-indulgence and splendid ease. It cost me a bitter sense of shame, to perceive in myself a positive effort to bear up against the effect which Zenobia sought to impose.

I have known him to begin a model of the building in which his philanthropic dream strove to embody itself, with little stones gathered by the brookside. Unlike all other ghosts, Hollingsworth's spirit haunted an edifice which, instead of being time-worn and full of storied love, had never materialised.

slits like squinting eyes, and the paper itself (at left) is beginning to come away. And the palettes – a nice pun – which form the crude backdrop for the absent figure, imply a whole language of goods, transportation, commodification. The text, then, is opened up, unravelled, diversified.

The composition of the image is one that resists the intrusions of the spectator, and particularly any spectatorial impulse to become a narrator or protagonist. It is built on diagonals, at a variety of angles, so that the eye cannot get a purchase, but slips over the surface in a multitude of directions and necessarily off to the left. Faced with this obliqueness, these shifting planes, we can only chase a vanishing point which constantly changes position. The exposures that follow either have a stable, but petrified laterality (exposures 2, 6, 7), allowing us the leisure to look (but what at/for?) but preventing the images from centring on the spectator by their frieze-like construction. Or they have a deep perspective, which draws the spectator straight into the image, only to find that the horizon is a prison or labyrinth (exposure 3), or a blank wall (exposure 4), or simply leads to an exit (exposure 5). We pass into the represented space, only to be trapped in it, or to pass through it without discovering a goal.

The final two exposures problematize these underlying configurations. Exposure 8 is laterally composed, but the horizontal is broken by the two-dimensional diagonal of a tank on a ramp (outside the Vickers Armstrong factory, Newcastle) and the steeper diagonal of a reflected ray of sunlight. Exposure 9 takes up exposure 1 diegetically or isotopically (it is the workroom of architectural/graphic designers) and compositionally (it is built on recessive diagonals). But this image has its *point de fuite* on the right rather than the left, and the colouration is not a warm amber but cool greens and blues.[5] This colour contrast is played out through the whole sequence; exposures 3 and 6 echo the amber colouration of the first exposure; all the others are in the green/blue range, though touches of amber warmth are still to be found in exposures 4, 5, and 8.

The connections which exist between exposures 1 and 9 might suggest some kind of narrative progression, from the human body as focus to the impersonality of buildings/institutions, from the free, individualistic responses of the life class to the regimented drawing-desks and careful geometries of architectural designers, from the values of Zenobia – carnality, liberation of the oppressed

(women), theatrical display, mercuriality – to those of the 'self-concentrated Philanthropist', Hollingsworth – abstract philanthropy, rehabilitation of the still imprisoned (criminals), self-repression, obsession. Accordingly, one might argue that the first exposure is a utopian view of art/community (Blithedale) and that this ideal must gradually surrender to the uniformities and subjections of an adult, metropolitan, social organization, in which the construction of institutions has replaced the interpretation of people.

In making these connections, however, we must remember three things. First, in producing this reading, we are not interpreting a narrative but trying to construct one, just as Miles Coverdale is in *The Blithedale Romance*. As Charles Swann points out: 'Coverdale is forced to recover and re-create his narrative without knowing what the origins, the genesis of the actions he observes, really are.'[6] Coverdale, the translator, is doubled by Fauntleroy/Old Moodie, the forger.

Second, we are, like Coverdale, spectators/narrators looking to find a place in our own narratives, to make our looking, our perceptions, autobiographical. We have seen how the compositional features of the exposures either make our gaze glance over and off the image, or draw us in, but only to a dead end. Coverdale, in *The Blithedale Romance*, tries at the last minute, in the final chapter, to salvage a place for himself, a centrality, in the story he has just told. Initially he admits, 'I have made but a poor and dim figure in my own narrative, establishing no separate interest, and suffering my colorless life to take its hue from other lives.'[7] But at the close, he claims that his story cannot be understood at all, unless the reader takes into account his final confession: 'I – I myself – was in love – with – Priscilla!' (p. 247). So Coverdale tries to force his way into a narrative which does not really want him. We might be accused of doing the same thing with John X. Berger's version; indeed the fact that the figure in exposure 9 is almost invisible tells us that the stage is still almost empty, mute in its indifference to us, moving off from us.

Third, we must not suppose that a photographic sequence is a sequence. A book allows photos, particularly if accompanied by texts, to operate as autonomous units of meaning, or, if on facing pages, as diptychs, or as a series (as opposed to sequence) in which the *entr'images* can mean either simultaneity or non-sequentiality,

or the traversal of different levels of consciousness (memory, fantasy, etc.). Just as a series cannot compel linearity of reading, so it cannot guarantee narrative progression. What Victor Burgin says about his twenty-panel sequence *Hôtel Latône* might be applied to *Details from Hawthorne*:

> Formally the work is ordered to resist its own linearity. It works recursively. In a sense, you can never really get to the end, and if you do it's only to be sent back to the beginning. Have you had this experience in day dreaming? You know in advance where the fantasy is supposed to wind up, but the cost of deferring that *dénouement* – which, after all, is all that narrative does – is that you rarely succeed in arriving where you intended. Chains of associations take you continually away from your goal – or perhaps they know better than you do where you *really* want to go.[8]

Exposure 9 may have more to do with the second exposure than the first. Both 2 and 9 are accompanied by texts about Hollingsworth, both are about public buildings, both are about petrification (of hand-drawing in sculpture, of hand-drawing in graphics), both share the same windows and strip-lighting, so that exposure 9 becomes the inside of exposure 2's outside, the internal thinking/planning/design that inhabits its own external products in a process of constant duplication. But exposure 2 relates to exposure 8, by snow, by their shared laterality and two-dimensional diagonals (sculpted swans and tank) which mount in opposing directions, to the left (swans) and to the right (tank). Exposure 9 also relates to exposure 4, by similarity and contrast: both depict regimented workplaces, but 4 has a frontal perspective rather than an oblique one, its strip-lighting moves in a different direction, its blue is livelier, it expresses more anarchy and disorder. The workers sit facing each other (rather than one behind the other), it is a feminine rather than a masculine space, and it works with the tangible and with living models, while the architectural draughtsmen work with abstract plans of elevation. And exposure 4 relates to exposure 5 by perspectival composition (where table = carpet, and ceiling patterns are similar). While in 4, however, objects move towards a shared centre, objects which are the detritus of daily life (wool, plastic containers, spools, paper), objects in 5 are pushed to the margins, objects of unusual monetary value taken out of use by their display cases.

The order of these two strata of civic existence, of community life, are reversed in exposures 2 and 3, both of which have birds as their subject. But while there may be obvious parallels between 2 and 5 on the one hand, and 3 and 4 on the other, 3 has affinities with 5 in the shared theme of display (cage/case) and the shared centralized perspective. The pet shop of 3, however, displays living creatures and its space is altogether more intimately, if claustro-phobically, conceived. But let us not be mistaken; these caged birds have their prices, too, and highly differential ones. The identified pied love-birds are at least three times as expensive as the anonymous birds 'across the way'. Even the vegetable world has its price as exposure 7 makes clear; and the more exotic the plant the more conspicuous a place it earns on the shelf. This 'perchedness' of the plants, their frieze-like arrangement (in a row, multiplying frontal points of view) echoes exposure 6, the arcade of Newcastle's railway station, in whose shelter and on whose ledges rows of birds are roosting.

So we shift restlessly backwards and forwards, across different pairings or longer strings, pausing over single images, discovering diegetic or isotopic associations. But the activity is too intense, too permutative, for a narrative line to disengage itself, or for us to feel that a graduated progression of meaning is recuperable.

Text. The status of the text is highly problematic. For one thing, the extracts are out of order: exp. 1 = p. 44, exp. 2 = p. 56, exp. 3 = p. 213, exp. 4 = p. 35, exp. 5 = p. 205, exp. 6 = p. 35, exp. 7 = p. 69, exp. 8 = p. 164, exp. 9 = p. 56. Accordingly, we are invited to remake Hawthorne's text, to reread it constructively, in the way that Benjamin would have us read history, reconstituting its fragmentary survivals and quotations into alternative versions. But this text is not to be understood only as something to be deciphered. It is also to be understood as a forgery – it has been edited (but by whom? the [new] author? the [re-]narrator?) and, where appropriate, silently 'corrected' (e.g. text 1: where the original has 'womanliness incar-nated', the edited text has 'womanliness incarnate'). This is an unreliable and inauthentic text. (But what is inauthenticity? A textual technicality which presupposes that an original text is retrievable? What *really* constitutes the authenticity of the authentic text? Does not authenticity lie, rather, in the reader's response to the text,

and cannot any text, however plagiarized, bastardized, etc., produce authentic perceptual experience?). This is a text, moreover, that has been edited to make room for the image, apparently: 'The images are sequenced to articulate relations between characters in the novel in terms of gender and discourse, producing an irony where what is said is not seen and what is seen remains silent.'[9] This metatextual theorizing is both adequate and inadequate. It is adequate in relation to the first exposure and text, in that 'what is seen remains silent' i.e. the image stands in for suppressed text, in a relationship of complementarity and completion:

> *Zenobia was truly a magnificent woman.* The homely simplicity of her dress could not conceal, nor scarcely diminish, the queen-liness of her presence. The image of her form and face should have been multiplied all over the earth. *It was wronging the rest of mankind, to retain her as the spectacle of only a few.* The stage would have been her proper sphere. She should have made it a point of duty, moreover, to sit endlessly to painters and sculptors, and preferably to the latter; because the cold decorum of the marble would consist with the utmost scantiness of drapery, so that the eye might chastely be gladdened with her material perfection, in its entireness. I know not well how to express, that the native glow of coloring in her cheeks, and even the flesh-warmth over her round arms, and what was visible of her full bust – in a word *her womanliness incarnated – compelled me sometimes to close my eyes, as if it were not quite the privilege of modesty to gaze at her.* Illness and exhaustion, no doubt, had made me morbidly sensitive.
> (p. 44; italics indicate edited text 1)

The image of the life class is able to imply the reproducibility of the image of the model, but also her sequestration, the theatricality of the poseuse, an erotic impulse suppressed (or, conversely, given heightened relief) by aesthetic 'decorum', and the desired materiality of the desired body. But, as we have seen, the photograph also supplies its own subtexts, its own conventions for decipherment. The 'what is seen' then may be a silence in the text which is much more than the text edited out, an interpretation of the text which amounts to a renarration of the text.

The text supplied with exposure 4 runs as follows:

Priscilla produced from a work-bag some little wooden instruments and proceeded to knit a silk purse. I remembered having been the possessor of just such a purse. Its peculiar excellence lay in the almost impossibility that any uninitiated person should discover the aperture.

This is the original version:

She now produced, out of a work-bag that she had with her, some little wooden instruments, (what they are called I never knew,) and proceeded to knit, or net, an article which ultimately took the shape of a silk purse. As the work went on, I remembered to have seen just such purses, before. Indeed, I was the possessor of one. Their peculiar excellence, besides the great delicacy and beauty of the manufacture, lay in the almost impossibility that any uninitiated person should discover the aperture; although to a practised touch, they would open as wide as charity or prodigality might wish. I wondered if it were not a symbol of Priscilla's own mystery.

(p. 35)

Characteristic of this latter text are the temporizing habits of its narrator, the way he postpones knowledge and even pushes it away: '(what they are called I never knew,)'; 'knit, or net'; 'an article which ultimately took the shape of'; 'I rememembered to have seen [...] Indeed, I was the possessor of one.' Characteristically, too, the narrator entertains diametrically opposing values in his speculations: impossible of access/easy of access; wide as charity/wide as prodigality – the purse, as a sexual image, is the guarantee of a virginity, but also the source of a sexual generosity; this sexual generosity is either granted on request (charity) or given spontaneously (prodigality). The purse is not only a symbol of Priscilla's sexual mystery but also of her spiritual mystery – as the Veiled Lady – for her trance is impenetrable and yet opens on to all humanity. The purse is also part of her inheritance from her mother, who was, like her daughter, a seamstress.

The edited text removes both the temporizations and the apparent contradictions. The photograph, however, reinterprets this temporization. Hawthorne's narrator, Coverdale, appropriates a product

of feminine labour and puts it to use as an image of female sexuality, and of female clairvoyance. The photograph re-installs the purse in the community of female labour, to which Priscilla and her mother belonged. Coverdale's temporization indicates an awareness of female labour, about which, however, he wishes to know nothing, or rather, of which he wishes to have only sexual knowledge. Coverdale is both initiated (sexuality) and uninitiated (awareness of working women), and it is this latter lack that the photograph begins to put right. At the same time, the disorder and heterogeneity of elements within the depicted workroom tell us that the makers of 'purses' cannot be conveniently categorized. The edited text does not allow for the 'initiated', for the charity and prodigality; it allows only for the shared complicity and secrecy of the makers of purses, who alone have knowledge of themselves. It allows for an aperture as various, as difficult of legibility, as the untamed disorder of the workroom.

We have called the introductory summary of *Details from Hawthorne* by Berger and Richon 'both adequate and inadequate'. It is inadequate in the sense that it does not do justice to the wealth of perceptual modes the 'narrative' makes available. The images may be sequenced but they do not enterprise a sequence so much as those permutational collocations which we have described. And the photo-series does not 'articulate relations between characters of the novel', because the text is no longer a novel, and Priscilla, Zenobia and Hollingsworth are no longer characters. Extracted from their original setting, these figures function as ghosts, who may have had another life, but who are no longer determined by it and may be seeking other incarnations, may wish to shake off the interventions of any narrator. As readers, we cannot prevent ourselves from referring to the novel as though it had some authority, but we know that it has none and that it threatens to hinder our seeing 'details from Hawthorne'.

This selection of extracts and photos is not a commentary on Hawthorne's novel, but a reconstitution of certain of its elements. Most of all, the novel is useful as the model of a certain kind of narrative in which the narrator does not know enough to narrate and must try to create a plausible narrative on unreliable evidence, always imagining his material in other configurations. Such a narrator will never succeed in implanting himself in the lives and situations of those he wishes to write about. Hugely important in the resulting photo-series is the fact that, lacking cohesion, it does not, like the

popular photo-story, refer to the cinematic, does not present itself as a sequence of stills; it refers instead to a series of independent perceptions and verbal realizations, which do not supersede each other, but which persist, resist and complicate each other as the eye passes over them.

If John X. Berger's *Details from Hawthorne* flirt with a literary text, Victor Burgin's *Office at Night* (1989; illus. 80–81 [exposures 1 and 5 in a sequence of 7]) grows out of a painting, Edward Hopper's *Office at Night* of 1940. Hopper's picture owes much, thematically, to his illustrative work (1912–16) for the commercial journal *System: The Magazine of Business* and much, compositionally, to the French Impressionists, and to Degas (*The Cotton Exchange*, 1873) in particular. This latter debt is explored by Gail Levin,[10] whose importance as a critical mediator of Hopper's work is acknowledged by Burgin in his introductory verbal acrostic. Already we begin to feel Burgin's interest in the process of mediation: Hopper's mature works are 'B' movie stills – by atmosphere and motif – mediated through high-cultural composition; Hopper's meanings are mediated through the meanings of art-historical research; Hopper's expressed narrative brinkmanship ('Any more than this, the picture will have to tell, but I hope it will not tell any obvious anecdote, for none is intended')[11] is mediated through Burgin's own self-confessed 'diagephobia' (*sic*),[12] just as Levin's perception of an 'implied sexual and psychic tension' within the picture is sifted through Burgin's 'politics' of 'the organization of Desire within Law, couched in terms of the particular problem of the organization of sexuality within capitalism'.[13] Burgin is an inhabitant of the 'between': 'between gallery and book; between "visual art" and "theory"; between "image" and "narrative" – "work" providing work between reader and text';[14] The scare-quotes indicate only too vividly that this is a 'between' in which concepts slip into meta-existences as we realize what kinds of manipulation they are. This 'between' is not a conveniently empty space between fixed points, but an oscillatory dynamic of mediation, interpenetration, *mise en abyme*, semantic slippage. In four of the seven exposures of *Office at Night*, the motif of the parallelogram, derived from the light cast by a street lamp on the back wall of the office in Hopper's picture, reminds us that images are projected over, or into, other images, in a receding infinity of intertextuality.

Victor Burgin, *Office at Night*, from *Other Than Itself: Writing Photography* (1989).

Victor Burgin, *Office at Night*, from *Other Than Itself: Writing Photography* (1989).

One form of the oscillatory dynamic is reversal, which manifests itself in several ways in these images and is forestalled by another section of Burgin's introduction, which is laid out as an acrostic of the title, *Office at Night*:

> Freud, in his 1911 essay, 'A child is being beaten', describes a sequence of fantasy identifications in which spectator and participant, aggressor and aggressed, perpetually exchange places in a drama which, like an image, neither changes nor remains the same. A drama whose purpose is to stage the desire it would deny.[15]

Among the reversals are the following exchanges: between Hopper's secretary and Burgin's (exposure 1); between Hopper's businessman and Hopper's secretary; between Hopper's businessman and Burgin's secretary (exposure 5); between the paired isotypes; between black and white; between the different images of Burgin's secretary (particularly when aided by similar colour-coding). The most significant reversal of all, perhaps, is that between secretary and spectator. The secretary has, consistently, a deeply self-absorbed facial expression, and her thoughtfulness makes it almost impossible to 'objectify' her. The viewer can get no visual purchase on this figure because she is elsewhere, and her elsewhere subjugates spectatorial power-seeking and assimilates it into her own gaze. The spectator feels thought by the image even as he/she attempts to take possession of it by the look.

The pattern of reversal is crucial, too, for the isotypes. In the acrostic introduction, Burgin explains the aim of Neurath's isotypes (International System of Typographic Picture Education): to create a universally unambiguous picture language – 'Heir to the dream of "pure vision", it expresses the desire to know in a simple act of *seeing*.'[16] Burgin's sequence is designed to show the infantile futility of such an endeavour. But we should remember that Neurath's ambition differs little from the capacity often explicitly claimed for, or tacitly attributed to, photography itself (in documentary photography, photojournalism, photographic portraiture). Isotypes, too, as Burgin intimates in his introduction, belong to a tradition which stretches back to Egyptian hieroglyphs (pictograms), where 'each picture was a kind of understanding, and wisdom and substance given all at once, and not discursive reasoning and deliberation'.[17] This tradition includes Renaissance art theory and relates, structurally at least, to psychoanalytic theory:

For Renaissance art theory, Hopper's painting would be both *tableau* and *hieroglyph* – both the *mise en scène* of a moment of narrative crisis, and the cryptic inscription of a general truth. Psychoanalytic theory finds this same duality in the formation of the unconscious fantasy.[18]

Neurath's mistake, it seems, is to have tried to bypass the cryptic, not to have realized that the cryptic is an essential ingredient of comprehension, that the perception of truths requires as much intuitive as rational activity. *Office at Night* compels the isotype to re-enter the cryptic, just as the photograph, too, in the secretary's 'elsewhere' gaze, in the failure of narrative, refuses its status as hieroglyph. And what is colour if not, on the one hand, a simplified method of coding (in a filing cabinet, for instance) and, on the other, a complex set of expressive languages and relational possibilities, an abstract art.[19]

Burgin's photo-sequences are characterized by their explicit (verbal) multiplication of perceptual sources. For *Office at Night*, we have already mentioned Hopper, Levin, Freud, Neurath, Egyptian hieroglyphs commented on by Plotinus, Renaissance art theory, and Burgin himself. We might add that Burgin's introduction also suggests that the filing cabinet of exposure 1 is Pandora's box. In other words, the politics of sexual patriarchy participates in the Prometheus myth. And the secretary's abstracted, down-tilted gaze might remind us of Rossetti's several depictions of Jane Morris, already referred to in Chapter 1. Rossetti attributes the opening of the box to Pandora, as Burgin does, rather than to Epimetheus, the brother of Prometheus, as other versions of the myth do. Here is a narrative thread that tells us, perhaps, what Desire does to the Law, paradoxically in the name of the Father (Zeus), what Desire does to the fraternality of the patriarchy, and how the feminine remains, despite these devastations, the repository of Hope. At all events, these various sources are then fed into a triad of interactive codes – isotype, colour, photograph – in which painting and the graphic arts are 'assimilated' media. Daedalus has constructed the Labyrinth, but is it in order that the Minotaur of Meaning, of the symbolic order, should be destroyed?

Jessica Evans, in a chapter on the development of Burgin's theoretical concerns, argues that 'the presentation of his work along with copious texts and commentary as explication of their multitextual

references represents the need to control the reading of his works'.[20] This is, in the case of *Office at Night*, to assume that the text is adequate to the images, that the sources of possible meaning are the meaning itself, that the presentation of commentary in the form of an introductory acrostic is not significant. In the acrostic, on the contrary, there is a peculiar tension between its arbitrariness as an order of utterance and its powerful cryptic significance (Greenaway's alphabets and numbers exploit the same tension). It has a cryptic significance because it implies an essentialism, implies that the acrostic name is projected by, but ultimately subsumes, all the statements made with its letters, that these statements are ideas embodied within it, but which it exceeds.

On this argument, Burgin does not assimilate the 'real', the decoded (the codally deconstructed) into symbolic orders of his own choosing (authorship) – 'this loss of emphasis upon human intersubjective experience and the flight towards a masculinist, abstract and universalising theory'[21] – but the reverse. We may feel that a purely formal structure can be recuperated from this photo-sequence: e.g. colour variation leads ultimately (in the final pair of exposures) to the juxtaposing of complementary colours, in images of identical format, which also contain self-complementing pairs of isotypes. But these final images do not resolve the sequence, they merely stabilize it. In Jakobsonian terms, they strengthen the metaphoric axis of substitution, equivalence, repetition, while still leaving to the metonymic all its capacity to make undecidable, to undo code by context and to make available the endless negotiations of transitivity. In this sense, metonymy is the instrument of Desire and metaphor is the instrument of the Law. It is not *in* the images that this drama is played out, but through their organization. The narrative is in the narratology, in the dialectical play of de-codings and re-codings. In these senses, Burgin's work is a worthy exemplum of postmodernist narrative.

Burgin's note on his *Hôtel Latône* already quoted has, in a sense, been a key to the narratives we have considered in this chapter. The weak intentionality of the photograph, its inbuilt unreliability, its polarization of the authentic and the inauthentic, make it a narrative vehicle for prevarication and infinite reconstructibility. We might indeed argue that recent photographic narrative has attempted to combine the extremes of the indexical and the symbolic, the

contingent and the fantastic, the referential and the fictional, against the steadily coded, iconic, middle path of realism:

> The strong impulse towards the real produced by the photographic image will, in the same way, impose the presence of things on me as a perpetual challenge to realism, because of the fascinating impossibility I feel of assigning, to the different elements of the message, a stable place, strict limits, a single definitive meaning. In both cases – the real and the effect of the real – things will certainly not seem to have the gratuitousness of nonsense, but rather seem an appeal to meaning which is always disappointed, a mobile universe of multiple meanings, contradictory, shifting, always provisional and ambiguous.[22]

Photography has proved to be a fruitful means of enquiry into narrative, variously because (a) being itself illusionistic, it is perhaps the best instrument for deconstructing illusionism; (b) unable itself to narrate, it shifts attention from the narrative to the narratological; (c) the difficulty of 'entering' photographs dramatizes our need to use narratives as refuges, as ways of reading/justifying our lives; the photograph excludes us, both as spectator and narrator from the narrative we are constantly trying to inhabit; (d) given its visual availability and its 'all-over' focus, and given (c), the photograph often takes us on journeys we did not expect to go on.

This last is a feature of Julio Cortázar's story 'Las Babas del Diabolo', on which Antonioni's *Blow-Up* (1966) is loosely based. What Cortázar's story makes available to the reader is not only a multiplicity of narrative viewpoints, but a narrative which is improvising itself as it goes along, making choices which most frequently run against expectations. There is also the suggestion that the narrator/photographer (Roberto Michel) is a participant (the boy), although the 'crisis' Michel lives through is about his ability to affect, arrest, change, what he has seen. The latter situation dramatizes two ideas: the curious sense of being both invited into and rejected by the narrative, at one and the same time; and the implication that those 'photographic' images which bring external reality to us are only projections of inner reality.

Antonioni's *Blow-Up* takes up these themes, but does so with two important reversals: while Michel's still photographs turn into a cinematic experience for his encounter with the truth, Antonioni's

film turns into Thomas's photographs when the hidden story is revealed. The second reversal is pointed out by Richard Lee Francis:

> By converting the central character in the tale from an amateur photographer whose real occupation is words into a professional who, while visually successful, is almost inarticulate verbally, Antonioni shifts the perceptual mode of the story from its fictional base to a dramatic one.[23]

In other words, Thomas's inability to narrate, to fabulate, turns the narratological into the presentational, where point of view is potentially as multiple as the characters involved. *Blow-Up* can act as a fitting conclusion to this enquiry, because, in some ways, it prefigures Greenaway's *A Zed & Two Noughts*. Still photography seems the only way of establishing a truth and a narrative in a film whose own narrative is lost, irretrievably cryptic or whimsical in the extreme. While the principal protagonists treat the still photograph as something nearer to a source, to an originating reality, than the film that it might help to constitute, both films manage to suggest that the reverse is true, that the still photographs are merely decorations, or meta-realities, constructed on the founding reality of the film itself. What price now photography's authenticity?

In an interview with Pierre Billard, Antonioni declares: 'Today stories are what they are, with neither a beginning nor an end necessarily, without key scenes, without a dramatic arc, without catharsis. They can be made up of tatters, of fragments, as unbalanced as the lives we lead.'[24] He then goes on to emphasize the element of improvisation in his film-making:

> I believe in improvisation. None of us has the habit of preparing for a meeting to further business, love, or friendship; one takes these meetings as they come, adapting oneself little by little as they progress, taking advantage of unexpected things that come up. I experience the same things when I'm filming.
> (pp. 6–7)

Thomas, the photographer, lives in something of the same opportunistic and discontinuous way (does not the photographer peculiarly represent this ethos?): his actions seem driven by unpremeditated impulse. Just as Antonioni searches for his story as he makes the film, allowing his characters to emerge out of him, as aspects of his

intimate life, so Thomas is looking for his story, and looking to use his camera as a means of relating people to himself, of drawing them into his 'plot'. But Thomas has accustomed himself to so centrifugal a life, so vicarious an existence, that the camera has become an indispensable mediator, and his own role that of an *agent provocateur* in other people's lives. The camera is the sexual stimulus in the opening fashion sequence; Thomas acts as the animator/director of the erotic struggle between the blonde and the brunette; and he is the substitute lover in Patricia's lovemaking with Bill: 'Close up of Patricia smiling. She stares at Thomas right until the orgasm, as if the man who is on top of her were excluded from the act, and instead it was Thomas exciting her' (p. 99). Like Hitchcock's Jeff Jefferies in *Rear Window*, Thomas needs to generate an action in order to make sense of his life, in order to edit his career and cut the dead time. Sense-making is a retrospective activity which allows one to hold on to one's past life and discover its hidden purposefulness. This is the mode of meaning that operates in Bill's paintings:

> *Bill*: They don't mean anything when I do them – just a mess. Afterwards I find something to hang onto – like that – like – like ... that leg. And then it sorts itself out. It adds up. It's like finding a clue in a detective story.
>
> (p. 45)

But this is a salutary reminder that narratives can only be recuperated from what is, after all, a leap in the dark, chance. At the end, after the theft of his prints and negatives, Thomas is left only with the over-enlarged print of the corpse itself, which loses its power to mean and reverts to the state of one of Bill's paintings prior to its 'sorting itself out' (p. 102).

This enlargement, however, has gained its very power to mean from a chance set of circumstances. Thomas's initial scrutiny and ordering of the photo-sequence is an exercise which at last gives him a central role:[25]

> *Thomas*: Ron? ... Something fantastic's happened. Those photographs in the park ... fantastic ... Somebody was trying to kill somebody else. I saved his life ...
>
> (p. 90)

It is interrupted by the arrival of the two girls (the blonde and the brunette), looking for an entrée into modelling. This visit ultimately involves a playful orgy of stripping. The episode has attracted plenty of attention but relatively little critical comment. Its significance seems to be threefold:

(i) The game makes a corpse of Thomas. The stripping sequence ends with the girls beginning to dress Thomas, and his inertia makes the action reminiscent of the dressing of a dead body. It is precisely at this moment, and as if by an association of ideas, that Thomas realizes what the illegible dark patch on the final photo might be.

(ii) Relatedly, the episode sustains the theme of triangularity. Thomas's ability to become a protagonist seems to depend on the opportunities he has to become a third party, that stand-by of traditional plots, the accomplice, adulterer or rival. He is the intrusive go-between in the transaction between his agent and the owner of the antique shop; he becomes a potential third party in the murder drama, hunting the girl (Jane), himself being hunted by her accomplice – this story has a clear sexual dimension. Also sexually motivated is his intervention in the affairs of Bill and Patricia, and the final exchange between himself and Patricia seems to hold out the possibility that, like Jane and her accomplice, they might become partners in a crime by which Bill would be disposed of:

> *Thomas*: That's the body.
> *Patricia*: It looks like one of Bill's paintings.
> *Thomas*: Yes.
> *Patricia*: Will you help me? I don't know what to do.
> *Thomas*: What is it? Huh?
> *Patricia*: I wonder why they shot him ...
> (p. 102)

Thomas's mischievous interventions are part of his challenge to life to come out and engage with him. Many critics wonder why Thomas did not report the suspected crime to the police. One reason may be his desire for involvement in an ongoing drama. The final enlargement forces him to revise his claim that his part in the story is that of a saviour. Perhaps he now fancies being an avenging angel? Or another victim?

(iii) The episode also relates clothing and unclothing to the photographic studio. The photographic studio is a place where truth reverses into fiction, and back again, in a constant dialectical play. Different perceptual modes interact: the independent and static eye of the tripod camera, the mobile eye of the photographer activated by the hand-held SLR, the spectatorial and narratorial eye, as enquiring as it is directive, of the movie camera. We see things in black-and-white, but this black-and-white serves deceit (fashion) as much as it serves the documentary (the doss-house). Sheets of glass/perspex, which promise a transparency, a visibility, suddenly become a labyrinth and play optical tricks. Women reveal themselves in order to take on roles in images. In this particular world, there is no telling where Paris is. The studio is, in fact, the point of convergence of two conflicting principles: on the one hand, masquerade (fashion models and rag students), and on the other, rock-bottom reality (the dossers). Thomas flirts with both principles. Even the demonstrators seem caught between the two (their slogans have an element of reversibility in them; we never discover what the demonstration is about; Thomas is given a placard which then blows away). Thomas goes to the park to take photographs to complete his album on the down-and-outs, and there he bumps into Jane whom he subsequently sizes up as a fashion model. Thomas has dreams of escape from the treadmill of fashion photography, but his fantasy of freedom is brought to earth by Ron:

> *Thomas*: I wish I had tons of money. Then I'd be free.
> *Ron*: Free to do what? Free like him?
> *Close-up of a photograph of an old man on a plot of derelict land — dirty, witless, a human wreck.*
> (p. 67)

Rather melodramatic perhaps, but no story can be initiated with any confidence, and fact and fiction are difficult to pull apart, and tell very different stories.

In the story of the murder in the park, for instance, the enlarged photograph of the corpse, the central evidence, is, on its own, no more factual than one of Bill's abstract paintings. Two factors are absolutely vital to its constituting evidence of a felony: its corroboration by material evidence (but the corpse disappears); and its being given sense by a narrative (but the other prints and negatives are

stolen). The corpse has been quite literally revealed to Thomas by a combination of the preceding sequence of photos and of a revelation associated with his own momentary corpse-likeness (in the orgy of stripping with the blonde and the brunette). Ultimately, all he is left with is the illegible enlargement. By the close of the film, it seems as though Thomas has thrown in his lot with the studio's masquerade aspect. The drugs party has postponed the verification of the corpse's existence, and the mimed game of tennis does impose its alternative 'reality', a fiction in acceding to which Thomas forfeits his own reality: the final shot removes him from the empty park.

The parallel which is, after all, the most revealing is that between the park encounter (with Jane and her 'older' lover) and the pop club. The park encounter turns into a search not for the girl but for the corpse. The girl is shown to be only an accomplice, by the sequence of photographs – she looks away, towards the murderer, and the murderer, in turn, 'produces' a corpse. This sequence of shifts corresponds to, is generated by, the process of narrative and enlargement: the process of development, ordering and enlarging diverts one narrative impulse (a girl and her lover disport them-selves in a park) into another (the commission of a crime). But enlargement tests the limits of visibility, gravitates towards the abstract, and its evidential value becomes, as we have seen, increas-ingly dependent on facts external to it. Once the corpse has been removed, the enlargement ceases to operate as evidence-in-itself. But what enlargement allows is the discovery of photographs within photographs; just as cropping may add to, or alter, the tendentiousness of any image, so may the inflation of a detail. The trouble is that such skewing of the image may turn out to be a blind alley or a red herring. Narrating forwards, in anticipation, is a wager beset by the risks of having chosen wrong. Narrative can only be stably constructed out of a past.

The pop-club episode is like a parody of this pattern. Thomas enters the club in search of the girl, a search made sense of by past events. What he emerges with is the piece of the broken guitar. What produces this ill-assorted outcome? A process of amplification similar to that of 'blowing up' photographs and their meaning. Mid-way through their performance, the pop group, the Yardbirds, are troub-led by a malfunction in a loudspeaker, which ultimately provokes the lead guitarist to smash his guitar over it. As a result, the detached

guitar piece becomes a trophy, a holy relic, a talisman, fought over by the audience. Thomas emerges triumphantly with it, only to realize its uselessness once he is in the street again, out of the theatre of operation. What had seemed important, or been made to seem important, within a specific, self-generating context, becomes meaningless immediately the context changes, rather in the way that the demonstrator's placard, thrust into Thomas's passing Rolls, flies off inconsequentially as he leaves the vicinity of the march.

In other words, the filmic consumes the photographic; the anti-cipatory nature of film, its continual forward momentum into an ever reconstituted 'blind field', its subjugation to unpredictable process, its future-orientedness, prevent the sequence of still photographs, and the cohesion between them constructed by Thomas, coming to anything. As Thomas feverishly seeks the clues, the narrative sequence which will tell him how to look at the photographs, he finds himself increasingly implicated. This is precisely what he desires: in making sense of the photographs, he is making sense of himself. But the drive of the film prevents his achieving his ends. Film undoes the pastness of the narrative of photographs, and provides a continuity which, in *Blow-Up*, guaran-tees neither cohesion nor coherence: the lyrics of 'Stroll On' which intersperse the action in the club episode (e.g. 'You didn't see ... / ... I love no more/If you wanna know I love you so' [p. 107]) are full of the same kinds of contradiction and reversal that we find on the demonstrators' placards, or in Thomas's explanation to Jane of his domestic arrangements: 'She isn't my wife really. We just have some kids ... No ... No kids [...] She isn't beautiful, she's ... easy to live with. No she isn't. That's why I don't live with her' (p. 72).

If words provide continuity, and if words do not register facts any more, but instead produce the gratuitous incoherence that we find in Thomas's words or in the song lyrics, then perhaps photo-graphic images can supplant them. This is the promise of Thomas's reconstruction of the park encounter. But (a) words cannot be dispensed with – the find has to be communicated even if commu-nication malfunctions (how powerless words are to convince either the distracted Ron or the distracted Patricia!); and (b) the filmic, as a parallel to words, creates a tireless but dispersive momentum which deconstructs the image-sequence and, by implication, anything that attempts to found itself on a past.

In this sense, Antonioni's and Greenaway's films represent a new narrative, which undermines the backward-looking photographic narrative proposed by their protagonists (Thomas, the Deuce twins). In attempting to establish a photographic reality, Thomas and the Deuce twins are attempting to establish an alternative to filmic reality, an alternative to the reality which constantly takes them out of themselves, distracts them, cuts away from confrontation, multiplies narrative strands. The cost of the filmic, in *Blow-Up*, is inarticulacy; the cost, in *A Zed & Two Noughts*, is the loss of other kinds of control (scientific experiment, classification, fatherhood) which manifest themselves verbally. It then seems that the silent (photography) might transform inarticulacy into a constructive speechlessness, but the stable narrative which would give purpose and power to this silence is, by definition, not available in the filmic. Photography, weak in intentionality, can get no support from the filmic and is frittered away. As Barthes puts it, the referent which, in photography, clings, in film shifts.[26]

The distinctions between photograph and film made by Barthes continue to be relevant. While the film always presents the partial and provisional image, photography moves towards totality and finality. In film, the passive spectator has no time for *punctum*; in photography, the pensive spectator has time to 'add' *punctum* (although it is already there). While the experience of film tends towards the public and collective, that of the photograph is private. While film works to create an illusion of reality, photography operates like an hallucination. And we might add two further distinctions, one supplied by Sontag – shots in film are constantly superseded, whereas the photograph presents itself as a privileged moment[27] – the other by Price – 'In moving pictures, photography serves, and is subservient to, narrative. Photography of moving pictures does not come into being as a discrete element of the final picture.'[28]

It is, of course, dangerous to insist overmuch on such distinctions. What Price says, for example, may be equally true of still photo-sequences (e.g. the popular photo-story), and, conversely, films with a high degree of montaging, or long-held shots, may privilege photography over narrative. But these distinctions serve to remind us that the filmic and the photographic, being different, can each contribute to the other's development. *Blow-Up* and *A Zed & Two Noughts* make cases for the filmic as the modern narrative and the

narrative of the postmodern; and they do so by providing critiques of conveniently 'old-fashioned' models of narrative. These photographic models emerge from an existential crisis, from a nostalgic attempt to recover a sense of implantedness, an attempt, by still camera, to get beyond a reality orchestrated by the movie camera, to make the moment stay.

Our brief consideration of some recent photo-'narratives' has shown us that the photo-sequences within these films are by no means fair reflections of the state of the art. Our examples have shown efforts to transform the photograph from scenario for a written text into a counter-text; to transform linear sequence into a non-chronological or a-chronological series; to transform the consecutive into what Benoît Peeters calls 'rhymes';[29] to transform the page from passive support to active 'modalizer' of the photograph, affecting its temporality, its grammar (the grammar of its determination) and the spectator's approach to it. Ironically, we might argue that the single 'discontinuous' photograph flirts with the promise of continuity supplied by the photo-sequence only to make better sense of its very discontinuity, or to make its discontinuity an active, expressive resource rather than an inescapable condition of its existence. This new discontinuity is no longer the discontinuity of the 'has-been', but, thanks to the accompanying photos, of the 'being'.

The new photo-sequence accepts the findings of modern film and those narrative conventions associated with the *nouveau roman*: reduction of narrator to point of view, of character to a pronoun of relationship; illusionistic effects of *mise en abyme* and metatextuality, the creative/frustrated/baffled/opportunistic reader, reading as confrontation with the self and its needs and expectations; not telling an event (as though it existed outside narrative), but creating an (narratological) event. But it scores over the film in preserving the reader's freedom of relationship with the 'text', in making room for the reader's mental processes in its own text (the *entr'images*), in allowing the interaction of the heterogeneous and qualitative duration of the photo and the reader's own heterogeneous and qualitative inner duration.

We still lack a thorough study of the way in which the status of a photograph changes when it is introduced into a series. But we can say that there is an increase in its tension, that the photograph

withdraws more into itself (increased implicitness), that its details are increasingly loaded, that it loses its totality and finality, that it loses its historicity, as its fictionality increases and as it acquires a new charge of futurity and possibility. But these qualities must be held in check, controlled, if the photo-sequence is to find its unique place in the narrating arts. If the photographs in a sequence are multiplied, then the text, or the reader's reading of it, will push towards the cinematic. Perhaps the simplest truth of the photo-sequence is also the most important: weak in intentionality, a photograph does not need language to give it purpose, but another photograph, alongside. And the relationship between photographs is so exponential in its associative power that the mind can only cope with any excess by downgrading the photograph's expressive function to an illustrative one, by removing the photograph from the twentieth century and re-installing it in the nineteenth.

For a long time, language hauled photography back into a servant's role, that of seeming to ground rhetoric in the literal, claim in fact, effect in cause. Photography's narrative capabilities were left untapped, because the medium was allowed no access to fiction, other than as an illustration of a language of fiction. Language alone seemed to have the authority to bestow meaning on images. In the course of our investigations, through Part I and Part II, we have learned a strange truth: when the function of photography is to create or reinforce the evidential, by virtue of its indexicality, it is, para-doxically, most vulnerable to language and to linguistic manipulation. Conversely, when photography, by sequencing, activates memory, fabulation, fictionality, 'intertextuality', it becomes most self-sufficient, best able to find its own expressivity. In such circumstances, language can act either as a facilitator or as a saboteur. Both *Blow-Up* and *A Zed & Two Noughts* show us a language finding it difficult to inhabit the photographic and the filmic. The photo-story provides a reminder of how completely the verbal can incapacitate and, quite literally, obliterate the photographic. Berger and Mohr seem to find a way out of linguistic dependence for the photo-sequence, but only because they can propose that photography has an inherent linguistic structure. Only with the work of artists such as John X. Berger and Victor Burgin do we see photography and language each occupying its own ground and no longer substituting one for the other — usually the latter for the former. Language and photography become partners

in the construction of a new self-deconstructing narrative, which compels each to be (other than) itself.

By way of conclusion, I should reiterate that it has not been my intention to write a history, either of the relationship between titles/captions and images, or of photographic narrative. Inevitably fragments of possible histories have emerged: a sense of the slowly changing face of the family snap and its storage, the latter important inasmuch as it affects the way in which we construct individual and family pasts and relate photography to the processes of memory; a glimpse of the relatively short life of the teenage photo-story; hints of the ways in which the relationship between tabloids and quality newspapers, upmarket and downmarket fashion magazines, are constantly redefining themselves; a sense, too, of the way in which the still photograph has repositioned itself in relation to narrative, as narrative modes have evolved in other media. But trends such as these have not been systematically pursued, and the contexts of change have not been filled out. My overriding concern has been with the analysis of individual images and works, and with the habits of certain photographic genres, as they engage with printed language. This engagement is highly complex and variable; not only does language change as one shifts from one generical setting to another, but so also does the relative 'distance' between the image and its title/caption. Additionally, language ostensibly varies the position of the image on the semiotic map (indexical, iconic, symbolic) to control the modality of our reading.

But however powerful language is in determining the power-play of the photograph, the photograph is artful in its evasions and slippages. Faced with photography's weak intentionality, we assume that, without the support of language, photographs would become souls lost in the limbo of their own gratuitousness. But gratuitousness is independence, the never completely assimilated, the uncontrollable. Language exploits the photograph, puts it to any number of ideological uses, calls upon it as evidence in many different kinds of cause. But language may come unstuck from the image, may have a bad memory and be unable to repeat itself reliably. When this is so, the photograph escapes the plottings and mappings of history, and re-enters the carnival (in the Bakhtinian sense),[30] recovering its intrinsic unreliability. Barthes's distinction between *studium* and *punctum* is revealing not least because it reminds us of the

photograph's paradoxicality: the photographic image is 'fixed' and 'fixing', an indelible trace from the world of its taking; and yet its effects are unpredictable. Language bestows the cachet of *studium*, an entitlement, but for all that, the photograph may slip through the fingers of *studium* and lacerate any viewer at any time with an unsuspected shaft of *punctum*. Apparently one hundred per cent evidence, the photograph never, finally, gives itself away.

References

INTRODUCTION

1 See T. Wright, 'Photography: Theories of Realism and Convention', in E. Edwards, ed., *Anthropology and Photography 1860–1920* (New Haven and London, 1992), pp. 18–31. Victor Burgin describes the 'shortcomings' of the retinal image thus:

> We do not however see our retinal images: as is well known, although we see the world as right-way-up, the image on our retina is inverted; we have two slightly discrepant retinal images, but see only one image; we make mental allowances for the known relative sizes of objects which override the actual relative sizes of their own images on our retina; we also make allowances for perspective effects such as foreshortening, the foundation of the erroneous popular judgement that such effects in photography are 'distortions'; our eyes operate in scanning movements, and the body is itself generally in motion, such stable objects as we see are therefore *abstracted* from an ongoing phenomenal flux, moreover, attention to such objects 'out there' in the material world is constantly subverted as wilful concentration dissolves into involuntary association, and so on.
> ('Seeing Sense', in *The End of Art Theory: Criticism and Postmodernity* [London, 1986], p. 52).

2 'Photography: Theories of Realism and Convention', p. 27.
3 M. Kozloff, *The Privileged Eye: Essays on Photography* (Albuquerque, 1987), p. 105.
4 V. Burgin, 'Photography, Phantasy, Function', in V. Burgin, ed., *Thinking Photography* (London, 1982), p. 192.
5 See W. Mitchell, *The Reconfigured Eye: Visual Truth in the Post-Photographic Era* (Cambridge, MA., 1992).
6 M. Price, *The Photograph: A Strange, Confined Space* (Stanford, 1994).
7 P. Wollen, 'Fire and Ice', in J. X. Berger and O. Richon, eds, *Other Than Itself: Writing Photography* (Manchester, 1989), unpaginated.
8 In 'The Work of Art in the Age of Mechanical Reproduction', for example, Benjamin observes: 'For the first time in the process of pictorial reproduction, photography freed the hand of the most important artistic functions which henceforth devolved only upon the eye looking into a lens' (*Illuminations: Essays and Reflections* [ed. H. Arendt, trans. H. Zohn; New York, 1969], p. 219). And in 'On Some Motifs in Baudelaire',

he describes 'aura' as the associations which 'tend to cluster around the object of a perception', whose analogue in the case of the utilitarian object 'is the experience which has left traces of the practised hand' (*Illuminations*, p. 186).

9 Hockney justifies his use of collage in photography in these terms: 'With my work you can have photographs using chemical inventions to bring the hand in. The joiners bring the hand back. There's no way you can start joining pictures together mechanically, and the more complicated the photography is, the more subtle the hand work becomes' (P. Joyce, *Hockney on Photography: Conversations with Paul Joyce* [London, 1988], p. 75).

1 THE NATURE OF PHOTOGRAPHY

1 A. Bioy Casares, *The Adventures of a Photographer in La Plata* (trans. S. J. Levine; London, 1991), p. 72.

2 See H. Schwarz, *Art and Photography: Forerunners and Influences* (ed. W. E. Parker; Chicago, 1987), p. 93:

> The photographer's artistic performance is thus displayed in pre-photographic and in post-photographic action; in preparation for real photographic action and in the reproduction of the photograph [...] the chemical and physical work of the camera is, after the pre-photographic functions, forcible and unchangeable.

The distinction we are making here, important though it is, should be handled with care, (a) because it is certainly not watertight – Ansel Adams, for example, looks upon careful darkroom work as a way of intensifying the viewer's sense of contact with reality; and (b) because digital imaging has, over recent years, totally exploded the evidential link between subject and photographic image, and very little imagery in the commercial world escapes digital 'enhancement'.

3 Other critics have described the symbiotic relationship between Surrealism and photography in other ways. For Benjamin ('A Short History of Photography' [trans. P. Patton], in A. Trachtenberg, ed., *Classic Essays on Photography* [New Haven, 1980], p. 214), Surrealism pioneered the 'photographic construction' necessary to penetrate the deceptive public façades of reality. Sontag (*On Photography* [Harmondsworth, 1978], pp. 51–82) disparagingly explores the ways in which photography is the 'one art that has managed to carry out the grandiose, century-old threats of a Surrealist takeover of the modern sensibility'. Rosalind Krauss ('The Photographic Conditions of Surrealism', in *The Originality of the Avant-Garde and Other Modernist Myths* [Cambridge, MA., 1986], pp. 87–118) argues that photography is a privileged medium for Surreal ism because its semiological functions reveal an underlying perceptual homogeneity in Surrealism's apparent heterogeneity.

4 'Il est beau [...] comme la rencontre fortuite sur une table de dissection d'une machine à coudre et d'un parapluie!' (Lautréamont, *Oeuvres complètes* [Paris, 1963], p. 327).

5 'Je suis surpris par les photos que je trouve. Ce n'est pas moi qui fais le
 paysage. Il est là. Je suis d'autant plus surpris que je ne fais rien. Il suffit
 d'ouvrir les yeux et, de temps en temps, d'appuyer sur le bouton'
 (Edouard Boubat, in P. Borhan, *Voyons voir* [Paris, 1980], p. 89).

6 'Je voudrais être toujours disponible: pour être étonné par ce que je
 n'attendais pas – et assez vif pour reconnaître ce que j'attendais. Deux
 étonnements différents [. . .] L'important est de réussir à faire les photos
 qui confirment lémotion que je me fais de la vie' (Guy Le Querrec, in
 Voyons voir, p. 121).

7 Jacques-Henri Lartigue, in *Voyons voir*, p. 15.

8 See, for example, F. Patterson, *Photography and the Art of Seeing*
 (Toronto, 1989).

9 Lartigue, in *Voyons voir*, p. 16.

10 'A Short History of Photography', pp. 202–3.

11 *On Photography*, pp. 9–10.

12 Brassaï, *The Secret Paris of the '30s* (trans. R. Miller; London, 1976),
 unpaginated.

13 M. Tournier, *The Erl-King* (trans. B. Bray; London, 1983), p. 100.

14 P. Theroux, *Picture Palace* (Harmondsworth, 1978), p. 306. Victor Burgin
 would put us on our guard against such easy assumptions: 'Seeing is not
 an activity divorced from the rest of consciousness; an account of visual
 art which is adequate to the facts of our actual experience must allow for
 the imbrication of the visual with aspects of thought [including the
 verbal]' ('Seeing Sense', in *The End of Art Theory: Criticism and Post-
 modernity* [London, 1986], p. 53).

15 Amphoto Editorial Board, *Photographic Tricks Simplified: A Modern
 Photo Guide* (New York, 1974), p. 7.

16 'A Short History of Photography', p. 201.

17 See *Art and Photography*, particularly pp. 97–108 and 109–17.
 Definitions of photography reveal alarmingly different perceptions of
 its role and being. Georges Potonniée places photography firmly in a
 fine-art tradition, as a development of the camera obscura: 'Photography
 is the art of making permanent the images perceived in the camera
 obscura, by means other than those of manual drawing' (quoted in J.-L.
 Daval, *Photography: History of an Art* [Geneva and New York, 1982],
 p. 9). László Moholy-Nagy, on the other hand, insists on those first
 principles which made possible the delayed 'purist' investigations of
 Constructivism, the Bauhaus, and Surrealism:

 > As a matter of fact, the main instrument of the photographic process
 > is not the camera but the photosensitive layer; the specific rules and
 > methods of photography accord with how this layer responds to
 > lighting effects produced by different materials according to their
 > light or dark, smooth or rough characteristics.
 > (quoted in K. Passuth, *Moholy-Nagy* [London, 1985], p. 302).

18 F. Webster, *The New Photographer: Responsibility in Visual Communi-
 cation* (London, 1980), p. 20.

19 J. Berger, *Ways of Seeing* (Harmondsworth, 1972), p. 10.

20 J. Berger and J. Mohr, *Another Way of Telling* (London, 1982), p. 96.

21 *Ibid*, p. 95.

22 R. Barthes, 'The Photographic Message', in *Image-Music-Text* (ed. and trans. S. Heath; London, 1977), pp. 15–31.

23 R. Barthes, *Camera Lucida: Reflections on Photography* (trans. R. Howard; London, 1984), pp. 88–9.

24 'The Photographic Message', p. 30.

25 R. Barthes, 'The Third Meaning: Research Notes on Some Eisenstein Stills', in *Image-Music-Text*, p. 61.

26 *Ibid.*, p. 57.

27 Graham Clarke's definition of *punctum* (*The Photograph* [Oxford, 1997], p. 36), as that which 'allows us to read [the photograph] critically and to claim it as not so much a token of the real, but as part of a process of signification and representation' seems to me misleading.

28 K. Wales, *A Dictionary of Stylistics* (London, 1989), p. 225.

29 *The New Photographer*, p. 156.

30 J. Hunter, *Image and Word: The Interaction of Twentieth-Century Photographs and Texts* (Cambridge, MA., 1987), p. 168.

31 *Camera Lucida*, p. 76.

32 C. Baudelaire, *Selected Writings on Art and Literature* (trans. P. E. Charvet; London, 1972), p. 295.

33 H. P. Robinson, *The Elements of a Pictorial Photograph* (New York, 1973), p. 76.

34 Clarke, *The Photograph*, p. 24, puts it thus: 'Thus another paradox, for we look at a photograph as recording time, as a historical record, whereas invariably it stops time and, in turn, takes its subject out of history. Every photograph, in that sense, has no before or after: it represents only the moment of its own making.'

35 'Les photographies qui saisissent davantage sont celles où l'imperfection même du procédé pour rendre d'une manière absolue, laisse certaines lacunes, certains repos pour l'oeil qui lui permettent de ne se fixer que sur un petit nombre d'objets' (A. Joubin, ed., *Journal de Eugène Delacroix*, vol. III [Paris, 1932], p. 232).

36 See, for example, *Photography and the Art of Seeing*, pp. 61–4.

37 *Camera Lucida*, pp. 98–9.

38 P. Dubois, *L'Acte photographique et autres essais* (Paris, 1990), pp. 55–108.

39 *Selected Writings on Art and Literature*, p. 296.

40 *The Erl-King*, p. 93.

41 *L'Acte photographique*, pp. 17–53.

42 See, also, A. Solomon-Godeau, *Photography at the Dock: Essays on Photographic History, Institutions, and Practices* (Minneapolis, 1991), p. 233: 'Hence, it is the ramifications of the dual nature of photographic imagery – indexical and iconic – that historically underwrites all debates in and around the medium: its status as art, its status in law, its claims to science, its utility to power, its range of instrumentalities.'

43 *The Erl-King*, pp. 93–4. Antonino Paraggi, the hero of Calvino's 'The Adventure of a Photographer' (*Difficult Loves* [trans. W. Weaver; London, 1985], p. 50), has a very different view: 'It's a question of method. What-

ever person you decide to photograph, or whatever thing, you must go on photographing it always, exclusively, at every hour of the day and night. Photography has a meaning only if it exhausts all possible images.'

44 *On Photography*, pp. 133–5.
45 See Benjamin, 'The Work of Art in the Age of Mechanical Reproduction', in *Illuminations: Essays and Reflections* (ed. H. Arendt, trans. H. Zohn; New York, 1969), pp. 217–51.
46 M. Freeman, *Achieving Photographic Style: Lessons from the Great Professionals* (New York, 1992), p. 158.
47 'A Short History of Photography', p. 215.
48 See, for example, Solomon-Godeau's 'Canon Fodder: Authoring Eugène Atget', *Photography at the Dock*, pp. 28–51.
49 Benjamin, 'On Some Motifs in Baudelaire', in *Illuminations*, p. 163.
50 In a letter to Michael Wilder (30 September 1983), Ansel Adams observes: 'I have done no color of consequence for thirty years! I have a problem with color – I cannot adjust to the limited controls of values and colors. With black-and-white I feel free and confident of results' (quoted in H. M. Callahan, ed., *Ansel Adams in Color* [Boston, 1993], p. 10).
51 'C'est difficile de marier ce que voit l'objectif avec ce qu'on a en soi. Pour cela, le noir et blanc est plus facile' (*Voyons voir*, p. 20).

2 TITLE AND CAPTION: PROJECTING THE PHOTOGRAPHIC IMAGE

1 C. Baudelaire, *Selected Writings on Art and Literature* (trans. P. E. Charvet; London, 1972), pp. 291–2.
2 *Selected Writings*, p. 292.
3 Quoted in H. B. Chipp, *Theories of Modern Art: A Source Book by Artists and Critics* (Berkeley, 1968), p. 117.
4 J.-H. Martin, ed., *Man Ray: Photographs* (London, 1982), p. 35.
5 W. Benjamin, 'A Short History of Photography' (trans. P. Patton), in A. Trachtenberg, ed., *Classic Essays on Photography* (New Haven, 1980), p. 215.
6 P. Joyce, *Hockney on Photography: Conversations with Paul Joyce* (London, 1988), p. 75.
7 R. Samuel, *Theatres of Memory, Vol. I: Past and Present in Contemporary Culture* (London, 1996), p. 335, observes: 'Captioning of photographs is often very *knowing*, suggesting that we are on familiar terms with the subject and are privy to their innermost feelings and thoughts.'
8 M. Tournier, *The Golden Droplet* (trans. B. Wright; London, 1988), pp. 179–80.
9 J. Berger and J. Mohr, *Another Way of Telling* (London, 1982), p. 42.
10 *Ibid.*, pp. 50–51.
11 *Ibid.*, p. 51.
12 Hockney puts it thus: 'However good the photograph, it doesn't haunt you in the way that a painting can. A good painting has real ambiguities which you never get to grips with, and that's what is so tantalizing. You keep looking back. A single-eyed photograph can't have that quality: when you look back, it's the same' (*Hockney on Photography*, p. 18).

13 G. Swift, *Out of this World* (London, 1988), p. 78.
14 Samuel (*Theatres of Memory*, p. 365) makes the following pertinent remark: 'Thus a place name, though seemingly no more than descriptive and locating a particular scene, doubles in the role of a signifier, allowing the single image to stand for a larger whole – a mere back alley in the Bill Brandt picture which he chose to label "Limehouse".'
15 *Out of this World*, p. 105.
16 Quoted in M. Weaver, ed., *The Art of Photography 1839–1989* (London, 1989), p. 266.
17 *Selected Writings*, p. 292.
18 *Ibid.*, p. 294.
19 'A Short History of Photography', p. 215.
20 W. Benjamin, 'On Some Motifs in Baudelaire', in *Illuminations* (ed. H. Arendt, trans. H. Zohn; New York, 1969), p. 191.
21 R. Barthes, *Camera Lucida: Reflections on Photography* (trans. R. Howard; London, 1984), p. 82.
22 *Ibid.*, p. 70.
23 *Ibid.*, p. 53.

3 LISTENING TO THE DOCUMENTARY PHOTOGRAPHER

1 A. Solomon-Godeau, *Photography at the Dock: Essays on Photographic History* (Minneapolis, 1991), p. 170.
2 W. Benjamin, 'A Short History of Photography' (trans. P. Patton), in A. Trachtenberg, ed., *Classic Essays on Photography* (New Haven, 1980), p. 202.
3 P. H. Emerson and T. F. Goodall, *Life and Landscape on the Norfolk Broads* (London, 1886), p. 59 (text by Goodall). We might usefully remind ourselves here of the way that Emerson and Goodall describe the relationship between the text and the photographs:

> Our aim has been to produce a book of art for lovers of art; and the text, far from being illustrated by the plates, is illustrative of and some what supplementary to them; sometimes explanatory, and containing interesting incidental information or folk-lore intended to bring the scene or phase of life treated of more vividly before the reader, and depicting in words surroundings and effects which cannot be expressed by pictorial art.
> ('Preface', unpaginated).

4 J. Berger, 'Photographs of Agony', in *About Looking* (London, 1980), pp. 39–40.
5 T. Hopkinson, 'Introduction', in G. Rodger, *The Blitz: The Photography of George Rodger* (London, 1990), p. 9.
6 C. Killip, *In Flagrante* (with an essay by J. Berger and S. Grant) (London, 1988).
7 T. O'Shea and C. Tóibín, *Dubliners* (London, 1990).
8 N. Waplington, *Living Room* (with essays by J. Berger and R. Avedon) (Manchester, 1991).

9 Brassaï, *The Secret Paris of the '30s* (trans. R. Miller; London, 1976).
10 *In Flagrante*, p. 90.
11 *Living Room*, unpaginated.
12 *The Blitz*, p. 9.
13 D. McCullin, *Hearts of Darkness*, with an introduction by J. Le Carré (London, 1980), p. 10.
14 McCullin's account of his interview with Le Carré, and of the resulting introduction, runs as follows: '...he produced the sort of surgical operation on my psyche for the book that I am sure I did not deserve. Yet he helped me to put a painful, self-searching period behind me' (*Unreasonable Behaviour: An Autobiography* [with L. Chester; London, 1990], p. 227).
15 D. McCullin, *Perspectives* (London, 1987).
16 J. Lewinski, *The Camera at War: A History of War Photography from 1848 to the Present Day* (London, 1978).
17 In McCullin's more recent *Sleeping with Ghosts: A Life's Work in Photography*, with an introduction by M. Haworth-Booth (London, 1994), this photograph is entitled *The Anglia regiment counter-attacking stone-throwers*.
18 In *Sleeping with Ghosts*, this photograph is entitled *Civil war, Cyprus, 1964 – Turks retrieving the body of an old man*.
19 In *Sleeping with Ghosts*, this image has an equally judgemental caption: *The voice of liquor*.
20 This photograph has a slightly blander, less 'interested' gloss in *Sleeping with Ghosts*: *American soldiers humiliating a Vietnamese civilian*.
21 In *Sleeping with Ghosts*, this photograph is entitled *An American marine throwing a hand grenade moments before being wounded by a sniper*. The reciprocating indefinite article – 'An American marine' > 'a sniper' – insinuates a tit-for-tat mechanism.
22 G. Swift, *Out of this World* (London, 1988), pp. 119–20.
23 *Unreasonable Behaviour*, p. 106.
24 In *Sleeping with Ghosts*, this image is encaptioned *Falange gunmen serenading the corpse of a young Palestinian girl*.
25 *Unreasonable Behaviour*, p. 214.
26 *Ibid.*, p. 214.
27 The caption for this image, in *Sleeping with Ghosts*, runs: *An albino boy in a camp of 900 dying children*.
28 *Unreasonable Behaviour*, p. 123.
29 *Ibid.*, p. 123.
30 *Ibid.*, p. 56.
31 *Ibid.*, p. 165.
32 *Ibid.*, p. 56.
33 *Ibid.*, p. 125.
34 *Ibid.*, p. 101.
35 *Ibid.*, p. 123.

4 THE BEHAVIOUR OF CAPTIONS IN THE PRESS

1 All references to newspapers in this chapter are provided in the main text.
2 P. Chippindale and C. Horrie, *Stick It Up Your Punter! The Rise and Fall of the 'Sun'* (London, 1992), p. 18.
3 [...] je voulus jeter un regard sur le Figaro, procéder à cet acte abominable et voluptueux qui s'appelle *lire le journal* et grâce auquel tous les malheurs et les cataclysmes de l'univers pendant les dernières vingt-quatre heures, les batailles qui ont coûté la vie à cinquante mille hommes, les crimes, les grèves, les banqueroutes, les incendies, les emprisonnements, les suicides, les divorces, les cruelles émotions de l'homme d'État et de l'acteur, transmués pour notre usage personnel à nous qui n'y sommes pas intéressés, en un régal matinal, s'associent excellemment d'une façon particulièrement excitante et tonique, à l'ingestion recommandée de quelques gorgées de café au lait.
(M. Proust, 'Sentiments filiaux d'un parricide', in P. Clarac and Y. Sandre, eds, *Contre Sainte-Beuve précédé de Pastiches et mélanges et suivis de Essais et articles* [Paris, 1971], p. 154).
4 G. Swift, *Out of this World* (London, 1988), p. 102.
5 R. Fowler, *Language in the News: Discourse and Ideology in the Press* (London, 1991), p. 15.
6 A 'straw' survey reveals that the percentage of head-and-shoulder shots in the tabloids varies, roughly, between 50% and 65%, and, in the quality papers, between 25% and 35%. A further 'straw' survey of *The Sun* (2 Nov. 1993) reveals thirteen shots of stars of TV and film, nine of pop stars, eight of 'ordinary people', one of a politician. The number of genuine news photos, on 12 Nov. 1993, is recorded as 8% for the *Daily Express*, 21% for *The Sun*, 36% for *The Times*, and 44% for *The Independent*. The percentage of photos in colour, for 17 Nov. 1993, worked out as follows: *Daily Star* (53%), *Daily Express* (45%), *The Sun* (35%), *The Independent* (35%), *The Guardian* (0%). It should be emphasized that these figures are rough and ready, and can be taken to indicate no more than general trends.
7 S. Sontag, *On Photography* (Harmondsworth, 1979), pp. 22–3.
8 *Ibid.*, p. 23.
9 See, for example, *Language in the News*, Chapters 6 and 7.
10 See *Stick It Up Your Punter!*, pp. 55–62 and 128–43.
11 H. Evans, *Pictures on a Page: Photo-Journalism, Graphics and Picture Editing* (London, 1978) has no doubts about the still photograph's power to withstand moving images: 'There was no escape from the still silence of the corpse in Jarecke's photograph. Once seen, it has a permanent place in one's imagination. Anyone who can replay moving images in the mind has a very rare faculty. The moving image may make an emotional impact, but its detail and shape cannot easily be recalled [...]' (unpaginated 'Introduction'). Sontag (*On Photography*, pp. 17–18) has similar things to say: 'Photographs may be more memorable than moving images, because they are a neat slice of time, not a flow. Television is a stream of underselected images, each of which cancels its predecessor.

Each still photograph is a privileged moment, turned into a slim object that one can keep and look at again.'

12 *Pace* J. Berger (with Jean Mohr), *Another Way of Telling* (London, 1982), pp. 92–6 and 111–14.

13 'Le deux-points est un miroir dans lequel se regardent les deux parties de la phrase. La linguistique moderne nomme cela "une assertion adjacente"' (J. Drillon, *Traité de la ponctuation française* [Paris, 1991], p. 396).

14 M. Mauser and N. Turton, eds, *The Penguin Wordmaster Dictionary* (Harmondsworth, 1987), p. 549.

15 *Ibid.*, p. 324.

16 See, for example, J. Hartley, *Understanding News* (London, 1982), and A. Bell, *The Language of the News Media* (Oxford, 1991).

17 T. Trew, '"What the Papers Say": Linguistic Variation and Ideological Difference', and R. Hodge, 'Newspapers and Communities', both in R. Fowler, R. Hodge, G. Kress and T. Trew, eds, *Language and Control* (London, 1979), pp. 117–56 and 157–74; Fowler, *Language in the News*.

18 E.g. Evans, *Pictures on the Page*.

19 E.g. V. Goldberg, *The Power of Photography: How Photographs Changed Our Lives* (New York, 1991).

20 J. Taylor, *Body Horror: Photojournalism, Catastrophe and War* (Manchester, 1998).

5 THE LANGUAGE OF FASHION PHOTOGRAPHY

1 On the subject of fashion and fashion photography, see also J. Craik, *The Face of Fashion: Cultural Studies in Fashion* (London, 1994), and A. Ramamurthy, 'Constructions of Illusion: Photography and Commodity Culture', in L. Wells, ed., *Photography: A Critical Introduction* (London, 1997), pp. 151–98.

2 All references to newspapers and magazines in this chapter are supplied in the main text.

3 See A. Lurie, *The Language of Clothes* (London, 1992).

4 One must not forget here that a woman may be persuaded, or tempted, to construct 'femininity' rather than her own identity: 'Dress, fashion and cosmetics were considered to be trivialities which functioned ideologically to construct a false femininity. Femininity was something that women had been forced to apply, to dress up in; liberation and the search for an authentic self meant taking it off, getting out of it' (C. Evans and M. Thornton, *Women and Fashion: A New Look* [London, 1989], p. 1).

5 E. Wilson, 'Fashion and the Postmodern Body', in J. Ash and E. Wilson, eds, *Chic Thrills: A Fashion Reader* (London, 1992), p. 9.

6 I. Trump, *For Love Alone* (London, 1992), p. 260.

7 *Ibid.*, p. 264.

8 We also need to remember that the materials of this study are limited, roughly speaking, to fashion 'glossies'. There is a whole world of 'alternative' fashion photography, to be found in publications such as C. Nickerson and N. Wakefield, eds, *Fashion: Photography of the Nineties* (Zurich, 1996), which we must inevitably overlook, as we must overlook

developments in 'bad girl', or punk, clothing and modelling (e.g. Eve Salvain, Jenny Shimizu).

9 R. Barthes, *The Fashion System* (trans. M. Ward and R. Howard; London, 1983), p. 242.

10 *Ibid.*, pp. 23–4.

11 R. Quirk, S. Greenbaum, G. Leech and J. Svartvik, *A Comprehensive Grammar of the English Language* (London, 1985), pp. 1337–42.

12 What might this preoccupation with youthfulness imply? 'This is, in part, an instance of fashion's rejection of the mature female body which reflects the fear and repugnance it evokes in contemporary Western culture. The use of very young models, however, also evidences the infantilized and infantilizing nature of fashion' (*Women and Fashion*, p. 98).

13 Fashion photography sometimes borrows poses from the family snap – unposed, friendly, unselfconscious or self-conscious in the wrong way – particularly when it moves more unequivocally towards advertising, or when it exploits dynamic renderings in outdoor settings.

14 *The Fashion System*, pp. 64–5.

15 *Ibid.*, pp. 254–5.

16 *Ibid.*, p. 243.

17 M. Luther, 'Defining the Moment: Photography's Influence on Fashion', in L. Benney, F. Black and M. Bulzone, eds, *The Color of Fashion* (New York, 1992), p. 28.

18 M. Harrison, *Appearances: Fashion Photography Since 1945* (London, 1991), p. 11.

19 W. Packer, *Fashion Drawing in Vogue* (London, 1983), p. 173.

20 J. Sinclair, ed. in chief, *Collins Cobuild English Language Dictionary* (London, 1987), p. 615. The presence of the word 'charm' in this definition might remind us that the etymology of 'glamour' – C18th Scottish variant of 'grammar' – relates it to the casting of magic spells.

21 D. Summers, ed. dir., *Longman Dictionary of Contemporary English* (London, 1987), pp. 1005–6.

22 *The Fashion System*, p. 258.

23 S. Callahan, 'Photography, Fashion, and the Magazines That Made Them', in *The Color of Fashion*, p. 14.

6 NARRATIVE AND TIME-LAPSE PHOTOGRAPHY IN PETER GREENAWAY'S *A ZED & TWO NOUGHTS*

1 For recent treatments of Greenaway's cinematic oeuvre, see B. Elliott and A. Purdy, *Peter Greenaway: Architecture and Allegory* (London, 1997); A. Lawrence, *The Films of Peter Greenaway* (Cambridge, 1997); D. Pascoe, *Peter Greenaway: Museums and Moving Images* (London, 1997).

2 P. Greenaway, *A Zed & Two Noughts* (London, 1986). All further references to this screenplay appear as page numbers in the main text.

3 Pascoe gives much fuller consideration to Muybridge's presence in Greenaway's visual thinking (*Peter Greenaway*, pp. 109–14), but curiously observes that 'his name is not mentioned in the script' (p. 111).

4 Nyman's music also serves a non-visual, narrative strategy, as Greenaway

himself explains: '…one might say that *ZOO* is a story organized around Darwin's Eight Evolutionary Stages. This explains why I asked Michael Nyman, the composer of the film's music, to write a score based on eight musical cells, each more complex than the one before' ('…on peut dire de *ZOO* que c'est un récit organisé autour de huit stades de l'évolution selon Darwin. C'est ainsi que j'ai demandé à Michael Nyman, le musicien du film, une partition basée sur huit cellules musicales, chacune plus complexe que la précédente') (N. Simsolo and P. Pilard, 'ZOO: L'Infini cerclé de vide', *Revue du Cinéma*, CLXV [April 1986], p. 26). The series 'Life on Earth' is also in eight parts.

5 'J'aimerais un cinéma où l'on trouverait normal de voir les films plusieurs fois … J'aime un cinéma qui, au lieu de faire semblant de donner des réponses, pose des questions … Rien que des questions …' ('ZOO: L'Infini cerclé de vide', p. 27).

6 J. K. Cutler and T. E. Benediktsson ('A Zed & Two Noughts', *Film Quarterly*, XLVII [1993–4], p. 39) call the twins 'undifferentiated psychologically because of their obsessive grief'. I think this is mistaken.

7 Pascoe (*Peter Greenaway*, p. 94) mistakenly attributes the cutting up of newspapers to Oswald.

8 But Greenaway's introduction to the screenplay does ask: 'Are animals like car-crashes — Acts of God or mere Accidents — bizarre, tragic, farcical, plotted nowadays into a scenario by an ingenious storyteller, Mr C. Darwin?' (p. 15).

9 The ampersand is peculiarly associated with the world of business and business partnerships, a connection very pertinent to the world of the zoo.

10 'Comment la pourriture devient vie, et redevient pourriture après la vie' ('ZOO: L'Infini cerclé de vide', p. 23).

11 See Cutler and Benediktsson, 'A Zed & Two Noughts', p. 41:

> In his essay 'Freud's Masterplot', Peter Brooks argues that this desire for closure (death) and the concurrent wish to delay and anticipate its fulfillment are intrinsic to the nature of narratives. If narrative systems, as Brooks believes, are inevitably figurations of mortality, then Greenaway's quarrel with narrative can be understood as an attempt to check or defer the necessity of closure, while at the same time acknowledging its inevitability. Plot, after all, is merely another taxonomy, and Greenaway's taxonomies are always structured within a finite series of numbers.

12 'Mon parti pris, c'est de faire un film qui se veut résolument du cinéma, c'est-à-dire artificiel. Et l'un des procédés que j'utilise à cette fin, c'est de concevoir des scènes qui se développent un peu comme au théâtre ou dans l'opéra […] De même le dialogue est "écrit" et les comédiens le disent sans chercher le naturel …' ('ZOO: L'Infini cerclé de vide', p. 27).

13 'Z.O.O. qui ne fait plus qu'1h 50 faisait 3h 30. Il a raccourci les plans, et il a quand même tout utilisé. Il a serré' (H. Niogret, 'Entretien avec Sacha Vierny', *Positif*, CCCII [April 1986], p. 47).

14 'Habituellement, le montage veut se faire oublier, l'enchaînement des images doit paraître "naturel". Moi, je veux, au contraire, que le public

perçoive nettement le montage, le passage d'une scène à une autre [...]
Un peu la même chose avec la musique: je ne cherche pas du tout à ce
qu'elle "se fasse oublier"' ('ZOO: L'Infini cerclé de vide', p. 27).

15 *Time Out*, 17–30 December 1982; French trans. T. M. Kim, *Positif*, CCCII
(April 1986), pp. 27–45.

16 '[...] en tant qu'êtres uniques, nous sommes incomplets et nous cherchons
notre "autre moitié"' ('ZOO: L'Infini cerclé de vide', p. 25).

17 Cutler and Benediktsson, 'A Zed & Two Noughts', p. 37, also point out the
connection between Van Meegeren's surgical skills and the cutting and
splicing of the film.

18 '[...] la nature [...] a une prédilection pour la symétrie et pour les choses
qui vont par deux' ('ZOO: L'Infini cerclé de vide', p. 25).

19 A. Hollander, *Moving Pictures* (Cambridge, MA., 1991), p. 34.

20 Pascoe (*Peter Greenaway*, pp. 114–20) has interesting suggestions to make
about Vermeer's role in the film, as does Lawrence (*The Films of Peter
Greenaway*, pp. 84–91).

21 'J'ai la conviction que Vermeer utilisait un dispositif optique, un peu
comme celui qu'on voit dans *The draughtsman's contract* [*sic*], en plus
perfectionné. Une sorte de "caméra" primitive ...' ('ZOO: L'Infini
cerclé de vide', p. 26).

22 *Moving Pictures*, p. 20.

23 R. Barthes, *Camera Lucida: Reflections on Photography* (trans. R. Howard;
London, 1984), p. 77.

24 It is too easy to assume, it seems to me, that the film script and the film
are essentially the same 'texts' and have the same end in view. There are
not only savoury details that the viewer is likely to miss (e.g., in the
Prologue, Shot 5, a policeman 'dips his finger into egg yolk that is spattered
on the bonnet' [p. 19]), elements that simply cannot be seen (e.g. Fallast's
thunderbolt tie-pin [p. 29]), identifications which are not made
(e.g. Shot 52, the Deuce brothers are playing cards with a pair of *twins*
[p. 84]), but also omissions and additions in the dialogue, scenes whose
circumstances are changed (e.g. Shot 70, the meeting of Alba and Felipe
takes place, in the film, in the zoo itself, rather than in Alba's apartment
bedroom), and sequences whose order is changed (e.g. in the film, Shot 23
precedes Shot 22, Shot 32 precedes Shot 31, and Shot 63 precedes Shot 62).
The film script and the film contribute to each other's construction of a
continuity, and accumulation of 'significant' detail. At the same time,
however, they insidiously and reciprocally undermine each other's
account of things.

7 THE MAGAZINE PHOTO-STORY: THE RISE AND DECLINE
OF A GENRE

1 In its 'Some Hints on Writing Photo Stories', the D. C. Thomson organi-
zation averages the photo-story at 25 frames and the photo-novel at 120
frames. I shall use the term 'photo-story' to cover all magazine examples.

2 S. Saint-Michel, *Le Roman-Photo* (Paris, 1979), p. 13, reminds us that,
from 1855, packets of stereoscopic views depicted stories (e.g. 'A Marriage

under Louis XV') or songs, and that the interview with the celebrated chemist Eugène Chevreul, photographed by Nadar in 1886 (with his son, Paul), was presented as a photo-sequence. We might also mention Henry Peach Robinson's photo-story of Little Red Riding Hood (1858).

3 A. Robbe-Grillet, *The Immortal One* (trans. A. M. Sheridan Smith; London, 1971), pp. 5–6.

4 A. Robbe-Grillet, *Last Year at Marienbad: A Ciné-Novel* (trans. R. Howard; London, 1962), p. 11.

5 For a fuller account of this history, see F. Lecoeuvre and B. Takodjerad, *Les Années roman-photos* (Paris, 1991).

6 I am grateful to Frank Hopkinson, formerly editor of IPC Magazines photo-story publications, for this information.

7 Frank Hopkinson puts the age range of his targeted readership at between eleven and twenty. The publicity formerly used by the D. C. Thomson group of magazines states: 'Our photo stories are aimed at readers in their early teens. The characters can be a little older, perhaps starting their first jobs or going on to college, but for the most part, they are the same age as our readers.'

8 J. Berger, 'Stories', in J. Berger and J. Mohr, *Another Way of Telling* (London, 1982), p. 286.

9 The D. C. Thomson publicity advises budding script-writers:

> The storyline shouldn't be too complicated and should move smoothly from frame to frame. Captions can help a lot, but they should be used sparingly and mainly for the purpose of necessary explanation, where it is better to use a caption than a sequence of photographs. They are also useful to indicate changes of time and place, e.g. 'Later …' and 'That night at the disco …'.

10 *Last Year at Marienbad*, p. 7.

11 S. Eisenstein, *The Film Sense* (trans. and ed. J. Leyda; London, 1986), p. 37.

12 I use 'montaged' here, rather than 'montage', to indicate that I do not mean the Eisensteinian juxtaposition, or intercutting, of images from different spheres, but the sense of one part of the image being superimposed on the other.

13 We should not forget that there are purely practical reasons for the choice of non-exotic locations. As the D. C. Thomson guide to prospective writers puts it: 'Try not to go over the top with exotic locations and dozens of characters. The stories must be practical in terms of photography. We occasionally use "ghost" stories, but remember that there is a limit to the special effects a photographer can produce.'

14 R. Barthes, 'The Third Meaning: Research Notes on Some Eisenstein Stills', in *Image-Music-Text* (trans. and ed. S. Heath; London, 1977), p. 66.

15 M. Kozloff, *The Privileged Eye: Essays on Photography* (Albuquerque, 1987), p. 4.

16 Here, the D. C. Thomson group's set of hints advises: 'Always begin with a photograph and dialogue which will catch the readers' imagination and make them want to read on.'

17 'Alors que dans la B.D. chaque propos est opérationnel, c'est-à-dire doté

d'une fonction narrative ou humoristique, le P.R. est généreux en futilités et babillages qui émaillent les rencontres quotidiennes' (Y. Kobry, 'Le Langage du photo-roman', *Revue d'Esthétique*, III [1974], p. 177).

18 'Là où l'image cinéma est fugitive, voire fugace, celle du roman-photos demeure et constitue une référence. Elle est irréfutable' (M. Pivot, 'Préface', in *Les Années roman-photos*, p. 13).

19 'Parures et vêtements, bien qu'indispensables à la représentation des personnages, ne se détachent jamais à la surface de l'image tant il est vrai qu'ils sont dépourvus de valeur symbolique ou expressive au bénéfice d'une rigueur normative imposée en fonction d'une option esthétique naturaliste' ('Le Langage du photo-roman', p. 171).

20 These kinds of magazine do well to achieve circulation figures of 50,000. *MG* (*My Guy*)'s circulation was 45,400 in April–October 1995. Compare this with the circulation figures of *Shout*: 199,501 (July–December 1997).

21 Je pense d'ailleurs que le créneau dit éducatif est une filière intéressante parce que novatrice. C'est un bon moyen de faire passer un message. De nos jours on associe de plus en plus des bandes dessinées au contenu de livres scolaires. On pourrait envisager sérieusement d'alterner ces illustrations avec des romans-photos qui, j'en suis convaincu, paraîtraient beaucoup plus vivants et plus attrayants pour les jeunes.
(C. Creuzot, 'Les Films du Lézard', in *Les Années roman-photos*, p. 108).

22 Il me semble qu'on néglige un aspect important qui est ce plaisir de lire, ce plaisir de revoir plusieurs fois la même image. L'image télévisuelle détient un pouvoir fugitif alors que la lecture d'un roman-photos avec une mise en scène de qualité, de beaux décors, de beaux acteurs, demeure un plaisir permanent qu'on renouvelle à volonté.
('Hubert Serra', in *Les Années roman-photos*, p. 130).

23 These photo-novels obviously have close affinities with the cinematic photo-story/novel, whose origins are probably to be found in Chris Marker's *La Jetée* (1964). In the early 1990s, several cinematic photo-novels (e.g. *Deadly Tango*, 1990, written by Manuel Vasquez Montalban, photographed and directed by Paolo Nozolino; *The Return*, 1990, written by James Kelman, photographed and directed by Keiichi Tahara; *The Penitent Corpse*, 1991, written by Jean-Pierre Bastid, directed by Stéphane Huter) were shown on Channel 4 and shared the same characteristics: voice-over narrative, interspersed with some direct-speech shots; sound track, including music as well as natural sounds; variation in transitions between shots (cuts, fades, dissolves); bold photographic styles; small moving elements occasionally disturbing the still surface of the photograph (bird flying, cigarette smoking, fire burning, etc.); mobile camera exploring the still (zooming, panning); and variations in the pacing of the 'frames'.

8 THE NARRATIVE RESOURCES OF THE PHOTOGRAPH

1 U. Apollonio, ed., *Futurist Manifestos* (London, 1973), p. 38.
2 *Ibid.*, p. 40.
3 It is usual, and justified, to associate the machine-part close-ups and the odd-angle architectural geometries to be found in the work of Paul Strand and Morton Schamberg with Cubist influence (see Van Deren Coke, 'The Cubist Photographs of Paul Strand and Morton Schamberg', in Van Deren Coke, ed., *One Hundred Years of Photographic History: Essays in Honor of Beaumont Newhall* [Albuquerque, 1975], pp. 35–42). Similar influences are to be found in the photography of Russian Constructivism and the Bauhaus. But Hockney's photocollages are underpinned by the argument that the ocular experience offered by Cubism was never properly understood, a failure he attempts to put right.
4 L. Weschler, ed., *David Hockney: Cameraworks* (London, 1984), p. 9.
5 P. Joyce, *Hockney on Photography: Conversations with Paul Joyce* (London, 1988), p. 18.
6 J. Berger, 'Appearances', in J. Berger and J. Mohr, *Another Way of Telling* (London, 1982), pp. 81–129.
7 J. Berger, 'Drawing', in *The Look of Things: Selected Essays and Articles* (ed. N. Stangos; Harmondsworth, 1972), pp. 165–6.
8 *The Guardian*, 28 October 1988.
9 *Hockney on Photography*, p. 89.
10 A. Robbe-Grillet, *In the Labyrinth* (trans. C. Brooke-Rose; London, 1967), p. 181.
11 *David Hockney: Cameraworks*, p. 11.
12 D. Kenyon, *Inside Amateur Photography* (London, 1992), p. 24.
13 As Patricia Holland puts it: 'Family photography is not expected to be appreciated by outsiders, yet there is a need to produce the correct pictures, as if the audience were the public at large' ('Introduction: History, Memory and the Family Album', in P. Holland and J. Spence, eds., *Family Snaps: The Meanings of Domestic Photography* [London, 1991], p. 7).
14 P. Bourdieu *et al.*, *Photography: A Middle-Brow Art* (Cambridge, 1990), p. 7.
15 *Inside Amateur Photography*, pp. 25–62.
16 'Superficially, women's lack of involvement in vernacular photography is apparent from the infrequency of their camera usage and the overwhelming male orientation of the amateur market' (*Inside Amateur Photography*, p. 43). How true does this remain? Don Slater reminds us that Kodak specifically targeted the female population, while acknowledging that women took on the responsibility of keeping the family's photographic records: '[...] from the start, Kodak heavily targeted women and children as prime consumers of snapshot photography, both as symbols of the extraordinary ease of taking pictures (even they could achieve photographic success) and as those most identified with the emotional continuity and commemoration of the domestic' ('Consuming Kodak', in *Family Snaps*, pp. 54–5).
17 J. Spence, *Putting Myself in the Picture: A Political, Personal and Photographic Autobiography* (London, 1986), p. 82.

18 Waplington's work reminds us that the art of the family snap is not caught in a time capsule. Sally Mann (*Immediate Family*, 1992), for example, uses photography to get to know her growing children, as they connive in the making of images which she can treat as gifts from them.

19 M. Livingstone, 'Certain Words Must Be Said', in *Duane Michals: Photographs – Sequences – Texts 1958–1984* (Oxford, 1984), unpaginated.

20 As J. Roberts puts it:

> For the photographer to place himself or herself into the picture is to immediately invert the place where the truth supposedly resides. Instead of the image serving as the *object* of study, it becomes a shared process of understanding between the photographer/subject and the spectator/subject, a process of transference between photographer and spectator in which what is being theorized is seen to be lived out on the part of the photographer.
> ('Jo Spence: Photography, Empowerment and the Everyday', in *The Art of Interruption: Realism, Photography and the Everyday* [Manchester, 1998], p. 204).

21 *Putting Myself in the Picture*, p. 85.

22 S. Sontag, *On Photography* (Harmondsworth, 1979), pp. 3–24.

23 M. Proust, *Remembrance of Things Past*, vol. 3 (trans. C. K. Scott-Moncrieff and T. Kilmartin; and A. Mayor; Harmondsworth, 1981), pp. 899–900.

24 R. Barthes, *Camera Lucida: Reflections on Photography* (trans. R. Howard; London, 1984), p. 103.

25 *Camera Lucida*, p. 53.

26 *Putting Myself in the Picture*, p. 172. Rosy Martin describes phototherapy as follows:

> . . . photo therapy is about transformation and change. It challenges the fixity of the photographic image and the search for an ideal self. By creating a wide range of images I have been able to examine many different aspects of myself and my past history, and to integrate these into a whole. By acknowledging aspects of myself and my past, which I might otherwise hide, or see as my 'shadow' side, I have freed myself from internalized restrictions and oppressions, and have come to accept myself as I am, complete with all the contradictions that have formed me.
> (*Ibid.*, p. 174).

27 K. Holabird, ed., *Women on Women: Twelve Photographic Portfolios* (London, 1980), unpaginated.

28 F. Bondi, in J. T. Cohen, *In/Sights: Self-Portraits by Women* (London, 1979), p. 116.

29 *Women on Women*, unpaginated.

30 *In/Sights*, pp. vii–viii.

31 *Ibid.*, p. 114.

32 M. Kozloff, *The Privileged Eye: Essays on Photography* (Albuquerque, 1987), p. 102.

33 M. Teitelbaum, 'Preface', in M. Teitelbaum, ed., *Montage and Modern Life 1919–1942* (Cambridge, MA., 1992), p. 8.

34 *The Privileged Eye*, p. 122.

35 For an account of the historical context and political motivations of this photomontage, and for a detailed structural analysis of its composition and meanings, see E. Siepmann, 'Heartfield's Millions Montage: (Attempt at) a Structural Analysis' (trans. S. Gohl), in T. Dennett, J. Spence *et al.*, eds, *Photography/Politics: One* (London, 1980), pp. 38–50.

36 'The Political Uses of Photo-Montage', in *The Look of Things*, p. 185.

37 *Ibid.*, p. 185.

38 C. Phillips, 'Introduction', in *Montage and Modern Life 1919–1942*, pp. 26–7.

9 THE OTHER WAY OF TELLING OF JOHN BERGER AND JEAN MOHR

1 The edition used here is London, 1976. Page references to this edition are provided in the main text. The three texts dealt with in this chapter are analysed by J. Roberts, 'John Berger and Jean Mohr: The Return to Communality', in *The Art of Interruption: Realism, Photography and the Everyday* (Manchester, 1998), pp. 128–43. Roberts's approach concentrates on Berger's 'understated attempt to extend the critical place of the archive within the legacy of the avant-garde' (p. 128).

2 *Another Way of Telling* (London, 1982), p. 37. Roberts observes:

> Photography for Berger was always a specific act of sharing, and it is this notion of photography as a form of social exchange that has dominated his photographic theory and distinguished it from much of the semiotic-deconstructive writing that overlapped with his own interests in the mid to late 1970s.
> ('John Berger and Jean Mohr', p. 128).

3 See M. Price, *The Photograph: A Strange, Confined Space* (Stanford, 1994), pp. 40–43.

4 The edition used here is Cambridge, 1989. Page references to this edition are provided in the main text.

5 G. Dyer, *Ways of Telling: The Work of John Berger* (London, 1986), p. 114.

6 *Ibid.*, p. 115.

7 Around the clock is a votive fresco of twenty women, nude and shameless. The prayer is that his own virility be one day recognized. The vow is that he will not for an instant forget what women are like. The pictures have been taken from posters or magazines published in the metropolis. The women are unlike any he has spoken to. They have instant breasts, instant cunts, which propose instant sex: the proposition as rapid as the action of the press that printed them. (p. 187).

8 N. Papastergiadis, *Modernity as Exile: The Stranger in John Berger's Writing* (Manchester, 1993), p. 94.

9 J. Berger, *Pig Earth* (London, 1979), p. 6.

10 *Modernity as Exile*, p. 14.

11 J. Berger, *And Our Faces, My Heart, Brief as Photos* (London, 1984), p. 95.

12 Curiously, in his comparison of drawing with photography, while Berger allows that drawing combines the time of its own making with the living time of what it portrays, he omits this latter form of temporality from the instantaneousness of the photograph (p. 95).

13 There is already an established photographic practice which uses pictures in sequence: the reportage photo-story. These certainly narrate, but they narrate descriptively from the outsider's point of view. A magazine sends photographer X to city Y to bring back pictures. Many of the finest photographs taken belong to this category. But the story told is finally about what the photographer saw at Y. It is not directly about the experience of those living the event in Y. To speak of their experience with images it would be necessary to introduce pictures of other events and other places, because subjective experience always connects. Yet to introduce such pictures would be to break the journalistic convention. Reportage photo-stories remain eye-witness accounts rather than stories, and this is why they have to depend on words in order to overcome the inevitable ambiguity of the images. In reports ambiguities are unacceptable; in stories they are inevitable. (p. 279).

10 IN CONCLUSION: MODERN NARRATIVE IN PHOTOGRAPH AND FILM

1 M. W. Messmer, 'Apostle to the Techno/Peasants: Word and Image in the Work of John Berger', in D. Downing and S. Bazargan, eds, *Image and Ideology in Modern/Postmodern Discourse* (Albany, 1991), p. 216.

2 J. X. Berger and O. Richon, 'Introduction', in J. X. Berger and O. Richon, eds, *Other Than Itself: Writing Photography* (Manchester, 1989), unpaginated.

3 'Introduction', unpaginated.

4 L. Hutcheon, *The Politics of Postmodernism* (London, 1989), pp. 118–40.

5 For an appreciation of the associative play of colour, see the exposures as they originally appeared in *Other Than Itself*, unpaginated.

6 C. Swann, *Nathaniel Hawthorne: Tradition and Revolution* (Cambridge, 1991), p. 119.

7 T. Tanner and J. Dugdale, eds, *Nathaniel Hawthorne: The Blithedale Romance* (Oxford, 1991), p. 245. All further references to this edition appear as page numbers in the main text.

8 V. Burgin, *Between* (Oxford, 1986), p. 142.

9 'Introduction', unpaginated.

10 G. Levin, *Edward Hopper: The Art and the Artist* (New York, 1980), pp. 58–9.

11 Quoted in *Ibid.*, p. 59.

12 *Between*, p. 154.

13 V. Burgin, *Office at Night*, in *Other Than Itself*, unpaginated.

14 *Between*, p. 6.

15 *Office at Night*, unpaginated.
16 *Ibid.*, unpaginated.
17 Plotinus, quoted in *Ibid.*, unpaginated.
18 *Office at Night*, unpaginated. To keep the record straight, I quote here, in extenso, a comment sent to me by Burgin:

> Unfortunately, the acrostic form does not lend itself to expository clarity. It was not my intention to link psychoanalysis to the Platonic doctrine of understanding achieved through a simple act of vision. This would be to slander psychoanalysis. Psychoanalytic theory demonstrates that 'just looking' can never guarantee understanding. Indeed, this might be considered the very founding insight of psychoanalysis. Medical psychiatry before Freud was a science of appearances. Jean Martin Charcot, with whom Freud briefly studied, commissioned a volume of photographs depicting the bodily postures adopted by his hysterical patients at the Salpetrière hospital in Paris. He hoped that the images would provide doctors with a means of diagnosing mental illnesses. Freud made a radical break with the established medical tradition of diagnosis through observation. Not content to look at his patients he listened to them.

> The significance of these last words has already been explored in our treatment of John Sassall, in Berger and Mohr's *A Fortunate Man*. Burgin's critique of the 'purely visual' can be found in 'Seeing Sense' (1980), while his discussion of tableau and hieroglyph appears in 'Diderot, Barthes, *Vertigo*' (1984); both essays are reprinted in *The End of Art Theory: Criticism and Postmodernity* (London, 1986), pp. 51–70 and 112–39.

19 The effects of the interplay of colour bands can be seen in the sequence as published in its entirety in *Other Than Itself*, unpaginated.
20 J. Evans, 'Victor Burgin's Polysemic Dreamcoat', in J. Roberts, ed., *Art Has No History: The Making and Unmaking of Modern Art* (London, 1994), p. 222.
21 *Ibid.*, pp. 224–5.
22 Le fort effort de réel produit par l'image photographique va, de la même manière, imposer à mon esprit la présence des choses comme un perpétuel défi au réalisme, à cause de cette fascinante impossibilité que je ressens d'assigner aux divers éléments du message une place stable, des limites strictes, un sens unique et définitif. Dans les deux cas – le réel ou l'effet de réel – les choses ne vont certes pas m'apparaître comme le *n'importe-quoi* du non-sens, mais comme un appel au sens sans cesse déçu, un univers mobile de significations multiples, contradictoires, glissantes, toujours provisoires et ambiguës.
(A. Robbe-Grillet, 'Pour le roman-photo', in E. Lachman and E. Levine, *Chausse-Trappes* [trans. B. Eisenschitz; Paris, 1981], p. I).
23 R. L. Francis, 'Transcending Metaphor: Antonioni's *Blow-Up*', *Literature/Film Quarterly*, XIII (1985), pp. 46–7.
24 M. Antonioni, *Blow-Up* (London, 1971), p. 5. All further references to this screenplay appear as page numbers within the main text.

25 See S. Chatman, *Antonioni or, The Surface of the World* (Berkeley, 1985), pp. 144–52.
26 R. Barthes, *Camera Lucida: Reflections on Photography* (trans. R. Howard; London, 1984), pp. 89–90.
27 S. Sontag, *On Photography* (Harmondsworth, 1979), pp. 17–18.
28 M. Price, *The Photograph: A Strange, Confined Space* (Stanford, 1994), p. 3.
29 B. Peeters, 'Construire l'instant: Entretien de Benoît Peeters et Marie-Françoise Plissart avec Hubertus von Amelunxen', *Revue des Sciences Humaines*, 81 (1988), p. 89.
30 As opposed to the official feast, one might say that carnival celebrated temporary liberation from the prevailing truths and from the established; it marked the suspension of all hierarchical rank, privileges, norms, and prohibitions. Carnival was the true feast of time, the feast of becoming, change and renewal. It was hostile to all that was immortalized and completed.
(Mikhail Bakhtin, *Rabelais and his World* [tr. Hélène Iswolsky; Bloomington, 1984], p. 10).

Select Bibliography

Antonioni, M., *Blow-Up* (London, 1971)

Apollonio, U., ed., *Futurist Manifestos* (London, 1973)

Ash, J., and E. Wilson, eds, *Chic Thrills: A Fashion Reader* (London, 1992)

Bakhtin, M., *Rabelais and his World* (trans. H. Iswolsky; Bloomington, 1984)

Barthes, R., *Image-Music-Text* (ed. and trans. S. Heath; London, 1977)

——, *The Fashion System* (trans. M. Ward and R. Howard; London, 1983)

——, *Camera Lucida: Reflections on Photography* (trans. R. Howard; London, 1984)

Baudelaire, C., *Selected Writings on Art and Literature* (trans. P. E. Charvet; London, 1972)

Bell, A., *The Language of the News Media* (Oxford, 1991)

Benjamin, W., *Illuminations: Essays and Reflections* (ed. H. Arendt, trans. H. Zohn; New York, 1969)

——, 'A Short History of Photography' (trans. P. Patton), in A. Trachtenberg, ed., *Classic Essays on Photography* (New Haven, 1980), pp. 199–216

Benney, L., F. Black and M. Bulzone, eds, *The Color of Fashion* (New York, 1992)

Berger, J., *The Look of Things: Selected Essays and Articles* (ed. N. Stangos; Harmondsworth, 1972)

——, *Ways of Seeing* (Harmondsworth, 1972)

——, *About Looking* (London, 1980)

——, and J. Mohr, *A Fortunate Man: The Story of a Country Doctor* (London, 1976)

——, *Another Way of Telling* (London, 1982)

—— *A Seventh Man: The Story of a Migrant Worker in Europe* (Cambridge, 1989)

Berger, John X., and O. Richon, eds, *Other Than Itself: Writing Photography* (Manchester, 1989)

Borhan, P., *Voyons voir* (Paris, 1980)

Bourdieu, P., *et al.*, *Photography: A Middle-Brow Art* (Cambridge, 1990)

Brassaï, *The Secret Paris of the '30s* (trans. Richard Miller; London, 1976)

Burgin, V., *Between* (Oxford, 1986)

——, *The End of Art Theory: Criticism and Postmodernity* (London, 1986)

——, ed., *Thinking Photography* (London, 1982)

Callahan, H. M., ed., *Ansel Adams in Color* (Boston, 1993)

Chatman, S., *Antonioni or, The Surface of the World* (Berkeley, 1985)

Chipp, H. B., ed., *Theories of Modern Art: A Source Book by Artists and Critics* (Berkeley, 1968)

Chippindale, P., and C. Horrie, *Stick It Up Your Punter! The Rise and Fall of the 'Sun'* (London, 1992)

Clarke, G., *The Photograph* (Oxford, 1997)

Cohen, J. T., *In/Sights: Self Portraits by Women* (London, 1979)

Coke, V. D., ed., *One Hundred Years of Photographic History: Essays in Honor of Beaumont Newhall* (Albuquerque, 1975)

Craik, J., *The Face of Fashion: Cultural Studies in Fashion* (London, 1994)

Cutler, J. K., and T. E. Benediktsson, 'A Zed & Two Noughts', *Film Quarterly*, XXXXVII/2 (1993–4), pp. 36–42

Daval, J.-L., *Photography: History of an Art* (Geneva and New York, 1982)

Downing, D., and S. Bazargan, eds, *Image and Ideology in Modern/Postmodern Discourse* (Albany, 1991)

Drillon, J., *Traité de la ponctuation française* (Paris, 1991)

Dubois, P., *L'Acte photographique et autres essais* (Paris, 1990)

Dyer, G., *Ways of Telling: The Work of John Berger* (London, 1986)

Eisenstein, S., *The Film Sense* (ed. and trans. J. Leyda; London, 1986)

Elliott, B., and A. Purdy, *Peter Greenaway: Architecture and Allegory* (London, 1997)

Emerson, P. H., and T. F. Goodall, *Life and Landscape on the Norfolk Broads* (London, 1886)

Evans, C., and M. Thornton, *Women and Fashion: A New Look* (London, 1989)

Evans, H., *Pictures on a Page: Photo-Journalism, Graphics and Picture Editing* (London, 1978)

Fowler, R., *Language in the News: Discourse and Ideology in the Press* (London, 1991)

——, R., R. Hodge, G. Kress and T. Trew, eds, *Language and Control* (London, 1979)

Francis, R. L., 'Transcending Metaphor: Antonioni's *Blow-Up*', *Literature/Film Quarterly*, XIII (1985), pp. 42–9

Freeman, M., *Achieving Photographic Style: Lessons from the Great Professionals* (New York, 1992)

Goldberg, V., *The Power of Photography: How Photographs Changed Our Lives* (New York, 1991)

Greenaway, P., *A Zed & Two Noughts* (London, 1986)

Harrison, M., *Appearances: Fashion Photography Since 1945* (London, 1991)

Hartley, J., *Understanding News* (London, 1982)

Holabird, K., ed., *Women on Women: Twelve Photographic Portfolios* (London, 1980)

Holland, P., and J. Spence, eds, *Family Snaps: The Meanings of Domestic Photography* (London, 1991)

Hollander, A., *Moving Pictures* (Cambridge, MA., 1991)

Hunter, J., *Image and Word: The Interaction of Twentieth-Century Photographs and Texts* (Cambridge, MA., 1987)

Hutcheon, L., *The Politics of Postmodernism* (London, 1989)

Joubin, A., ed., *Journal de Eugène Delacroix*, vol. III (Paris, 1932)

Joyce, P., *Hockney on Photography: Conversations with Paul Joyce* (London, 1988)

Kenyon, D., *Inside Amateur Photography* (London, 1992)

Killip, C., *In Flagrante* (with an essay by John Berger and Sylvia Grant; London, 1988)

Kobry, Y., 'Le Langage du photo-roman', *Revue d'Esthétique*, III/IV (1974), pp. 155–81

Kozloff, M., *The Privileged Eye: Essays on Photography* (Albuquerque, 1987)

Krauss, R., *The Originality of the Avant-Garde and Other Modernist Myths* (Cambridge, MA., 1986)

Lawrence, A., *The Films of Peter Greenaway* (Cambridge, 1997)

Lecoeuvre, F., and B. Takodjerad, *Les Années roman-photos* (Paris, 1991)

Levin, G., *Edward Hopper: The Art and the Artist* (New York, 1980)

Lewinski, J., *The Camera at War: A History of War Photography from 1848 to the Present Day* (London, 1978)

Livingstone, M., 'Certain Words Must Be Said', in *Duane Michals: Photographs – Sequences – Texts 1958–1984* (Oxford, 1984) unpaginated

Lurie, A., *The Language of Clothes* (London, 1992)

McCullin, D., *Hearts of Darkness* (with an introduction by John Le Carré; London, 1980)

——, *Perspectives* (London, 1987)

——, *Unreasonable Behaviour: An Autobiography* (with Lewis Chester; London 1990)

——, *Sleeping with Ghosts: A Life's Work in Photography* (with an introduction by Mark Haworth-Booth; London, 1994)

Martin, J.-H., ed., *Man Ray: Photographs* (London, 1982)

Mitchell, W., T*he Reconfigured Eye: Visual Truth in the Post-Photographic Era* (Cambridge, MA., 1992)

Nickerson, C., and N. Wakefield, eds, *Fashion: Photography of the Nineties* (Zurich, 1996)

Niogret, H., 'Entretien avec Sacha Vierny', *Positif*, CCCII (April 1986), pp. 46–52

O'Shea, T., and C. Tóibín, *Dubliners* (London, 1990)

Packer, W., *Fashion Drawing in Vogue* (London, 1983)

Papastergiadis, N., *Modernity as Exile: The Stranger in John Berger's Writing* (Manchester, 1993)

Pascoe, D., *Peter Greenaway: Museums and Moving Images* (London, 1997)

Passuth, K., *Moholy-Nagy* (London, 1985)

Patterson, F., *Photography and the Art of Seeing* (Toronto, 1989)

Peeters, B., 'Construire l'instant: Entretien de Benoît Peeters et Marie-Françoise Plissart avec Hubertus von Amelunxen', *Revue des Sciences Humaines*, LXXXI (1988), pp. 83–96

Price, M., *The Photograph: A Strange, Confined Space* (Stanford, 1994)

Quirk, R., S. Greenbaum, G. Leech and J. Svartvik, *A Comprehensive Grammar of the English Language* (London, 1985)

Robbe-Grillet, A., *Last Year at Marienbad: A Ciné-Novel* (trans. R. Howard; London, 1962)

——, *The Immortal One* (trans. A. M. Sheridan Smith; London, 1971)

——, 'Pour le roman-photo', in E. Lachman and E. Levine, *Chausse-Trappes* (trans. B. Eisenschitz; Paris, 1981)

Roberts, J., *The Art of Interruption: Realism, Photography and the Everyday* (Manchester, 1998)

———, ed., *Art Has No History: The Making and Unmaking of Modern Art* (London, 1994)

Robinson, H. P., *The Elements of a Pictorial Photograph* (New York, 1973)

Rodger, G., *The Blitz: The Photography of George Rodger* (London, 1990)

Saint-Michel, S., *Le Roman-Photo* (Paris, 1979)

Samuel, R., *Theatres of Memory Vol. I: Past and Present in Contemporary Culture* (London, 1996)

Schwarz, H., *Art and Photography: Forerunners and Influences* (ed. W. E. Parker; Chicago, 1987)

Siepmann, E., 'Heartfield's "Millions" Montage: (Attempt at) a Structural Analysis' (trans. S. Gohl), in T. Dennett, J. Spence *et al.*, eds, *Photography/Politics: One* (London, 1980), pp. 38–50

Simsolo, N., and P. Pilard, 'ZOO: L'Infini cerclé de vide', *Revue du Cinéma*, XLV (April 1986), pp. 23–7

Solomon-Godeau, A., *Photography at the Dock: Essays on Photographic History* (Minneapolis, 1991)

Sontag, S., *On Photography* (Harmondsworth, 1979)

Spence, J., *Putting Myself in the Picture: A Political, Personal and Photographic Autobiography* (London, 1986)

Swann, C., *Nathaniel Hawthorne: Tradition and Revolution* (Cambridge, 1991)

Tanner, T., and J. Dugdale, eds, *Nathaniel Hawthorne: The Blithedale Romance* (Oxford, 1991)

Taylor, J., *Body Horror: Photojournalism, Catastrophe and War* (Manchester, 1998)

Teitelbaum, Matthew, ed., *Montage and Modern Life 1919–1942* (Cambridge, MA., 1992)

Waplington, N., *Living Room* (with essays by John Berger and Richard Avedon; Manchester, 1991)

Weaver, M., ed., *The Art of Photography 1839–1989* (London, 1989)

Webster, F., *The New Photographer: Responsibility in Visual Communication* (London, 1980)

Wells, L., ed., *Photography: A Critical Introduction* (London, 1997)

Weschler, L., ed., *David Hockney: Cameraworks* (London, 1984)

Wright, T., 'Photography: Theories of Realism and Convention', in E. Edwards, ed., *Anthropology and Photography 1860–1920* (New Haven and London, 1992), pp. 18–31

Photographic Acknowledgements

The author and publishers wish to express their thanks to the following sources of illustrative material and/or permission to reproduce it:

© AFP/Eric Cabanis: 24; © John Angerson: 30; the author: 53; courtesy of Anna Bardwell-Dix: 52; © John X. Berger: 69–79; Bibliothèque Nationale de France, Paris: 8; © Victor Burgin: 80, 81; © Henri Cartier-Bresson/Magnum Photos: 10, 11; © *Cosmopolitan*/Richard Imrie: 34; Crookes Healthcare: 6; © DACS, 1998: 55, 56, 58; Dunlopillo: 5; © *Cosmopolitan*/Andrew Dunn: 33; Family of P. H. Emerson: 16, 57; Gallimard/Le Sourire Qui Mord: 46; Martin Gardner/*The Guardian*: 31; © *The Guardian*: 23, 29; *The Guardian*/'PA' News: 25; © Hergé/Moulinsart 1998: 41; © David Hockney: cover, 48–51; Courtesy of Frank Hopkinson: 40, 43–5; *The Independent*/Edward Sykes: 28; Neil Kirk/*Elle*: 35; Lancio France: 42; © Don McCullin: 17–22; © Man Ray Trust/ADAGP, Paris and DACS, London, 1998: 4; © Ministère de la Culture – France/A.A.J.H.L.: 14; © Jean Mohr: 9, 59–70; The National Magazine Company: 33, 34; Popperfoto/Yannis Behrakis: 27; Popperfoto/Mark H. Milstein: 26; George Rodger/Katz Pictures: 13; © Willy Ronis/RAPHO: 3; The Royal Photographic Society Collection, Bath: 7, 54; © David Seymour/Magnum Photos: 12; Julie Sleaford/*The Observer*: 32; V&A Picture Library: 2; Paul Viant/*Prima*: 36.

Index

This index does not include the names of factual 'characters' who appear in newspapers or films. A page number may refer to a page where the person listed is quoted but not named. Italicized page numbers refer to illustrations.